The Tory View of Landscape

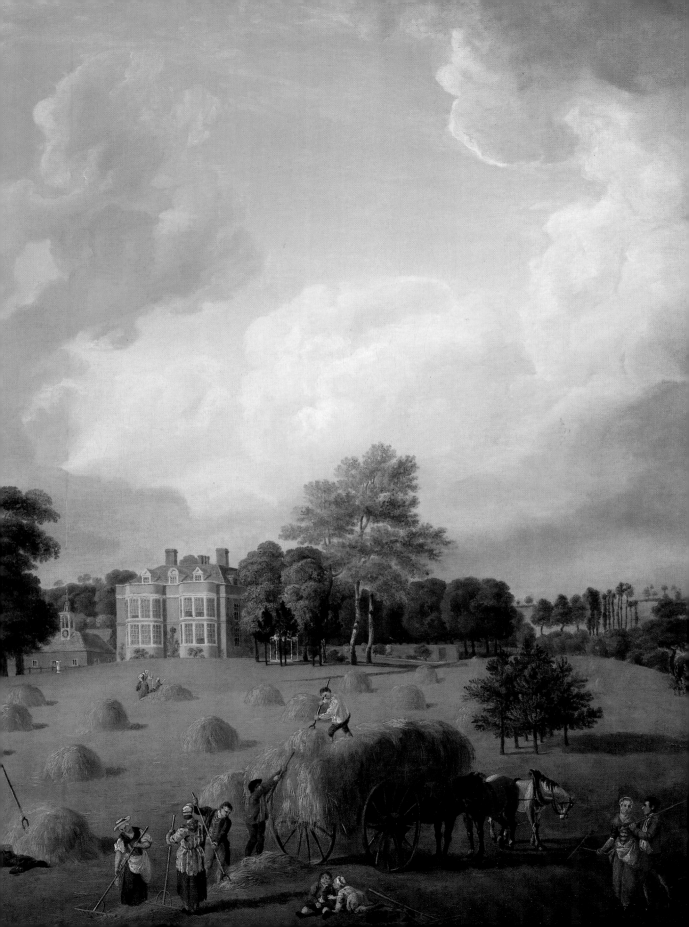

The Tory View of Landscape

NIGEL EVERETT

Published for
THE PAUL MELLON CENTRE
FOR STUDIES IN BRITISH ART
by
YALE UNIVERSITY PRESS
New Haven & London

Frontispiece: Detail of plate 12, showing a view of Jennings Park.

Designed by Gillian Malpass
Set in Sabon by Best-set Typesetter Ltd, Hong Kong
Printed in Hong Kong through World Print Ltd

Library of Congress Cataloging-in-Publication Data
Everett, Nigel.
The Tory View of landscape / Nigel Everett.
256 pp. 25.6 × 19.2 cm.
Includes bibliographical references and index.
ISBN 0-300-05904-3
1. Great Britain–Historical geography. 2. Landscape–Political
aspects–Great Britain–History. 3. Land use–Political aspects–
Great Britain–History. 4. Culture–Political aspects–Great
Britain–History. 5. Nature–Political aspects–Great Britain–
History. 6. Great Britain–Civilization–18th century. 7. Great
Britain–Civilization–19th century. 8. Tories, English.
I. Title.
DA600.E93 1994
911′.41—dc20 94-2734
CIP

A catalogue record for this book is available from
The British Library

Contents

Illustrations

Acknowledgements

Several versions of this book were read by Michael Rosenthal and John Barrell who made a large number of helpful criticisms and contributed substantially to its final form. I am particularly grateful for their help and encouragement because their own approaches to the issues discussed here are often quite different from my own. Gillian Malpass of Yale University Press has been a most helpful and tolerant supporter of the project.

I have discussed the material treated in this book over a number of years with David Dallas who has been particularly helpful in pointing out illustrative material. Anthony Mould kindly brought my attention to the painting of Esholt Hall and supplied background information relating to it. Lowell Libson of the Leger Gallery provided valuable material relating to the work of Thomas Jones. Richard and Diana Lamb were enthusiastic guides to Hafod during a memorable long weekend in Cardiganshire. George Dallas supplied helpful material relating to Stowe and was kind enough to arrange a tour of the gardens. Major David Davenport and Sir John Cotterell, Bt. kindly allowed access to what remains of Uvedale Price's plantations at Foxley, and to original material by Humphry Repton. The staffs of the University Library at Cambridge and of the Acton Library and Kunsthistorisches Institut in Florence have been most helpful.

A number of friends have assisted, in various ways, in the writing of this book, particularly Mario Angelini, Jon and Annie Auerbach, Serena Dallas, Eden Endfield, Henry Ford, Kitty and Mary Rose Gearon, Martin Golding, Andrew Green, Michael Halls, Barbara Kirschten, Lorna Koski, Rupert Maas, Roland Mayer, David McEuen, Michael Meehan, Mungo Park, Hamish Parker, Oona Sperr, Angela Webster, and Angela Wilkes.

This book is dedicated to my wife Lisa, who spent a good part of 1993 typing and criticizing numerous versions of the text while involved in the more important task of giving birth to a most promising daughter.

Redemption

Having been tenant long to a rich Lord,
 Not thriving, I resolved to be bold,
 And make a suit unto him, to afford
A new small-rented lease, and cancell th' old.

In heaven at his manour I him sought:
 They told me there, that he was lately gone
 About some land, which he had dearly bought
Long since on earth, to take possession.

I straight return'd, and knowing his great birth,
 Sought him accordingly in great resorts;
 In cities, theatres, gardens, parks, and courts:
At length I heard a ragged noise and mirth

 Of theeves and murderers: there I him espied,
 Who straight, *Your suit is granted*, said, & died

George Herbert

Introduction

The use of the word Tory to describe a theme of English writing from the mid-eighteenth century to the first two decades of the nineteenth is undeniably loose and involves certain difficulties. Many of the writers here held to contribute to the idea would, particularly in the eighteenth century, have regarded themselves more or less passionately as Whigs. In the twentieth century the use of the word as shorthand for the Conservative Party inevitably tends to conceal the increasing dominance in that party of a version of what in the nineteenth century would generally have been described as 'liberal' values. This study does not attempt to describe the complex history of Toryism; it employs the term broadly and simply in the sense that it may be used, more or less controversially, of writers as diverse as Jane Austen, Wordsworth, Southey, Coleridge, and Ruskin. In this sense, Toryism was one of the diverse bodies of opinion that stood against the dominant theories of political economy which, often claiming to be based above all on the economic writings of Adam Smith, seemed to argue that society was best conceived as a conglomeration of prudently self-regarding individuals divorced as far as possible from traditional restraints and with little responsibility to a future incompatible with present self-interest.

The Tory idea of landscape described here is a point of view opposed to a narrowly commercial conception of life and associated with a romantic sensibility to the ideas of continuity and tradition felt to be embodied in certain kinds of English landscape. In a simple form it is expressed perfectly in Ford Madox Ford's hero Christopher Tietjens, 'the last Tory', whose loyalty to England is in large part founded in landscapes that remind him of the life and values of George Herbert and certain political principles perfected in the seventeenth century. He assumes, like many before him, that some older sense of conscience, tradition, and manners has given way to a generalized selfishness, coarseness of sentiment, and specious habits of reasoning used to justify self-interest. He links together imaginatively his values of cultivated Anglicanism, accuracy of thought, and the responsible ownership of land, with English church towers, 'quiet fields', 'heavy-leaved timbered hedgerows', and 'slowly creeping ploughlands, moving up the slope'. The landscape has outlived the values that are imagined to have created it — 'the land remains' — but the total triumph of the new over the old must soon lead to its destruction. The land will be seen as a source of potential profit like any other commodity. While Tietjens may be

envisaged as the last Tory, similar values took a while longer to disappear from the cultural vocabulary. One of their last concerted expressions was in the set speeches at the Cublington public inquiry in the late 1960s, when objectors to the siting of the proposed third London airport talked sentimentally of the value to countrymen of their attachments to the 'land which bore us' and made analogies with English oaks whose roots run deeply into ancestral earth. Clergymen quoting Latin sources spoke of the divine wrath that would await those who desecrated ancient churches and churchyards. They sought to equate a traditional landscape with evident 'spiritual and moral values'.[1]

An early, brilliant assault on the Tory view was contained in Thomas Babington Macaulay's *Edinburgh Review* essay of 1830 on Robert Southey's *Colloquies*, in which Sir Thomas More returns to berate the condition of a quickly industrializing England. Southey had been increasingly distressed by the rise of 'what are called liberal opinions' and by the unnatural ugliness of the new industrial system. He was at the same time offended by the conditions in which the workers, including children, seemed forced to live, virtually unregulated as to length of labour, safety, and health, and saw them dehumanized by these conditions and by the effects of the division of labour. The blighting of the earth and sky by the growth of the industrial system, and the congregation in towns of large numbers neglected in their mental, moral, and physical improvement, would destroy at once the traditional landscape and the health of civil society. Only through a revival of traditional social relations and reinforced religious sentiment, and of personal responsibility combined with government regulation, could disaster be avoided.[2]

For Macaulay this was sheer nonsense. Southey had made his taste for the recently fashionable picturesque the test of all political good. Weather-stained cottages, set beautifully and apparently naturally in the landscape, were in reality images of early mortality and crushing poor rates. Unmellowed factories, unlikely ever to harmonize with nature, were signs of independence and health; or at least they would become so as the levels of mortality, still greater in the towns than in the country, would inevitably tend to improve in favour of the former. The regulations and barriers to progress demanded by Southey and others would merely serve to strengthen the power of the 'all-devouring' State, which is always inherently inefficient and corrupt. To confuse aesthetic concerns with political, as Southey had done, was absurd; government is not a branch of the fine arts in which actions are to be judged by their effect on the imagination, as in a painting. Chains of association cannot substitute for reasoning, and opinions be merely expressions of taste. The proper function of goverment is to deregulate, to remove all those barriers which might prevent capital from following its most lucrative course and commodities finding their fair price. Industry and intelligence should be left to attain their natural reward and idleness and folly their natural punishment. Instead of relying upon government and regula-tion, men should look to the natural tendency of society to improvement and the natural tendency of the human intellect to discover truth. In the market of ideas the best will succeed, and in the market of social relations each man's pur-suit of self-interest will eventually lead to the universal benefits of greater wealth and enlightenment.[3]

The passing of the Poor Law Amendment Act of 1834, usually regarded as an expression of the Benthamite branch of English liberalism, suggested that there was a natural tendency to intrusive government among some liberals as well as Tories. The chaotic state of the eighteenth-century poor laws, which left much to local and individual discretion, was to be resolved through general and therefore centralized principles which sought to concentrate relief in new workhouses. Like the improved prisons and lunatic asylums, they were intended to be highly disciplined and scientifically organized. To many the new arrangements seemed to institutionalize the punishment of poverty, already harshly dealt with by market forces and human neglect. In 1835 William Wordsworth argued that the new Act proceeded too much on the idea that necessitous poverty was a sign of fault or individual guilt, without attending to all the circumstances, such as sickness, injury, or fluctuations in wages and prices, that might drive men into dependence. Wordsworth argued that much distress arose from the incompetence of masters in the management of commerce and from the recklessness of governments, often acting under the influence of the rules of political economy, in the sudden deregulation of industries or the alteration of credit. He endorsed the more traditional view that all who were unemployed or who received wages insufficient to support their families in health should be entitled to maintenance as a right inherent in society. He argued that all forms of employment were not interchangeable; a man skilled in one trade, and thrown out of work, should not necessarily be expected to undertake other work unsuited to his skills. Political economy, as an abstraction, was not to be placed above what Wordsworth termed the 'instincts and wisdom of the heart', and the various tempers, dispositions, and circumstances of individuals.[4]

Wordsworth felt that the new Act tended to penalize generosity and disinterestedness by making it more difficult for men to share their savings or time and in any way neglect their own immediate needs in favour of the relief of others. It promoted a culture of selfish individualism in which the only sources of respect and security were in personal prosperity. To object to this was, as Wordsworth made clear, partly a question of taste regarding the pains and pleasures of living in such a state of society and a personal sense of whether its tendency was to degrade or exalt human nature. Such issues seemed inseparable, however, from questions of common prudence regarding the stability of public order. The selfish, without any legal obligation for the relief of distress, would transfer the whole burden to the benevolent. The frequent observation of suffering in real life, unlike in fiction, tends to harden the heart and even the benevolent, distressed by their incapacity to help and to turn sympathy into effective action, would soon begin to shrink from attentive observation and relief. Society, appearing to place little value on life, would leave the necessitous to the uncertain benefits of occasional charity, to despair, or to crime as a desperate act of self-preservation. Wordsworth accepts the argument, central to eighteenth-century constitutional theory, that the right to self-preservation, being founded in nature, remains valid in civil society and is, in principle, a higher claim than individual property rights. Men could not be expected to give allegiance to society if they received no reciprocal benefits from it and did not feel that their own lives and attachment to that society were of some value.

Like Southey in Macaulay's interpretation, Wordsworth is obliged to look to the State as a guarantor of equity. He describes a Christian government standing *in loco parentis* before all its members, seeking to ensure that nobody would perish by the neglect or harshness of its laws. The provision of such security would not lead to the ruin of industry and individual effort. Despondency, distraction, and the ruin of cheerfulness by anxiety would promote, not prudence, but reckless hopelessness. Dependence on casual charity, administered in circumstances that humiliate a poverty that is constantly surrounded by images of private wealth, often gained by thoughtless greed, would undermine the entire order of society, including its capacity for commercial expansion. Partly because of this, and despite theories of political economy, the masters would be obliged eventually to support some system of compulsory minimum provision to maintain order and to allow them more flexibility in regulating the price and availability of labour in response to international competition. The question was how much damage would be done to individuals and to society before the masters realized this necessity and how limited or restrictive of freedom their minimum provision would be. Partly to defend the workmen against the natural tendency of the masters to combine together to regulate, and in general keep down the price of labour, Wordsworth advocated the removal of the statutes that tended to discourage the creation of small enterprises in which workmen could have a direct interest in their own labour. Such changes, together with minimum levels of support and a free system of compulsory education, would help to produce a society at once more contented, equitable, and consistently productive.

Wordsworth offered these comments, among many others, in a postscript to his poems because he felt that the inexorable rise of the doctrines of political economy was incompatible with the general tendency of his work. No reader truly appreciative of his poetry and his vision of the English landscape could give much credit to such doctrines. Wordsworth's idea of nature was not Macaulay's: improvement in society was not some spontaneous fruition of growth that expressed itself in constant amelioration. It was a gradual and uncertain process of deliberate cultivation, of reconciliation and composition, in which it was important that the instincts of commercialism and change be balanced by more or less permanent bodies, in large part resident in the country. Men had a direct responsibility to the past as well as to the future, inseparable from their responsibility to the existing physical, moral, and social landscape.

Traditional social relations, in Tory terms, emphasized a hierarchical view of society in which wealth was supposed to be accompanied by obligations and rank by duties. Dependent poverty was a complex problem that could not be resolved in the simple terms suggested by such important enthusiasts for the New Poor Law as Edwin Chadwick and Nassau Senior, who insisted that the workhouse was to be held *in terrorem* over the poor, made 'as disagreeable as it can be made' in order that no one would willingly enter it. In *A Word for the Poor* (1843) Sir George Crewe follows Wordsworth in denouncing the new legislation as being designed merely to defend the property of the rich and showing no concern with the minutiae of the actual circumstances of its victims. He writes in a traditional, paternal language, as

one who seeks to mix with the poor and is familiar with their virtues, needs, and difficulties. In the formulation of the law, Crewe declares:

> Necessity was called Improvidence; Despair was deemed Recklessness; the Broken-hearted and worn-out were called Idle and Importunate; and the struggle of the Destitute to keep life and soul together was characterized living upon the Poor Rates — no allowance made for Ignorance — none for Neglect.

The New Poor Law had dissolved the ancient bonds of civil society and replaced them with the abstract certainties of economic theory.[5]

A similiar, even more urgent debate between Tory views of social obligation and versions of liberal ideology characterized some important aspects of the English response to the disastrous situation of Ireland in the 1840s, the period of the Great Famine. On 30 March 1846, speaking in a debate in the House of Lords, Lord Londonderry declared that he was 'deeply grieved' at the brutal eviction of seventy-six families at Ballinglass, County Galway. They had been 'mercilessly driven' even from the shelter of nearby ditches. Such scenes, Londonderry insisted, meant that it was hardly 'to be wondered at' that 'deeds of outrage and violence should occasionally be attempted'. Londonderry was not a sentimental man; in 1842, for example, he had led the campaign of the mine owners against government regulation. He had, however, been offended by a speech given by Lord Brougham, one of the principal promoters of the New Poor Law in England, who had insisted on the 'sacred' right of the landlord, in Ireland as in England, 'to do as he pleased'. If the landowner 'conferred a favour' he was 'doing an act of kindness'; all tenants challenging, in any way, the legal rights of the landlord must 'be taught by the strong arm of the law that they had no power to oppose or resist'. Such a defence of the landlord's authority was essential, since without it property would be valueless and 'capital would no longer be invested in cultivation of land'. Charles Trevelyan, in charge of Government supplies during the famine, was also an enthusiast for a certain kind of political economy. He argued that relief should be left principally to the market and that high prices and extraordinary dealing profits in corn were a guarantee of supply and a 'regulating influence' on demand. Charity was to be kept within bounds in order to avoid 'dependence' becoming 'an agreeable mode of life'. Lord Clarendon, appointed Lord-Lieutenant in 1847, argued that the 'doctrinaire' policy which Trevelyan termed the 'operation of natural causes' had its inevitable consequences in 'wholesale deaths from starvation and disease'. In any event, the Government's capacity to afford relief was diminished by the financial crisis of the mid-1840s in which massive speculation, particularly in railways, was followed by a major tightening of credit and loss of economic confidence.[6]

The maintenance of the Irish peasantry in the 1840s was inevitably compromised by the sharply declining status of rural values among improved opinion in England. The future, as Macaulay made clear, lay in the industrial towns rather than in the country. Indeed, the political economist Thomas Malthus had insisted in the 1820s that the country must be deliberately depopulated in order to stimulate the creation of a workforce frightened into a spirit of independence by the withdrawal of parish relief. An extraordinarily rapid change had occurred in this, as in other aspects of

British economic theory. In *The Wealth of Nations* (1776) Adam Smith argued that agricultural labour often tends to generate an acuity and flexibility of mind exceeded only in the liberal professions, and that rural life is an essential element in the social and moral stability of an improving nation. In 1840, however, John Stuart Mill could dismiss the 'peasantry' with near contempt:

> The least favoured class of a town population are seldom actually stupid, and have often in some directions a morbid keenness and acuteness. It is otherwise with the peasantry. Whatever it is desired that they should know, they must be taught; whatever intelligence is expected to grow up among them, must first be implanted, and sedulously nursed.

Poverty and peasantry seemed to be offensive objects to be improved away through economic expansion and urbanization.[7]

Mill's extensive praise for systems of peasant proprietorship in *Principles of Political Economy* (1848) makes it clear that his sympathies and interests were considerably wider than some rather thoughtless single passages may suggest. In 1840 Mill also published his important essay on Coleridge, in which he emphasizes the need for a much broader understanding of human affairs than that promoted by Benthamite ideas of progress. Throughout his work there is a tension between these two tendencies of his thought. Much of the *Principles* has little to do with the abstract concerns of most of those who occupied themselves with the 'operation of natural causes'. Within political economy, narrowly conceived as a science of market behaviour, a difficult concept such as wealth is easily defined, being merely the sum of 'all useful and agreeable objects which possess exchangeable value'. There are no moral considerations involved and nothing that relates to what Mill later describes as the 'aesthetic branch' of experience. The inadequacy of such narrow definitions is made abundantly clear throughout the *Principles*, a work that is, in many ways, a severe criticism of the restricted conception of economic activity it initially seems to endorse.[8]

On the whole, Tories reversed the emphasis of political economy and dwelt on ethical and aesthetic values without seeking to engage in detail with economic theory. Probably the most important exception to this rule in nineteenth-century England is contained in the work of John Ruskin, a writer deeply influenced by a childhood reading of Wordsworth as well as the Bible. In *Unto This Last* (1860) Ruskin concerns himself directly with Mill's economic writings in order to emphasize that solemn conceptions of the market are often nonsensical. It is impossible, for example, to separate the workings of the market and its definitions of value from the general levels of morality and information that characterize its participants:

> the agreeableness or exchange value of every offered commodity depends on production, not merely of the commodity, but of buyers of it; therefore on the education of buyers, and on all the moral elements by which their disposition to buy this, or that, is formed.

Beyond the agreement of price relative to basic commodities, in which decisions will often be informed by need, all more difficult market decisions may be seen as in some

way related to wider ideas of value. Indeed, the moral dimension will tend to increase with the complexity of supply and demand as levels of general wealth increase. The kinds of goods offered, their quality and design, and the consequences of their production for the safety, health, and general welfare of those who make and consume them will all be defined by ideas of value according to the ethics, interests, and preoccupations of market participants. Wealth and value cannot be narrowly and scientifically defined. Any productive process can easily generate what Ruskin terms 'illth', causing 'destruction and trouble' to individuals or communities. A society regulated chiefly by abstract laws of supply and demand will soon be in moral chaos. The rich and influential will be the 'industrious, resolute, proud, covetous, prompt, methodical, sensible, unimaginative, insensitive, and ignorant'. Those remaining poor and uninfluential will be the 'entirely foolish', the 'entirely wise', the 'idle, the reckless, the humble, the thoughtful, the dull, the imaginative, the sensitive, the well-informed', the 'improvident', and the 'just'.[9]

Ruskin's principal interest was not in economics but in landscape and its interpretation in art. He found, however, that the discussion of landscape could not be separated from a broad variety of other concerns, and that the easy distinctions favoured by Macaulay between politics and the fine arts, and between natural and moral processes, were meaningless. Ruskin's difficulty is reflected in the much more modest undertaking of this study, which constantly moves between moral, economic, religious, social, and aesthetic theory and relates these theories to what are essentially political considerations. It does so because its central premise is that throughout the eighteenth century, and much of the nineteenth, arguments about the aesthetics of landscape were almost always arguments about politics. Intervention in the landscape was understood as making explicit and readable statements about the political history, the political constitution, the political future of England, and about the relations that should exist between its citizens. In the Tory view, those who abandoned the landscape to the market were also abandoning the order of civil society to fragmentation.

The first chapter of this study discusses changing conceptions of improvement in the eighteenth century, noting the growing influence of doctrines of political economy, and the replacement of the traditional ethic of benevolence — increasingly regarded as uncertain, intrusive, and unjust — with a greater emphasis on market-influenced social relations. The second chapter notes how many observers in the eighteenth century perceived changes in the landscape as disturbing expressions of the fragmentation of English society. The remaining chapters describe various attempts at the end of the eighteenth century, and the beginning of the nineteenth, to seek the reintegration of the culture on lines presented as traditional. One of the characteristics of the Tory view of landscape that emerges clearly is the growing reluctance of much traditional opinion to engage with commercial considerations at the same time as commercial relations were becoming, under the influence of political economy, the dominant feature of English life. The Tory view was constantly seeking means of composing society, reluctant to relinquish it to individual greed and taste or to a natural tendency towards improvement. To this end it sought balances and principles of regulation in tradition, in religion, in a higher order of

nature, in social hierarchy, and increasingly, as such principles came to seem less reliable, in ideas of the State.

This study is offered as a contribution to the history of the politics of culture written, as will by now be apparent, from a position more sympathetic to the Tory view than is normally the case. The bulk of illuminating work on the political culture of landscape in the eighteenth and early nineteenth centuries has been undertaken by writers of a leftist persuasion. The insights they have afforded have been considerable but partial, since there has been a clear determination to suggest the existence of a simple, homogeneous, ruling-class ideology, governing all aesthetic and social attitudes, and opposed to the higher understanding of the modern critic. With important exceptions, most notably, perhaps, in the work of E. P. Thompson, discrimination between the values of individual landowners, for example, has been of little or no interest, because the very fact of owning extensive tracts of land, and therefore being involved in hierarchical relationships, is deplored. To distinguish between the benevolence of some, and the proprietorial and market-oriented attitudes of others, is to play the game of ruling-class ideology, since both attitudes conspire in an unacceptable notion of social distinctions being somehow natural.

John Barrell, one of the most perceptive cultural historians of English landscape and painting, has offered a stimulating interpretation of the development of aesthetic ideas in the eighteenth and nineteenth centuries. Using terminology influenced by the writings of J. G. A. Pocock, Barrell has shown how a 'discourse of civic humanism' was 'progressively attenuated and abandoned' as the growing influence of an ideology of self-interest led to the remorseless 'privatization' of many aspects of life. Barrell has found in the writings of the artist Henry Fuseli a particularly striking confirmation of this view at the beginning of the nineteenth century: 'The ambition, activity, and spirit of public life is shrunk to the minute detail of domestic arrangements — every thing that surrounds us tends to show us in private, is become snug, less, narrow, pretty, insignificant.' Barrell argues that by the end of the eighteenth century ruling-class culture was wholly dominated by the abstract certainties of political economy and a system of moral philosophy based on almost identical values. Romantic and pastoral versions of literature, art, and civil society, previously suggestive of the value of leisure, were abandoned by the dominant culture and appropriated by radicals. Benevolence, itself an 'act of oppression', gave way to an unvarnished insistence on market-driven relations. The division of labour destroyed traditional ideas of the integrity of work and the happier informality of a world in which the workman, in Adam Smith's phrase, 'commonly saunters' between his varied tasks. As social relations were increasingly subjected to 'authority and discipline', a good deal of art became a form of disengagement from the real world. The picturesque movement of the latter part of the eighteenth century was a typical expression of this phenomenon; it was 'concerned only with visible appearances, to the exclusion of the moral and the sentimental'.[10]

This study does not seek to reject these views; in some ways, indeed, it endorses them, but it also seeks to qualify such ideas and give a greater sense of the complexities of traditional culture. The bracketing together of different aspects of a ruling culture — giving equal moral weight, for example, to the benevolent and the

malevolent — is justified for certain writers on the Left because the 'correct' alternatives to relations of class or rank are self-evident to them and easily attainable by forms of radical action. The approach of this book, on the other hand, is to dwell on some of the tensions in ruling-class ideology, for example, the attempts of conscientious individuals to propose challenging interpretations of such ideas as constitutional tradition, social responsibility, the duties attached to the possession of property, and the values of community under threat by self-interest. It is suggested that the Tory view was a keen and perceptive source of criticism of the version of civil society promoted by eighteenth- and nineteenth-century liberalism and modern Conservatism. It attempts to show that some of the insights into the nature of power proposed by twentieth-century critics as revolutionary were sometimes the commonplaces of eighteenth-century parsons.[11]

By neglecting the complexity of historical ideas — Smith's analysis of the division of labour, for example — criticism on the Left can be said to have helped the re-emergence of crude versions of free-market theory by endorsing the view that such ideas have always been conceived in simple terms. Further, by opposing what they denounce with a set of vague and often unconvincing abstractions, such critics may be thought to have aided, rather than hindered, the general decay of civil discourse. Modern Conservatism has, after all, grown up in an intellectual vacuum in which its declared alternatives and its own history have both been obscured by dogma. The vacuum has been created by differing, but equally simple, forms of appropriation of the past, whether the determination of the radical to level ancient prejudices, the wish of the political economist or speculator to realize a version of progress, or the desire of some of the defenders of the 'national heritage' to dignify the present state of English cultural and political life.

1

The Perception of Improvement

Nature revolves, but man advances.
Edward Young, *Night Thoughts* (VI. l. 691)

Macaulay's easy distinction between politics and the fine arts reflects a broad departure from an assumption quite widespread in the eighteenth century, that of the interdependence of political and aesthetic thought and their common basis in a view of human nature described by moral philosophy. His assertion of the central importance of enterprising individuals, almost in opposition to an idea of community, is more commonly found in the eighteenth century but gathers strength in the latter part of the period together with the dissociation of morality and taste. In the first half of the eighteenth century, in particular, it is often difficult to distinguish aesthetic ideas from moral and religious ones. The point is well illustrated in the important theme of connection, in which the role of the artist, politician, or benevolent landowner is to compose images of harmony. The landed gentleman best achieves his own happiness in the happy blending together of a whole community, itself conceived as a work of art. Such ideas took various forms and continued to be influential far into the nineteenth century, but with changing emphases and degrees of confidence regarding their likely success. Perhaps the most important changes relate to the growing acceptance of the idea that the improvement of civil society depends less on benevolence than on the competing energies of individual citizens. According to this view, men have a natural desire to distinguish themselves from their fellows, to express in their personal natures and property their differences rather than what is common to them. Society is enriched in every sense by this process, providing it is kept within control. Such changes relate to the rise of ideas of political economy in some ways comparable with those recommended by Macaulay. In general, however, it is rarely argued in the eighteenth century that aesthetic theory may be divorced from moral, or that a simple distinction may be made between the realization of individual personality and the welfare of the community as a whole.

Following Macaulay and Southey, it is tempting to think of the older ideas as Tory and their more liberal successors as Whig, although such a distinction is convenient rather than accurate. The pragmatic and commercial values often associated with the Whig oligarchy that ruled England for much of the first half of the eighteenth

century, and whose dominant figure in the 1720s and thirties was Sir Robert Walpole, provoked opposition among many who regarded themselves as principled or cultivated, regardless of party. Walpole himself was happy to denounce many of his opponents as Jacobites, and therefore traitors, without an always scrupulous regard to evidence. In 1740 a Whig lawyer, Henry Berkeley, argued that a conscientious man might 'take up with any party' since they were separated, not by principle, but 'by favour and dislike of Sir Robert's Ministry'. The eighth Earl of Winchilsea, a 'Patriot Whig' and critic of Walpole, wished to see an alliance of 'honest Country Gentlemen' that would form a government independent of 'idle' party distinctions. He appears to have felt that the supposedly Tory virtues were common to good men in both parties. Those virtues were identified, among others, by the *London Evening Post*, when it praised an independent landowner who acted as a 'liberal Benefactor' in his neighbourhood. His house was open to all in the ancient spirit of 'true English Hospitality' and was uncorrupted by the new foreign fashions that led gentlemen to 'reject the Appearance' of humbler 'Freeborn Britons'. Toryism projected itself, in its propaganda, as a moral pursuit of cohesive social order, contrasting, for example, its support of charity schools with the neglect of the education of the poor recommended by those, such as the Whig MP Soames Jenyns, who thought ignorance an essential opiate of the people.

Real Tories did not necessarily live up to an ideal of rural integrity, any more than all Whigs were promoters of urban corruption. Some Tories were important participants in the financial markets and in entrepreneurial activities such as iron, coal, brewing, real estate, and textiles. The notorious South Sea Company, the speculative enthusiasm that collapsed under a Whig administration in the 1720s, was founded in 1711 by a Tory, Robert Harley. Tory politicians actively sought alliances with metropolitan men of commerce and were often assiduous in place-seeking and the market of patronage. In the management of their estates they could be enthusiastic in the enclosure of commons, the passing of game laws, and the protection in general of their 'parks, paddocks or enclosed ground'. The first Earl of Gower campaigned against local enclosure in the election of 1743 at Newcastle under Lyme, and then evicted cottagers who had failed to vote for his candidates. The Tory fourth Earl Ferrers was executed in 1760 for the murder of his steward.[1]

The complex and still actively debated questions concerning the nature and organization of the Tory Party in its opposition to Walpole, its survival or extinction after 1750, and its relations with Jacobite and various radical movements are not of central importance to this study. Historians of literature have long identified a broadly Tory outlook, in large part independent of party, among some of the literary opponents of Walpole, notably Alexander Pope, Lord Bolingbroke, and George Berkeley. One of its central themes may be summed up in the phrase 'the use of riches', emphasized by Pope in his *Moral Essays* (1731–5). The question seemed to be whether the end of the generation of wealth was simply to be rich — with all its likely consequences in corruption and social disintegration through the neglect or exploitation of the poor — or whether the real value of wealth was to promote works of benevolence, encourage the arts and sciences, and in general to improve the nature and condition of mankind. In this view, the culture of a selfish, deceiving, and

corrupt individualism, typified by the South Sea Bubble, opposes examples such as Bolingbroke's virtuous retirement at Dawley Farm, Pope's Man of Ross, or Berkeley's ideal of an Ireland of prosperous small farmers. The complications and contradictions of this view of Tory values are considerable and will be discussed later. The Tory–Whig contrast of virtuous land ownership opposing a corrupt oligarchy centred on London and in a few palatial country houses is, however, too useful an image to be abandoned willingly.

It was an image naturally strengthened and made in some senses radical, at least in a moral sense, by the long period without power experienced by the Tory Party under the first two Georges. In 1743 Edward Harley, third Earl of Oxford, emphasized how he and his colleagues were uncorrupted by the temptations of office and Court life. Many politicians, he declared, 'see no other scenes' but the magnificent, the splendid and the gay; inevitably they occupy themselves little with the distress of the millions who support their luxury. It was his own custom, when free of parliamentary duties, to retire to his estate in the country and take a 'calm and deliberate survey' of the condition of men and women in his neighbourhood. He sought to 'enter their houses' and 'mingle in their conversation', often finding that the complaints of the people against Government were just. Such political innocence was clearly more difficult to sustain after the Tories were re-admitted to power with the accession of George III. The second Earl of Shelburne lamented what he perceived as the consequences of this change in 'the alienation of all the landed interest from the ancient plan of freedom'. Every landed man was inclined to set up 'a little Tyranny' with a pliant magistracy and 'oppressive Laws'. Instead of 'controlling the abuse of Power', they would 'take their Choice with that Government under which their own peculiar Tyrannies were maintained'. Once become merely conservative, in the sense of being uncritically attached to the existing conduct of power, Toryism lost its most important functions in the political arrangements of the country.[2]

The Idea of Connection

Tory views, emphasizing personal integrity and the benevolent fulfilment of local responsibilities, were highly favoured in much of the orthodox moral philosophy of the first half of the eighteenth century. The most important figure here is probably Joseph Butler (1692–1752), whose role in the history of conservative thought, and in particular his influence on Edmund Burke, has long been acknowledged. Despite what may be regarded as his worldly success, in so far as he ended his career as Bishop of Durham, Butler's ascetic personal habits and some of his doctrinal emphases were sometimes accompanied in his own time and after by vague charges of popish sympathies. His *Analogy of Religion* became perhaps the most important Anglican apologetic text of the eighteenth century and is of considerable value in the analysis of the Tory view of landscape. It was one of a number of contemporary attempts to identify common principles of order in nature, the arts and sciences, morality, and civil society. In common with many of these attempts, it owed a good deal to Sir Isaac Newton's suggestion, at the close of his *Opticks* (1704), that moral

philosophy had much to learn from the scientific insights which, largely through his own work, had discovered the mechanical functions of nature. The universe was clearly not the work of a blind and fortuitous series of events but the creation of a First Cause, Newton's version of the Christian God, who is admirably skilled in mechanics and geometry and reveals astonishing powers of comparison, adjustment, composition, and reconciliation of a great variety of contrasting bodies. If men could understand through the increasing perfection of natural philosophy the complex nature and intentions of the First Cause, what power He has over men and what benefits they receive from Him, so their duty towards Him as well as towards one another would appear 'by the light of nature'.[3]

In the tradition of analogy developed by Butler, it is argued that there are consistent patterns throughout nature, that its laws of organization may be the same as those of society, that the same methods of analysis and criticism may be appropriate throughout experience, and that patterns of organization found in individual systems might reveal the pattern and regularity of the whole creation. At the same time natural systems, being productions of the mind of God, are considered objects worthy of the most profound respect as sources of instruction as well as pleasure or use. Man is seen as a dependent part of a system, and Self in large part a contradictory idea. Science, morality, politics, and aesthetics, all being languages for the analysis of analogous systems, are considered inextricably connected, while the sense that all that man observes in nature is a product of mind, like himself, is supposed to induce a heightened sense of responsibility to the entire created system and to any part of it.

Analogy theory has ancient roots and many forms, taking inspiration from both classical philosophy and such biblical sources as Romans 1: 20: 'For the invisible things of him from the creation of the world are clearly seen, being understood by the things that are made, *even* his eternal power and Godhead.' The theory is often closely linked to the familiar theme of the great chain of being and to the related idea of plenitude, in which nature is perceived as a complete system without wastage or gaps; everything has an actual and final purpose. It was a theory that was to last well into the nineteenth century, and to influence some minds of great distinction. Michael Faraday, a scientist strongly influenced by the eighteenth-century theologian Robert Sandeman, insisted on a cosmology of nature in which the 'smallest provision is as essential as the greatest. None is deficient, none can be spared.' The function of science was to discover the invisible nature of divine providence from the visible evidence. Faraday's chief teacher, Humphry Davy, had assumed at the end of the eighteenth century that the laws of chemistry and gravitation were to be considered as subservient to the 'one grand end' of contemplative 'perception' of a comprehensive natural order. It was within this tradition, strengthened by post-Kantian *Naturphilosophie*, that Coleridge could write hopefully of a time 'when all human Knowledge will be Science and Metaphysics the only science'.[4]

In his *Sermons*, largely published in 1726, and in his *Analogy of Religion* (1736) Butler's principal purpose was to defend Christian doctrine against various types of infidel philosophy. One of his targets was the work of the Whiggish third Earl of Shaftesbury (1671–1713), who appeared to argue that there was no necessity for

fixed religious doctrine since a tendency to virtue exists naturally in men, or at least in a cultivated and generally aristocratic part of mankind, naturally pre-eminent in the community. Much more disturbing was the body of opinion associated with the Dutch expatriate physician Bernard Mandeville (1670–1733). In his most important work, *The Fable of the Bees*, published in various forms between 1714 and 1724, Mandeville popularized the doctrine that 'public benefits' arise principally from 'private vices'. An innocent society has no capacity for progression; vice, luxury, and personal greed are the motive forces behind all the comforts and advantages of an improving society:

> Would you have a frugal and honest Society, the best Policy is to preserve Men in their Native Simplicity . . . remove and keep from them every thing that might raise their Desires, or improve their Understanding.
> Great Wealth and Foreign Treasure will ever scorn to come among Men, unless you'll admit their inseparable Companions, Avarice and Luxury. Where Trade is considerable Fraud will intrude. To be at once well-bred and sincere, is no less than a Contradiction.

A virtuous, passive individual merely consumes; a vicious highwayman, on the other hand, may supply employment and other advantages through his conspicuous spending of stolen property. Society is a conglomeration of selfish individuals; its continuing prosperity depends on the vice of its more enterprising members and the ignorance and poverty of the bulk of mankind, who labour in order to feed the vanity of their betters.[5]

Butler did not address much of Mandeville's case because he was himself convinced of the great difficulty of reconciling trade with morality. He chose to concentrate on criticism of the doctrine of assertive individualism, which saw all improvement as deriving from narrow self-interest without any natural concern or responsibility for the opinion or welfare of others. In opposing this doctrine Butler calls upon the entire evidence of Newtonian nature. He argues that both the natural and moral worlds were deliberately created in subservience to the redemptive intentions of God. 'Late improvements' in science had 'opened to view' the amazing mechanism, beauty, and variety of the 'oeconomy, . . . scheme, system, or constitution' of nature and of its natural government. In a similar way the moral system of the world intended by God was a pattern of harmony based on each man's sense of connection and dependence on his fellows and on society as a whole. Virtue, in its very nature, is a 'principle and bond of union'; it is natural to man because he exists and fulfils himself through such a union, whereas vice is a violation or 'breaking in upon' this nature. The natural argument for moral conduct goes beyond the simple demonstration of the normal consequences of vice — illness, antagonism, violence, and the unremitting penalties of a bad conscience. In Butler's universe every action is remorselessly connected with every other in an infinite variety of connections and mutual dependencies. The whole experience of rational life reveals the absurdity of the idea that man can consider himself to be 'single and independent':

> In this great scheme . . . individuals have various peculiar relations to other individuals of their own species . . . and to other species. Nor do we know, how much

farther these kinds of relations may extend . . . there is not any action or natural event . . . so single and unconnected, as not to have a respect to some other actions or events . . . all creatures, actions, and events, throughout the whole course of nature, have relations to each other . . . all events have future unknown consequences . . . [and influences] past and present . . . Nor can we give the whole account of any one thing whatever . . . By this most astonishing connection, these reciprocal correspondencies and mutual relations, every thing which we see in the course of nature is actually brought about . . . And things seemingly the most insignificant imaginable are perpetually observed to be necessary conditions to other things of the greatest importance.

Butler's argument that connection and responsibility are natural does not imply a simple optimism; he is describing God's moral constitution and to some degree 'what in fact or event commonly happens' is irrelevant. The mechanism is clearly out of order and selfish individualism rampant, but this is so far from being the essential nature of things, or 'according to its system', that beyond a certain, and quite limited, point of tolerance, such individualism would totally destroy it. Similarly, so far is self-love from being the real basis of civil society, as Mandeville seemed to argue, that mere 'contracted affection' is constantly seen to disappoint itself and even to contradict its own chief end of private good through individual discontent or the dissolution of groups or communities. Self-love, if made general and the ruling principle of society, would 'lay waste the world'. Friendship, gratitude, and compassion are the principal motivations of civil society and keep the world in such order as it enjoys.[6]

The broken mechanism of God's moral constitution is identified inevitably, and with detailed inspiration from Bishop Burnet's *Sacred Theory of the Earth* (1684–90), with the Christian doctrine of the Fall, as Butler observes that 'the earth our habitation has the appearances of being a ruin'. The redemptive process, and indeed the continued existence of mankind, depend on attaining some degree of conformity to the underlying moral constitution of things; on this man's 'whole interest and being' and the 'fate of nature' depend. Butler argues a common responsibility, lest men 'remain deficient and wretched', to 'improve ourselves, and better our condition'. But his intention in these terms, which are perhaps chiefly associated with Adam Smith, is not primarily economic. Beyond a 'plainly natural' desire for necessities in 'external things', the 'proper self' has no use for continuous economic improvement. The 'restless scene of business' merely 'diverts us from ourselves', while 'appearances of opulence and improvement' in 'common things' tend to distract men from the study of moral appearances in nature. Improvement in virtue calls for the 'science of improving the temper, and making the heart better'. It is the cultivation of this astonishingly neglected field that is the duty assigned to men. The seeds of goodwill have been implanted in man's nature; but that rude soil, with its tendency to grow vicious, has to be cultivated and improved. Its produce must be brought forth in a steady and uniform manner in emulation of the images of perfection and connection everywhere present in the endless variety of nature.[7]

Taste and critical observation have an important part in this pursuit. Man has a natural tendency to feel affections for patterns of order, resting in such objects as an

end. Ideas of order, harmony, proportion, and beauty in general are intellectual images or forms which beget approbation, love, delight, even rapture, whether in art or in nature. Such feelings are associated with, but not sufficiently explained by, sensual pleasure or self-interest. They really represent moral preferences since, acting in accordance with the moral constitution of things, everything of grace and beauty in nature recalls everything excellent or amiable in human relations. These affections are in themselves 'instances of final causes' since they encourage certain determinate courses of action in favour of virtue. Evidences of wisdom, power, and greatness in nature lead men yet further as they reflect on God as the natural object of all affections. Men accordingly find their proper self in large part through a critical observation of nature.[8]

The pursuit of harmony leads in turn to an active principle of benevolence in social relations. Men are capable of an extremity of misery beyond all comparison with their capacity for happiness, so compassion is one of the most natural of emotions, a 'demand of nature', as hunger is a 'natural call for food'. Cultivated, it leads men to 'bring before their view' and to relieve the miseries of others, regardless of any 'returns either of present entertainment or future service'. The reader is encouraged to seek out circumstances of disadvantage, putting aside the common prejudice that regards the state of distress or the condition of poverty as sufficient reason for 'neglect and overlooking a person'. Those in distress are not to be judged according to simple ideas of blame; all men have a claim to relief under circumstances of necessity, regardless of their vices.[9]

The benevolent man of superior rank in 'wisdom, fortune, authority' does not find his satisfaction in contracting his heart to the pursuit of narrow interests, or in taking custom, fashion, honour, and imaginations of present convenience as his only moral rules. He regards his advantages as a trust, is 'easy and kind' to his dependants, compassionate to the distressed, a good neighbour, master and magistrate, and a common blessing to the place where he lives. Happiness and morality grow under his influence, dependence is made easy, and the lower ranks of society, whose minds have been formed by nature and by experience to be easily influenced by their superiors, respond to fair treatment with respect, gratitude, and obedience. This relationship is the 'natural course of things', because connection assumes rank and dependence, because it is just to base relations on affection rather than self-interest, and because there is a natural tendency in the lower ranks of men to deference towards their superiors, even when there is no moral justification for that superiority.[10]

Man, so far from being by nature single and independent, 'having no restraint from, no regard to others', seeks every possible form of connection. His life is constructed of prejudices, systems of manners, and attachments, which, however apparently artificial, are natural in that they foster instincts of familiarity and community:

> Mankind are by nature so closely united, there is such a correspondence between the inward sensations of one man and those of another, that disgrace is as much avoided as bodily pain, and to be the object of esteem and love as much desired as any external goods ... There is such a natural principle of attraction in man

towards man, that having trod the same tract of land, having breathed in the same
climate, barely having been born in the same artificial district or division, becomes
the occasion of attracting acquaintances and familiarities many years after; for
any thing may serve the purpose. Thus relations merely nominal are sought and
invented, not by governors, but by the lowest of the people; which are found
sufficient to hold mankind together in little fraternities and copartnerships: weak
ties indeed, and what may afford fund enough for ridicule, if they are absurdly
considered as the real principles of that union: but they are in truth merely the
occasions, as any thing may be of any thing, upon which our nature carries us on
according to its own previous bent and bias.

It is natural, therefore, to fear change and to be sceptical of political and social
programmes founded on simple rationalism, doctrines of economic theory, or 'ro-
mantic schemes' of natural rights. Butler prefers to conform to the general plan of
the constitution 'transmitted down to us by our ancestors', regarding indeed as
sacred its 'regulations of long prescription and ancient usage'. All political improve-
ment is to be a gentle amelioration of abuses, conscious of 'our imperfect view of
things', never impatient, but attentive to the pattern of nature, which normally
accomplishes its ends through slow successive steps over a great length of time.
Accordingly, Butler places a high value on the visual memorials of ancestors, which
are to be prized not only for their beauty but as natural checks on precipitate change.
This is particularly true of religious buildings and memorials, 'monuments of ancient
piety' which should be preserved in their 'original beauty and magnificence' in
respect to 'our ancestors' and to social principles that could act as counterweights in
the landscape to the growing appearances of 'opulence and improvement' in, for
example, private houses and gardens.[11]

The idea of a total scheme of analogy, in which improvement is undertaken at
once through the discovery of the essential harmony of the natural constitution of
things and the cultivation of individual and social nature, is expressed by Butler with
the greatest clarity and influence, drawing upon the much more abstruse philosophi-
cal work of George Berkeley (1685–1753), Bishop of Cloyne. In his writings on
vision, largely published between 1709 and 1713, Berkeley identified all perception
as a social and religious act. Far from arguing the simple form of idealism still
commonly associated with his name, Berkeley was anxious to demonstrate that
men's purely personal ideas, and 'abstract general ideas', are faint, weak, unsteady,
and not to be relied upon. On the other hand: 'those impressed upon them according
to certain rules or laws of Nature, speak themselves the effects of a mind more
powerful and wise than human spirits . . . [there is] more *reality* in them . . . they are
more affecting, orderly, and distinct.' The universe is the continuous creation of the
mind of God, reflecting His nature, affording instruction, and capable of being
clearly perceived only through a vision that has begun to grasp its essential charac-
teristics, and to this extent has participated in the conceptual processes of God
Himself. Man's visual faculty has been designed to be able to take in enough of
the vast extent and variety of nature to perceive clear patterns and laws, while at
the same time being struck by constant evidence of a 'glimmering, analogous
praenotion' of truths placed beyond his certain discovery in this present state. As

experience and science render vision more acute, more harmonies, agreements, and analogies will become apparent so as to facilitate the formulation of laws that will 'extend our prospect beyond what is present, and near to us' and promote conjectures of past, present, and future experiences and effects. The end of this is moral — nature is a book written in the 'universal language of the Author of Nature', whereby men are instructed how to 'regulate their actions' in all the 'transactions and concerns of life'.[12]

Berkeley's nature is much richer in visual impact and sensuous delight than Butler's infinitely various but more mechanical universe. The world seems to exist to 'recreate and exalt the mind' with the prospect of the beauty, order, extent, and variety of natural things. Berkeley rapturously and romantically describes the delightful verdure of fields, the soothing intricacy of woods and groves, the soul-transporting delight of rivers and clear springs. He finds everywhere beauty and exquisite contrivance, pleasing horror in hills, agreeable wildness in forests, and endless forms of delicacy and energy. The manifestations of the divine mind in nature, and the 'mutual dependence and intercourse' of all created things, exceed the powers of language; they are 'immense, beautiful, glorious beyond expression and beyond thought'. An apparently endless sensual pleasure in nature is made a moral experience in the insistence that God has created nature and man's faculty of vision to serve the mind's 'strong instinct for a better state, . . . something unknown and perfective of its nature'.[13]

In his sermons Berkeley uses what became increasingly familiar conservative imagery; the 'accumulated experience of ages', laws human and divine, and the national constitution provide 'plain land-marks' for all political conduct. In his schemes for model communities in America, however, and in his interrogations into the general state of England and, more particularly, his native Ireland, he shows a wider conception of the idea of improvement. He feared the moral consequences of the vast expansion of wealth and credit taking place in England, predicting that the vanity and luxury of a few would overlay the 'well-being of the whole'. A culture of selfish individualism, as apparently advocated by Mandeville, was not only incompatible with the philosophical view expressed in the works on vision, but would inevitably tend to the ruin of all Great Britain, as the disastrous events surrounding the South Sea Bubble seemed to demonstrate. The active promotion of vice was as repulsive as the Mandevillian insistence that the children of the poor should be neglected in order to leave them better suited to be cheap and servile labour for the creation and distribution of goods directed to satisfy the desire for luxury. In Ireland, where a general excess of wealth was not an issue, Berkeley imagined an improved class of landowners educated in the beauties of nature and morality and becoming happily resident on their estates, enjoying a 'handsome seat amidst well-improved lands, fair villages, and a thriving neighbourhood'. Rather than seeing prosperity trickle down to the poor by the general expenses of the rich, he imagined that 'to provide plentifully for the poor' might itself be to feed the roots of industry and comfort, causing the tops to flourish by the creation of new wants. Peasants accustomed to eat beef and wear shoes might become promoters of a virtuous wealth diffused through the creation of many small farms, a wealth free of the corruptions,

cruelties, and uncertainties of foreign trade. Gardens and plantations might be a basis for elegant distinctions among the rich, employing many hands and being part of a wider equitable landscape in which one could 'conceive and suppose a society [of men and women] . . . clad in woollen cloths and stuff, eating good bread, beef and mutton . . . in great plenty; drinking ale, mead and cider, taking their pleasure in fair parks and gardens'. Such a society would be judiciously improved in every area of essential human interest.[14]

Analogies between the order of nature, human society, and ideas of beauty are central to the work of another Irishman, Francis Hutcheson (1694–1746), Professor of Moral Philosophy at Glasgow from 1730 until his death, and an important influence there on the young Adam Smith. Hutcheson argues that the beauty of regularity, order, and harmony in the arts and sciences is essentially the same in character as the 'moral sense of beauty' that men find and naturally delight in when confronted with virtue in affections, characters, actions and manners, because such virtue itself tends to regularity, order and harmony. The constitution of things is such that virtue is not only a judicious but a lovely form, clearly attractive to what Butler calls the 'proper self'. All this beauty, whether of manners, external forms, or ideas, seems to have a common characteristic — a 'surprising uniformity amidst an almost infinite variety' — in which diverse but corresponding parts, each adapted to their own perfection, are yet connected within and dependent on a consistent whole. Inevitably, Hutcheson offers examples from the planetary motions, but also from the forms of animals, architecture, poetry, mechanisms, intellectual systems, politics, morality, and the improvement of landscape. All such creations, and indeed all forms of judicious reasoning, are at once natural in that they are congenial to man and necessary to his well-being, and at the same time 'an improvement upon our nature'. Virtue itself is profoundly natural, not 'wholly artificial', as Mandeville seems to have argued.[15]

Improvement through skill and experience realizes the natural order of things but it is consistently natural only if it attends as much to 'infinite variety' as to principles of coherence. The love of uniformity, necessary in itself, becomes an inconvenience when it substitutes personal ideas or abstractions for the variety of nature. Hutcheson criticizes the 'fantastic beauty' of some human intellectual systems, such as those of Descartes and Leibniz, which endeavour to deduce all knowledge from a single proposition. Rather than seeking to contort nature, the philosopher should help to enlarge the mind to make it capable of a more comprehensive understanding that can take in as many 'particular truths' and 'irregular objects' as possible without falling into a 'labyrinth of confusion'. This principle is applicable to all fields, including the political, since government is properly the expression, not of parties, factions, and 'particular wills', but of the common good of the whole society defining itself at once in individual rights and in general laws that allow men to have a rational expectation of the consequences of their actions, whether good or ill. Similarly, personal virtue should discover itself in a benevolence towards the 'most extensive system in which our power can reach'. Its improvement to the 'highest perfection of our nature' is the chief purpose of civil society, which has as its ultimate end the happiness of every 'known sensitive nature' amid a 'universal calm good will

or benevolence'. Against the narrow vulgarity of those whose 'fancy arises no higher than the cold dull thought of possession', Hutcheson offers his image of a cultivated man in whom 'pleasure is joined to the contemplation of those objects which a fine mind can best imprint and retain', and 'those actions which are most efficacious and fruitful in useful effect'.[16]

In the improvement of the landscape nature is clearly the chief authority. God has 'constituted our sense of beauty', and made the theatre of the world infinitely 'agreeable to the spectators'. In the laying out of grounds the intention should not be a minor perfection or abstraction of design, as in the 'confined exactness' and regularity of vistas, parterres, and parallel walks. It should be what Hutcheson terms a 'relative beauty', an imitation of some of the wildness, variety, and endless irregularity of nature, brought together in a composition agreeable to the smaller scale of human activity. Man can hardly emulate the 'rudest mountains', but he can properly pursue 'some wild pleasure from variety' founded in more modest forms of nature.[17]

If Hutcheson's calmly reasoned view of order is one branch of analogy, another is to be found in the neglected field of eighteenth-century mysticism, particularly in the religious aestheticism of William Law, who resigned his fellowship at Cambridge in 1716 after refusing to swear allegiance to George I and abjure the Stuart Pretender. Law began his career with reasoned controversial works against Mandeville, deism, and the spiritless Christianity he found in the fashionable latitudinarian faith, with its easy reconciliation of religious observance and the pursuit of worldly prosperity. His *Serious Call to a Devout and Holy Life* (1729) was a summons to the middle classes for a greater seriousness regarding religion 'in all the ordinary Actions' of life, and to a pious regularity, temperance, and order that would conform better with the 'beauty and glory of the rational world'. Personal vanity, attention to business, concession to customs and manners for the sake of form are all sinful, and taste is seen as an idle preoccupation with style, display, and expense. A fortune is a 'talent to be improved' through benevolence. A rich man's 'whole estate' is to be devoted to a 'constant course of charity', not to fine furniture, gardens, and the 'improvement of Architecture'. The Christian is concerned only with the 'improvement of human nature', recovering for man the use of his reason and supplying the loss of his original perfection.[18]

From the 1730s onwards, under the influence of Jacob Boehm, Law became increasing concerned with the moral implications of vision and the outward appearance of nature as he reflected on what he took to be Newton's demonstration that 'all outward Nature, all inward Life' are connected in the same manner. He became preoccupied with the idea of the world as a ruined paradise in which 'Light, Beauty, Order, and Harmony' are everywhere evident but found alongside constant corruption and disorder — diseases, irregularities, poisonous earth, unfruitful seasons, doing and undoing, building and destroying to no clear end. In the human world selfishness, sickness, pride and malice were as evident as excellence, beauty, health, and disinterestedness. Since evil, either natural or moral, could not be the original creation of God, the 'Misery of human Life, the Disorders of outward Nature' were confirmation, available to the senses as well as the intellect, that the Fall had

deprived the entire world of its 'original Condition and Nature'. The recovery from this state, as far as regards mankind, depends to a great extent on a sensuous discrimination and selection from nature:

> Everything that is disagreeable to the Taste, to the Sight, to our Hearing, Smelling, or Feeling, has its Root . . . in and from Hell . . . stink of Weeds, of Mire, of all poisonous, corrupted Things, Shrieks, horrible Sounds, wrathful Fire, Rage of Tempests, and thick Darkness . . . [arose when] fallen Angels disordered the State of their Kingdom . . . All that is sweet, delightful, and amiable, in the Serenity of the Air, the Fineness of Seasons, the Joy of Light, the Melody of Sounds, the Beauty of Colours, the Fragrancy of Smells, the Splendour of precious Stones . . . [is] . . . Heaven breaking through . . . [displaying] in such Variety so much of its own Nature.

A true Christian would show himself not only in the virtues of justice, meekness, benevolence, and all 'Desire of Union', but in his being an agent of a redemption that would make nature 'that which it ought to be'. He is 'sowing That which grows and must be reaped in Eternity', and part of his means of improvement is a 'strong Sensibility and reaching Desire' after 'the endless Variety of delightful Forms' that can be 'picked up in fallen Nature'. Discrimination in taste and choice in landscape are in some degree clear evidence of a man's moral state and work either to elevate or depress his condition.[19]

Benevolence and the Improvement of Landscape

Anglican-inspired views of improvement, as expressed in different ways by Law, Butler, and Berkeley, tend to emphasize, much as Mandeville did, the difficulty of reconciling the moral welfare of the community with the pursuit of commerce. Hutcheson, whose work is more clearly related to the deistical Shaftesbury than the other writers discussed here, also had a greater interest in the distribution of resources than in their creation or expansion. In the landscape of benevolence the gentleman occupies an estate whose resources are used to stimulate morality as much as prosperity. He seeks to realize the underlying harmony of a nature valued for its variety and instructive analogies rather than merely exploited for use or made subject to the desire for display. The favoured approach is contemplative, innocent of ambition and competition. The landowner is attached to a particular place and values its customs, institutions, and traditional landmarks. He eschews many fashionable activities, including forms of architecture and gardening, which seem devoted to private opulence, luxury, and narrow ideas of possession. By means of inheritance, the prudent management of an estate, and perhaps marriage, he pursues a diversity of local duties without himself becoming much involved in commercial activity. The state of man, fallen from grace or perfect reason, necessitates various forms of improvement, but ensures that many of those forms are treacherous to pursue.

A desire to reconcile such a traditional view of social and economic relations with

a more open, progressive, and commercial approach was reflected in the work of a number of writers in the early decades of the eighteenth century. In the first number of *The Spectator*, for example, the Whig Addison describes his ideal gentleman as a man born to a 'small Hereditary Estate', bounded for six centuries by the 'same Hedges and Ditches', and passed from father to son without the 'Loss or Acquisition of a single Field or Meadow'. Yet this same gentleman seeks to combine a variety of interests through his friendship with men of commerce and passes much of his time in town, in turn improving the minds and values of the urbane. The rural and the commercial are to be regarded as complementary aspects of an improving nation. The most familiar attempt to reconcile the benevolent and the commercial from a Tory point of view is probably the 'use of riches' theme in Pope's *Moral Essays*, in which landscapes of benevolence are evoked alongside those of private opulence. In striving to achieve this reconciliation, however, Pope is obliged to promote at least two, sometimes contradictory, ideas of nature. One is essentially Butlerian; the other, less specifically Anglican, looks to the long tradition of the great chain of being theory that postulates a natural economy so various and integrated that the deficiencies of one part are always being naturally balanced and corrected by abundance in another part. This view, important in the development of political economy, has its most influential expression in Adam Smith's idea of the 'invisible hand' that provides for the production and distribution of economic goods without any deliberate intervention on the part of benevolent individuals or the community as a whole. In some cases, most famously in the work of Soames Jenyns, such a view of nature happily regards all experience, however painful, as inherently useful — poverty, for example, promotes enthusiasm and enterprise. Unfortunately, Pope's attempt to formulate an idea of improvement using such views, and to reconcile it with traditional values, is not particularly successful. The reader may well feel that the landscapes of benevolence are evoked with much more conviction and moral clarity than the landscapes of fashion and enterprise.[20]

In 1724 Pope wrote to Martha Blount describing the genial Lord Digby's seat at Sherborne with its Tudor house and 'romantick', unimproved landscape containing a Norman tower ruined during the heroic defence of the family seat against Parliamentary aggression in the Civil War. Without concerning himself with the original sources of the Digby estates, whatever they were, Pope felt the scene to be sanctified by ancient integrity, loyalty, courage, and benevolence:

> I cannot make the reflection I've often done upon contemplating the beautiful Villa's of Other Noblemen, rais'd upon the Spoils of plundered nations, or aggrandiz'd by the wealth of the Publick. I cannot ask myself the question, 'What else has this man to be lik'd?' what else has he cultivated or improv'd? What good, or what desirable thing appears of him, without these walls? I dare say his Goodness and Benevolence extend as far as his territories.

Virtue, as well as vice, is linked to property; an old, responsible, possession is contrasted with a new subversion, plundering, or peculation of others' property. Maynard Mack cites this passage as evidence that Pope, under the influence of intellectually gifted aristocrats such as Digby and Bolingbroke, was contemplating a

social order, 'based on *noblesse oblige* and responsible stewardship', which he was to explore more fully in the *Satires* and *Epistles* of the 1730s. The position is not, however, as simple as this remark might seem to suggest. While Digby appears to have been true to his traditional ideas of aristocratic benevolence, it is notoriously difficult to find consistency in Bolingbroke, and not much easier to detect it in Pope. There are clear pointers to the Tory idea of landscape in, for example, the Man of Ross passage of the *Epistle to Lord Bathurst* and the 'father's acres' sequence in the *Epistle to Lord Burlington*. They exist, however, in a total composition that is in many ways disrupted by Pope's desire to engage sympathetically with more extensive ideas of improvement. The difficulties Pope encounters are in some large degree related to his treatment of commercial values, but they may be reinforced by the fact that Bathurst's estate at Cirencester was noted, not only for its vastness, but for its wide manipulation of the landscape through formal planting, while Burlington, who was also Earl of Cork, was an aristocrat who had major landholdings in Ireland but was chiefly known, perhaps, for his expensive suburban villa at Chiswick.[21]

In the *Epistle to Bathurst* Pope makes it clear that the possession of riches does not imply any inherent virtue:

> No grace of Heaven or token of the elect;
> Given to the fool, the mad, the vain, the evil,
> To Ward, to Waters, Chartres, and the Devil. (ll. 18–20)

Riches are distributed unequally and unjustly and they spread corruption and luxury. Those who sow the bread of mankind tend themselves to starve. The rich consume almost everything and riot carelessly while regarding poverty with contempt:

> Perhaps you think the poor might have their part;
> Bond damns the poor, and hates them from his heart:
> The grave Sir Gilbert holds it for a rule
> That every man in want is knave or fool. (ll. 99–102)

All this, however, turns out to be of little importance, since Pope goes on to insist that the economic constitution of the world will adjust everything into a kind of equitable balance:

> Extremes in Nature equal good produce,
> Extremes in man concur to general use . . .
> Who sees pale Mammon pine amidst his store,
> Sees but a backward steward for the poor. (ll. 161–2, 171–2)

However morally disagreeable, however offensive their manners and their vanity, the rich are led by an unseen hand to be generous even in their avidity. The poor may think they are inequitably distressed, but they are really being more than adequately fed by some process of nature. Further, the pride and greed of the rich generate everything that tends to civilize mankind. Pope includes among these improving influences the growth of trade, international competition, and the existence of strong armies.

Moderation, good manners, justice, and the golden mean are therefore not absolutely necessary to the general welfare. They are, however, more attractive, and may be essential to individual or local happiness. Under the miserly administration of Old Cotta the 'good old hall' fails to perform its social function:

> Tenants with sighs the smokeless towers survey. (l. 191)

Cotta's son, however, tends to the opposite extreme, and habits of free spending, themselves praiseworthy, 'more go to ruin fortunes than to raise'. The patrimony accumulated by the miserly father is wasted and

> The woods recede around the naked seat. (l. 209)

The ideal, the rule of sense, is to 'balance fortune' by a 'just expense'.

At this point, however, perhaps to accommodate Bathurst as well as the exigencies of the rhyme, Pope urges the difficult combination of 'economy' and 'magnificence' (l. 224), a mixture traditionally associated with the divine order of the universe. He goes on to express admiration for the Man of Ross who, with a mere £500 a year, had improved a good part of southern Herefordshire and thus exemplified the principle that 'Wealth in the gross is death, but life, diffused.' Where this leaves Bathurst and 'magnificence' is not clear. The Man of Ross is directed by paternalism to works of useful improvement

> Who hung with woods yon mountain's sultry brow?
> From the dry rock who bade the waters flow?
> Not to the skies in useless columns toss'd,
> Or in proud falls magnificently lost,
> But clear and artless, pouring through the plain
> Health to the sick, and solace to the swain. (ll. 253–8)

In this scene, which brings to mind some of the central images of the Tory view of landscape, everything contributes to human comfort and nothing is 'magnificently lost'. It is not particularly clear where this leaves the broad picture of the economy of the world, in which the careless expenses of the rich inevitably trickle down to the poor. Indeed, Pope sees the Man of Ross involved in a precise direction of the local economy; for example, he 'divides the weekly bread'. Whether the bread is only weekly because of a lack of magnificent resources is not stated. In such circumstances, however, it may not be surprising that it is unclear whether Want is about to be relieved or is awaiting his weekly supply:

> He feeds yon almshouse, neat, but void of state,
> Where Age and Want sit smiling at the gate. (ll. 265–6)

The benevolence of the Man of Ross regulates everything; there is no need for the intermediation of 'despairing quacks' and 'vile attorneys' (ll. 273–4) — the whole society is quietly controlled.

In the *Epistle to Burlington* Pope concerns himself more directly with the art of landscape gardening, which was being in some degree naturalized under the influence of Burlington and William Kent. The rule of sense is that men should seek to

follow Nature and consult the 'genius of the place', observing whether the water, for example, wishes 'to rise or fall'. The gardener 'calls in the country', breaking down the distinction between the natural and the artificial. He 'catches opening glades' and works to paint a whole from a combination of parts, using natural light and shade and the diverse effects of chance. The gardener remains, however, a manipulator of nature — he 'surprises, varies, and conceals', and the ideal example that Pope offers, a 'work to wonder at', is Stowe, a landscape often considered quintessentially Whig (ll. 46–70).

Pope proceeds to berate the magnificence of Timon's Villa as the folly of a man 'Smit with the mighty pleasure to be seen', who lavishes expense and abolishes the 'pleasing intricacies' and 'artful wildness' presumably exemplified at Stowe (ll. 115–16, 128). Timon constructs great formal landscapes and orders painted ceilings that 'bring all Paradise before your eye' (l. 148). In another of Pope's shifts towards magnificence, however, Timon is justified because it is through his 'charitable vanity' that the 'poor are clothed, the hungry fed' (ll. 169–72). Further to add to the confusion of the argument, Pope then changes direction again by a move to the pastoral. The great structure of artificial charity, which feeds the poor even while it exploits their labour for selfish purposes, is to be succeeded by the reclamation of Timon's Villa by the landscape. Through some unexplained process, presumably analogous with Oliver Goldsmith's later sense of the unnatural character of an unwieldy and artificial power, corn will come to 'nod on the parterre' and a deep harvest bury Timon's pride (ll. 173–6). Ceres will reassume the land and the compensating power of nature destroy that magnificence which had recently been feeding the hungry (l. 176). Whether the poor will live better under the rule of Ceres or that of Timon's selfishness is unclear. The reader necessarily recalls that Pope's pastoral landscapes are generally inhabited by poetical gentlemen in disguise, rather than by productive labouring men.

The tone of the poem changes again as Pope makes admiring reference to Bathurst's planting and Burlington's building, noting that 'Tis use alone that sanctifies expense' (l. 179). The moral advantage of all planting, however geometrical, is that a tree can almost always be identified as somehow useful, but the use of Burlington's architecture is not clear. It is the non-luxurious view of improvement, of virtuous cultivation by benevolent gentlemen, that raises fewer complications in Pope and there is, perhaps, a sense of relief as the poem addresses less magnificent images:

> His father's acres who enjoys in peace,
> Or makes his neighbours glad, if he increase:
> Whose cheerful tenants bless their yearly toil,
> Yet to their lord owe more than to the soil;
> Whose ample lawns are not ashamed to feed
> The milky heifer and deserving steed. (ll. 181–6)

Yet even this pastoral or Tory view, so clearly redolent of Ben Jonson, is not unqualified and left to its own virtues as an independent, moralizing ideal of civil society. It serves a vague, expansionist conception of improvement. Pope explains

that the men working their 'father's acres' and busily planting 'rising forests', without thought of 'pride or show', are doing so in order that 'future buildings, future navies grow'. The hope is that great plantations will

> . . . stretch from down to down,
> First shade a country, and then raise a town. (ll. 187–90)

Burlington himself is exhorted to 'Bid harbours open, public ways extend' and to control, rather than follow, nature:

> Back to his bounds their subject sea command,
> And roll obedient rivers through the land. (ll. 201–2)

Such works are worthy not only of an aristocrat, or even a king, but of a great imperial nation (l. 204). The reader may recall a famous passage in which Adam Smith describes how man's desire for improvement had entirely changed the whole face of the globe through the clearing of the 'rude forests of nature' and the management of the 'tractless and barren ocean'.

Pope probably intended in the *Moral Essays*, and perhaps in his wider career, to achieve some common ground between the rural, the benevolent, the magnificent, the urban, the commercial, the Tory, and the Whig. The resulting synthesis is not entirely clear, but it seems that the Tory part of the landscape is a rather marginal part of the whole, most truly itself when it exists essentially in retirement. Pope seems very uncertain as to whether benevolence or selfishness is the more essential element in the improvement of civil society. Clearly both have an important part, but benevolence is easier to imagine in a concrete and attractive form, and as a poet Pope is aware that an economy of productive selfishness might have little calling for his finer powers, if 'whatever is, is right.' His work shows how landscapes such as that of the Man of Ross, the 'father's acres', and Sherborne, can be portrayed as objects of beauty, respect, and stability, whereas more improved landscapes are usually less defined, more ambiguous and morally inconsistent. Pope does not offer any comprehensive solution to the issues he confronts; the confusion is a result of an attempt to reconcile aspects of society that many of his successors assumed to be essentially irreconcilable.

The work of Pope's great contemporary, Henry Fielding, is in many ways more clearly Tory than his own — paradoxically so, given the importance in Fielding's novels of the wealthy businessman, Ralph Allen, and the fact that Tory values are often associated with the boisterous and brutal squires most familiarly represented by Squire Western in *Tom Jones* (1749). However much the reader may admire Western's energies, and perhaps his suspicion of courts and lords, he is hardly an ideal landowner. His principal interest is in the defence of the game laws in order to ensure the pleasures of hunting. Fielding's intense admiration of Allen, a man who had risen by genius and commercial acumen to immense wealth and patronage, seems to suggest another, more meritocratic idea of the proper order of society. Yet Squire Allworthy, generally taken to be based on Allen, is unmistakably a product of ancient respectability. His mansion is described, in the manner of contemporary country-house portraits, amid an extensive landscape that seems to be in some

essential sympathy with the mansion without being dominated by it. It is not a self-sufficient centre, but part of an entire natural and moral order that is difficult to reconcile with much of the prevailing spirit of improvement.

Allworthy's house has an air of grandeur and nobility and strikes the observer with awe, partly because of its age. It is in the Gothick style with beauties that rival the best of the much more fashionable Greek architecture. It is as commodious within as venerable without. It is placed on the lower part of a hill, sheltered by a grove of old oaks. The grandeur of the scene is enhanced by the presence, atop a 'fine lawn', of a spring gushing from a fir-covered rock to form a thirty-foot cascade that tumbles naturally rather than over regular steps. The water then flows over broken and mossy stones, eventually to join a lake placed amid a beautiful plain 'embellished with groupes of beeches and elms'. All this forms part of a delightful prospect from the house, and the eye continues to convey pleasurable emotions as the water meanders through an 'amazing variety' of meadows and woods until it meets the sea. In another direction is an equally delightful prospect, adorned with several villages and terminated by one of the towers of a ruined old abbey, grown over with ivy. The mansion has a park that is extensive but merges with the surrounding country. Its 'very unequal' ground is diversified with hills, lawns, wood and water, 'laid out with admirable taste', but owing less to art than to nature. Beyond the park may be seen the cloud-covered tops of 'wild mountains'. The breadth of this varied prospect is given an essentially cosmic scale by the description of Allworthy himself as he stands, replete with benevolence, upon his terrace. He is a being even more glorious than the rising sun he admires. Clearly Allworthy is no worldly improver; he is a perfection of nature, a preserver of the moral order. His wicked brother-in-law, Captain Blifil, enthused by the hope of inheriting Allworthy's estate, is on the other hand obsessed with improvement, largely to enhance the 'grandeur of the place'. He devotes his extensive leisure to the study of fashionable manuals of gardening and architecture.[22]

Ralph Allen, however admirable — he was, according to Pope, the 'Most Noble Man in England' — cannot have been much like Allworthy, whom it is impossible to imagine in the conduct of a complex business involving extensive dealings with the politically great. Allen's own house, Prior Park, was a new Palladian mansion, elegant but not awesome, placed on a hill overlooking the expanding town of Bath. It had a fashionable park of which the best known feature was a Palladian bridge modelled on those at Stowe and Wilton. Fielding may even manifest some small sense of embarrassment at the siting of the house when he notes in *Joseph Andrews* that Allen's 'charity is seen farther than his house, though it stands on a hill'. When Fielding writes directly of Allen, and of the 'useful wealth' he generates, he is not describing some new and attractive commercial spirit. It is part of Allen's genius that he is what he is — benevolent and cultivated — almost in spite of his business acumen. He has risen while retaining the 'most perfect preservation of his integrity' and has done injury to no one. He is an unequivocal 'advantage to trade' and to public revenue because his character rises above the normal nature of commercial ambition. His virtues are essentially aristocratic — there is an 'inherent greatness in his manner', in his taste, dignity, and simplicity. All his works reflect his mind in

being rich, noble, and without 'external ostentation'. Clearly the improved design of Prior Park does not reflect this as ideally as the dramatic landscape of Allworthy's mansion. Fielding expresses in his novels brief and rather conventional admiration of such fashionable places as Stowe, Wilton, and even Vauxhall Gardens, but would not imagine Allworthy resting in such places. Allworthy's house and its setting recall rather those landscapes, at once aristocratic and natural, associated with Fielding's much-admired friend, Lord Lyttelton. The reader may recall James Thomson's 'Spring', with its broad idealized landscape seen from Hagley, and Lyttelton's own poem 'The Progress of Love'.[23]

Allworthy's benevolence is described as expressing itself in a determination to seek merit and want throughout the neighbourhood of his influence. He is hospitable to his neighbours and charitable to the poor. Tom Jones himself is portrayed as a man who is never an 'indifferent spectator of the misery or happiness of anyone'. Benevolence gives deep and lasting satisfaction while the vapid pleasures of the rich and vain are fleeting, dull, and debilitating. Tom's goodness is highlighted by the contrast between his generosity of perception and the selfishness embodied in one of the maxims of greatness promulgated by the mock-hero of *Jonathan Wild* (1743). Wild aims 'To shun poverty and distress, and to ally himself as close as possible to power and riches.' This pragmatic principle is pursued not only by thief-catchers and politicians, however. The clergyman who accompanies Wild to the gallows anxiously escapes from his company to defend himself from the missiles directed by the mob at the unfortunate hero. Conveying himself to a place of safety in a hackney carriage, the parson awaits the conclusion of the affair with a temper of mind that Fielding defines using a quotation from Lucretius, in which the poet describes how men derive a kind of pleasure from the sight of others who are in some ways worse off than themselves.[24] The full passage (*De Rerum Natura*, Book II, part II, section VIII) is as follows:

> Suave mari magno turbantibus aequora ventis
> E terra magnum alterius spectare laborem;
> Non quia vexari quenquam est jucunda voluptas,
> Sed quibus ipse malis careas quia cernere sauv'est.

(There is something pleasant in watching, from dry land, the great difficulties another man is undergoing out on the high sea, with the winds lashing the waters. This is not because one derives delight from any man's distress, but because it is pleasurable to perceive from what troubles one is oneself free.)

Benevolence is not a simple concept in Fielding's work. The essential equality of man consists less in mutual sympathies than in a selfishness of spirit that pervades the majority of people in all classes, regardless of birth and education. There are indeed particular corruptions encouraged by the class system — especially the servility and resentment that it provokes — but Fielding generally insists that the poor have nothing to learn from the rich in vice, malice, scandal, falsehood and 'ogling'. The mob preys on the rich at least as much as the rich prey on the mob.

Compassion and forgiveness are, as Allworthy insists, great virtues, but become evil when they countenance the deep-seated vices present in a great number of men and women. The function of the administration of law, centred in the Justice of the Peace, is to protect the innocent and distressed, but also to punish the wicked without mercy. Benevolence does not bring automatic benefits either to the giver or to the public as a whole. Allworthy's judgement is often faulty and his charity creates widespread envy and resentment from provincial moralists and those believing themselves to be suffering the neglect of the great. He has alienated many of his neighbours; there is little sense of a cultivated benevolence diffusing well-being through a large circle of influence.[25]

The reader may detect in Fielding's last novel, *Amelia* (1752), the recognition of a wider spirit of benevolence and equality than in the earlier works. There are various declarations, offered as moral insight, that generosity, benevolence, and even love are not confined to the great but are found sometimes, even more frequently perhaps, among the low. Society in England is too much separated by prejudice, not only between rich and poor, but even among the polite. Acquaintance is of 'slow growth as an oak'; men are shy of letting a stranger into their houses, as if they imagine all men unknown to them to be thieves. There exists in England, Dr Harrison notes, a 'strange reserve' that is in many ways irreconcilable with Christianity. The virtuous Amelia loses faith in the whole system of patronage, promises, and acquisition of influence, which seems so much to corrupt the conduct of affairs and which her husband continues to pursue. She desires to become independent of the system and imagines herself to be able to compete in the market-place of real activity. She is 'able to work' as much as those 'more inured' to labour. She will not complain of her 'hard fate' while so many poorer than she seem to be content with their lot. 'Am I of a superior rank of being to the wife of the honest labourer?' she asks, insisting that she partakes of 'one common nature' with the poor. Fortunately, however, this declaration of independence and of moral, social, and economic liberalism is not tested. Fielding clearly believes that she is indeed of a 'superior rank', and the conventional apparatus of suddenly discovered bequests and recovered respectability restore a good fortune that has been threatened but not finally overthrown. Having established the moral idea of equality, the author hastily reasserts the social principles of birth and rank.[26]

The virtuous Dr Harrison, who despises vanity in those with low incomes but admires greatness and dignity in the rich, declares his outrage at a system of patronage that favours the inept and threatens to discourage virtue, ability, and the incentive of emulation and free competition among the able. What is at issue, however, is not so much the system itself, which could be the quickest and most efficient means of rewarding ability, but its corruption. Harrison confuses the moral image somewhat by holding up for admiration the efficiency of the rule of Cromwell and its consequence that England became a salutary terror to her neighbours. Dr Harrison goes even further than Allworthy in suggesting that the legal system of England is defective not so much for its injustices but for its tolerance of wickedness. It often seems made for the 'protection of rogues', who should, it would seem, be hanged in much greater numbers than is currently the case. Benevolence, which

clings to virtue, is seen as properly inseparable from a vigorous suppression of vice, which remains in *Amelia* essentially fixed, and virtually incapable of reformation.[27]

The reconciliation of the benevolent and the pragmatic, the traditional and improved was not, therefore, as simple as Fielding and Pope may have hoped. It seems clear that both writers were more at ease in the presence of benevolence than of commercial ambition and that even a successful businessman of merit, such as Ralph Allen, has to be seen largely in terms of his traditional qualities. Both writers are reluctant to admit that a man who had risen by commerce might be a better landowner than a born country gentleman, and that consistent kindness and integrity are very often independent of rank. New landscapes such as Stowe, or even Prior Park, exist in an uneasy relationship with the wider, in many ways more natural settings of an established and careful benevolence. Equally, the local influence of a man of integrity such as Allworthy provides an attractive centre of civilization and connection much to be preferred to the tensions of the larger world. As a good deal of this study will suggest, the reconciliation of local virtue and fashionable improvement seemed to many to become more, not less, difficult as the eighteenth century progressed.

Benevolence and Political Economy

The difficulty was not only a function of the ambiguous benefits promoted by many active improvers in commerce, agriculture, and landscape design. Distinguished moral philosophers also increasingly undermined the idea that civil society may be founded primarily on sentiments of connection. Fielding's citation of Lucretius in the cynical context of *Jonathan Wild* (1743) brings to mind a reference to the same passage in David Hume's *Treatise of Human Nature* (1739–40), one of a number of texts in which Hume criticizes the concepts of benevolence that had long dominated British moral philosophy. Men do not judge objects with a regard to 'intrinsic worth and value', Hume insists, but by a comparison with their own situation and state of mind. The sight of another's suffering enhances a man's sense of the value of his own security and may induce a desire, above all, to protect or ensure it. Hume insists that this disposition in mankind, far from being simply destructive, as some ideas of benevolence might contend, is the principal stimulus to the progress of civil society. Poverty in persons, or in a 'barren and desolate' country, induces fewer pleasures than the 'enjoyment communicated to the spectator' by images of comfort, prosperity, and apparent happiness. Improvement is promoted by the emulation of such images. Men 'naturally respect the rich' because the latter possess most of the means that make life agreeable and commodious. The progress of civil society advances through the individual constantly making a 'just calculation' of his own means of happiness and improvement in a context in which others are doing the same. A free market in trade, offering the inducements of the 'pleasures of luxury and the profits of commerce', is clearly essential to this process. Society is not natural in the Butlerian sense because 'uncultivated nature' does not offer any 'inartificial principle' of security and social justice. Society is a construct of individual interests and prudent calculations held in balance, often precariously, by artificial institutions.[28]

These views, expressed in a much subtler manner than in Mandeville, were easy to caricature and instrumentalize from a variety of points of view, and without necessarily being studied in detail, while Hume's religious scepticism encouraged the hostility with which some conservative commentators perceived his work. Responses to the writings of Hume's friend and fellow Scot, Adam Smith, confirmed the way in which new emphases in moral philosophy might serve to divide opinion among bodies of readers who did not always appear to engage very carefully with increasingly complex arguments. Smith wrote extensively on a diversity of themes, including literature, jurisprudence, and astronomy, as well as moral philosophy and political economy. In some degree he may have encouraged a simple view of his work by appearing to announce, early in his career, an intention of creating 'a system of human nature' that would comprehend all experience; he would find the 'one great connecting principle' in human affairs comparable with Newtonian gravity in the natural world.[29] Smith seemed to suggest that the 'immense variety' of knowledge could be moulded into a 'complete and regular system' that would emulate the 'perspicuity and distinctness' of Classical form, rather than the baffling intricacy of the Gothick. He was operating in a tradition of analogy in which all knowledge might be perceived as connected, but his central focus was somewhat more prosaic than the mind of God. The underlying principle of *The Theory of Moral Sentiments* (1759) and *The Wealth of Nations* (1776) is that the formation and improvement of civil society are founded, not in benevolence, but in the 'desire implanted in every man's breast of bettering his condition'. God moves in more complex ways, and to more complicated ends, than Butler and others might have supposed. Society is united less by 'mutual goodwill and affection' than by a 'mercenary exchange of good offices according to an agreed valuation'. Men rarely feel much for those with whom they have no direct acquaintance and in general rate every small convenience of their own as higher in importance than any misery of their fellow creatures. Society flourishes to the extent that men understand these essential qualities of human nature and find ways of reconciling the energies and risks associated with them.[30]

As in the proponents of benevolence and in Hume, Smith's argument assumes that the desire for improvement conditions the way that objects, and indeed entire landscapes, are perceived. He insists, for example, that ambitious men normally pursue riches in order to make themselves prominent, to be seen. They are most happy when they are being observed with 'complacency and approbation', and to this end seek to display 'decisive marks of opulence' which they possess and others do not. They dread the thought of being overlooked, which they know to be the common fate of the poor. 'Proud ambition and ostentatious avidity' determine most of their ideas of taste. 'Humble modesty and equitable justice' may be more attractive to those of more refined sensibilities, but they have much less appeal to those gripped by a desire to improve themselves. The rich construct great palaces and gardens in order to be admired as different from their fellows. Smith explains that the general abandonment in England of the art of topiary — one that he admires for its elegance and neatness — was caused by the great expansion of wealth in the eighteenth century which had enabled the humblest tallow-chandler to afford such

pleasures. The rich accordingly sought other means to express their distinction; in France, where there had been no such material improvement, the fashion for topiary remained.[31]

The ambitious convince themselves and others that their strivings are necessary to their fulfilment, happiness, and indeed virtue. Great country houses may appear to the moralist to be great and terrible machines, requiring a lifetime to raise and constantly threatening to crush those who occupy them. To the ambitious, however, they appear to be essential means of happiness, settings for a complete 'oeconomy' of noble and beautiful experience. Men are so moved by the sight and emulation of wealth that in any free society a considerable number of its citizens are always striving to seek means of enriching themselves. There is a 'natural progress of things to improvement', fed by competition and encouraged by liberal conditions of trade.[32]

As the nature of Smith's argument constantly suggests, little of this improvement is without individual and social costs. Entrepreneurs are in general perceived as men whose instincts as well as interests are rarely in accord with the public good, and are often directly opposed to it. On many occasions the reader is warned to distrust the claims of commercial men. For example, Smith mocks the attempts of over-extended projectors in real estate to seek public subsidies and portray their speculations as noble and spirited undertakings intended primarily to enhance the beauty and improvement of the country. Smith argues that many improvements have an inherent tendency to hurt a section of the community, at least in the short term. Since 'gain is the end of all improvement', it will often be accompanied by rising prices, lower wages, and unemployment. The division of labour, so essential to economic progress, is also an ambiguous benefit to the community. It will tend to lower the level of individual skill, narrow the faculties of workmen, and threaten a large part of the community with mental mutilation. There are many other risks to a rapidly improving society. The growth of commerce will lead to the transfer of power away from a landed interest that is inherently stable, rooted in a particular spot and in general at ease with itself, and place it in the hands of men who have no fixed residence but pursue gain where they can hope to find it. Smith warns his readers that the worst form of government is one directed chiefly by the ends of commerce. He gives the example of the 'charter government' of India, where the long-term interests and consistent improvement of the nation were made secondary to the pursuit of quick gains.[33]

A balanced account of Smith's work would be a lengthy undertaking, but it is not essential to the purposes of this study, since his influence has always consisted more in what he was assumed to have written rather than a detailed investigation of the work itself. Given Smith's image as an uncritical advocate of the 'market economy', it is striking that Jeremy Bentham, writing in 1787 and 1790, should have criticized him for his underestimation of the value of projectors, those who pursue their self-interest in the employment of risk capital. Bentham thought such men the most useful in the community, the essential promoters of a general improvement, and regretted Smith's frequent criticisms of their motives and effects. Most conservative writers, on the other hand, seem to have made an early identification of Smith as a

man largely uncritical of commercial interests. For example, in a correspondence with Smith in 1776, the colonial governor and controversialist Thomas Pownall worried about the nature of a society, such as he supposed Smith to advocate, in which everything was left to a 'natural tendency towards improvement'. Noting the doctrine that rising prices were harbingers of improvement, Pownall felt that in many cases the labourer, 'though improving', will be unable to improve so much as to emerge from a 'continued distress'. If this was not 'constantly adverted to with feeling' and directly addressed with 'exertions of precaution and benevolence', then society would be the deliberate and constant oppressor of those who have the best title to share in the national prosperity. Commenting on the tendency to reduce economic and social thought to the theory of the free market, Pownall referred to inevitable problems arising from easy credit and the influx of riches which are not the product of real or sustainable generation of wealth. Artificial plenty would promote a commerce of luxury that would make retailers proliferate, encourage extravagance in the possessors of land, unbridled speculation in property, and 'ambitious and dangerous projects' in general. In the delusive abundance of luxurious expense, rents would tend to rise and real savings to erode, while great quantities of money would be directed away from useful investment and lost forever. In this cycle of boom and bust the market would eventually correct itself, but meanwhile many will be ruined, the influence of the country further undermined, and much of the wealth of the nation absorbed by 'adventurers, jobbers, and cheats' who will shape society to their own ends.[34]

The justice of Pownall's objections to the argument of *The Wealth of Nations* may be debated, but his correspondence shows a serious intention to engage critically with a complicated argument. Many who read Smith, or at least suggested that they had done so, adopted a much simpler attitude to his work. A good number were too enthused by the promise of expanding riches achievable through liberal principles to be attentive to Smith's analysis of the risks that might be entailed in such wealth, the various kinds of investment needed to sustain it, and the need for countervailing forces in the community to check some of its consequences. Others, including minds as distinguished as those of Burke, Wordsworth, and Coleridge, seem to have regarded Smith as a dogmatic and uncritical supporter of free markets. Dr Johnson, who was in many ways unusually well qualified to engage with Smith's ideas, seems not to have done so in depth. In much of his work, from the 1740s onwards, Johnson strives to find a balance between the rather static view of mind, society, and indeed landscape, apparently implicit in the work of the Christian moralists of the first half of the eighteenth century, and the creative energies that seemed to be promised in the growth of a commercial society. Johnson was one of the few conservative thinkers to acknowledge the stimulating qualities of Mandeville's work. He insisted that a society without 'progression or advancement', such as pastoral life, is unjust because it tends to entail poverty on subsequent generations. It leaves the low wretched and subject to a lust of dominion, a delight in seeing others oppressed. Commerce corrupts the language and morals, but it is also a potential moral force, a use of divinely ordered powers that can enhance the development of the social virtues. A necessitious level of poverty, far from being, as

Jenyns had argued, a divinely appointed spur to industry and improvement, often tends merely towards a motionless and merciless despondence. Wealth is stimulated by the application of mental vigour to a series of wants, albeit often flippant, created from the endless variety of tastes and circumstances of men. It is supplied by the natural genius of energetic projectors and by vigorous contention for superiority in sciences directed to the understanding of 'new powers of nature'. Desire increases with possessions so that this chain of supply and demand remains continually stimulated, generating credit and new investment as 'mutual convenience' creates 'mutual confidence'. Commerce is therefore a natural and necessary part of the improvement of civil society. It is not, however, its end, and not inherently beneficial when it conflicts with Christian teaching, which is the best hope of seeking to control or mitigate its tendency to corruption and achieve a reconciliation of competing ideas of improvement. How such a reconciliation might take place in a complicated society is not necessarily clarified in Johnson's later work. In particular, his political writings of the 1770s propose a static view of the established order in which the principal enemy is innovation, and institutions seem to be valued according to their age and unsuitability for improvement.[35]

The second half of the eighteenth century saw an increasing desire on the part of many conservative thinkers to distance themselves from the commercial, and a parallel tendency of many to regard a particular view of political economy as an all-embracing account of nature. The tendency may be noticed as much in religious discourse and moral philosophy as in other fields. Such popular writers on religion as Jenyns, Beattie, Reid, and Paley were significantly inferior intellectually to the leading Christian apologists of the first half of the century, and the increasing reduction of analogical discussion to the 'argument from design' tended to under-value everything in nature that did not easily reflect the divine benevolence. William Paley, perhaps the most widely read apologist for the Anglican Church in the late eighteenth and early nineteenth centuries, compares nature not only to a watch, as Butler had done, but to a silk or cotton mill, and sees her ruled by similar commercial realities. Writing in 1790, Paley emphasizes that scarcity, though a 'temporary distress', is often a 'permanent benefit' in that it acts as a 'stimulus to new exertions' and to 'further improvements'. In his works on moral philosophy and natural theology, largely published between 1785 and 1802, Paley argues at length that the fitness of animals to predatory functions, including their suitability as prey, is, if not an indication of benevolence, at least one of brilliance of design, in which consumers, commodities, and producers are kept in perfect equilibrium. Those evils that cannot be explained are simply discounted: 'when we cannot resolve all appearances into benevolence of design, we make the few give way to the many.' The consequence of this generalizing theory applied to social relations is reflected in Paley's defence of the great number of capital penalties in the eighteenth-century legal code. The end of law is to deter; penalties need not be proportionable to offences, and if a few innocent people are executed, this will still serve the wider good of society by discouraging criminal activity and safeguarding property. The argument from design, reduced by Paley and others almost to a branch of political economy, was to collapse early in the nineteenth century, as much as a consequence of intellectual

shallowness and moral inconsistency as of the new emphases of the geological and evolutionary sciences. Ruskin's later attempt in *Modern Painters* to argue that the form of every leaf, cloud, or any other particular of nature, in detail or the whole, demonstrates aspects of the divine mind, brought natural theology to a new level of precise observation, but in doing so created intellectual tensions vastly more unmanageable than those in Butler and Berkeley.[36]

The increasing sense of the incompatibility of commercial and Tory thinking by the end of the eighteenth century, the growing gap between benevolence and improvement, and the weakening of the idea that taste could be directed by a moral emulation of a connected nature, may be illustrated in a variety of ways. One of the most compact bodies of evidence is the extensive pamphlet controversy of the mid-1790s regarding the proposals of William Pitt's administration for the reform of the poor laws. The system of relief was agreed by virtually all commentators to be in a desperate state of repair in a nation at war and faced with scarcities arising from bad harvests and naval blockades. Those who urged Pitt to undertake a greater degree of involvement in the support of the poor — there was much talk of minimum wages, more effective emergency relief, superannuation, assistance in the purchase of cows, cottages, and land — have been on the whole forgotten. Some of them are discussed in this study. On the other hand, those who urged Pitt to liberalize the labour market include names with still formidable reputations.

In his *Observations on the Poor Bill* (1797) Bentham attacked what he took to be the sentimental and vague good intentions of contemporary benevolence. It was all very well to assist a poor man in the purchase of a cow or a piece of land, but if, for example, the cow became ill or the land was flooded, and new funds were demanded, there was the prospect of an endless potential burden on property and the State. What was required was a scientific approach in which all costs would be quantifiable and predictable and nothing left to individual emotions and inclinations. In his *Essay on the Principle of Population* (1798) the Reverend Thomas Malthus rejected any ethic of benevolence in favour of the argument that everything fine in human affairs has its origin in self-love. He urged the end of poor laws that artificially depress wages and raise prices by subsidizing poverty. Only the idea that dependence is disgraceful, and its consequence a life of hard fare and discipline in the workhouse, can oblige the poor to be independent and provident. Malthus's argument was confused by his evidence that the increasing wealth of nations had done little or nothing to aid the poor, and that the inexorable trend of history was for rising populations to outstrip the capacity of cultivation to feed them. His conception of improvement is therefore unclear, although part of it may be hinted at in an extended picturesque image assembled in different passages of his major work. Determined, he writes, to qualify the romantic pictures of nature painted in the 'captivating colours' of much philosophical speculation, his own unjaundiced view emphasizes its melancholy hues and shades, its roughness and inequalities. To the enlightened mind, however, such features serve only to demonstrate the beauty and harmony of the whole composition. They show how delightfully its inferior parts support and make more prominent the superior, while the variety of the whole delights the mind and affords endless scope for intellectual curiosity and improve-

ment. Malthus offers a view of analogy clearly reminiscent of Jenyns and Paley. The blemishes and inferior parts of nature are necessary to the whole because they stimulate industry, balance what would otherwise be unstable, and, above all, maintain in their proper place the superior, more ornamental, members.[37]

The most distinguished thinker to embrace a simple doctrine of political economy was probably Edmund Burke, who did so at a time when his powers were under severe strain. His most important statement on the question of the poor, the *Thoughts and Details on Scarcity* addressed to Pitt in 1795, uses an unimproved conception of nature that is a curious blend of Jenyns, Old Testament theology, and free market theory. The agricultural writer Arthur Young reported Burke's frame of mind after visiting him at his country house, Gregories, in 1796, the year before his death:

> His conversation was remarkably desultory, a broken mixture of agricultural observations, French madness, price of provisions, the death of his son, the absurdity of regulating labour, the mischief of our Poor-Laws, and the difficulty of cottagers keeping cows. An argumentative discussion of any opinion seemed to distress him.

Burke was angry with Coke of Norfolk, among many others, who had argued that it was the duty of the landed proprietors to protect the poor from the suffering arising from increases in the cost of bread. The national legislature should reinforce the powers of local justices to regulate prices and prosecute millers who adulterated wheat or combined to control markets. The weights and measures of shopkeepers should be periodically checked as a further means to protect the poor. One of the best known agricultural improvers in England, Coke clearly believed that careful regulation could coexist with progressive economic management.[38]

For Burke such views were expressions of atheism and Jacobinism. It is not in the power of government, or even of the rich, he argues, to supply what Nature has chosen to withhold. To seek to interfere with the markets in corn or wages is to challenge natural and therefore divine law. In France, the well-intentioned but misplaced regulation of 'universal officiousness' had provoked the Revolution by attracting to government all the blame for the ills, natural and artificial, of society. The poor, a term Burke disliked as suggesting a canting pity for men who were poor only because they were numerous, were to be recommended to patience, labour, frugality, religion, sobriety, and, oddly enough, gin. Sentimental thinking would turn scarcity into famine; guaranteed relief would merely lead to higher prices. To regale the poor with stories of their once happy condition was a cruel deception. Their circumstances had improved steadily, so that current scarcity would have been plenty to earlier generations. Death from hunger was virtually unknown, owing to the 'great care and superintendence' of the poor.

The meaning of this last phrase is unclear but seems inconsistent. Burke strongly denounces the standard idea of rural benevolence that the relations of the farmer and labourer are to be regulated by enlightened country gentlemen acting in their role of justice of the peace as protector and restrainer. All such relations are to be left to the market. There can be no contradiction between the interests of employer, labourer,

trader, and consumer. It is in the entire public's interest that the farmer should prosper and the corn speculator grow rich. The market is the only guarantor of equity since all contracts are made freely and can therefore never be onerous. The speculator serves the customer, and the farmer's interest is to keep his men healthy and happy on the same principle, Burke insists, that the farmer takes care of his beasts — presumably regardless of contract. To interfere with this natural 'chain of subordination' is unjust and imprudent. A magistrate enacting abstract and often inapplicable laws, or following his blind discretion, can never emulate the 'just proportions' in wages and profit created by the 'natural regulation' of self-interest, habit, tacit convention, and a 'thousand nameless circumstances'. If a labourer has nothing to claim from the rules of commerce or the 'principles of justice' — which are undefined — he becomes subject to the rules of mercy with which, Burke writes rather disturbingly, the magistracy can have nothing to do. In this context, mercy means discretionary charity, in which property and individual freedom are not invaded, and manners are set against regulation. As charity is naturally pleasing to men, and a part of their religious duty, the poor can have reasonable expectation of assistance and the economy as a whole can continue to generate a prosperity that will inevitably result in a general improvement.[39]

Burke's analysis admits none of the problems hinted at by Smith, at least not in Burke's writings on political economy, which most admirers of his subtler constitutional theories have chosen to ignore, just as many who concern themselves with political economy have shown a limited interest in Burke's more familiar preoccupation with tradition.* It is fascinating to find, at the close of the eighteenth century, that the most important conservative thinker in Britain, much of whose work suggests the influence of Butler, was also one of the most extreme critics of benevolence. Given the strident nature of this 'liberal conservatism', it is not surprising that Tory thought should tend to feel increasingly ill at ease when confronted with the language of commerce.

* In Conor Cruise O'Brien's *The Great Melody* (1992), an enthusiastic account of Burke's genius and consistency, the economic writings receive no mention whatsoever in a work of over 700 pages. O'Brien limits himself to noting that Burke was a 'free-trader by instinct' who became one in principle after the publication of *The Wealth of Nations*. This was, according to Burke, 'in its ultimate results ... probably the most important book ever written' (p. 144). What Smith would have made of Burke's *Thoughts on Scarcity* can only be surmised, but a critic of its author might feel that Burke bears some moral and intellectual responsibility for the treatment of his native Ireland during the Great Famine. Charles Trevelyan's simple economic certainties were far more reminiscent of Burke than of Adam Smith.

2

The Whig Idea of Landscape and its Critics

The mind that would be happy, must be great.
Edward Young, *Night Thoughts* (IX. l. 1381)

Various attempts have been made in this century, as in the eighteenth, to argue that the style of informal landscape design that seemed to pervade England in the early eighteenth century was a 'national style' based on ideas of constitutional liberty expressed in the Glorious Revolution of 1688. This type of improvement is often contrasted with the formality of less fortunate nations, in which nature was suppressed by a 'presumptuous art', and topiary, avenues, and parterres could be seen as manifestations of some despotic tendency. In this view, liberty in Britain, together with security of property, created the conditions for a rapid increase in national wealth and the general improvement of the landscape. Daniel Defoe, writing in the 1720s, saw the proliferation of country villas with informal parks and gardens as the best indication of a trading and improving country, the most flourishing and opulent in the world, and luxuriant in culture and commerce. James Thomson's *The Seasons*, completed by 1746, warns of the dangers of luxury and the indulgence of unreal wants, but describes improvement advancing through the whole physical, moral, and political landscape of Britannia. Such problems as the unregulated gaols could be seen as remnants of an unimproved past, as yet untouched and awaiting the patriotic statesman's 'weeding hand', so that the national garden could be perfected through the general diffusion of constitutional liberty.[1]

The most extensive expression of the informal style was to be found in the parks of what are often described as the great Whig mansions — massive structures apparently designed to fulfil what Adam Smith regarded as the supreme end of improvement, the desire to seen. The normal characteristic of these houses was their setting in vast parks distant from any activity that could be interpreted as their economic base, whether in agriculture, trade, or political peculation. Architectural historians sometimes differentiate what may be loosely termed a Whig idea of the placing of the country house from a more traditional pattern in which the mansion was clearly seen as part of a community, with adjacent village and parish church.[2]

In the Whig idea of the arrangement of landscape it is often difficult to distinguish ideas of taste from the assertive expression of private property and control of

territory. The style that had its supreme exponent in 'Capability' Brown (1716–83), characterized by a standard formula of artificial water, clumps and belts of trees, could be stretched over a landscape as far as funds and property would allow, and clearly at a lower total cost of planting and maintenance than a formal style. Defending Brown's work in the revolutionary 1790s, the Reverend William Mason sought to demonstrate its national values and constitutional validity: 'Liberal tho' limited, restrain'd tho' free', an 'emblem of pure legal liberty'. The principal theoreticians of Brown's work in his own time were quite deliberate, however, in equating taste with the heightened display of property and the appropriation of nature to personal use. The love of possession is 'deeply placed in every man's breast', noted William Marshall, and 'places should bow to the gratification of their owners.' Horace Walpole, while arguing that the English spirit of liberty manifested itself in the school of gardening perfected by Brown, admitted under pressure that the real end of such improvement was 'mere luxury and amusement'. The most influential theoretician of gardening late in the period of Brown's dominance, Thomas Whately, came close to the point of identifying taste with obvious possession. He was particularly insistent on the use of a riding

> to extend the idea of a seat, and appropriate a whole country to the mansion; for which purpose it must be distinguished from common roads [and] . . . the marks of distinction must be borrowed from a garden . . . as evidence of the domaine . . . [The] *species* of the trees will often be decisive . . . Where the species are not, the *disposition* may be particular, and any appearance of *design* is a mark of improvement; a few trees standing out from a hedgerow, raise it to an elegance above common rusticity; and still more may be done by clumps in a field; they give it the air of a park . . . When a riding is carried along a high road, a kind of property may in appearance be claimed even there, by planting on both sides trees equi-distant from each other, to give it the air of an approach; *regularity* intimates the neighbourhood of a mansion; a *village* therefore seems to be within the domaine, if any of the inlets to it are avenues.

Little is left to nature, accident, or discretion; the end of improvement is the clear distinction of personal property from the common, the rustic, the public.[3]

Emparkment seems to have had some of the same emotional appeal as the game laws in the pursuit of privileges and those 'marks of opulence' noted by Smith, which others do not and generally can not enjoy. Brown's principal successor, Humphry Repton (1752–1818), urged that ornamental 'marks of grandeur' should be scattered about a dependent landscape so as to distinguish by their number and design the taste, wealth, and dignity of the proprietor. The local church, the inn, and indeed the entire village, could be made to conform to the mansion, with coats of arms set on the milestones of the neighbourhood in order to give the impression of 'united and uninterrupted property'. What Repton termed 'objects of mere convenience' — stables, barns, the kitchen garden, the village with its almshouse, school, and churchyard — should no longer, in an improved age, be allowed near the mansion. If they could not be made ornamental, they were to be concealed or, best of all, removed altogether. In a similar spirit, Mason's suggestions for the improvement of

Sir Joshua Reynolds's Richmond villa expressed a desire to 'hide the Alms houses and stables that stood in my way'.[4]

Other critics emphasized the removal of evidence of agricultural activity lacking in interest, dignity and ornament. In his illustrations of country seats in Leicestershire, published in 1789, John Throsby quietly suppressed all that was ordinary—stables, barns, offices, and ploughed land. Such liberties, he wrote, every 'Gentleman of taste' must approve, following Dryden's dictum that nothing 'which is not proper or convenient to the subject' — no features, persons, or incidents — may be admitted save those that serve to carry on the main design. According to William Marshall, a serious writer on agriculture, an improver could create near to the park or within it obviously artificial farms to convey to the observer a pleasingly edited view of the rural in its characters of simplicity, meekness, and peaceful security. A commentator on Mason's *The English Garden* described how a real farm near a gentleman's park could be masked with the 'fictitious ruins' of a castle or a church, buildings of clearly higher dignity. Improvement would conform to the pastoral ideal expressed in the fashionable aesthetics of Hugh Blair, in which rural life could be seen as a state of tranquil ease, natural sentiments, and amiable simplicity, without any of the displeasing characteristics of the real life of the country — the dull, laborious, mean, servile circumstances and 'low ideas' of actual peasants. As Bishop Watson wrote in 1793, peasants and mechanics were useful and agreeable enough members of the community as long as they did not intrude themselves into areas of life suitable only for gentlemen.[5]

Such views of improvement, dependent on the clear separation of the polite from the rustic, seemed absurd and vulgar to the critics of Brown's style. It may be supposed, however, that many of those who commissioned great parks saw themselves, not in the often trivial terms of landscape theorists, but nearer to the theory and practice of Sir Joshua Reynolds's 'grand style', in which the essential, ideal nature is distinguished from the deformities of common nature. In Reynolds's very secular version of analogical thinking, the artist seeks the perfect forms that may be assumed to have been the standard in the original will and intention of the Creator. Far from understanding the divine harmony in terms of the vulnerability and mutual dependence of humanity, such a view is clearly intended to enforce divisions in nature. Everything imperfect and deformed is eschewed, as is everything singular, individual, or merely local. The ideal is everywhere hinted at in nature but may be unlike any particular object; it is a selection of beauties derived by long study of the enormous variety of nature and the exemplary works of great artists. Men's powers of observation are sharpened by the accumulated experience of past ages, enabling them to extend the narrow circle of their own endlessly repetitive ideas, and more easily to reject what is ordinary and common. The grand style confers a superior dignity, therefore, on both subject and object.[6]

Reynolds uses a very conventional idea of composition as being a balance of uniformity and variety, but, like the theorists of Brownian improvement, he argues that the principal figure must dominate over the whole and that all inferior figures or circumstances must be 'sacrificed without mercy to the greater'. He seems to be following, and at the same time outdoing, the aristocratic aesthetics of Lord

Shaftesbury's *Characteristicks* (1711): 'Particulars . . . must yield to the general Design . . . all things be subservient to that which is principal: in order to form a certain *Easiness of Sight*; a simple, clear, and *united View* . . . [not] broken and disturb'd by the Expression of any thing peculiar or distinct.' As Reynolds argues, when many inferior objects make too many 'pretentions to notice', the leading figure, and therefore the whole composition, must be in danger of neglect. The mind in all its interests wishes to focus on what is clear, steady, and durable, and therefore seeks images, and indeed moral and political circumstances, in which all things are defined in relation to the whole. The enlightened observer does not wish to be perplexed and harassed by a Gothick confusion of equal parts vying with each other for attention. The highest form of art is clearly history painting because a heroic figure, not necessarily bearing any likeness to an individual, may be exhibited in circumstances in which sublime landscapes, classical references, and dependent minor figures serve only to elevate the status of the principal figure. Such dressings-up of nature are designed to avoid the risk that a rich man, for example, would convey the 'vulgarity and meanness' of new consequence, rather than the natural, unaffected dignity of genius or ancient family. In contrast with the grand style, rural scenes function in Reynolds's view of the world merely as temporary refreshment and recreation in his artistic passage between great estates and London sophistication. He expresses a degree of admiration for Gainsborough's depictions of the 'interesting simplicity and elegance' of 'little ordinary beggar children', and the interesting, if 'mean and vulgar', forms of Gainsborough's woodcutters.[7]

Whatever the aesthetic justifications of improvement, the creation of parkland clearly led to the alteration of many traditional landscapes and social relationships. In his plans for the great Whig palace of Blenheim, Sir John Vanbrugh argued for the preservation of the ruins of Woodstock Manor because ancient buildings may 'move . . . many lively and pleasing Reflections' on the 'Persons who have Inhabited them'. Yet this valuing of the past and its remembrances appears to have been very selective. At Castle Howard Vanbrugh was responsible for the demolition of Henderskelfe church, castle, and village in order to open prospects. The pattern of removing villages inconveniently near a mansion or a favoured view is one of the most familiar aspects of eighteenth-century improvement. Sometimes some or all of the inhabitants were moved to new, often formally designed and possibly more comfortable villages, usually carrying clear marks of the landowner's possession. One of the best known examples was undertaken in the 1720s by the greatest of the Whigs, Sir Robert Walpole, at his newly constructed seat of Houghton in Norfolk. The creation of the gardens at Stowe, begun after 1710 by Sir Richard Temple, later Viscount Cobham, and dedicated in large part to the 'liberty of Great Britain', involved the almost complete destruction of three villages. One of them, Boycott, survived only in the name of two garden pavilions designed by James Gibbs. Stowe Church was allowed to remain but carefully screened by trees. A later commentator suggested that nearby Buckingham Church had been rebuilt to form an object from the park. It carried the family motto *Templa quam dilecta*, suggesting in a sense that it had no more significance than the Temple to Bacchus, with its inscription encouraging the pleasures of the moment in an uncertain world, or the Witch House.[8]

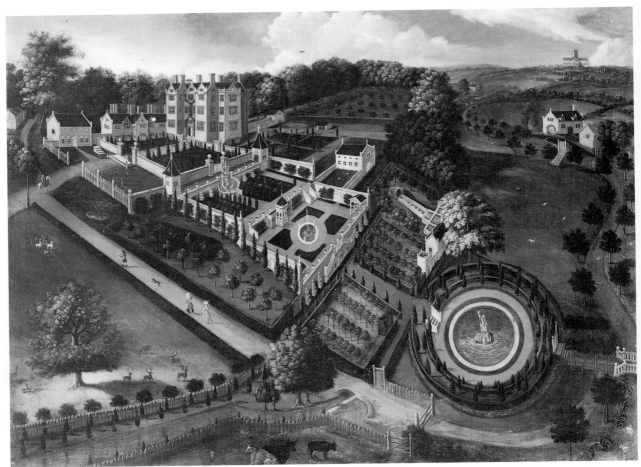

1 In traditional images of the country house the mansion is often featured within a wide landscape of which it has fully appropriated only a part. Public life appears to carry on with some degree of independence beyond the confines of the garden or park. It is not always clear whether the artist sees the house as a burden or a benefit to the landscape, but most paintings allow the spectator to assume that those who commissioned the scene wished to present the mansion as a contribution to an idea of social order and organizing culture. In *Massey's Court* (1662) the emphasis appears to be on the house as a centre of skill and plenty, combining intellectual refinement with agricultural abundance.

2 (facing page top) In the image of Sprotborough Hall near Doncaster, attributed to Adrien van Dienst and probably painted in the 1690s, the mansion is the principal object in the composition but hardly dominates it. The limited appropriation of land to a formal garden encourages a sense that public life, agricultural and religious, may be carried on undisturbed, perhaps even improved. At the same time, an observer may feel that something is happening in the landscape which might become threatening to an older equilibrium.

3 (facing page bottom) A continuing desire to relate local, formal settings to the wider country beyond may be seen in Balthasar Nebot's views of the gardens at Hartwell House, Buckinghamshire (1738). In the view illustrated here the organization of the hedges leads the eye to semi-formal parkland and then to the wider agricultural landscape.

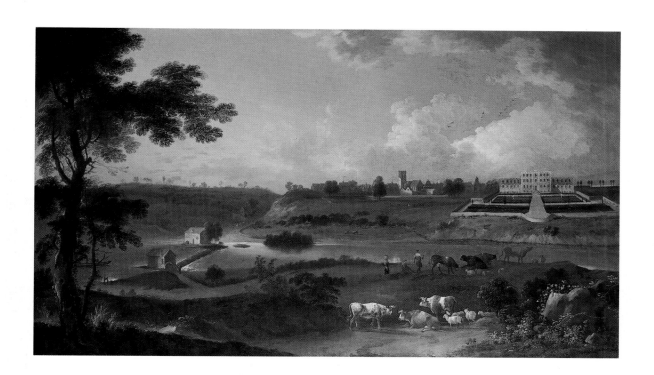

At Shugborough Thomas Anson spent a good part of his energies in the 1740s and 1750s buying up the local village, nearby hamlets, and cottages in order to sweep them away to expand the reach of his park. He also began to occupy about a thousand acres of the adjoining slopes of Cannock Chase, sometimes ignoring the legal status of common land. By the late 1750s he had created a considerable private domain, marking the appropriation of the landscape by scattering about it clumps of trees and ornamental buildings in various Classical, Chinese, and Gothick styles. Writing in 1760, the poetess Anna Seward depicted the improvements at Shugborough as an image of national liberty, since only 'in Freedom's Land' could forms reminiscent of the 'Mandarins' despotic power' be happily combined with 'Grecian domes' and be taken as images of pure delight rather than oppression. At Nuneham Courtenay the poet William Whitehead celebrated the liberal delights of improvements undertaken in the 1760s, in which Lord Harcourt, an admirer of Rousseau, destroyed the entire village because it was too near his house. The church was replaced with a Roman-style temple carrying Harcourt's arms and formed a 'noble ornament' in the pleasure grounds. Constructed without pews, pulpit, or bell-tower, and two miles from the new model village, it appears to have performed its

4 An image of Painswick House, Gloucestershire (1748) by Thomas Robins the Elder, depicts a formal garden incorporated, albeit rather oddly, into the older landscape. Rural pursuits continue to carry on at the confines of the polite improvements. The image suggests a balance, perhaps precarious, between the formality of elegant life and the rustic simplicities beyond the appropriated land.

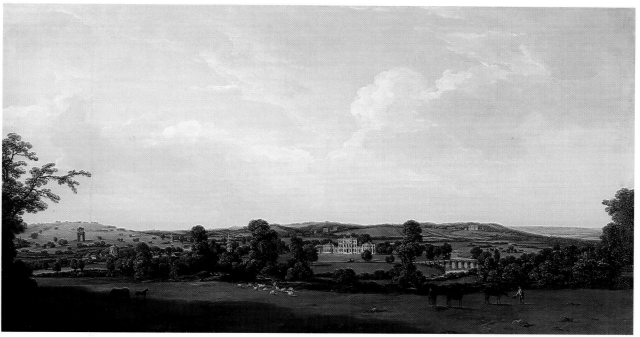

5 In Nicholas Dall's painting of Shugborough, Staffordshire (*c*.1769) the private has very clearly begun to dominate the public realm. The entire landscape provides opportunities for display, as follies and plantations exhibit the scope of the proprietor's taste and influence. The historical characteristics of Thomas Anson's improvements—such as the removal of the village of Great Haywood and the appropriation of common land—seem to be reflected in this image.

religious function no better than Sir Francis Dashwood's church at West Wycombe, built in 1761–3 complete with a golden sphere for an observation post, and placed, according to John Wilkes, at the top of a hill for the convenience of the parishioners at the bottom.[9]

Developments in the landscape garden, from the work of Stephen Switzer, Charles Bridgeman, and William Kent through to Brown, can be characterized in a number of ways, but it seems appropriate for the purposes of this study to emphasize an increase in the desire to rework or transform great stretches of traditional landscape. In general the reach of improvement grew as the number and scale of projects expanded. Landscapes became more fluid, not only in the obvious sense of a supposedly more natural style of design, but in being perceived as commodities that needed to be altered with changing fashion. A formal garden may seem to be timeless in character, a natural garden more malleable. In 1734 Sir Thomas Robinson reported a sudden and 'general alteration' of important gardens, including Chiswick and Stowe, as the fashion for the work of William Kent induced owners to modernize works that had only recently seemed to be completed. Later commentators, notably Sir William Chambers and Uvedale Price, wrote of improvement as an increasingly ruthless destroyer of established landscapes and works of gardening art.

As the scope of the projects increased under the influence of Brown, so apparently did the wish either to disguise or to remove the immediate observation of common, cultivated nature. Bridgeman at Richmond Gardens and William Kent at Rousham, Claremont, and elsewhere, seem to have sought to merge their work in some way with meadows and fields, rather than enforce a feeling of clear separation of the polite from the ordinary. Writing of Stowe in 1748, the young William Gilpin emphasized not only the presence of fields, hedges, and haycocks within the park, making up a 'rural scene' that afforded 'great Relief' to the eye, but the 'Advantage of low Walls' that allowed the view of 'every thing entertaining' in 'half a County'. 'Villages, Works of Husbandry, Groups of Cattle, Herds of Deer' were 'brought into the Garden', and made a 'Part of the Plan'.[10]

Comparisons between Switzer, Bridgeman, and Kent are made difficult by the impermanent nature of their works and the fact that only Switzer sought to explain his intentions at length in writing. He appears to have believed that the increasing extent of gardens in his lifetime undermined the moral intentions he associated with his own work. In his *Ichnographia Rustica* (1718) Switzer argues that a major part of gardening should be concerned with the revelation of God's power and goodness. As human intervention could often interfere with this purpose, Switzer insists on the importance of what he terms 'the natural'. The garden should 'fall into natural Coppices, Paddocks, Corn Fields' and similar features. Gravel walks carefully laid in such places would provide comfortable settings for quiet study and meditation. The gardener should make his 'Design submit to Nature' and not 'Nature to his Design'. The 'adjacent Country' should be 'laid open to View', so as to allow the observer to read the 'expansive Volumes of Nature'. If the fringes of the garden were carefully and delicately fenced, the 'adjacent Country' might appear as if it 'were all a Garden'. As this formulation suggests, Switzer's idea of nature appears somewhat confused, and a study of his rather formal designs confirms this impression. It seems clear, however, that Switzer's generally small-scale plans were intended to portray a kind of rural ideal founded in a mixture of Christian and Classical sources. He was particularly attached to the theme of a farm-like design related to the Roman *villa rustica*, carrying literary and historical associations of virtue and independence. Like the *Imitatio Ruris* in Robert Castell's *The Villas of the Ancients Illustrated* (1728), the rural involves an irregularity of design that is disposed with 'the greatest Art'.[11]

Switzer, who died in 1745, found during the 1730s that he was losing touch with fashion. In the second edition of the *Ichnographia Rustica* (1742) he accused Bridgeman of pursuing the idea that 'true Greatness consists in Size' and of 'aiming at Things beyond the reach of Nature'. Gardens were no longer proportionable either to the size of the house they accompanied or to principles of judicious expenditure. The design of lakes took no account of the goodness of the land they flooded or its suitability for the retention of water. In Switzer's account Bridgeman seems a spoiler rather than an improver of the landscape. Though he was nominally a Tory and was friendly with Pope, there is certainly little ideological consistency in some aspects of Bridgeman's work. He started his career as part of the circle of Edward Harley and may have worked at Dawley Farm, the centre of natural virtue that was part of Bolingbroke's challenge to the 'man of craft', Sir Robert Walpole.

However, at least five of Bridgeman's clients were active promoters of the South Sea Company and his portrait was to feature in Hogarth's *The Rake's Progress* among those who tempt the prosperous to ruin. One of Bridgeman's most distinguished clients was the man of craft himself. At Houghton Bridgeman was involved in early plans for laying out Walpole's 337 acres of woods, clumps, and avenues. In 1732 Harley described Houghton as exhibiting 'very great expense without either judgment or taste'. Six years later, however, he noted that the plantations were 'very fine and thriving extremely'; nature, it appears, could flourish despite the rule of Walpole. Even Richmond Gardens, where Bridgeman, in Horace Walpole's phrase, 'dared to introduce cultivated fields', may appear to be less fanciful or idyllic if credit is given to the remark of Sir John Clerk of Penicuik that the fields were present for the 'benefite of the game'. The idealism of Richmond Gardens also has to be read in terms of the residence of the poet Stephen Duck in Merlin's Cave, where his formerly vigorous sense of the pains of the rural poor gave way under royal patronage to a more deferential type of versifying.[12]

The Whig interpretation of landscape gardening saw Bridgeman as a pioneer of a style, brought to perfection by Kent and Brown, in which all nature might be 'rescued and improved'. Horace Walpole described how the invention of the ha-ha enabled the garden to be 'set free' from its 'prim regularity' so that it might 'assort with the wilder country without'. William Kent was the great pioneer who finally 'leaped the fence, and saw that all nature was a garden'. A garden was generally considered private property, of course, and Walpole's account of Kent's techniques underlines the irony of how a more natural style of gardening led to the increasing regulation of nature. The 'living landscape', Walpole writes approvingly, was 'chastened or polished' without being transformed. Streams were 'taught to serpentize', borders were smoothed, and a few trees scattered over 'the tame bank'. 'Loose groves' were planted to crown 'an easy eminence' with 'happy ornament', and statues and buildings employed to decorate the horizon. Walpole found some deficiencies in Kent's work. There was a 'too great frequency of small clumps', 'no large woods' had been 'sketched out', and much seemed done 'for immediate effect'. Kent 'planted not for futurity', as his occasional habit of using dead trees clearly testified. Yet, taken all together, his achievement was a triumphant preamble to the greater perfections of Brown.[13]

The idea of a garden having a political or ethical programme, most familiar at Stowe and Chiswick, clearly became less fashionable as the natural style of gardening developed. Stowe and Chiswick were created by men who had, at various times, quarrelled with Sir Robert Walpole and chose to present themselves as defenders of liberty against a corrupt ministry. Chiswick pays tribute, in its exedra, to Socrates, Lycurgus, and Lucius Verus, all perceived as opponents of tyranny. The Temple of British Worthies at Stowe, designed by Kent *c.* 1735, included busts of Inigo Jones, Milton, Shakespeare, Pope, Ralegh, Drake, Gresham, Newton, Bacon, Locke, Hampden, Kings Alfred and William III, and Queen Elizabeth. All had opposed 'slavish systems' of artistic, political and religious prejudice, fought for the glory of Britannia, or expanded the horizons of exploration and trade. The Gothic Temple was originally dedicated to Liberty and the Temple of Modern Virtue was built in

the form of a ruin to contrast with the delicately colonnaded prosperity of Kent's
Temple of Ancient Virtue. Gilpin noted that Lycurgus, Socrates, Homer, and
Epaminondas, all honoured in this last building, were promoters of Virtue, Justice,
Liberty, and the Welfare of Mankind. They were men 'in whose Breasts mean Self-
interest had no Possession' and who occupied themselves 'searching into Nature'
and 'laying up a Stock of Knowledge' for posterity. They stood against the 'Corrup-
tions of a licentious Age' and of an 'invidious City', rejecting any 'Fame, built upon
Conquest and popular Applause'. Modern Virtue, in ruins even though 'within a few
Yards of a Parish-church', was naturally embodied in Walpole, whose headless
statue presided over the Temple. He appears as an 'old Gentleman' and a 'worthless
Fellow' in whose image it is difficult to find 'any thing extraordinary' except his
having met the fate he so entirely deserved. As Stowe developed in mid-century its
sense of virtue carried an increasingly imperialistic emphasis, as befitted its close
connections with the elder Pitt. In 1759 a monument to General Wolfe was erected,
and in 1763 the Temple of Concord was rededicated to Concord and Victory in
celebration of Conquest in the Seven Years War.[14]

In his poem *The Enthusiast* (1744) Joseph Warton criticized the artificial and
narrow feelings stimulated by Stowe and other modern gardens 'deckt with Arts'
vain Pomps'. He preferred the raptures experienced in such natural settings as 'the
thrush-haunted copse'. In 1748 Lady Grey, wife of the future second Earl of
Hardwicke, also found Stowe unsatisfactory, but for different reasons. She agreed
that, in a naturally ill-favoured landscape, Cobham had relied too much on Art. He
had crowded the place with buildings and managed the land according to a 'stiff set
Plan'. Everything manifested 'vast Expense and Labour', 'scarce anything' was
concealed, and the whole conception was dependent on show and size. The grounds
were 'all open and bare', the better for visitors to see and be seen, and there was a
noticeable absence of the 'Shade of a few high Trees'. The buildings were generally
lacking in taste and judgement, were trifling, clumsy, and already beginning to
decay. Enraptured by the pleasures of vanity and novelty, Cobham had concentrated
on increasing the size of Stowe and had neglected previous work. The iconography
of the place she found intrusive and absurd; she refers, for example, to the 'mon-
strous siz'd Bas-relief' attached to the Palladian Bridge. The elegance of the bridge's
design was compromised by the 'History of Commerce and the Four Quarters of the
World bringing their Productions to Britannia'. So lacking in variety was Cobham's
recent work that Lady Grey found herself preferring the earlier parts of the gardens,
where the formal parterres, hedges, and walks at least afforded the pleasures of
privacy, elegance, and comfort. The proper function of improvement was to com-
bine such pleasures with more interesting, various, and natural forms. Lady Grey's
Nature was not, however, Warton's. She was offended, not only by images of
commerce, but by the blending of the rural and the improved, expressing disgust at
the sight of 'ugly, rough Fields' admitted into the landscape to provide a contrast
with the clearly artificial. To allow such things was to emulate the defects of Nature
instead of showing her in 'her Best Dress'. A rough field should be 'smooth'd into a
level green Lawn with a few Clumps or single Trees scattered over it'. Open

prospects of the surrounding country were similarly offensive, particularly as that part of Buckinghamshire was 'dirty and not at all beautiful'.[15]

Lady Grey anticipates in these comments a number of the standard terms of criticism of improvement current in the second half of the eighteenth century. In some cases such criticisms were directed against Brown; on the whole, however, her remarks may be taken as evidence of changes in taste that would generally welcome his work. Brown was employed at Lady Grey's birthplace, Wrest Park, in the late 1750s, and at her husband's estate, Wimpole, after 1769. There she watched admiringly as Brown created a lake, planted clumps, destroyed formal avenues, and spread the park to the west to incorporate what had been cultivated fields. Comparable ideas were expressed by a source sympathetic to Brown, Isaac Ware, in his *Complete Body of Architecture* (1756). The eye is to be regaled with the 'collected beauties' of nature assembled from her 'remotest regions'. Pains must be taken to separate such beauties from the 'rude views' in which nature reveals her many blemishes. Delightful objects are to be brought 'nearer to the eye', and disposed and grouped so as to create 'an universal harmony among them'. In this arrangement everything may be free, but 'nothing savage'; all that is pleasing is to be 'thrown open', but all 'disgustful' objects are to be 'shut out'. Both Ware and Lady Grey offer hints of the increasingly aggressive tone in which the issues of improvement were being discussed. Writing after a visit to Stowe in 1754, when Cobham's heir, Earl Temple, was reworking the grounds, a future King of Poland, Joseph Poniatowski, referred to the strident enthusiasms of the proponents of natural gardening. They were 'une espèce de secte nouvelle', full of an 'antipathie intolérante contre la doctrine ancienne'. All 'alignement' was to be removed to produce 'paysages artificiels' con-structed in obeisance to a particular idea of nature.[16]

The moral self-image of much improvement before Brown may or may not be taken very seriously. Few elements in the composition were susceptible to simple interpretation. For example, William Shenstone, creator of the Leasowes, generally described as a farm, noted that a cottage is a pleasing object 'partly on account of the variety it may introduce; on account of the tranquillity that seems to reign there; and perhaps (I am somewhat afraid) on account of the pride of human nature: "Longi alterius spectare laborem".' The values of pre-Brownian improvement were often contradictory, their morality controversial, their sense of English tradition very partial, and the ideals apparently espoused often deliberately secular or indeed pagan. In the Hermitage at Richmond Park Queen Caroline placed a series of busts in which the scientists Newton and Boyle were accompanied by the philosopher Locke and the theologians Samuel Clarke and William Wollaston. The mixture was clearly calculated to suggest an unorthodox, perhaps rather Arian, view of religion, and was therefore a bold statement by the wife of the Defender of the Faith. An anonymous commentator on Stowe, writing in the late 1730s, noted the equestrian statue of George I and expressed surprise that the 'Noble proprietor' of the gardens should 'place the Image of what is call'd generally Sacred Majesty' among 'so many Temples, Deitys and Persons of Heathen reputation as we had lately passed by'. A poem in the *Gentleman's Magazine* of March 1743 regretted the neglect of Stowe

Church (the 'temple of the Lord') amid so many expensive shrines to 'heathen deities'.[17]

Other pre-Brown gardens suggest variations on similar themes, with the intentions of their owners, and their favourite forms of symbolism, often difficult to define with much precision. One of the more complex examples is Stourhead, the Wiltshire estate established by the banker, Henry Hoare, on lands that had belonged for many centuries to the Catholic Earls of Stourton. Hoare acquired the place in 1717, using resources from the family business founded by his father in 1672. He immediately pulled down the baronial mansion, which was probably in ruins, and built a neat Palladian villa designed by Colen Campbell. He began some improvements in the local landscape, which appears to have been uncultivated and devoid of trees. The famous garden at Stourhead was created by his son, Henry Hoare the younger (1705–85), who inherited in 1725 and began work on the grounds in the early 1740s. The garden was placed well away from the mansion in a sheltered valley at the head of the River Stour, whose waters were dammed to make a lake of over twenty acres. The siting of the garden, surrounded by newly planted hills, to a large extent excluded views of the wider country, but the old hamlet of Stourton, with its cottages, church, and churchyard, was left standing at what was now the edge of Hoare's garden. The design of the new landscape was in a style of classical picturesque, reminiscent of the Italy of Claude and Gaspard Poussin, and featured a Grotto, a Pantheon, and Temples to Flora and Apollo. Later, more exotic Chinese and Turkish elements were added. The village of Stourton was always part of the total composition, influencing, for example, the siting of the Pantheon in the early 1750s.

Hoare, known in the family as 'the Magnificent' to distinguish him from his father, 'the Good', was a complex personality who appears to have sought in some ways to emulate Pope, or perhaps Ralph Allen, in a reconciliation of the cultivated and commercial. A Tory banker, he generated income as well as spent it, and insisted that his temples and 'Exotick Pines' were a demonstration of the virtues of striving, industry, and application. As a young man his clients included Vanbrugh, Kent, Burlington, and a good part of the landed interest, many of whose improvements throughout the eighteenth century were to be financed by the family business. He may well have reflected on the contrast between his own prudence and the increasingly mortgaged condition of many of his customers as their improvements became ever more ambitious. As the century progressed he certainly began to feel a mounting nervousness at the state of affairs in England, a view confirmed towards the end of his life by the loss of the American colonies. It is possible that there was a connection between this concern and the growing emphasis at Stourhead on what might be seen as traditional English images. The medieval Bristol High Cross was re-erected in the gardens in 1764 and a tower dedicated to King Alfred was built in 1769–72. A Gothick Convent was added about this time, given a 'monastic gloom' through the use of 'ancient painted glass' and the planting of dark firs. A Rustick Cottage was added a few years later. In an attempt to save Stourhead from general ruin, Hoare endowed the estate with an income independent of the banking business, and in 1783, having outlived his own children, he transferred possession to his grandson, Sir Richard Colt Hoare (1758–1838). Colt Hoare was both a benevolent

landowner and an accomplished antiquarian, deeply read in the ancient history of Wiltshire and Wales. He emphasized further the native aspects of the garden, eliminating the Chinese and Turkish structures. In 1791 he made, for the first time, an entrance from the village directly into the garden, and incorporated Stourton more fully into the wider composition through the management of lawns and plantations and picturesque improvements to the church and cottages.[18]

Complex landscapes such as Stourhead demand to be interpreted according to the particular intellectual and moral propensities of their owner-designers. The Brownian park, on the other hand, seems generally devoid of moral intentions and complexities or even of a particular personality. Its success reflected both a decreasing sense of the importance of an ethical programme in gardening and a growing desire to use the landscape as a setting for the display of the mansion, on which the majority of details and viewpoints could be made to centre. In some of the most familiar gardens of the mid-eighteenth century the garden was often quite separate from the house, as at Claremont, Stourhead, and Rousham. Commentators on the important gardens at the Leasowes and Painshill were generally happy to praise or blame them without feeling they had to admire a mansion. These gardens, and indeed a good part of Stowe, featured a diversity of scenes which could be experienced in a changing sequence, proposing particular themes for contemplation. Like the more extensive older formal gardens, they did not invite analysis or summary from a single point of view. Many visitors to the Brownian park, on the other hand, felt that the mansion was the focal point of the entire experience.[19]

Such an emphasis could alienate as many observers as it might impress. It is probably relevant to note here that the first half of the eighteenth century was widely perceived as a period in which rising national wealth was broadly, albeit inequitably, diffused. There was far less confidence in the second half of the century that the condition of the agricultural labourer, for example, was improving. A steady rise in population appears to have been accompanied by a fairly drastic increase in retail prices after 1750, following more than a century of price stability. Intense efforts to improve agriculture seem to have become less effective, in terms of yield, after the early decades of the eighteenth century, while often serving to undermine traditional forms of employment on the land. The growing size of farms and the effects of parliamentary enclosure tended to enhance a sense of imbalance in the rural economy and landscape. The divisions of commons, in particular, seemed to many to threaten an order of society in which competing interests and uses of land could be held in balance by law and custom. In this context, an extensive Brownian landscape dedicated to the display of property could present itself as an expensive confirmation of the triumph of the private interest over the public. Brown appears to have worked on well over two hundred projects between the 1750s and the 1770s. A landowner who employed such an active professional would have had difficulty suggesting that he was seeking to express a particular personality or set of local attachments.[20]

For a number of reasons, therefore, moral interpretations of improved landscapes often became less plausible, as well as less important, as the eighteenth century progressed. The language used to describe Prior Park in a letter of 1742 written by

the young Charles Yorke, brother of the second Earl of Hardwicke, may help to underline the point. Noting that his enthusiasm for the place was heavily influenced by admiration for its owner, Yorke describes Ralph Allen's improvements as part of a wider landscape in which art and nature are harmoniously balanced:

> The natural beauties of wood, water, prospect, hill and vale, wildness and culti-vation, make it one of the most delightful spots I ever saw, without adding any thing from art. The elegance and judgment with which art has been employed, and the affectation of false grandeur carefully avoided, make one wonder how it could be so busy there, without spoiling any thing received from nature.

The landscape was animated by the 'presence of the master':

> the tranquillity and harmony of the whole only reflecting back the image of his own temper: an appearance of wealth and plenty with plainness and frugality; and yet no one envying, because all are warmed into friendship and gratitude by the rays of his benevolence.

Reflecting on Allen's death in 1764, Yorke noted the enduring fame of the 'amiable and benevolent' and considered this one of their chief advantages over the 'great and ambitious'. Prior Park, a modest part of a broad landscape which its owner could be said to have enriched in a variety of senses, suggested moral ideas much more difficult to associate with the generalized landscapes of Brownian improvement. To many, Brown's work had much more to do with 'affectation of false grandeur' than the expression of a balanced and useful wealth characterized by generosity, plain-ness, and frugality.[21]

A change appears to have occurred in the general idea of the role of the country house, which seems reflected in the contemporary development of the estate portrait. In the late seventeenth- and early eighteenth-century prospect of a mansion, the house and its gardens typically represent an element in a wider landscape. While avenues and other kinds of formality may extend the reach of the house, there is normally a clear distinction between it and the wider view of villages, churches, and cultivated fields. The mansion and the public domain coexist in a way that is complex and uncertain, but at least open to the suggestion that the mansion is contributing to the improvement of the entire landscape. The formal environs of the house generally suggest a variety of exemplary skills in agriculture, horticulture, and other civilized arts. The image may be of a confident centre of civilization in which expense coincides with thought and ability. Comparisons with the poetical ideal of the country house, from Ben Jonson's 'To Penshurst' to Pope's *Moral Essays*, do not seem inappropriate. The general assumption is that the house is only properly itself when it is of benefit to the locality. In Jonson's words, it has been 'rear'd with no man's ruine, no man's grone'; it not only serves to represent virtue, but to 'give reliefe' and other benefits. The poor are essential characters in this ideal; they are, as Andrew Marvell puts it in 'On Appleton House', the frontispiece of the entire image. As the garden became more natural in the eighteenth century, the idea of the country house often became steadily less public. Familiar images of the second half of the century, such as Richard Wilson's *Tabley House* (c. 1765), and hundreds of views

of mansions set in Brownian parks, seem to see the house and its improved grounds as the entire world. Everything appears to be owned and controlled, clearly under the eye and authority of the proprietor. Indeed, Brown's work appeared to its critics to be a simple expression of property and display, whose effects on traditional communities could be far-reaching, as such well-documented cases as Nuneham Courtenay and Milton Abbey amply testified.[22]

The Critics of Improvement

The case of Milton Abbey is particularly interesting in that it displays the extent of the reach of improvement and the kinds of opposition it might provoke. Joseph Damer, first Baron Milton, rich through a family fortune created in large part by money-lending in Ireland, began the transformation of his recently acquired Dorset estate in 1763, planning to construct a new mansion and park that would appropriate to his purposes the ancient and largely intact Abbey church. Brown was employed at Milton at various times between 1763 and 1770, the period in which the decision was made to remove the substantial nuisance of the adjoining market town of Milton Abbas. Sir William Chambers, working at Milton between 1771 and 1774, designed both the exotic new mansion and an estate village intended to rehouse a small proportion of the local inhabitants. In its completed form, after about 1790, Milton's estate was a very impressive private domain, surrounded by over five miles of park wall and containing more than ten miles of carriage drives. The massive iron gates that gave access to this world were normally kept locked. Lord Milton, a man of notoriously irascible temperament, had by that time fallen out with virtually the entire neighbourhood. In 1774 Chambers, who had abandoned work at Milton Abbey, complained that its proprietor was an 'unmannerly Imperious Lord' who 'knows no reason but his Interest' and uses everyone brutally. Chambers's professional relations at Milton were not improved by the thinly disguised criticism of Brown in his *Dissertation on Oriental Gardening* of 1772. Lord Milton's own humours became yet more violent following the early death of his wife in 1775 and his son's suicide in the following year.[23]

A number of contemporary tourists and other commentators made favourable remarks on Lord Milton's achievement. His house had become the 'principal object' in its part of the county, a 'magnificent pile' situated on a knoll at the junction of three valleys. The hillsides, one observer noted with some disapproval, had been planted with Scotch fir rather than the local beech. The setting of the place, however, had been 'very much improved' by his Lordship's having 'swept away' the old market town, once of 120 houses, which had grown up under the protection of the Abbey but was now 'converted into a fish pond'. A small estate village had been built half a mile from the old town, out of sight of the mansion, with uniform cottages, 'crowded with peasants', set at regular distances along an approach road.* At the

* The two-storey cottages have front elevations comprising a central doorway with a transomed two-light casement window on each side and three two-light windows on the first floor. The moderately imposing eleva-

6 and 7 The transformation effected by the style of Lancelot Brown is illustrated in two engravings of Milton Abbey. The first (plate 6), dated 1733, seems to have a largely antiquarian intent as a depiction of 'remains', although most of the structures are intact. Between the church and the other principal building, once the Abbot's house, is a formal garden, clearly maintained. The old town of Milton Abbas may be glimpsed on the right of the church, while the wider landscape seems to be left in a natural state or to have failed to attract much artistic interest. In Edward Rooker's engraving of Brown's improved scene at Milton Abbey (plate 7), which may be dated 1773–4, all is changed, and the entire landscape has been ordered around the new mansion. Much of the old Abbey has been destroyed. The new structures on the hills and the design of the clumps and belts of trees demonstrate the reach of the landowner's power. Although the Abbey church is still the dominant structure in terms of visual mass, it is clearly a private appendage to the mansion and has been restored accordingly. Sir William Chambers's design for the house is barely deferential to the church, being an odd mixture of Perpendicular and 'Hindoo'.

8 and 9 Two paintings by Richard Wilson suggest the nature of the Brownian age of improvement. In the first, *Bourne Park* (plate 8), painted between 1756 and 1758, the mansion is a feature of an extensive mixed landscape, one element of property among many. In *Tabley House* (1764–8) (plate 9), the newly created mansion and park comprehend the entire visible world. This idea is not diminished, and may indeed be strengthened, by the placing of the house at the edge of the picture. It seems apparent in this landscape that everything is subject to the control of a landowner, who is keen to distance himself from images of productive activity. The example of Tabley is interesting historically in that the fourteenth-century hall and chapel of the Leicester family survived on a wooded island well away from the new improvements. It seems that the Tory Sir Francis Leicester, the last of the line, bequeathed his estates to a prosperous son-in-law, Sir John Byrne, on condition that the old mansion, the chapel, and associated woods should be preserved. Byrne's son, who inherited in 1742, began major works at Tabley around 1760.

centre of the village Milton had rebuilt the old town's seventeenth-century almshouse with its founder's arms replaced by his own. A new Gothick church, constructed using materials from the Abbey tithe barn, was completed by 1786.[25]

The destruction of Milton Abbas, as individual leases lapsed, appears to have taken about twenty years and to have been actively resisted. Various underhand measures, such as the flooding of a solicitor's house, are reported to have been employed in order to encourage the inhabitants to leave. In the early 1780s, when the destruction of the town was well advanced, Milton began to concentrate his attention on the removal of the ancient freehold grammar school, founded in 1521, which was an important feature of the old Milton Abbas. This plan led to prolonged litigation between Lord Milton and the local landowners and clergymen who were the school's hereditary feoffees. In 1775 Chancery had supported the feoffees in their claim that the school's property and management were entirely independent of the secular lords of the manor who were the successors of the abbots of Milton Abbey. In 1784, however, Milton introduced a bill into the House of Lords, seeking the school's removal to Dorchester, a distance of ten miles.

The Bishop of Bangor, as chairman of the bill committee, noted that 'great Expense' had been undertaken in the making of the new park and in other improvements, and that the school, only thirty yards from the mansion and half a mile within the park wall, must be a 'great Annoyance and Inconvenience' to his Lordship. The feoffees' comments that the school had predated the park, was a private foundation built for local children, and that Dorchester already had three grammar schools, did not impress the Bishop, who argued that the reduced state of the town, now housing only the families of 'Labourers and Mechanics', removed the need for such a learned institution.* The feoffees underlined their case in a petition which noted that the school, being built on private land in a public street, was clearly by legal definition 'not in any Park or Property' belonging to Lord Milton. The school was well maintained and attended, with ample land on which the scholars could exercise and play without trespassing. Its use was an inherited right of the public that should not

tion disguises the fact that each cottage, about 35 feet by 25 feet in its external measurements, was designed to hold two tenements. Chambers wrote in 1773 of forty 'double houses', each to contain two families, and each consisting on the ground floor of a kitchen, a 'work-house', and a pantry, and on the 'garret floor' of two rooms. Each house had a tiny garden. On a visit in 1791, Fanny Burney described a village built 'very regularly, of white plaister, cut stone fashion, and thatched, though every House was square, and meant to resemble a Gentleman's abode'. This was 'a very miserable mistake' of 'an intended fine effect', since 'the sight of the common people, and of the Poor, labouring or strolling in and about these dwellings, made them appear rather to be reduced from better Days, than flourishing in a primitive or natural state'. The existing evidence does not allow any informed judgement as to whether this accommodation was an improvement on the old, or indeed what relation there was between the inhabitants of the new village and the old town.[24]

* In *The Politics of Language 1791–1819* (1984, pp. 16–17). Olivia Smith notes a general tendency in the period of her study for the sixteenth-century grammar schools to become what she describes as 'non-local and élitist'. She offers the examples of Leeds, Rugby and, most notably, Harrow, the trustees of which were taken to court in 1810 for not fulfilling the terms of the original endowment. It seems that they successfully argued that the original intention of the grammar schools was to teach the classical languages and that they were therefore 'not now adapted generally for persons of low condition, but better suited to those of a high class'. The growth of a system of public schools, whose main appeal was their essentially private nature, presents a paradox comparable with that of a style of natural gardening directed in great part to the 'appropriation' of the more public landscape.

be made subject to a particular 'private Convenience'. The feoffees were not averse to a 'reasonable Indulgence' of Lord Milton's wishes, but could not deny the 'Duties of their Trust', which would be flagrantly violated if the scholars were deprived of a free education without the expense of boarding. The petitioners hoped that no parliamentary aid would be afforded to take away private property held for the good of the public. In this hope, however, they were disappointed, and the school was moved six miles to Blandford, effectively destroying its original purpose.[26]

In 1785 one of the school's feoffees, the Reverend George Bingham, published some anecdotes of the life of John Hutchins, late assistant master of the grammar school and author of the standard history of Dorset. Bingham noted that the statement in the *History* (1774) that the school had always been under the authority of the lords of the manor had no validity and was indeed contradicted elsewhere in the work. The passage had clearly been inserted by another hand when the manuscript was no longer with Hutchins. Bingham makes it clear through various classical allusions that he could identify this party but that to do so might be improper. A copy of the *Anecdotes* in Cambridge University Library has the following commentary: 'The insertion is well known to have been made by Ld Milton into whose hand the History was put in Manusc[ript], and who made this ungenerous use of the confidence placd in him. Ld M: is himself Lord of the Manor.' As if to emphasize the low nature of his adversary, Bingham praises the character of the late Jacob Bancks, MP, the previous and worthy possessor of Milton Abbey. He was a gentleman 'most deservedly beloved', and the 'very centre of union to the neighbourhood'; his house had been distinguished, not by the magnificence of the building, but by the dignity of its guests and its 'hospitality to all ranks and degrees'. Hutchins himself had described Bancks as 'open, candid, and sincere' — a man who scorned the 'mean arts of cunning, dissimulation, and design', and who tempered the 'plainness and simplicity of the ancient English' with the 'politeness of the modern'. His generous disposition had led him to revive the 'old English spirit of hospitality' and benevolent concern for the comforts of the tenants and the industrious poor. His popularity, interest, and reputation in the county had exceeded those who were his superiors only in point of fortune. Hutchins and Bingham accordingly make respectful reference to traditions that had obviously become unfashionable, but that are valued in such documents as Bishop Hurd's account of the simpler manners of the sixteenth century, when hospitality 'spread the interests' of society and 'knit mankind together' by the generous diffusion of wealth. The decorum and benefits of this conduct won the affection and veneration of the people, enabled rural industry to flourish, and discouraged private luxury. The country's grace and ornament was 'frugal simplicity of life'.[27]

After his destruction of the grammar school, Lord Milton turned his attentions more fully to the Abbey church in order to make it the private chapel to his mansion. Under the direction of James Wyatt it was 'repaired and beautified', being made 'very clean and neat' by an ample use of whitewash and the removal or obliteration of monuments and inscriptions. The churchyard was torn up and laid out to form part of the pleasure grounds. All this required permission; in common law a churchyard was a public place in which every parishioner had a right to be buried.

It was to be maintained in perpetuity in respect to the remains of former 'temples of the holy ghost', and not to be 'sacriligiously applied' to private convenience. Monuments and inscriptions were to be valued as the last works of charity of the living towards the dead, to be held in 'reverend regard', and protected from decay or defacement. Clergymen, most notably James Hervey in his 'Meditations among the Tombs', wrote of churchyards as 'peculiar, awful' places suited to reflection and moderation of conduct. Ancient churches themselves were valuable monuments to piety and witnesses to posterity; their careful maintenance was an expense infinitely to be preferred to 'opulence and improvement' in private seats and gardens. Despite all this, in 1786 the Bishop of Bristol approved without much apparent reflection the request that

> the whole of the said Old Church Church yard and Appurtenances thereto should go and wholly belong to your Petitioner the said Joseph Lord Milton and be by Him suffered to remain in its present State or to be repaired or altered or taken down at his own Expense and for his own Use as he shall think fit.

By the late 1780s, therefore, and after more than twenty years' effort, Lord Milton had succeeded in appropriating and transforming a wide landscape through legal elimination of customs, rights, and attachments. Unfortunately for him and his heirs, the legal expenses, the acquisitions of land, and extensive building and improvements, including enormous sums spent in altering the shape of the hills and trying to form a lake where nature had refused to accommodate one, resulted in the substantial diminution of his once ample financial resources. The records of his account at Hoare's Bank document the serious difficulties in which he found himself by the 1790s.[28]

The interplay of aesthetic, legal, constitutional, and moral issues in the improvement of Milton Abbey, at least as seen by Lord Milton's opponents, may be reflected fairly closely in some of the imagery of change expressed in the principal legal source of the period, the *Commentaries on the Laws of England*, written by Bingham's close friend, William Blackstone, and first published in 1765–9. Through complicated imagery and allusion, and with assistance from the common law, Locke, de Lolme, Montesquieu, and the analogical tradition, Blackstone sought to argue that the grounding of the British constitution in the past, in ancient principles and traditions rather than constant innovations, was a main foundation of liberty, stability, and general rights. The Lockeian idea that the main end of civil society is the protection of property — to enclose and fence the 'wild Common of Nature' — is not particularly helpful in outlining how the enclosure occurred so unequally, but it includes the premise, not always associated with it, that all units of property, however small, are to be defended. In Locke, a rich man in possession of a whole country who chooses to seize the 'Cottage and Garden of his poor Neighbour' effectively dissolves society, creating a natural right of resistance on the part of the poor man. Further, the unequal division of land and the existence of strong legal defences for property are supposed to be accompanied by a sense of its possession as a trust for the entire public.[29]

Blackstone seeks to absorb this approach and at the same time to give legal weight to the principle embodied in the Bill of Rights that the 'true, antient, indisputable' rights of Englishmen included those of liberty, security of person and property, and sustenance, which meant, among other things, a legal right to relief in periods of necessity. The abdication of these rights, and of a system of laws that will protect the meanest citizen from the 'insults and oppression' of the greatest, theoretically, but of course not in practice, removes the obligation of obedience to the laws. Property rights are central to the law because property 'strikes the imagination and engages the affections' in a very special way, and because its security and transmission to posterity, whether for individual or charitable ends, not only make life more commodious and agreeable, but encourage better and more useful citizens. Blackstone notes that there were clear tendencies in contemporary society, expressed in such areas as changes in the laws relating to enclosures, relief, game, and the definition of felony, which suggested that the property rights of the poor, and through them their other rights, were being steadily undermined. As a result of increasing inequality before the law, the hopes of a community 'friendly and social', established throughout in 'mutual assistance and intercourse' in the common enjoyment of rights, was under constant assault. Blackstone seeks to give authority to what he takes to be more equitable traditions by using imagery to contrast showy modern change with the ancient dignity of the older creations. He often describes the British constitution as an elegantly contrived machine, its parts artificially but brilliantly connected together in Newtonian tensions, but his preferred image is that of a venerable 'noble pile', which must be sedulously repaired and protected from the rage of unskilful 'modern improvements'. The ancient edifice manifests the accumulated wisdom of past ages, and the nation is bound by ties of nature, honour, and religion to transmit it intact to posterity. The common law, regarded as having reached its most perfect expression in the time of Lyttelton, is a 'venerable edifice of antiquity', a Gothic castle that bears the marks of later, rash, and inexperienced workmen who have attempted to polish and refine the old structure, adding specious embellishments and fantastic novelties designed to suit the fashions, whims or convenience of particular individuals or interests.[30]

Like earlier theorists, Blackstone sees the common law as somehow mystically embodying the customs and universal agreement of the whole community, as being, as Sir John Davies had put it, 'connaturall' with the nation. It is at once ancient and full of variety, as it has struggled to embody principles of security and redress suitable to the circumstances of every citizen. When critics of the English law complained of its lack of simplicity or reason they were, Blackstone argues, mistaking a natural variety for mere confusion, and a capacity for complexity as simple contradiction. Selecting from laws, customs, and precedents, while insisting all the time that he was replacing innovation with tradition, Blackstone created a version of English law on which a deeply critical stand could be taken against such things as slavery, compulsory workhouses, the game laws, the abuse of the settlement laws, and virtually all capital punishment. It was quackery in government, arguing a want of solid skill, to apply universal and easy remedies to every case of social difficulty,

in particular to limit the natural and legal rights of citizens, and offend the principles of humanity, in the uncertain defence of the more powerful members of society.[31]

Blackstone's treatment of English law may be compared with his friend Samuel Johnson's conception of his duties in the creation of a Dictionary of the English Language, another ancient body of matter created from a complex blend of necessity, accident, affectation, learning, and ignorance, all 'thrown together' and composed of 'dissimilar materials' without 'uniformity and perfection'. The 'wild exuberance' of the language was to be regulated and choices made from its 'boundless variety' without neglecting its inherent instincts of liberty, its copious and energetic variety. The selection was somehow to be accomplished without innovation, since all change brings inconvenience. The values inherent in Johnson's approach were to be confirmed in his political writings of the 1770s, in which the British constitution is described as a complex growth of chance, neglect, and occasional improvement. It must be carefully preserved since a structure of such intricacy is not susceptible to analysis by 'regular theory' and cannot be safely tampered with by inexperienced hands. Once destroyed, it can never be reproduced; its forms are, therefore, to be 'our rules' and determine future conduct. Blackstone's conception of English law was, on the other hand, generally thought to have widened the scope of English liberties by insisting on the importance of traditional rights against attempts to extend the power of particular interests. The intricate structure of law raised by Blackstone caused considerable problems, for example, to government prosecutors in the treason trials of the 1790s. It posed similar difficulties for those who wished to denounce the existing order in favour of an idea of reason. Blackstone's work was an early target of Jeremy Bentham's science of utility, which would emancipate morals, language, and above all the law, from the past, and make them conform to the busy spirit of an age in which knowledge was 'rapidly advancing to perfection'. Teeming discovery and improvement in the natural world would be followed by a quick reformation in the understanding of human affairs. Everything distant and recondite in nature was being explored, mapped, and appropriated to use; it was inconceivable that morals and political arrangements should remain in any sense unknown or mysterious. Blackstone's image of the law as a castle, a respected relict of Gothic prejudices, was therefore deeply offensive. The 'fabric of felicity' must be erected by the hands of reason and of law, and be founded entirely in the scientific principle of utility. Everything that attempted to question that principle dealt in 'sounds instead of senses, in caprice instead of reason, in darkness instead of light'. Ironically, Bentham used the language of Montesquieu and Beccaria to assault a system of ancient law in England which many writers of the Continental Enlightenment on the whole admired.[32]

Whatever the specific implications of utility, it seems clear that in Blackstone's terms such improvements as that at Milton Abbey could easily be considered contrary to the letter and spirit of the law. Property, in Blackstone, is sacrosanct and charity is 'interwoven with our very Constitution' through the statutes of mortmain and the appointment of the sovereign, the *parens patriae*, as the ultimate guarantor of charitable foundations. The legal concept of nuisance cannot apply to a 'mere matter of pleasure', such as a 'fine prospect', and is in any case established in

precedence. If one builds adjacent to a nuisance it is one's folly so to have built, and potentially itself a nuisance if such building prejudices 'what has long been enjoyed by another'.[33]

That a specific, potent, and constructive language of protest could be founded in opposition to innovation may be confirmed in a sermon given in 1777 by a country rector, the Reverend James Ibbetson. He denounces the many 'new plans or systems of improvement' that were being proposed as public benefits but were really schemes to 'lay field to field' to serve the 'sole emolument of a few pragmatical men'. In the conduct of enclosure bills, in particular, ancient rights were annihilated and the 'public, political law of the Constitution' — a system of inherited rights agreeable to the 'law of God and nature', and guaranteed by the king — was replaced by the 'municipal or civil law of the State', which changes with political ideas of convenience. Such improvement served only the oppressions of the rich and increased the distress of the poor, since many a 'petty lord' of a hamlet thought it a disparagement in a treaty of enclosure to condescend to 'low capitulations' with his poorer neighbours, regarding them with 'careless inattention' and a 'certain penurious and niggardly disposition'. Improvement meant the racking of rents, the projection of monopolies, the enlarging of farms, and the depopulation of villages. Far from increasing the general wealth, it led to a decreasing quality and quantity of cultivation as thistles and 'hateful docks' replaced verdant blades of corn. The rage for enclosures would cease as they became too general and too expensive, but by the time the market had decreed this change the political and physical landscape would be laid waste. Against this model of improvement, Ibbetson urges one nearer to that of Butler. A generous heart, not contracted in itself and confined to the narrow little views of selfishness, 'improves, realizes, and completes' its own happiness in that of others. It is the property of goodness to 'diffuse and communicate itself' universally, to become the more glorious the greater its extent. Benevolent actions are the 'genuine and original growth' of the human heart and are the only real basis of moral and social judgement; 'they only are our Betters who do more good than we.'[34]

Enclosure embodied many of the central premises of progressive ideas of improvement because it seemed that the pursuit of individual self-interest, finding market opportunities, would bring about massive public benefits. It would be, in the title of an important pamphlet of 1787, the 'Cause of Improved Agriculture, of Plenty and Cheapness of Provisions, of Population, and of both Private and National Wealth'. If its tendency was also to lower the cost of labour, accentuated eventually by new machinery, this would be compensated for by the new riches that, trickling down to all, would promote new enterprise. The attractions of enclosure were enhanced by aesthetics, since nature's fertility and useful beauty would be discovered as wretched commons became fruitful fields and luxuriant pastures. England would become one 'large, rich, and variegated garden':

> The Waste shall smile
> With yellow harvests; what was barren Heath
> Shall soon be verdant mead.

The precarious returns of a common, where the nature of things was unfavourable to improvement through insecurity of tenure, and produced a dull and dispirited peasantry, would be replaced by secure tenure, enhanced industry, and improving comforts. The truly valuable parts of common rights — the ability to keep livestock and to gather fuel — would be compensated for or reproduced in some other form. Any individual inconvenience would be outweighed by the general benefit. Critics of enclosure were concerned that any such change would create at least as many problems as it resolved, if undertaken independent of moral restraints and regulated chiefly by the perceived self-interest of its promoters.[35]

The Literature of Anti-improvement

The apparent nature and pace of change in the second half of the eighteenth century led to a widely diffused sentiment among many of the most sensitive minds of a desire to arrest and redirect the improvement of the landscape. The country house and its park, at least if they were newly built or improved, were often regarded with a considerable degree of dismay, and the ancient and established features of the landscape with an increasing nostalgia or romanticism. The moral end of this criticism was to challenge the new, provoke discussion as to the direction of change, and seek to define the real nature of improvement. Such writers rejected the progressive premise that the interests of projectors are normally identical with those of the public. Oliver Goldsmith's work, particularly *The Traveller* (1764) and *The Deserted Village* (1770), is the most familiar example of one version of this point of view. It was undertaken in a period notable not only for the crises regarding John Wilkes and the American colonies but for deep economic difficulties. The later 1760s were afflicted by scarcity, rising prices, lower wages, and unemployment. Governments felt obliged to intervene in the corn markets, several times suspending exports and seeking to enforce the ancient legislation against withholding. Despite major improvements and colonial expansion, England seemed incapable of feeding itself adequately, but the conviction that statesmen should do nothing in such circumstances had not yet taken hold.

Goldsmith argues that 'rural manners' and virtues, which are valued as the essential basis of national well-being, are incompatible, beyond a certain point, with the general progress of commerce. These values, being founded in a sense of community, cannot long survive in confrontation with the unfeeling logic of a system dominated by the vigorous pursuit of self-interest. The point of transition is inevitably vague, but the village of Auburn before its ruin is in no state of nature. Without embracing the vices of luxury, it has moved well beyond subsistence to attain a state of improvement that is reminiscent, in some ways, of Butler and Berkeley. A moderate toil produces plenty and 'humble happiness', and there is ample leisure for neat gardens, village games, personal whim and individuality in manners and tastes. Auburn's virtues are hospitality, mutual concern, piety, loyalty, plainness and frankness of expression; whether through distance from the greater world or deliberate rejection of its values, its inhabitants are seen as content in a stable, largely independent, economic system based on agriculture. The poet, who

has lived in the greater world and participated in at least its literary commerce, is keen to come back to the village and inform the 'gazing rustics' that the wider world has nothing to offer them. He hopes to return to the company of honest emotions and to distance himself from an economic system in which wealth depends on the degradation of 'wretches, born to work and weep' in dangerous and dispiriting trades.[36]

Auburn therefore represents a life that the poet has chosen, at least for a time, to reject, but to which he hopes to return; it hardly grows, as the poet does, and he hopes it will be there when he himself is tired of growth. The essential values, which the poet needs to discover through the market-place, exist independently of that market. It is the paradox central to Adam Smith, of the progressive instinct constantly disappointing itself. Goldsmith elsewhere berates a life of dissipated variety, spent in the vain search for something new, and criticizes the poet-gardener William Shenstone for never sitting down peacefully to enjoy life, but always scheming new enjoyments, so that improvement becomes voracious, and a man a stranger to himself. The greatest pleasure is to grow old in the spot in which one was born. Native walks and fields have, by association, beauties beyond the most delightful scenes 'that ever art improved' or 'fancy painted'. To observe familiar objects, and to measure the years by the growth of trees planted by one's own hands, are the basis of personal contentment, of loyalty to individuals and communities, and ultimately of love of country.*[37]

Goldsmith's Auburn and its 'bold peasantry, their country's pride' are ruined by the imparking of their village by someone grown rich in commerce. It is characteristic of an unchecked commercial system that discrepancies in wealth increase. Requiring great capital, international trade can only be carried on by a few, and while the total wealth of the nation may increase — although, as in Ibbetson, this is not guaranteed — the number of poor is likely also to rise. Further, the acquisition of this wealth is itself corrupting, degrading to the character of those who pursue it and always won at the expense of the suffering of others, whether at home or among foreign peoples ill-equipped to defend themselves. The 'rage of gain' and the 'baneful arts' it employs 'to pamper luxury and thin mankind' have the common goal of separating the successfully wealthy from the condition of others, above all, of course, the poor. The strong desire to defend one's gains and the constant fears for their security in a society increasingly divided, lead to the property of the wealthy being 'paled up with new edicts' and 'hung round with gibbets' to scare the invader. Law is subverted almost wholly to the interests of a minority at the expense of natural rights and long traditions; in short, wealth plundered from slaves abroad is

* Goldsmith gives a general form to emotions that are most poignantly expressed in occasional lines by Christopher Smart in his 'Jubilate Agno'. (in *Selected Poems*, ed. K. Williamson and M. Walsh, Harmondsworth, 1990, pp. 62–3). Personal and national identity are centred in the remembrance of particular places:

> For I bless God in SHIPBOURNE FAIRLAWN the meadows the brooks the hills.

Change threatens the sensibility of those who have loved such places:

> For they began with grubbing up my trees and now they have excluded the planter.

The landscape is appropriated, and with it the equilibrium of the poet.

used to make slaves at home. Society is increasingly disunited and not at peace with itself. Work is hireling toil requiring servility from the employed, who, giving up their dignity to the flattery of superiors, are disposed to exact the same favour from those below.[38]

Far from all this being the setting for an explosion of creativity in the arts and moral sciences, as some progressives claimed, Goldsmith implies the gradual decay in England of poetry and all the 'nobler arts'. The structure of the culture will be increasingly unsound as the trading ethic expands. It will manifest an unnatural, rank, and unwieldy growth whose sickly greatness and florid vigour will mask internal decay and gathering loss of independence. Nature's ties — duty, love, honour — will give way to a cash nexus regulated only by law and conditioned by mere self-interest. The threat of losing out in this pursuit, and suffering the humiliation of poverty, will induce a uniformity of self-dependent avidity. Eventually, all men will lie in 'one sink of level avarice', with customs, manners, and the arts sacrificed to gain.[39]

The destruction of Auburn by imparking accentuates the selfishness of the change; there is in the creation of a park none of the claim of public good that could be attached to enclosure. The nearby commons are referred to as bare-worn and scanty, whereas Auburn is a flourishing place with clear traditions of cultivation and practical knowledge. Imparking takes its land out of production and destroys the culture of the village solely to serve an idea of taste. Modern wealth expresses itself in a solitary, monopolistic view of the landscape; the freedom, independence, and space of many are sacrificed to extended display. Vistas 'strike' and palaces 'surprize' to serve the tastes of 'unwieldy wealth' and 'cumbrous pomp'. The 'gloss of art' destroys the 'spontaneous joys' and real benefits of nature that ought to lie in being 'unenvied, unmolested, unconfined'. Improvement is therefore a completely self-contradictory idea. The tyrant who undertakes it is a spoiler of established landscapes, who leaves buildings ruined, gardens wild, and the former inhabitants forced to wander in yet wilder landscapes abroad. Goldsmith follows Montesquieu in identifying tyranny with landscapes empty of activity and characterized by lifeless uniformity. Images of separation usurp the spirit of unity that derives from Christian charity. Providential activity ceases:

> Dans ces États, on ne répare, on n'améliore rien. On ne bâtit de maisons que pour la vie, on ne fait point de fossés, on ne plante point d'arbres; on tire tout de la terre, on ne lui rend rien; tout est en friche, tout est désert.

> (In these states, nothing is repaired, nothing improved. Houses are built only for a lifetime; men dig no ditches, plant no trees. They draw all from the land and return nothing to it. Everything is fallow, all deserted.)

The victim of despotism sees the fruits of civil society but is antagonized by the perception of benefits in which he has no part:

> il trouve la sûreté établie pour les autres, et non pas pour lui; il sent que son maître a une âme qui peut s'agrandir, et que la sienne est contrainte de s'abaisser sans cesse.

(he finds security established for others and not for himself; he feels that his master's soul can expand, and that his own is constantly constrained to lower itself.)

Slaves, the extreme victims of tyranny, necessarily become the natural enemies of the social order.[40]

The details of the change at Auburn are wholly unclear, since nothing is indicated of the tenure of land; all that one can assume is that it lacked the relative security of freehold possession. In its flourishing state of 'happy equality of condition' its community included a schoolteacher and a parson, both presumably educated beyond the village, but there is no hint of a squire. The ability of the tyrant to grasp 'the whole domain' may suggest the existence of a former general landowner, presumably an absentee. The point is important because most critics of improvement, however influenced by Goldsmith's work, tended to believe that the preservation or enhancement of rural virtues was in large degree the responsibility of the landowner or clergyman, acting both privately and as a representative of an improved society. Goldsmith's praise of Berkeley for having been familiar with the meanest peasant and for setting an example of agricultural practice in a desolate and unimproved country, offered an easier and perhaps more congenial model for the proponents of benevolence than the egalitarian world of Auburn. The links between prosperity, morality, and the tenure of land raise constant issues in the history of improvement.[41]

The increasingly vigorous campaign in the second half of the eighteenth century against the African slave trade and British activity in India tended to share the point of view expressed by Goldsmith that the impact of unregulated international trade and improvement on less sophisticated societies had been entirely destructive. This was a view already strongly expressed by Johnson. In *The Idler* number 81 of 1759, for example, he had imagined an American Indian chief contemplating the 'art and regularity' of European tyrants who had robbed his tribe of their former 'plenty and security' amid the 'woods, meadows, and the lakes' of their native country. The invaders continued to 'devour the produce' of the Indians. When the native population diminished under oppression they were replaced by human beings of another colour, 'brought from some distant country to perish here under toil and torture'. Reflecting on the argument for the civilizing effects of slavery, Bishop Warburton contrasted the Africans' inevitably unhappy existence amid the grandeur and 'accommodations of civil life', constructed on their misery, with the happiness that could be enjoyed among the 'native woods and desarts' of 'their own country'. The abolitionist Thomas Clarkson, obliged by his opponents to argue that Africans were sensitive human beings, noted the value to them of ancient customs and 'local attachments', their particular regard for the spot in which they were born and nurtured. Such feelings supplied the few agreeable sensations that remained to them after they had been 'bought and appropriated'. Clarkson and Peter Peckard, the Master of Magdalene College, Cambridge, between 1781 and 1797, described how innocent and peaceful inhabitants were torn from native countries whose verdant landscapes afforded them ease and contented plenty until the arrival of savage

Europeans led to their world being made 'compleatly wretched'. The villages in which the Africans formerly enjoyed their own property, the sweets of liberty, and the rights of humanity, were now ruined, desolate, and depopulated. Men by nature kind, hospitable, and industrious were made miserable and oppressed, presenting a depression and dullness of spirit that was sometimes used to justify their enslavement, or at least excuse it.[42]

Peckard insisted that the 'perfidy, injustice, and cruelty' of the slave trade, so cynically defended by 'mercantile men' and 'worldly Politicians', would lead not only to the destruction of Africa, but to that of England herself. Vice and profligacy, dissipation and luxury, were the frequent consequences of wealth honestly acquired, but the invariable effect of the unjust riches of unbridled 'Commercial Avarice'. They had created a 'torn and harassed country', a 'scene of discord and misery', in an England that had once seemed destined, by the indulgence of nature and the excellence of constitutional policy, to be the 'seat of earthly happiness'. Vicious refinement and external polish had replaced the ancient manners and social customs that could be traced back to the constitutional wisdom of King Alfred, and had served to save the 'Poor and Low' from the oppressions of the 'Rich and Great'. The current insupportable distresses of the poor, as of the slaves, were ignored in modern ideas of mere 'Political convenience' in which each man sought to raise himself and had little interest in the performance of duty. Crime, social discord, immorality, unjust laws, cruelty to animals, and a host of other evils were the direct offspring of the dedication of the powerful to avarice and self-interest. What was required was a universal and 'disinterested diffusion of heart', an 'affectionate devotion of soul to the good of others' amid a sense of common imperfection. Only moral education and religious revival, leading to the improvement of the natural inclinations of man, could restore older ways in the direction of recovered scenes of harmony and peace. In the 1790s Peckard saw the revolution in France and the likely invasion of England as providential punishments, the probable 'Tyrian destruction' of a long period of luxury and vice of which African slavery was the most infamous expression.[43]

In Henry Mackenzie's enormously popular *The Man of Feeling* (1773) the themes of improvement, trade, and delicacy of sentiment are brought together in the definition of the difficult virtue of feeling. Just sentiment is occupied by the ideal; reality is seen through, and improved by, a romantic and benevolent imagination that assumes a corresponding goodness of intention in others and so is constantly injured by selfish, interested, and unthinking conduct. The eponymous hero Harley (a very Tory name, of course) has clearly read Butler and other proponents of benevolence but finds himself in a Mandevillian world, particularly in town. Being possessed not only of feeling but of land, however, he is able, at least for a time and on his own property, to withstand the onslaught of false improvement. A wealthy merchant or nabob, made rich by the exploitation of India, buys a nearby estate and decides, on the prudential advice of his attornies, to eliminate all farms under £300 a year. The poorer tenants, including a loyal old soldier, are forced to leave their native spot, the village school is demolished because it stands in the way of a prospect, and the village green removed because it interferes with the despotic love

of seclusion. Fortunately, the old soldier is given the use of a farm on Harley's estate, and immediately goes about improving the 'neatness and convenience' of this new spot, making it a 'scene of tranquil virtue', plenty, and happiness, attained by an improvement in sympathy with nature and feeling.[44]

The idea of a virtuous use of landed property, manifesting sensibility and creating respectful attachment, clearly had a wider appeal than Goldsmith's equality. To be contrary to fashionable improvement appealed also to those whose sense of superiority to men of trade could be given a moral aspect by its identification with the despoiling of India. The greatest of the nabobs, Lord Clive, clearly unscrupulous, probably insane, and notoriously homosexual, had become a major landowner, employing Brown both as an improver and as the architect of his neo-Palladian seat at Claremont in Surrey. Warren Hastings, while presenting himself as an exemplary administrator, did not seek to disguise his view that the end of British rule was simple gain. His government was directed, not by constitutional principles, but by greed and by simple maxims of political economy, since 'when commerce is left to itself, it will correct its own evils.' He did not, however, seek to argue that commercial and national interests were identical. His government was 'an endless and a painful choice of evils', since the 'primary exigencies of the [East India] Company conflict with the interests of the Indian peoples who are subject to its authority'. It became commonplace in the literature of the second half of the eighteenth century to associate uncongenial changes in England with the low morals and ambitions of nabobs profusely scattering the 'spoils of ruined provinces', undermining the virtues of country people, and alienating their affections from their proper superiors. Hireling attorneys, including a Mr Rapine in Samuel Foote's *The Nabob*, are used to buy up estates on advantageous terms and secure seats in Parliament for their masters. Bad taste and morals always go hand in hand as venerable avenues are torn up by 'new-fashioned upstarts', and 'dotted clumps' of 'trumpery shrubs' put in their place. Neat cottages are torn down because they offend the eye of a new wealth always anxious to distance itself from the rustic. Parks are shut up to intruding neighbours, and mantraps and spring-guns laid at the confines. The poor are treated harshly by men of illiberal, offensive, and ill-natured habits of mind who, slaves to fashion and surfeited with prosperity, become caught up in the great machine of improvement with all its endless attention and expense. Sometimes the nabob ends up gloomy, lonely, disappointed with his connections, snubbed by his more polite neighbours, constantly humiliated by his servants, and tired of the splendours of a magnificent house and extensive territory. In such accounts improvement emerges as an activity destructive of self as well as of others, a confirmation of mental and moral imbalance. Lord Clive once again comes to mind, with his system of underground passages between his mansion and the servants' quarters, designed so that the common should be as far as possible invisible. Clive was to commit suicide. As in the case of the determined solitariness of Lord Milton, it is difficult to separate an improver's ideology from his psychological state. The image of rich men wandering aimlessly about their great, empty estates, destroying themselves as well as those around them, occupied a number of commentators, including Edmund Burke and Uvedale Price.[45]

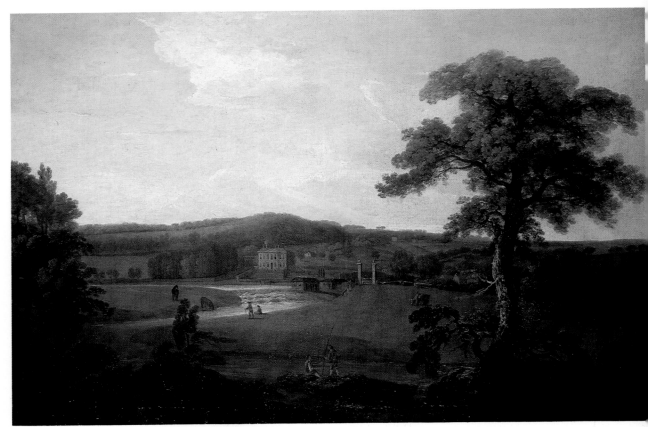

10 Nicholas Dall's *Esholt Hall* (*c.*1773) portrays a house that may be seen as either awaiting improvement or determined to express resistance to the latest fashion. The mansion of 1706–9 was built on the foundations of a priory and retains part of the earlier structure. At its front is a modest, quite formal, walled garden which, as at Sprotborough, has not received expensive attention. Agricultural buildings, including the home farm (1691), are scattered about the landscape. An elm avenue, planted at the time of earlier improvements, leads off to the right, connecting rather oddly with a pair of dignified gate pillars, which seem like a remnant of an abandoned scheme of grandeur. A farm gate is hung between the pillars, matching the rustic fencing of the farm. What appears to be an eel run has been constructed at the bend of the river, well within view of the house. A determined improver would sweep all this away.

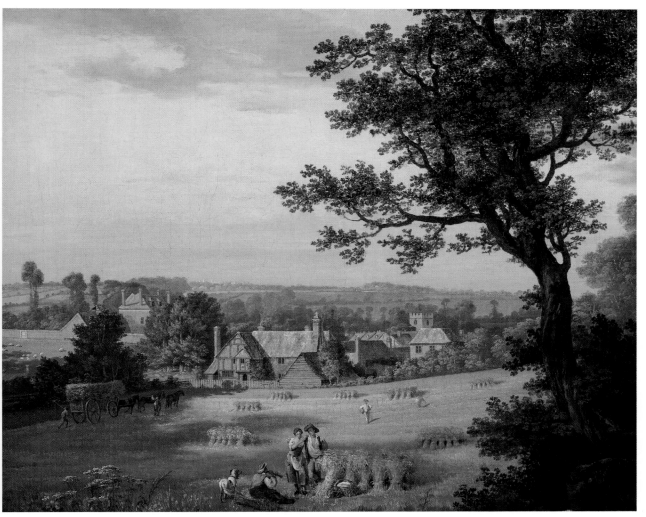

11 A view of Chalfont St Giles (1774) by the Welsh artist Thomas Jones, a pupil of Richard
Wilson, has a very specific subject. It was commissioned by Dr Benjamin Bates, an important
patron of Joseph Wright of Derby, to depict the house in which Milton lived during the
plague years and composed *L'Allegro*. Jones himself noted how his enjoyment of the
picturesque farmhouse was enhanced by association. He 'Contemplated every old Beam,
rafter and Peg with the greatest Veneration and Pleasure', as sanctified by the presence of the
'illustrious Bard'. Many observers will feel that the image has a general as well as a particular
significance. The composition of the picture, with its implications of social diversity within
a general harmony rooted in the past, is completed by the presence of Windsor Castle in the
distance, although the castle would be behind the artist in terms of topographical reality.
Labour is real, in the sense of being productive, but it is capable of being depicted within the
sauntering tradition of the pastoral. Milton's house has the look of a yeoman's dwelling,
absorbed within a village presided over by the church. The prosperous rector's house, the
most improved part of the scene, is walled off from the village but not aggressively so. The
composition, in which aesthetic and social values seem perfectly united, may embody an idea
of England that probably has its most influential expression in the novels of Jane Austen and
George Eliot.

In Tobias Smollett's *Humphry Clinker* (1771), a venerable old house with a stone gallery and an ancient avenue is improved by a nabob through the destruction of its tall oaks and the building of a modern screen to hide the unfashionable architecture. A formal garden of old walls and hedges is removed to make way for showy schemes of water management that soon dry up. A 200-acre farm is parcelled into walks and shrubberies and a basin made for an artificial river which fails to flow. In the wider landscape villages are depopulated and small farms eliminated as nabobs and slave-drivers introduce an economy of luxury and corruption.* A sympathetic landowner of the older stamp, Matthew Bramble, meanwhile runs his own estate on the happier principle of wishing to see his tenants thrive and the poor live comfortably. All partake in some degree of the 'common bounty' of nature through a lax application of the game laws. Eventually, when able to purchase the venerable old house himself, he undoes the improvements, turning watercourses into their old channels and restoring the extensive pleasure grounds to cornfields and pasture.[46]

In his *Village Memoirs* (1775) the literary squire Joseph Cradock, a friend of Richard Hurd, Goldsmith, and Bishop Percy among others, describes how a nabob, Mr Massem, buys an estate and engages in extensive works of showy and expensive improvement under the guidance of Mr Layout, clearly intended to be Brown. Mr Arlington, a respectable and long-settled figure, is old-fashioned enough to disagree with Mason's argument that avenues must be destroyed even though the trees 'in fraternal files, have pair'd for centuries'. Layout has no such scruples: his plans are completely mechanical and without reference to the 'genius of the place' and its traditions. Taste is talked of and executed as if it had been brought down from London in a broad-wheeled wagon and 'they had nothing to do but to scatter it at random.' Paltry shrubberies replace venerable shade and water is expensively and unnaturally manipulated. Massem buys a seat in Parliament and, more disturbingly, becomes a Justice, a position from which he can influence the morals of the entire neighbourhood. What Cradock terms the 'decent sobriety' of the old English gentleman, 'benevolent without vanity, and generous without ostentation', gives way to the 'inflated maxims of the modern Indian innovator'. Such men are often profuse in their expenditure and may at first be welcomed locally, but they undermine the economy of the country as well as its virtues, and when their interest or will are threatened, ferociously defend themselves through attornies and agents.[47]

In this blending of snobbery with morality it was naturally convenient for the unfashionable to reappraise the monuments and improvements of the past and to associate them with values finer than those of crude commercialism or innovation. This tendency, noted in Hurd and the critics of Lord Milton, is expressed in an *Essay on the Study of Antiquities* written in 1780 by Thomas Burgess, a young evangeli-

* Smollett's disapproving attitude to slave-drivers in *Humphry Clinker* may be contrasted with the argument of his *Roderick Random* (1748), in which African slaves are regarded as a mere trading commodity, often troublesome and perishable in its nature. This, for example, is the beginning of chapter LXVI: 'Our ship being freed from the disagreeable lading of Negroes, to whom indeed I had been a miserable slave, since our leaving the coast of Guinea, I began to enjoy myself.' Widespread changes in attitudes to slavery between the 1740s and 1760s are discussed in the works of Thomas Clarkson. The eventual abolition of the slave trade in 1807 took place when benevolent arguments sufficiently coincided with economic theory to make slavery appear both inhumane and inefficient.

cally inclined clergyman active in all the benevolent causes of the period. The 'generous virtues' of chivalry, honour, wit, and courtesy are identified with the 'proud monuments', often in ruins, of 'feudal splendour and magnificence'. Without any desire to replace the constitution of England with any less liberal system of rule, Burgess regards the castles and mansions of 'our ancient nobility' as being a chief 'pride and ornament' of the landscape, not only for their beauty, but because they represented a combination of power with cultivation and responsibility in periods theoretically less favourable to such virtues. They were 'open to all', particularly the noble and courteous, and were places of splendour, festivity, wit, fancy, and learn-ing, in which the minstrel, as a recording and civilizing voice, had an honoured position. As the idea of progress typified in Hume's *History of England* gathered vigour, so there emerged a counterbalancing desire for continuity with a romanti-cized rather than a degraded past.[48]

William Cowper's *The Task* (1783–4), written from a religious point of view not dissimilar from that of Burgess, represents a summation of most of the principal criticisms of improvement, the 'idol of the age' so diligently served by that 'omnipo-tent magician' Brown. Cowper sees in its progress an image of the relentless and incomprehensible growth of human cruelty, moral turpitude, irreligion, and colonial enslavement, creatures of an international commerce serving avarice and luxury rather than 'genial intercourse, and mutual aid' between nations. Country houses cease to be places in which 'English minds and manners' prevail, embodied in a resident class of landowners who are 'plain, hospitable, kind'. They are assets — the patrimonial timber is sold to any 'shrewd sharper' and landed property is seen merely as a series of landscapes to be gazed upon a while and then returned to the market in the expectation of a profit. Venerable piles are torn down in order to make way for palatial new structures starkly separated from the world, placed naked and shadeless in a vast domain of improved uniformity. Nature is not studied as an expression of the divine mind but as an object to be dominated by the hand of a showy, expensive, and hubristic taste — 'Woods vanish, hills subside, . . . vallies rise' and water is denied its natural course. The prodigious expense of all this has to be met by the further exploitation of provinces or by the proprietor buying his way into Parliament in order to join with other 'peculators of the public gold'.[49]

True 'English minds and manners' are associated with the gentle, ancient, long-cultivated landscape of Buckinghamshire:

> the rural walk, through lanes
> Of grassy swarth, close cropt by nibbling sheep . . .
> the grace
> Of hedge-row beauties numberless, square tow'r,
> Tall spire.

The 'small enclosures' gave this landscape an air of 'snug concealment' to be contrasted with the wild forests and mountainous hills of Sussex, which accentuate the poet's 'natural melancholy'. It is a landscape of cultivated gentry, ancient churches, country houses standing discreetly amid ancient trees, winding lanes, and workmen who seem to be industrious, modest, neat, and quiet. Culturally this

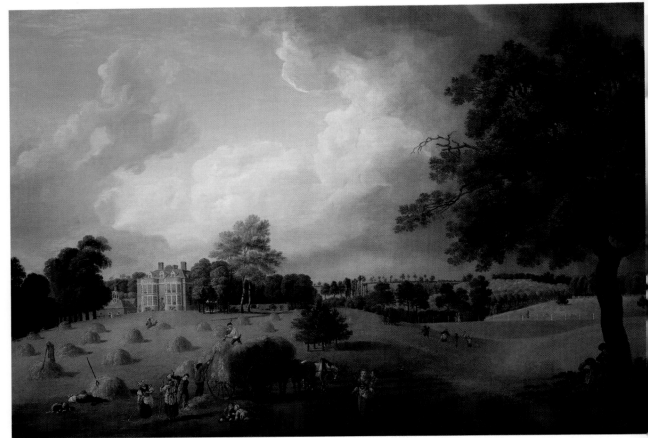

12 Michael Angelo Rooker's painting of Jennings Park (1776), the seat in Kent of the Duchess of St Albans, appears in its own terms to be an image of benevolence. The house, sheltered by some mature trees, is part of a wider landscape that combines the ornamental and the productive. Labour is light, even discretionary, and in harmony with the setting in that the mansion seems to be underpinning the local economy without dominating its participants. The landscape is ordered, but not explicitly improved in a way that distinguishes separate social interests. It may be argued that this is much more an image of social control than the empty landscape of Tabley (plate 9), for example, but the intention appears to be to present an image of an England that is united, and perhaps increasingly under threat.

landscape was far from the iniquities of London and even the sins and distresses of Olney, where 'the most watchful and unremitting labour' in lace-making hardly earned subsistence, and where order occasionally needed to be maintained by the energies of the local gentry. Protected within the park of his cultivated patron's country house, Cowper praised domestic life passed virtuously in 'rural leisure', consisting chiefly in the contemplation of nature mediated by care, tradition, and privacy. Silence and shade in the park and garden assist reflections on the order of things that serve to compose the passions and ameliorate the heart. The elegance of the garden, the product of a 'polish'd mind', shows the advantages of a secluded and protected culture cleared of the 'rank society of weeds', which, like a multitude 'made faction-mad', tend to 'Disturb good order, and degrade true worth'. Silence, shade, and elegance are features common also to those 'fallen avenues' whose fate at the hands of Brown Cowper laments, and whose destruction, like that of *The Poplar Field*, induces an intense sentiment of melancholy insecurity at the passing of the familiar. Within the avenue Cowper feels at once shaded, protected, and elevated by a pious sense that its form recalls the 'consecrated roof' of a Gothic church. He finds also a congenial variety of grace, airiness, and delicate and inanimate sensuality:

> So sportive is the light
> Shot through the boughs, it dances as they dance,
> . . . as the leaves
> Play wanton, ev'ry moment, ev'ry spot.

The avenue and the garden sustain Cowper and offer a degree of stimulation compatible with his equilibrium, but they do not resolve the question of the threat and corruption of the greater world, centred in patronage and corrupt parliamentary majorities. Protected within the park, Cowper is sometimes capable of an intense clarity of vision of the tortuous logic and morality of politics, as in his indignation at the 'cruelty and effrontery' of Pitt's defence of his candle tax on the grounds that the poor would not suffer from it because candles of the better quality were already too expensive for them to afford:

> I wish he would visit the miserable huts of our lace makers . . . and see them working in the winter . . . by the light of a farthing candle . . . I wish he had laid his tax upon the thousand lamps that illuminate the Pantheon. I wish . . . he would consider the pockets of the poor as sacred, and that to tax a people already so necessitous, is but to discourage the little industry . . . left . . . by driving the laborious to despair.

The gentle light of the avenue stands in marked contrast to the blindness of Pitt, the selfish glare of the Pantheon, and the enforced gloom of lace-makers working in a trade damaged by government action and soon to be eradicated by the free play of international market forces. The Pantheon, a fashionable assembly room in Oxford Street built in 1772, fared no better — with its timber dome, and its myriad candles, it was soon destroyed by fire.[50]

* * *

The Redefinition of Improvement

In an essay on Goldsmith published in 1785 the Quaker poet and critic, John Scott, noted the tendency of the argument regarding improvement to fall into simple and misleading distinctions between old and new proprietors of land. One of the effects of the rise of the 'modern Peer, Placeman, or Nabob', at the expense of the 'ancient, Feudal Lord, or Rural Squire', was that the easy acquisition of money by the 'new or commercial gentry' tended to induce habits of free spending ('light come, light go') that raised the price of all commodities. The desire of the gentry to maintain their familiar advantages of life led them to an anxious pursuit of measures to maximize the returns on their land, which usually involved an increase in the size of farms, the raising of rents, and the eventual pauperization of the small farmers. There was no simple distinction, at least in this respect, between the old and the new proprietors. Scott agreed with Goldsmith that it was the sudden influx of commercial money that was to blame for a tendency towards increasing divisions in society. A good number of landowners, old and new, had come to embrace a style of living and a mode of improvement in which much of the pleasure seemed to arise from evident expense and distance from the common. The fashionable park, with its interminable length of lawn broken only by a few gloomy woods, had an air of 'melancholy solitude and idle waste' that seemed far less pleasing than a 'vale of corn-clad inclosures', a winding lane, a 'shrub-hung brow', and groups of cheerful cottages with contented inhabitants. Such natural landscapes must clearly give pleasure to the humane observer, whereas the fashionable style of improvement was not only dull but impossible to contemplate without bitterness and guilty thoughts of 'immediate rapine, extortion, or oppression', the plunder of 'Hindoos', and the slavery of 'Negroes'.[51]

Thomas Whately, the admirer of Brownian improvement, was for a time an official of the Treasury, and wrote at length of the profit resulting from 'our very valuable' plantations in the West Indies, without concerning himself with moral issues. For Scott, however, it was impossible to consider English improvements as objects of taste without pondering their economic basis. He quotes some verses from *The Country Justice* (1774–7), a poetical tract by the magistrate and historian, the Reverend John Langhorne, concerned with the fashionable landscapes that had sprung up amid the failure of politicians and magistrates to regulate the British charter government in India and the flow into England of the enormous private fortunes its representatives had accumulated for themselves. The new landscapes arise as 'Justice sleeps, and Depredation reigns':

> . . . in those towers raz'd villages I see,
> And tears of orphans watering every tree.
> Are these mock-ruins that invade my view?
> They are the entrails of the poor Gentoo.
> That column's trophied base his bones supply;
> That lake the tears that swell'd his sabled eye.

Scott adds that, even when obtained relatively innocently, the new improvements,

'as they are called', soon begin to pall, just as Pope had described in his time how the vast expense of parterres and fountains had failed to satisfy the whims of a taste which, having finished its expensive plan, discovered a preference for a common field. Scott gives the example of the late Earl of Leicester who, after massive improvements around Holkham, felt himself to be Giant of Giant Castle. Solitary and satiated after having eaten up all his neighbours, he decided to vindicate his sensibility through the repopulation of the landscape.[52]

The second Earl of Shelburne (1737–1805) experienced a similar change of heart. He was a man of wide interests and sympathies who cultivated the friendship of Goldsmith and Johnson while giving enthusiastic, but by no means uncritical, support to such philosophical radicals as Richard Price, Joseph Priestley, and Jeremy Bentham. Adam Smith referred to him in 1788 as a 'most valuable friend'. In the mid-1760s Shelburne had employed Brown at his Wiltshire estate, but in 1791 he reported himself 'mortified' at the time and expense he had wasted in 'desolating about Bowood', instead of using his considerable financial and intellectual resources in 'creating houses, families and wants, and satisfying them'. The function of real improvement should be to encourage and strengthen the agricultural poor and cottagers, the 'strength and wealth and glory of England', who would be the only hope of saving the country after the 'misers of farmers' had sold it and the new manufactures had debased it. Fashionable improvement had served only to weaken the power of the great ancestral landlords. They should endeavour to keep their cottages in their own hands, not those of stewards or agents. They should treat their dependants with every liberality while exercising a 'wholesome and natural authority' that would encourage contented, virtuous, and peaceful industry. These landowners would be in the happy position of being welcome on their own estates amid their own people, instead of being unwelcome strangers surrounded by up-starts and beggars, outbid in local influence by any astute adventurer or nabob. For Shelburne as for other aristocrats, most notably the Duke of Richmond and Lord Rockingham, the desire to check the power of the nabobs and even, for a time, to reform the domestic Parliament, had a great deal to do with the wish to thwart the influx of new money which, sometimes in an unholy alliance with the Court, seemed to threaten a constitutional system that had given preponderant influence to those with great established property and 'personal influence in the Country'. The posses-sion of great houses amid vast solitary parks, while apparently an image of such influence, threatened in reality to destroy the political power of the aristocracy and undermine their claims of cultural superiority to the merely rich.[53]

It was possible to argue in a variety of ways less challenging than that of Goldsmith that an agriculture based on smaller units of production — not necessar-ily, however, on smaller estates — was at once beneficial to the national economy, conducive to general contentment, and necessary to the long-term survival of the landed interest. Among those who propagated this view was Nathaniel Kent, an important agricultural consultant to George III after 1790. His *Hints to Gentlemen of Landed Property* (1775) declared that agriculture would cease to be the 'life of industry' and the source of contented plenty if it was monopolized by the hands of a few rich men. Unchecked expansion of farms and inequitable bills of enclosure,

lacking in attention to the rights of the poor, destroyed small tenancies and obliged many skilled and industrious men either to move to the city and lose their health, happiness, and morals, or to become day labourers for a class of 'gentlemen farmers' who expanded their fortunes merely by superintending the business of farming. Such changes were not only offensive to sentiments of humanity, reducing many to distress, but also impolitic. They were the result of ill-digested and partial calculations of the national interest, since they lowered both the pace and quality of real agricultural improvement. The consequence would be smaller yields of lesser quality and, in particular, a lower output for both personal consumption and the general market, of healthy and perishable products — such as eggs, vegetables, and cows' milk — associated with a carefully tended, small-scale agriculture serving a populous local market. The rural poor suffered from an inferior diet, higher prices, and greater unemployment, and the landowners from the rise in the poor rates. The determination of miserly, overgrown, and rapacious farmers to tear down cottages near their farms and beat down the price of labour to below the level of subsistence, tended inevitably to create increasing burdens on a system of poor relief, often inefficiently and insensitively administered, which would become a growing, permanent, encumbrance on the national economy. At the same time it would create an embittered, dependent, and decreasingly skilled workforce, living in 'shattered hovels' that threatened their health and tended to entail distress on their children.[54]

This was a prospect 'truly affecting to a heart fraught with humanity'. To counter it Kent recommended the payment of wages rising with profits and the creation of a large number of small farms with tenancies ranging from £30 to £160, the great majority being at the lower end of the scale but with a gradation designed to stimulate the more able and industrious. Essential products, particularly corn, should be sold to tenants and labourers at the bulk market price rather than the retail one. Even in the 1799 edition of his work, after the triumph of political economy, Kent urged the duty of occupiers of land to supply their labourers with wheat at a moderate cost when the market price was oppressive. Kent's aim was to restore or create a just equilibrium between the proprietors and the workers of the land, groups of men intended by nature to be 'intimately connected together' in sentiments and interest, as the dependence of the landowner on the labour of his dependants implied a reciprocal duty to secure their comforts. Gentlemen should take on to themselves the superintendence of country business and consider their true duty as being 'the Poor Man's Friend'. They should mediate between the poor and their greatest oppressors, the farmers, who, in the absence of an influential landowner, controlled both the wages of the poor and the overseeing of the laws for their relief. They should consider their estates as in good or bad condition according to the comforts of those who labour on them. Kent includes in his work plans and designs of cottages to be built throughout an estate and to manifest everywhere taste, benevolence, and solid comfort. Such cottages would be of 'great use and ornament' to the country, a real credit to an estate, and the proper mark of distinction for an improving landowner. In such benevolent management of the landscape the poor would live comfortably in their own parishes amid their own native walks, enjoying

all those domestic comforts and local attachments that were at least as important to them as to their superiors.[55]

The argument that smaller divisions of the land and a greater attachment to the local soil on the part of its occupiers were conducive to the national good was common to a wide range of opinion. It was embraced by men as diverse as Adam Smith and the radical William Ogilvie, who called in the 1780s for the abolition of private property in land. He wished to see a society in which men would find happiness and virtue in the cultivation of small farms, protected by their 'comfortable independence' from the oppressions of the superior orders. Such an economic system would 'exclude idleness' but free men from 'excessive drudgery'. By moderate labour they would earn enough to be free and content but avoid the evils of luxury and refinement. The end of class and property divisions would itself encourage virtue by doing away with the cunning, fraud, hypocrisy, and malignant envy inseparable from a system of inequality. The question of whether great or little estates, tenures or freeholds, aristocratic paternalism or happy equality, or a combination of some or all of them were most conducive to the national welfare generated an extensive debate made even more complicated by local characteristics and traditions and the enormous discretionary power of landowners for good or ill. The common ground is that, for whatever reasons, the ability of the day labourer and the small tenant to own or rent land seemed to be diminishing and that the peasantry and yeomanry, neither of which is easily defined, were losing ground much more rapidly than their equivalents elsewhere in Europe. Improvement, in short, seemed to be destroying the basis of a contented and moral society.[56]

Kent was of the apparently paradoxical opinion that great estates were necessary to counter the monopolizing, engrossing tendency of an active free market in land. In his 1794 report on Norfolk for the Board of Agriculture he argued that 'Persons of small fortune, and tradesmen, when possessed of a little land, are naturally inclined to get as much as possible for it; and farmers, above all others, when they become owners, make the worst landlords in the kingdom.' It was to large estates that the public needed to look for moderation and consistency in rents and for the price of land to be kept at a level that would give encouragement to an industrious occupier. In a county of great estates, Kent had particular praise for the simple and equitable structure of leases pioneered by the late Earl of Leicester at Holkham and carried on by Coke. They were a 'liberal contract' between 'a gentleman and an industrious tenant' without overbearing and 'compulsatory' clauses that tended to encourage obedience and servility rather than a husbandry adapted to the long-term improvement and fertility of the soil. Great estates were also often the best placed to make substantial provision for the comfortable accommodation of labourers. In a note to Coke of 1789, Kent emphasized that the building of cottages would serve the interests of both landowner and labourer by consolidating the authority of the former and enhancing the natural conservatism of the latter. Well provided for in housing and land, the poor would be 'permanently fixed to the soil and having some Interest in their Dwellings and possessing comforts superior to those who have not the same advantages will be the last men to risk them by joining occasional

Tumults.' The idea that comfortable cottages might be the best means of preventing disorder became increasingly influential in the 1790s.[57]

Clearly all these ideas of improvement are inseparable from the larger debate regarding the responsibility of the landowners to the poor, and, given an almost universal conviction that the existing poor laws were in need of reform, the question of its direction. The wide-ranging debate, in pamphlets, sermons, treatises and poetical discourses, included opinions ranging from the idea that the poor were a useless burden on landed property to the opposite extreme that landed property, and the whole culture it supported, was a useless burden on the poor and the obvious cause of their poverty. Some advocates of feeling recommended the justice and pleasure of smilingly giving relief to any beggar who could be found. The Reverend James Yorke advocated 'ardent zeal for the felicity of all mankind', a 'compassion to the poor and miserable' that would seek to 'extend our brotherly affection, courtesy and pity, to the whole human species, that our connection as neighbours might embrace the compass of the globe.' The Society of Universal Goodwill (1785), originally the Scots Society of Norwich (1775), aimed to relieve everyone needy and friendless, regardless of their religious and political opinions or national origins, in order to encourage an ideal of 'universal welfare'.

Some saw the beggar as a kind of moral sounding-box of society, revealing the true character of men and becoming intensely wise in his understanding of society and human nature. Thomas Price's account of Carew, King of the Beggars, expresses this view in detail:

> He saw in little and plain houses, hospitality, charity and compassion, the children of frugality; and found under gilded spacious roofs, littleness, uncharitableness, and inhumanity, the offspring of luxury and riot: he saw servants waste their master's substance, and that there was no greater nor more crafty thief than the domestic one; and met with masters who roared out for liberty abroad, acting the arbitrary tyrant in their own houses; he saw ignorance and passion exercise the rod of justice; oppression the handmaid of power; self-interest out-weighing friendship and honesty in the opposite scale; pride and envy spurning and trampling on what was more worthy than themselves; he saw the pure white robes of truth sullied with the black hue of hypocrisy and dissimulation; he met sometimes too with riches unattended by pomp or pride, but diffusing themselves in numberless unexhausted streams, conducted by the hands of two lovely servants, goodness and beneficence.[58]

Some religious enthusiasts, notably John Howard the prison reformer, showed their beneficence in an intricate control over the local poor, upbraiding the idle, supervising diets as precisely as morals, denying access to the alehouse on pain of the threat of eviction, and directing regular visits to church. Other writers sought to abolish beneficence. The bulk of the poor were undeserving, artful, cheats constantly imposing on the credulity of their betters and in need of the salutary regime of punitive workhouses in which they could be hidden away and dealt with, far from the meddling eyes of the kind-hearted. These writers often wished to see the enforcement of the laws that provided penalties for the relief of vagrants and obliged those in

receipt of parish assistance to be badged, or even branded, as paupers. Such laws, generally introduced or reinforced after the Glorious Revolution, had fallen into neglect without being repealed.[59]

Other writers, notably the Reverend Joseph Townsend, argued a severe version of free-market theory clearly redolent of Mandeville. No amount of workhouses and badging on one hand, or benevolence and education on the other, could adequately regulate the poor. Only the threat of hunger, social humiliation, and the contempt of the community could 'spur and goad' men to labour. The poor were more likely to be diligent in periods of scarcity; hunger taught decency and civility, and tamed the most brutish, perverse, and obstinate animals to obedience and subjection. The idle should be left to suffer the natural consequences of their indolence and the market left to determine wages, profits, the price of land, and the pace of enclosure. Even under this discipline a large part of the poor would always remain improvident and ignorant, but it was necessary and natural that they should be so, in order that there be labour to undertake the servile, ignoble, and sordid functions of society. The processes of the market excluded feeling, as the Scottish judge Lord Kames had argued before Townsend. Kames insisted that it is important to 'leave Nature to her own operations'; any 'neglect or oversight' of the poor that leads to death from hunger will offer an example that will tend more to the reformation of manners than the 'most pathetic discourse from the pulpit'. It is an irony of this idea of free-market discipline that it sounds remarkably like the condition of the African slaves described by Clarkson: 'tamed, like beasts, by the stings of hunger and the lash, and their education . . . directed to the same end, to make them commodious instruments of labour.' This depressed the mind, numbed the faculties, and gave the slaves an appearance of inferior capacities that was used as an excuse for 'any severity, that despotism might suggest'. The society that emerged tended, as Montesquieu and Adam Smith also argued, to be not only immoral and unstable, but extraordinarily unproductive.[60]

The cross-currents of sentimental benevolence on one hand and free-market theory on the other must have been in some part responsible for the changes between the 1760s and the 1780s in the opinions of some of the most important writers on the poor laws, especially Thomas Gilbert, Richard Burn, and Jonas Hanway. This change is most clearly marked in Gilbert. His treatise of 1764 advocated punitive measures for the idle poor, including houses of correction, restricted diets, badging, and the use of stocks. Those who gave to beggars were to be penalized and the most recalcitrant of the idle were to be whipped and eventually transported if intractable. In his 1787 pamphlet Gilbert retains a distinction between the deserving and the idle poor but has lost most of his confidence that they can be easily identified and, together with this, his zeal for punishment. Instead he sees country gentlemen acting as district commissioners whose function is to stand 'upon a vantage-ground' in order to ascertain, in an extensive and benevolent view, the distresses and necessities of a whole district. Instead of seeking to impose some abstract system of regulation, these men are to study the particular situation, habits, and circumstances of the local poor. They are to prevent any forced removals to the workhouse, which is to be considered the last resort of the desperate. They are to acknowledge instead the folly

and cruelty of disturbing the 'connections of life' — family, home, and community — and the validity of the poor man's 'natural abhorrence to restraint'. They are to judge by cases according to principles compatible with moral and constitutional duty. Gilbert's attitude to social issues was clearly influenced by his detailed work as chairman of the Commons Committee set up to report on the state of charitable foundations for the relief and education of the poor. In 1788 he reported that many, perhaps the majority, of such charities had been lost by neglect or the channelling of the funds to other purposes. The poor had accordingly suffered and the 'pious intentions' of the charitable had been thwarted.[61]

The image of the landowner justly surveying and improving his neighbourhood is, in one form or another, central to the benevolent approach to the poor laws which may be associated with such names as Langhorne, Scott, Potter, Rutherforth, Warren, Thicknesse, and the later works of Burn and Hanway. Common to these writers is a concern that the gap between the rich and the poor was increasing and becoming daily more evident. The neglected hovels of the poor contrasted with the extravagant improvements of the rich, not only in their private undertakings but even in their charitable works, such as hospitals, whose showy grandeur seemed a kind of 'insult upon poverty'. The expenses of the wealthy should be tempered with the recognition that they were in great degree founded on the often incessant and unhealthy labour of men whose returns from that labour, however diligent, were in many cases inadequate to the maintenance of themselves and their families. The natural susceptibility of human nature to illness, accident, and distress was exacerbated by neglect, and it was impossible to make any easy discrimination between the industrious and the idle, the deserving and undeserving. The granting of relief, often the topping up of inadequate wages, was too often done with abuse, ceremony, or in a manner designed simply to humiliate. Humanity should not 'wound with the tongue of reproach those on whom the hand of oppression lies heavy', or upbraid the distressed for their 'defective economy'.[62]

Among these writers, the public officials charged with overseeing the poor were almost always tending to the neglect of their 'wide domain of trust'. In the absence of gentlemanly supervision a few 'upstart necessitous freeholders' would seek to combine and engross the whole power of the parish in their own hands. The poor were accordingly obliged to seek relief from the very farmers and tradesmen who were their chief oppressors and who showed themselves to be sly, pilfering, cruel, selfish, sordid, wretched, and low. The chief interest of the farmers and tradesmen was to keep down wages and the poor rates and they would pull down cottages and depopulate the parish to a level compatible with their ends, enforcing where possible the laws of settlement and vagrancy. In a vigorously illustrated pamphlet of 1769, *An Account of the Four Persons found Starved to Death at Datchworth, in Hertfordshire*, Philip Thicknesse described the English day labourer as a slave to his low oppressors. He insisted that the situation of the poor was at its worst in extensive but obscure parishes, 'where scarce any gentlemen reside'.[63]

For the benevolent, the management of the poor was a stain on the 'moral and political character' of the nation, with a large part of the population deprived of the rights due to them by religious principles and constitutional guarantees. The figure

of the Justice of the Peace, as the commonest administrative function of the landed interest, is central to this argument. Langhorne wrote *The Country Justice* in order to cultivate humanity, feeling, and 'social mercy' in the conduct of the office and recommend vigorous 'controul' over the low-bred and insensitive among the overseers, farmers, and tradesmen. The work was suggested by another clerical magistrate, Richard Burn, the editor of the ninth to eleventh editions of Blackstone's *Commentaries*, and the author himself of the standard manual on the duties of the Justice. Both men made it clear that any further increase in the number of the necessitous, neglected, and uneducated members of society would give the magistrates endless new work in dealing with rising crime, as genuine need would be stimulated to felonies by the temptation arising from inequitably distributed opulence. The Reverend John Warren worried that the poor, if abandoned to themselves, must often be faced with the 'dreadful alternative' of 'breaking through' the laws of property or perishing by a strict observance of them. With the 'utmost diligence' many of the poor could 'acquire only a scanty maintenance' as they 'impair their health' to 'supply the Rich with luxuries'.[64] It was, perhaps, unfortunate for Warren's image of benevolence that he became the Bishop of Bangor who was chairman of the Lords Committee in the case of Milton Abbey School (see page 56).

The idea of the country gentleman as regulator of the neighbourhood, so much ridiculed by Burke, naturally looks to the past and to a lost tradition of hospitality. The 'Ancient Justice's Hall' described by Langhorne was noted for its 'bounteous board' and was a more manly structure than the effete, showy, works of fashionable improvement. The magistrate is invited to recover a system of authority in which the unity, integrity, permanence, and continuity of the local community were in large degree dependent on him. In the common tradition of benevolence the landowner is committed to a particular place and proceeds on the assumption that the poor share this affection. In all these writers, therefore, the native or domestic spot is given considerable weight; although most familiar from Goldsmith, the idea is presented most expressively by the Reverend Robert Potter. In his treatise on the poor laws, which was the source for John Scott's story of the Earl of Leicester's regrets at Holkham, Potter describes an honest, industrious cottager rendered incapable of labour and obliged to seek relief:

> by a long continued residence, an association of ideas, a partial affection to one particular spot; [he] is wedded to his little habitation; to divorce him from it would be cruel; he raised that hedge; he planted that tree; or some unaccountable attachment hangs upon his mind; in the churchyard of his village lies, his wife, a son, or a darling daughter. All this is indeed ideal . . . It is a prejudice: but it is founded in human nature; and from this prejudice the noblest of our passions, the love of our country arises . . . an indulgence to it can be attended with no ill consequence; he surely will not be refused; the philanthropy of an English Gentleman cannot refuse him.

By linking, as had Butler and Goldsmith among others, the prejudice for domestic attachments with patriotism, and therefore the safety of the constitution and of property, Potter makes discretionary indulgence on the part of the landowner not

only a pleasurable sentimental gesture but a matter of general prudence; as in the work of Nathaniel Kent, feeling and interest may be made to coincide.[65]

Benevolent Improvement

The critics of improvement broadly seek a return to some degree of equilibrium in the landscape, a balance of both scale and equity that excludes grand works of personal indulgence and values ideas such as hospitality, connection, local affections, and continuity. The benevolent improvements recommended, for example, by Mackenzie, Smollett, or Kent are seen as corrections to damage caused by change, as restoration to a more natural form of landscape. The theme of actively benevolent improvement, of what a rich man might do with a dependent landscape to realize his ideal of morality and nature, is more fully explored in the 1790s and beyond, but there are important texts before that period. The most familiar, Samuel Richardson's *Sir Charles Grandison*, was published in 1753–4 before the major impact of improvement and reflects an older aesthetic in gardening and landscape; but partly because of this it was full of suggestions for later writers. The novel has a declared purpose — to offer pictures and patterns of behaviour that might stimulate moral improvement in the reader and raise his general estimate of human nature. Some modern writers, among whom is clearly intended Mandeville, had shown human nature in a 'light too degrading'. Richardson works from a moral tradition that owes much to Butler, and much to Bishop Tillotson's argument that the Christian virtues are productive not only of salvation but of wealth. According to Tillotson, the laws of God are reasonable, 'suited to our nature', and 'advantageous to our interest': 'some virtues plainly tend to the preservation of our health, others to the improvement and security of our estates, all to the peace and quiet of our minds, and, what is somewhat more strange, to the advancement of our esteem and reputation.' As Langhorne writes of Tillotson, 'his plainness is often dry, and his truths unaffecting.'[66]

Sir Charles Grandison, a wealthy, handsome, and chivalrous baronet, is un-improved in his tastes, both in landscape and in political economy. He is in favour of the reintroduction of sumptuary laws to limit the growth of private luxury and goes out of his way to favour the trades and manufactures of England in preference to those fashionable items that can only be acquired from abroad. He feels no false superiority to men of trade and commerce — the 'glory and strength' of the nation — but equally does not expect to see such men interfering in country business. He manages to combine all the virtues of a gentleman with an extraordinary acuity and organizational capacity when dealing with his own and his friends' affairs. An efficient and exemplary conduct towards his tenants and day labourers is essential to the judicious, long-term improvement of his inheritance that will soon leave him 'immensely rich' and free of the debts left by his father. While many of his class are wasting their assets in frivolous pleasures, Grandison is demonstrating how the great landowners need to behave for the sake of their own happiness, and indeed survival, in a country increasingly under the influence of men of narrow and commercial interests.[67]

Grandison's father had a magnificent turn of mind. He possessed a number of great estates in England and Ireland in which expenses had proliferated, mortgages had been taken out, and repairs and productive improvements neglected. Sir Charles consolidates his assets, disposing of many, and concentrates his attentions on the principal ancestral seat, where he intends to reside for the greater part of the year. He inherits a 'large and convenient' house situated in an extensive park with several fine avenues. A winding stream, almost a river, runs through the park, its current quickened by a noble cascade where the water tumbles over a ledge of rock-work 'rudely disposed'. The park is remarkable for prospects, lawns, and 'rich-appearing clumps of trees of large growth' — the clear inheritance of several generations of ancestors. On some higher ground, approached by a 'natural and easy ascent', is a neat villa built in the rustic taste for the accommodation of guests who can enjoy a 'noble prospect' from its roof. Nearby is a three-acre orchard with a neat stone bridge at its centre, constructed over the stream. It is planted in a peculiar taste along a natural slope, with fruit trees arranged in semicircular rows according to species so as to present in season a 'charming variety of blossoming sweets'. Just to the north of the orchard are three semicircles, respectively of pine, cedar, and Scotch fir, planted at 'proper distances' to afford protection for the orchard and to create shady summer walks and 'perpetual verdure'. This planting was done by Grandison's father in those 'days of fancy' when his taste in landscape ran to the poetical. Beyond the orchard are the gardens, an orangery, and a vineyard, with alcoves, small temples, and seats placed for the enjoyment of different points of view.[68]

The landscape is clearly of a different taste, and of a greater profusion of expense, than Grandison would have allowed himself, but it is soon made to reflect his natural character. The gardens are flourishing, as 'every-thing indeed is' that belongs to Sir Charles Grandison. The orchard, the lawns, and the grass walks, all tended by sheep, are bound only by sunken fences so that the eye is carried to views that seem 'as boundless as the mind of the owner, and as free and open as his countenance'. When improvements are undertaken in the park they are executed without significant expense and without the employment of professional taste. Grandison studies 'situation and convenience' and does not attempt to level hills or direct rivers, to 'force and distort nature'. He rather helps nature as he finds it, avoiding the display of art and obvious contrasts and effects. He does not seek 'comparative praise' but a discreet pleasure derived from assisting a fine natural effect, one that a stranger might admire 'as if it were *always* so'. He works to 'open and enlarge' the prospects but delights to preserve as much as possible of the planting of his ancestors, believing (with Addison) that the felling of patrimonial timber is a kind of impiety. Grandison's landscape reflects himself in the sense that his own personal culture is so improved that he 'has *no* art, . . . is *above* art'. He eschews the glaring, the ostentatious, and the deliberately singular in everything he does, seeking instead a greater conformity to the natural order of things, and respecting the past so that it becomes effectively incorporated within nature, defining the terms of improvement.[69]

Under the guidance of virtue Grandison Hall comes to be what a great house should be, and might according to Adam Smith seem to be, a machine of happiness,

an 'oeconomy' of order and harmony. The servants go about their business knowing precisely their place and function and benefiting from the scale of the house — there is room for everything to be in order. In contrast with Goldsmith's image of great wealth as a vortex destroying everything about it, Grandison endeavours to 'draw around' himself a 'collection of worthies' and aims to relieve the necessities of every honest person in the 'large circle of his acquaintance', especially the poor. He seeks to 'find out the sighing heart before it is overwhelmed' and, although his benevolence is disinterested in intent, it brings many gratifying tears as the blessings of the formerly distressed pour in upon him. Taking note of the increasing influence in the country of lawyers, overseers, and land agents — men generally 'mean and mercenary' in nature — Grandison insists upon the duty of 'men of consideration' to make available to those on whose industry they rely for their affluence all the advantages of rank and education. Grandison is active in the adjustment of local differences; he has studied both husbandry and the law in order to be a complete steward of his own property and a beneficial influence in the neighbourhood. Like Lord Oxford, he undertakes a 'personal Survey' of his entire estate in order to understand the circumstances and necessities of every tenant and day labourer. He promptly carries out repairs, forgives arrears when appropriate, consults regarding the level of rents and the optimum size of farms, and offers advice and money for judicious improvements. His acuity prevents him from being imposed upon by the encroaching or dishonest. As a result of his justice to his dependants he finds that they 'grow into circumstances around him' and naturally his income grows with them. The result is the reinforcement of the social fabric. Grandison's view of improvement is not dynamic, but seeks to preserve a system of authority from change by fragmentation or the emergence of countervailing views of society, whether despotic, democratic, or wholly commercial. In calling for the better education of the poor he emphasizes that it should be designed to improve their fitness for husbandry and other rural trades in order that each may seek a degree of eminence in being a useful, productive, and contented link in the 'great chain' of civil society. The honest ploughman, skilled in the 'contracted sphere' of his operations, will be a better man than the bulk of the bookishly educated. On the other hand, those of 'peculiar ingenuity' or 'genius' should be encouraged to the full in the realization of their own particular nature.[70]

Richardson's rational, perhaps rather prim, treatment of benevolence may be compared with the more romantic conception of Smollett's *Sir Launcelot Greaves* (1760–1). In 1755 Smollett had published a translation of *Don Quixote*, and in his novel he imagines the pleasures and absurdities of a revival of chivalry in eighteenth-century England, deliberately leaving unclear his sense of the point at which the enthusiastic virtues of a 'plain English gentleman' might become the excesses of a 'lunatic knight-errant'. Sir Launcelot believes that chivalry can still be practised 'to the advantage of the community' if passion is directed by an enlightened understanding of religion, ethics, science, morals, and the laws of England. A modern knight must be 'polite and conversible' as well as passionate. Sir Launcelot fulfils all the duties of a benevolent landlord; he is a 'careful overseer' of the poor, going from house to house industriously seeking out distress and supplying necessaries for the exercise of 'industry and other occupations'. He converts every cottage into a 'pretty,

snug, comfortable habitation' with a wooden porch, glass casements, and a vegetable garden. Pensions are paid to old dependants, and subsidies to those without means. The poor rates are reduced, Smollett notes, as the 'golden age' seems to return to part of Yorkshire. Knight errantry goes further than conventional benevolence. Greaves seeks to be the 'general redresser of grievances' and the 'oppression' and 'extortion' of the selfish are resisted by knightly arms as well as more familiar means.[71]

Like Sir Walter Scott, Smollett imagines Tory values in which the divisions of rank are lessened by familiarity. In his youth Sir Launcelot spent most of his time, and 'chiefly conversed', with ploughmen, ditchers, and other day labourers. He mingled in every 'rustic diversion' and was the best sportman and dancer in the village. Smollett, like Scott, sees both virtues and risks in such enthusiasms, a point made clear during the novel's depiction of an election contest between the Tory, Sir Valentine Quickset, a 'mere fox-hunter', and the Whig, Mr Isaac Vanderpelft, a rich stock-jobber. Sir Launcelot earns the wrath of both parties by proposing the unlikely political virtues of 'honesty, intelligence, and moderation'. He condemns Quickset for mistaking decorum for degeneracy and confusing rusticity with independence. Yet the novel's preference for even such a shadow of a Tory as Quickset is quite apparent; his assemblage of received ideas and prejudices includes such worthy elements as a tribute to 'old English hospitality'. The Whig, who is very obviously of foreign extraction, speaks a language of innovation and commercial pragmatism. When some of Sir Launcelot's enemies escape abroad in a cowardly flight from justice, they are described as fleeing 'on pretence of travelling for improvement'.[72]

Benevolence is perceived as a bond of community against narrow, vulgar self-interest. One villain cites Hobbes to justify his assertion that man, being in a state of nature, is right to pursue his individual ends 'even at the expense of his fellow-creatures'. A Justice who, in the 'insolence of office', practises cruelty and 'oppression', acting the 'tyrant among the indigent and forlorn', is a man who betrays the 'intent and meaning' of the law and reveals himself to be without 'sentiment, education, or capacity'. Amid the well-managed order of the King's Bench, Sir Launcelot feels satisfaction in being part of a community that has provided such a 'comfortable asylum for the unfortunate'. When the knight is confined in a private madhouse, Smollett describes the contrast between an order regulated by law and one, evidently beyond public 'question or controul', run by a 'low-bred barbarian', who 'raises an ample fortune on the misery of his fellow-creatures'.[73]

When Jonas Hanway described a model process of improvement in the 1770s he chose, like Richardson and Smollett, to embody his values in an ideal baronet, one Sir George Friendly, but his emphases reflect the particular experiences of the age of the very un-quixotic Lancelot Brown. The general run of improvement is mere fashion, expense, and greed — in large part an insult to the tenants and labourers of an estate, who are its real improvers, but see the wealth they generate spent in ways that tend to alienate them from their familiar landscapes, often by the destruction of cottages. Sir George, however, plants and improves with the 'friendly view' of delighting his neighbours and dependants and securing their comforts. His charity

'has no bounds' as he repairs and beautifies the parish church and builds a village of 'durable and commodious cottages' with gardens 'smiling in verdure'. He seeks always to combine the improvement of the fertility of his farms with his pleasure in 'beautifying the face of the country'. His mansion stands upon an 'eminence' from which he can see the necessities of the poor. He looks down on parade and the 'noise and pride of trade and opulency' which lead men from the country. He regards his tenants and day labourers as his best friends.[74]

Following Goldsmith, Hanway argues that great accumulations of wealth born of commerce or the engrossment of farms tend to induce an 'insolence' on the part of the rich and a 'servile submission' on the part of the poor contrary to the spirit of liberty and the stability of civil society. Necessitous poverty would increase as reduced possibilities of employment in the country coincided with an increasing monopoly of power among the wealthy — fewer masters meant a greater oppression of their servants. The 'gay appendages' and 'splendid ornaments' of modern improvements, and the 'lofty domes or palaces' of lords and gentlemen, alienated them from the poor and removed them even from any sensuous contact with their distress, as landowners rushed from an isolated experience in the country to a crowded, but inattentive, life in the town. The proper duty of the landowner was to live amid those scenes which his property and education would allow him to improve by seeking to 'cherish the hearts' and 'enlighten the understandings' of his dependants. As with light or the common air, liberty and the rights of nature guaranteed in the constitution could not properly be said to subsist if not universally diffused through the community. Virtue supported by wealth could 'spread a glory round' and 'enlighten the horizon', but the denial of rights to any member of the community would threaten the country with the gloomy prospect of an 'Asiatic despotism'.[75]

The final treatment of benevolent improvement to be discussed here is the most eccentric, but it serves to develop the idea noted in Goldsmith, that the act of planting could in itself be a virtuous and improving art. Langhorne writes of the benefits of contemplating the trees in a 'fine tall grove' of one's own planting:

> They form a kind of epoch in your life, and when you look back to their plantation, you think of many scenes of early enjoyment, the remembrance of which may still be pleasing. They may also have a moral use, and by marking the progress of life, remind you that you have advanced so much farther on the race of life.

The moral nature of planting is emphasized in a number of botanical and horticultural texts, perhaps most notably in the works of the Reverend William Hanbury (1725–78), a Leicestershire clergyman who published in 1770–1 one of the most complete of the later eighteenth-century garden manuals. Hanbury argued that all planting could be directed at once to the 'glory of God and the Advantage of Society'. A gentleman dedicated to gardening and seeing the growth and improvement of his own Creation arising round him would be encouraged to reside on his own estate and avoid the smoke and artificial glare of London. He would beautify and dignify his property, give pleasure to his neighbours, and create eventual profits as his trees became 'noble, lofty, and valuable'. He would revive and sustain in

himself the much decayed sense of the Almighty as he contemplated the variety, perfection, and boundless liberality of the natural world. Passing quiet times in his garden or in 'the pleasing solitude of rural retirement' would relieve the brain, calm the passions, and promote serious thinking and better judgement. There would be endlessly useful lessons of analogy; for example, in noting the importance of attentive care and improvement in the perfection of natural things. Curious investigation of nature would increase the pleasures of its study while leading to such possible useful discoveries as natural medicines. Observation of the slow growth of trees to their venerable maturity, through a 'regular succession' of natural events, would suggest not only analogical lessons of the 'proportional series of time' required in all areas of experience, but increase a sense of obligation both to provident ancestors and to posterity. A man's attitude to planting would sum up his moral and political worth. Sir Robert Walpole, charged with concerning himself only with what will 'last our time', is described by Hanbury as a 'Contemner of Posterity' who was 'necessarily an Enemy to Planting'.[76]

Hanbury gives detailed instructions regarding the disposition and management of trees and shrubs in fields and pleasure grounds to create objects of beauty, to serve particular ends such as the attraction of song-birds, and to provoke specific emotions such as the solemn, the venerable, the gay. Some planting could be emblematic, with deciduous trees suggesting the fate of man and the hope of renewal, and evergreens offering images of immortality. The most important object of planting is to provide 'greater objects to assist our meditation' and to this end Hanbury opposes any formality, such as topiary. To serve their various moral purposes trees must 'naturally form their waving heads with the pleasing luxuriancy and beauty in growth'. Plantations must be laid out as 'imitations of nature', with everything placed in an easy manner, 'as if Nature had thrown it there'.[77]

Hanbury decided to further the cause of improvement by the foundation of charities funded from the profits of his nurseries. He began with the simple intention of repairing the parish church and installing an organ, believing that performances of Handel and Purcell, in particular, would calm the passions of his congregation, promote rapturous devotion, and help to train up the minds of the young in the divine principles of harmony. As the income from the nurseries grew so did the charitable projects, although he excluded from them the improvement of his own parsonage, noting that the glory of God was not to be advanced by 'fine rooms' and 'painted cielings'. Hanbury planned to construct a school at which children were to be taught English and the learned languages, botany, mathematics, and history. There was to be a professor of poetry who would 'dress up every one in the keenest satire' who had acted meanly or basely in his station; particularly, it seems, landowners who enforced the game laws. A drawing master was to be appointed who would work with a professor of antiquities to record the noble creations of eminent men of the past, or their ruins, as 'remembrancers', objects of respect and emulation. Within the expanding confines of the school, Hanbury planned gardens, a library, a picture gallery, a natural history museum, and a printing press devoted to the free distribution of religious works.

In addition to the school, Hanbury intended to acquire numerous livings for the

appointment of scholarly but poor men qualified to be clergymen. As resources increased with the growth of the nurseries, a further fund would be established with the extensive goal of 'universal charity' — the relief of distress, the reward of virtue, the prosecution of rogues, the relief of prisoners and the poor, and the acquisition of cows for cottagers. This fund was to be administered by twenty-four trustees, gentlemen of the county, whose efforts were to be recorded in portraits and commemorative inscriptions. Presiding over the entire foundation was to be a church set on top of a hill so as to salute the country in the 'most astonishing and pleasing manner'. It was to be built in the Gothic style in emulation of the ancient cathedrals so admired by Hanbury for their solemnity, the sublime awe and reverence they provoke, and their testimony to the commitment of generations of religious men.[78]

A Note on Crabbe's The Village

Although it concerns itself with many of the issues of improvement, George Crabbe's poem, published in 1783, is difficult to place within the wider argument because of the elusive character of its point of view. The initial premise is clear — a pastoral account of the English landscape, whether in poetry or painting, is a 'flattering dream', an idle, easy, trifling, commonplace, and mechanical echo of a discredited convention in which 'sad scenes' are 'painted fair' by spectators who are ignorant, emotionally shallow, careless, and wholly removed economically from the 'real picture' of the poor. The poor themselves have nothing to gain from this form of improvement of their 'ruin'd shed'. Real poetry is excluded from the country not (as in Goldsmith) because it is part of a wider creativity spurned by the oppressive hand of trade, but because rural life is a condition of poverty, oppression, vice, ruthlessness, painful labour, and plain dullness.[79]

Improvement in Crabbe's poem is a complicated issue as he proceeds to describe in detail at least three types of landscape. The first, that of his native Suffolk coast, seems inherently unimprovable, and embodies a kind of natural malice. The sterile soil produces only the rankness of weeds, defiant of any 'art and care': the natural beauties of those weeds are a mockery whose delights are lost on the inhabitants. They are as unimproved as the land and victims of it, since any virtuous toil has long since proved hopeless. Wild, savage, and joyless, without any social and civil arts, they scowl at strangers and are artful and surly among themselves. In this landscape of famine and guilty earnings, through such crimes as wrecking and smuggling, there is no social system, no clearly defined division of property and class, but an apparently unhappy equality of condition. The only resource for the ambitious or sensitive is flight to a more favourable market.[80]

In the second landscape, 'more fair in view', nature has been improved and social and property divisions clearly defined amid the corn-clad enclosures of plenty. In reality, however, such scenes have charms only for the owners or tenants of the land and for the careless spectator; not, certainly, for the 'poor laborious natives of the place', who are repeatedly referred to as slaves in terms that recall Montesquieu and Warburton. Like the African slaves who 'dig the golden ore', the labourers behold

wealth but do not taste it; indeed the wealth is responsible for their distressed condition and enslaves, humiliates, and embitters them. Writing at a time of intense debate regarding the abolition of the slave trade, Crabbe seems determined to suggest, as did the slave owners, that the condition of the English poor was no better than that of the Africans. They are all 'weary men oppress'd', exposed to burning suns and alternating dampness that leave their 'long-contending nature' to be overcome by labour, external nature, and time. In this improved landscape there is no responsible civil society; the rich disdain the poor and the poor disdain each other, forced into selfishness by the burden of their own cares. The squire, the surgeon, the priest, the churchwarden, and the 'kingly overseer' are all vicious, incompetent, and contemptuously neglectful — indeed their attentions are usually more damaging than complete neglect would be. The Bench is 'drowsy'. The poor man reduced to distress by labour is, like Christ, 'despised' and 'neglected' and left alone to die abandoned by the Church.* The farmer, a careful master only in the management of his self-interest, continues to berate the laziness of the poor and the indulgence of the laws for their relief. Of those of the poor not suffering a Christ-like fate, most are seen as repulsively unimproved with 'naked vices, rude, and unrefined'. Crabbe mixes pity with contempt as he depicts their slanders and crimes, and all the vices they have in common with the rich.[81]

Crabbe's rejection of the pastoral and his depiction of the 'real picture' of the poor do not lead him, indeed prevent him from embracing, any coherent, if clearly flawed position, such as benevolence. There is no past, no credible constitutional or moral tradition somewhere latent in the community, that can offer real hope of the improvement of the nature of things depicted. In the third landscape of the poem Crabbe seeks to distract or encourage the reader — and the poor — by holding up before them images of the exemplary virtues of the family of the Duke of Rutland. Crabbe's own position in life — poor, provincial, rootless, and classless by virtue of genius — has been relieved by, or obliged him gratefully to accept, the favours of a cultivated, powerful, distant, aloof aristocracy, rendered by their position disinterestedly superior to the ordinary nature of things. This aristocracy is a 'tall oak' that stands high above the 'subject wood' and is at once its 'guard and glory'. Superior to narrow views and paltry fears, it is a generous spirit that moves high above the world with all its 'worth in view' and calmly looks out beyond the trifling concerns of the moment and even beyond the grave. The Duke's family is like the pure, rushing stream of the Thames, which even with the loss of some of its tributaries, moves relentlessly onwards and gains in strength; as it flows its 'use improves' amid a constant stream of plenty.[82]

* Compare the Revd Samuel Hallifax in a 1770 sermon (*A Sermon Preached Before the Governors of Addenbrooke's Hospital, June 28, 1770*, Cambridge, 1771, p. 3) on the 'peculiar relation, which the distressed and miserable are said in Scripture to bear to Christ':

Nature prompts us to sigh for the afflicted, and forces us to feel for the infirmities of our fellow-creatures: but Grace carries our views from them to Christ, and teaches us to consider the Redeemer himself as suffering in all the sufferings of his followers. It is this regard to Christ, which constitutes the very root and principle of Christian charity.

How this stream will alter and improve the English landscape is unclear, but the impression that Crabbe is invoking some kind of Super Improver, Omnipotent Magician, or embodiment of the Grand Style, who could transform the landscape and is above difficulty, is partly confirmed in his funeral sermon for the Duke of Rutland (1788). The Duke was a man of many virtues suitable to his station in life; he was just, benevolent, and good, with dignity of mind, frankness of manners, and largeness of heart. He was an exemplar of what all men could in some small degree aspire to be, particularly in his kindness and compassion towards the poor and needy. But he was also an Improver beyond any normal capacity of man:

> he loved the great, the noble, and the magnificent in nature, in science, and in virtue; it was not so much his pleasure to view the accuracy of an object as the extent of it; nor to consider the precise bounds of duty, but how far it might be carried. As he looked at large on nature and on man, he thought how he might improve the one and benefit the other, without minutely attending to the difficulties in his way . . .

His improvements were of the 'noblest' kind: 'It was not his delight to form a cascade or adorn a parterre, but rather to pour forth a river and to plant a desert; and a taste congenial with this was displayed in his benevolence.' Not satisfied with the relief of individuals, he had felt obliged to transform an entire nation. As Lord-Lieutenant of Ireland, where constitutional arrangements were such as to afford him the power to answer his will, he had begun to bring peace and plenty as commerce began to grow and the peasantry felt his fostering hand. Perhaps England was in need of a similar treatment, if another such man could be found.[83]

3

The Mansion and the Landscape

Extended views a narrow mind extend.
Edward Young, *Night Thoughts* (IX. l. 1383)

The 'picturesque controversy' of the 1790s was conducted by important defenders of the tradition of 'Capability' Brown, notably Repton, Walpole, Mason, and William Windham on one side, and his principal critics, Uvedale Price (1747–1829) and Richard Payne Knight (1750–1824) on the other.*

The argument was concerned with many of the diverse issues, moral, political, and aesthetic, involved in the management of the landscape. It seemed to many that England had been transformed by various types of improvement. With the increasing uncertainties brought about by the revolution in France, the threat of invasion, and economic difficulties, it seemed appropriate to consider the consequences of these changes. This chapter is concerned principally with Price's attack on Brown and his suggestions of the underlying constitutional and moral implications of the latter's work. Price's clear intention was to link the rise and triumph of improvement with what he took to be a series of alien values — alien in the sense of being contrary to the ideal principles and habits implied by sound constitutional theory, and serving to undermine the legitimate authority of the landed interest, to which, as a major proprietor in Herefordshire, he felt strongly attached. Price sought in some degree to re-legitimize the country house, particularly in its less palatial manifestations, and to redefine the principles of improvement in the direction of a reconciliation of the interests of the country gentlemen with those of the public. The basis of his argument is in analogy and in its support he sought to employ a tradition of visual theory, most familiar in the nineteenth century, which argues that the contentment, stimulus, and growth of the mind require some kind of creative familiarity with the delicacy,

* Windham (1750–1810) was a cultivated politician, close to Burke, and Pitt's Secretary at War between 1794 and 1801. A close friend of Repton's, he defended the latter's work on a number of occasions. He appears to have spent little time at his country house, Felbrigg, being depressed by the solitude there. On grounds of principle, or of what Sir James Mackintosh termed 'love of paradox', he was a vigorous opponent, in his last years, of the abolition of the slave trade, penal law reform, and legislation against cruelty to animals (see R. W. Ketton-Cremer, *Felbrigg: The Story of a House*, 1962; *Quarterly Review*, XXXII, 1817, pp. 426–7; and Sir Samuel Romilly, *Memoirs*, 1840, vol. II, p. 316).

intricacy, and variety of natural form. The essence of the argument is that the prevalence in the landscape, or in architecture, of the mechanical, the quadratic, and the artificial, would tend to stunt, narrow, and frustrate the energies of the mind, in much the same way as had been noted in the division of labour. Improvement, far from being an expression of freedom, served to limit men's liberty, vigour, and independence.

The main principle behind Price's idea of the picturesque is that nature is too complex and confusing to be accurately perceived without the assistance of paintings, which can serve to distil and select its infinite variety into comprehensible forms. It is an argument that implies the importance of tradition, received wisdom, and conventions, and of a cultivated class of men who can define what is valuable and in some degree regulate taste. Art and criticism serve the purposes of civil society in a number of ways; in particular, they enable men to improve their capacity for judgement, self-expression, observation, and understanding while leaving them in no doubt that they are being guided and assisted by a superior body of wisdom. An intensive and sympathetic observation of nature will not lead men to believe that all opinions are of equal value or that truth and improvement are founded in a free play of competitive and social forces independent of rank and tradition. The picturesque is to be regarded as inseparable from the cultivated management of landed property.

Price's clearest influence is Burke, but a different Burke from that of the domestic political economist of the mid-1790s. Price looks to him as the author of a major aesthetic treatise, the noble defender of constitutional liberty in America, India, and Ireland, and the determined critic of certain kinds of fashionable change recently undertaken in Jacobin France, although Price's attitude to France, like that of his friend Charles James Fox, was more defensive than militant. This Burke, who looks backward to Butler and Blackstone and forward to nineteenth-century Toryism, chooses to employ imagery and principles that are not always easy to equate with simple conceptions of political economy. Because Burke's ideas of the theory and practice of improvement significantly influenced the work of Price and later writers on the picturesque, it may be helpful to outline some of these ideas and the relatively complex nature of their imagery.

The Mansion in Burke's Political Landscape

In a 1780 speech to his Bristol constituents Burke praised the efforts of John Howard, using the language of universal benevolence. The great reformer of the English gaols had spent his maturity in a 'voyage of discovery' throughout Europe, undertaken not for personal improvement or reward but for observation and research dedicated to the ends of charity and humanity:

> his labour and writings have done much to open the eyes and hearts of mankind. He has visited all Europe — not to survey the sumptuousness of palaces, or the stateliness of temples; not to make accurate measurements of the remains of ancient grandeur, nor to form a scale of the curiosity of modern art; not to collect

medals, or collate manuscripts: — but to dive into the depths of dungeons . . . to survey the mansions of sorrow & pain; to take the gauge and dimensions of misery, depression, and contempt; to remember the forgotten . . . to compare and collate the distresses of all men in all countries.

Howard, wealthy and cultivated enough to appreciate the beauty and interest of the works of art he was choosing to ignore, had in these researches served the values of what Burke later in his speech calls 'our natural family mansion', the 'grand social principle' which 'unites all men, in all descriptions, under the shadow of an equal and impartial justice'.[1]

Burke is constantly using imagery from travel, landscape improvement, architecture, design, measurement, and attentive observation in general, all of them central concerns of the dilettanti. Usually this imagery is employed in a manner that involves ambiguity, a sense that the reader does not quite know where Burke, or the reader himself stands. In contemplating the 'natural family mansion' the mind does not rest long on any simple ideas of benevolence and justice; the extended image, which combines a constitutional idea of regulated liberty with a more or less explicit Christian reference, inevitably brings to mind the more material mansions of the eighteenth-century landowners. The 'voyage of discovery' reminds one that Burke is addressing the merchants of Bristol, whose navigations of the world were directed to very commercial purposes, including dealings in slaves. The selfishness of touring English dilettanti occupied with the sumptuousness of foreign palaces and the interesting and valuable artifacts of the past may be more respectable than the dealings of the merchants, but neither has much to do with Christian self-sacrifice.

Such dilettanti occupy, design, and ornament the sumptuous mansions of England, which exist for their private gratification and pleasure. From 1765 to 1782 Burke was the political secretary of Lord Rockingham, owner of Wentworth Woodhouse, the longest mansion in England, whose east front, designed by Henry Flitcroft about 1730, is 606 feet long. Rockingham was inclined to argue that the liberty, morality, and justice of English society depended on power residing in the great ancestral estates. The passage reflects, in short, some of the ambiguities in Burke's position between the natural mansion of equity and the actual conduct of power. Burke seeks to resolve this ambiguity late in his career by arguing that the mansions of the nobility were themselves natural, because a powerful aristocracy, resplendent in character and outward display, was the most natural part of a civilized state, the one which most reflected the human desire to cultivate excellence, and therefore distinctions, in all fields of endeavour. The Butlerian argument that society is natural and at the same time hierarchical is therefore given a precise focus in a version of the Whig idea of landscape.

Before arriving at this point, however, Burke tended to use his mansion imagery to defend an idea of constitutional liberty much like that of Blackstone, and to regard his opponents as usurping improvers and wreckers of the political landscape. In Burke's speeches (1788–94) against Warren Hastings for high crimes and misdemeanours in the government of India, Hastings emerges as a despotic improver on an epic scale. He had by his own account headed an arbitrary government because

no other authority was respected in a nation in which the mass of the people were used to being slaves. Endless difficulties and inconveniences to a settled authority arose from an innumerable variety of tenures, rights, and claims founded in a mass of ancient and irreconcilable laws, religions, and prejudices. Confronted with all this 'unnatural and discordant' confusion, Hastings had declared that India would be a profitable market only if the 'whole of our territory' was 'rounded' and made an 'uniform, compact, mass' by 'one grand and systematick arrangement'. Burke's reply is that the essential principles of government cannot be subject to a 'geographical morality'; arbitrary power was as immoral in India as it would be in England. The object of political improvement is not to turn variety into uniformity by obliging men to conform to a narrow circle of ideas imposed from above. Politicians must take a general, comprehensive, well-connected and proportional view of the political system they find, stretch and expand their ideas to its dimensions, and understand and reconcile all the contrary influences in civil society. Hastings had deliberately destroyed the ancient political landscape and replaced it with nothing more complex than an experimental system of tyranny without any basis in morality, analogy, or the wisdom and experience of the past. It was a mere charter government of tradesmen, without regularity, order, or consistency. Hastings had none of the talents of a judicious improver. He was low, sordid, and mercenary, a wild and natural man void of instruction, discipline, and art.[2]

Burke's various descriptions of the ruined landscape of India recall very clearly the contemporary domestic controversy regarding improvement. Hastings had destroyed the 'cheerful face of paternal government and protected labour' under which the peasantry had lived contentedly in beautiful landscapes, the chosen seat of cultivation and plenty. Every legal principle had been laid level with the ground, to be usurped by a rapacious, peculating despotism that left in its wake a 'scene of desolation and ruin', overgrown fields and deserted villages. Hastings had enclosed great stretches of territory to form what was effectively his own private domain or park — 'a place, as it were, for game' to be drawn out and killed as it served his purpose. In his poem *St Thomas's Mount* (1774) Eyles Irwin had noted the absence in India of the game laws: men were free to enjoy the 'common' bounty of nature. He had called upon Britons to 'mourn' and 'Once feel inferior to the Indian swain':

> He shares, unquestion'd, Nature's bounteous board,
> Whate'er the fields or forests wild afford:
> The Hare, the Partridge, or the stately Deer
> Is his, in common with the Richest Peer. (ii. ll. 185–92)

Hastings, in Burke's allegation, had curtailed the liberty of the Indians through the imposition of one of the most contentious aspects of English law. Acting as a tyrant landlord he had also affronted the strongest principles of nature by obliging men to abandon their native soil. Burke notes that, after love of kindred, the strongest human instinct is affection for the place of one's birth and early sensations — an affection beyond the power of verse to express, and sanctified by its being the chief basis of love of country. The rebellions that Hastings had provoked were a natural

and legal reaction of all those who cared for their land and the welfare of their family. The people, and the 'physical works of God', had been ruthlessly destroyed; the 'true and natural' order of things, under which the rights of the people were everything, had been 'distorted and put out of frame'. The English in India were 'birds of prey and passage' who improved nothing and left no lasting monuments such as churches, hospitals, schools, or even palaces. They were there only to enrich themselves and depart. Hastings had to be punished both as an act of justice and as a declaration on the part of Parliament that all such conduct was contrary to any principle of English rule. Law and liberty would not survive at home if they were undermined in any territory under English influence or authority, or if new money, founded on the desolation of India, was able to return unpunished and unashamed to England, buy respectability through public acts of benevolence or by marriage into the mortgaged nobility, and enter into Parliament or the local administration of justice.[3]

The incompetence or rapaciousness of British rule abroad had already demonstrated itself in the events leading up to the loss of the American colonies. In his speeches of the mid-1770s during the dispute with America, Burke employed imagery similar to that of his denunciations of Hastings. The end of government is the happiness of mankind, not the creation of a 'spectacle of uniformity' made to gratify the schemes of visionary politicians. Statesmen must attend to the true nature and peculiar circumstances of the peoples they govern and not rely on narrow, contracted systems suggested by abstract ideas of the rights of government and the dependent status of colonies. Instead of seeking to impose an artificial set of principles manufactured in London ready for shipment to America, they must survey, minutely, slowly, and from every point of view, the characteristics of the object they seek to govern or improve. The accurate undertaking of this task required more than the talent or speculation of an age. It needed the whole patrimony of wisdom embodied in the ancient constitutional policy of England, with its roots in experience, nature, and philosophical analogy. Wise politicians would reject the polished maxims of fashionable theory in favour of the venerable rust and noble, ingenious, roughness of the older, more manly and rustic workmanship. Only from such an old basis could the Temple of Concord be reconstructed. If liberty was denied in America it would be devalued in England; in order to exist securely it needed to be a common blessing throughout the empire and as broad and general as the air, feeding and invigorating every member and communicating union and harmony through the 'great principle of connection'. If the 'dull, dismal, cold, dead' uniformity of servitude already inflicted on the slaves was extended into a complete principle of government the whole empire, including England, would collapse.*[4]

Shortly after his speeches calling for reconciliation with America, Burke described British policy in Ireland as a 'narrow and restrictive' plan of government that sought

* Ironically, as Dr Johnson in part perceived, an effect of American independence was to insulate the slave owners from the growing abolitionist pressures in Britain, and to place the future of the indigenous peoples in the hands of men often less disposed to respect their territorial and other rights than the imperial government at least claimed to be.

to cramp the natural faculties of the people, restrain their improvement, and make them a prey to their rulers. In 1792 he called for the political representation of Roman Catholics in order to bring about some degree of acquaintance between them and the dominant Protestants. If men were able to meet on more equal terms, the 'hideous mask' of prejudice might be removed and they might see each other 'as they are'. It was not unusual for a Protestant landowner never to converse with a Catholic unless he happened to talk with the gardener's assistants and stable lads at his mansion or ask his way when lost hunting. The inevitable consequences of this were alienation on one side and pride and insolence on the other. Manners always disagreeable would become dangerous in the event of a prolonged war with France, and the pursuit of security in oppression would provoke rebellion. In 1797 Burke described the government of Ireland as a 'Junto'. The country had been 'delivered over as a farm' to a small unprincipled faction that sought to arrogate the whole territory to itself, seizing upon 'poor Ploughmen in their Cottages' and fomenting discord as if upon principle. Such men were no different in any moral point of view from the Jacobin tyrants of a revolutionary and increasingly militant France.[5]

The triumph of the Jacobins represented a new refinement of systematic and abstract thinking infinitely more dangerous than anything in previous English experience. It was a 'wild attempt to methodize anarchy', to 'perpetuate and fix disorder' by destroying the ancient fabric of society and the 'course of moral nature' founded on hierarchical and reciprocal connections, order, virtue, morality, and religion. At the same time it was a despotic mode of thinking that substituted abstract ends for human instincts and sought to discipline men into a calculating ferocity beyond anything existing in man's natural state. In the 'rankness of uncultivated nature', and in ancient and savage societies, cruelty was generally balanced by 'rude, unfashioned virtues' such as mutual assistance, loyalty to tribe or family, and spontaneous mercy. However, men bred into a systematic mode of understanding the world according to a few abstract maxims would become artificial beings, destructive and merciless in their furthering of a cause more important than mere conventional considerations of humanity.[6]

The Jacobins' method of improvement was to treat the country as if it were conquered territory or *carte blanche*, to destroy all vestiges of the old ways, every ancient landmark, and everything that, lifting its head above the new uniformity, could serve as a rallying point for the defence of older sentiments. They had made universal the former, localized, taste of the French ornamental gardeners, who had cleared away as mere rubbish whatever they found and formed everything into an exact level. The ancient religious culture of the nation, its cathedrals and churches grown 'hoary with innumerable years', had served as a hopeful 'public consolation' and reminder of an ultimate justice. It was overthrown in favour of the rule of fashionable and hopeless enlightenment. Old administrative establishments, created by centuries of experience, effort, and adaptation to need and accident, were thoughtlessly demolished to make way for a rational division of the country into equal legislative squares. This 'new and merely theoretick system' of government by land-surveyor answered to no local needs or habits and required men to transfer to arbitrary and unfamiliar divisions, created by a 'sudden jerk of authority', all the

loyalties and affections naturally felt towards familiar 'habitual provincial connections', those essential sources of communal responsibility and ultimately of love of country.[7]

For Burke, as for Johnson and Blackstone, the simple replacement of the old with the new answers none of the purposes, and is indeed opposed to any satisfactory idea of improvement, which must be based on reform, not innovation. Innovation destroys the substance of things, removing substantial good as well as evil. It implies narrowness of mind, contempt for the established, and a preference for partial tastes or interests over the general good, since it tends to work by elevating into wisdom the prejudices of a particular moment or faction. The improvement of the fabric of the state, seen as a 'noble and venerable' castle, is served neither by demolition nor by the narrow mechanical skills of modern polish and refinement. It requires a disposition to preserve, a constant reference to models and patterns of approved beauty and utility, and the use of existing materials. Improvement is founded in respect for the patrimony of knowledge bequeathed by ancestors and for analogical precedent, authority, and example. Innovators are careless of what they receive and of what is due to posterity; they break the chain of continuity between generations, treating as affairs of mere convenience or commercial advantage what ought to be a continuing 'partnership in perfection' between the dead, the living, and posterity. They deliver the community over to every projector or adventurer with a plausible conception of the public good. Even on a commercial analogy they are foolish, since they live and trade on their private stock of reason, inattentive to the wisdom of calling on the 'general bank and capital of nations and ages'. Social freedom cannot survive if men pursue a 'solitary, unconnected, individual, selfish Liberty'.[8]

Improvement is properly conducted in analogy with the course of nature, not only in its attention to the endless and intricate responsibility of one generation to every other, but in taking account of the 'process of nature', which is inherently slow, unpredictable, and constantly subject to accident and necessary adjustment to changing circumstances. Patience and neglect may achieve more than force. What is true of the workings of inanimate nature is at least as appropriate as a maxim when attending to the affairs of sentient beings, 'by the sudden alteration of whose state, condition, and habits, multitudes may be rendered miserable'. The improver who ignores the processes of nature is comparable with an ignorant or systematic physician who applies quack remedies to every case of difficulty. Men should not be left to the mercy of 'every alchymist and empyrick'.[9]

A mature constitution is characterized by qualities that recall both the 'ingenious simplicity' of design of an ancient castle and the infinitely various but harmonious order of nature. It is intricate, of the 'greatest possible complexity', and manifests difficult workmanship rather than a clever 'simplicity of contrivance'. It is more Gothic than classical. It possesses a variety of parts corresponding with the variety of interests that make up the community. Its union is achieved, as in nature, by the constant agreement and opposition, action and counteraction, of the different interests. The strength of each social group enforces the spirit of compromise in the whole, countering precipitate change and the domination of one interest by another. The function of political improvement is to maintain and strengthen this equilib-

rium, which cannot be left to itself like a free market of tradesmen. Government has a function that at one end of the scale of things resembles that of Berkeley's God and, at a humbler level, that of the engineer or artist. It seeks to adjust by compensation, reconciliation, and balance, so that the various anomalies and contending principles may be harmoniously connected together. The most important talents required are not those of systematic thought but of comprehensive understanding and constant attention. The 'powerful and combining mind' of the statesman will manifest itself above all in an 'excellence of composition'. The capacity to identify solid and lasting principles analogous with the 'plastic principle' in the natural sciences, which can be fixed and afterward left, in large part, to their own operation, is of central importance, but never removes the need for the constant effort of adjustment, composition, and improvement.

Burke describes how the states of Europe had been improved to their pre-revolutionary condition through a great length of time and a great variety of accidents, with varying degrees of neglect, felicity, and skill. In no case had there been a regular plan, a peculiar end, or a unity of conception binding nature to abstract designs. In England in particular the state had been accommodated to the people, and the constitution had sought to embrace the greatest possible variety of interests, aiming indeed to take in the 'entire circle' of human desires and secure for them 'their fair enjoyment'. All the states of Europe, however, had a common patrimony of manners and education, so that no citizen of one part could feel himself completely a stranger in another. The shades of each nation had been softened, blended, and harmonized into a consistent whole, while leaving a pleasing variety to recreate the mind and freshen the imagination.[10]

This common patrimony had been thrown aside by a revolution that was an urban conspiracy of men whose occupations encouraged narrowness of mind and a spirit of envy — tradesmen, lawyers, literary hacks, minor priests, and academics. Among their first acts was to create a market in paper credits based on the confiscated estates of the Church and the landed interest, with the twin ideas of financing the public debt and destroying the traditional influence of the country. The spirit of trading had been incorporated into the 'mass of land', making it volatile and transforming its essence of stability into an 'unnatural and monstrous' form of speculation. Men without fixed habits or local predilections came to be the proprietors of land without any attachment to it other than the hope of gain. As speculation became as 'extensive as life', all customs of careful provision for the future ceased to have existence. The landed gentlemen, yeomanry, and peasantry, having no taste or capacity for this commerce, became reduced to the status of mere labourers for the insecure maintenance of the towns.[11]

A similar process, Burke declared, could occur in England. It would be provoked by the large numbers of political and religious dissidents and the many 'half-bred speculators' and East-India men who envied the old nobility and resented the prejudices that denied them an importance commensurate with their wealth. Among the 'ambitious great' there were those, such as the two greatest agricultural improvers of the day, the Duke of Bedford and Coke of Holkham, who were active in their desire to treat with France. A 'large part of the aristocratick interest' was

inclined to oppose the war which Burke regarded as necessary to the survival of England. Worst of all, the lesser squires and yeomen, formerly the 'hope, the pride, and the strength' of the country, were much reduced in numbers and often inferior in intelligence and energy to the merchants and manufacturing castes. The world in which Burke wished to live, even when he did not feel comfortable in it, was that of the great mansions whose power to civilize, reform, and rule seemed suddenly about to be eclipsed.[12]

The question Burke failed to resolve convincingly was whether the bulk of this threat arose internally or from the Jacobin revolution. Much of his energy in the 1790s was designed to mythologize and justify an old world of aristocratic power and to save it from the nabobs, the Jacobins, and the 'Junto' in Ireland. To this cause everything tends to be sacrificed. Burke becomes a curious propagandist at once for political economy and for restraint on domestic liberty as his central point of reference is increasingly the 'magnificent ancient country seats of the nobility'. A new emphasis, very different from the older idea of composition, enters the work. Men had a natural right to be restrained in some of their passions and inclinations 'by a power out of themselves', and had a right to all those connections, natural and civil, which regulate the community by a 'chain of subordination'. The stability and improvement of society require not only more minds than one age can furnish but also the diffusion throughout the community of instincts of authority, deference, respect for tradition and for rank and property. The mass of the people, being possessed of little property and lacking a comprehensive, connected view of things, are to regard themselves as designed to be instruments of government, never its controls. Men inveterately confined in 'the recurrent employments of a narrow circle' lack the leisure, experience, breadth of interests, and stake in the country that will secure their independence from the partial, the convenient, the short term. In this line of thought the people become almost the enemy of government.[13]

With all their power, the nobility and gentry have to be deliberately defended from the more energetic, talented, and less stable members of society. The road to eminence from obscure condition ought not to be made easy; it should require a severe probation, and the 'temple of honour' must be built on an eminence, rather like a spurious church in a landscaped park. Ability is a vigorous and active principle; property is sluggish, inert, and timid, and can never be safe unless it is predominant in political representation. Its 'great masses' — like the Whig mansions — must be inaccessible, dominant, and out of danger so that they form a 'natural rampart' protecting all lesser gradations of property. The same quantity of property, which by the 'natural course' of things — a free market — becomes divided among the many, is weakened the more it is diffused.[14]

Great property has to be defended not only by legal, political, and, if necessary, by military intervention, but by a vast weight of prejudice and mysticism. The mansions of the nobility, however 'marked with the lines of subordination, and the divisions and subdivisions of civilized inequality', are 'chearful haunts' that represent permanence and stability in a world in which the revolutionary spirit had 'left nothing, no, nothing at all, unchanged'. As man has a natural instinct for continuity this permanence rendered the mansions a natural part of the landscape. More

broadly, Burke repeatedly refers in his last works to the idea of the 'natural aristocracy', a concept very close to Reynolds's 'grand style'. Accomplished manners and 'sentiments of elevation' are natural because 'nature is never more truly herself, than in her grandest forms'. Indeed 'art is man's nature' in the sense that the *Apollo Belvedere* is clearly a higher form of nature than a mere rustic by Teniers. Pre-eminence and subordination are as inherent in civil society as they are in nature. As men advance in the cultivation of reason they naturally attach greater value to personal eminence and all the qualities that promote the pleasures of civilization. Government most accords with the nature of things when it has clearly marked all the boundaries and distinctions, connections and dependencies, which at once diversify and harmonize the order of nature. Society is most natural when due authority has been given to its 'leading, guiding, and governing part' so as to create a 'grand chorus of national harmony', a beautiful 'array of truth and Nature' that can be sustained as long as the common sort of men are not separated from their 'proper chieftains'. The great mansions of the nobility, surrounded by vast stretches of distinctive and well-defended property, are therefore among the greatest orna-ments of the English landscape, and the most perfect expression of nature. Burke, ever attached to grand images, ignores the objection posed by Lord Shelburne, among others, that this kind of 'separation' would inevitably undermine the integrity and strength of the landed interest. Many later Tories — notably Sir Walter Scott — were attracted by the idea of 'chieftains', but imagined that such men live in proximity to their 'people', not, in Scott's words, 'isolated' and 'detached from connections and relationship'.[15]

The gap between the natural aristocracy and the actual, political aristocracy, with its substantial proportion of weak minds, is in large part bridged by the dignity and respect attached to external forms, whether in clothing, equipage, manners, lan-guage, or in magnificent country seats. In 1780, calling for greater economy in the expenses of the royal household, Burke had complained of the 'cumbrous charge of a Gothick establishment'. Men had become 'fatigued and satiated' with the 'dull variety' of titles, palaces, and ceremonial offices still attaching to an institution whose daily conduct had sunk into the 'polished littleness of modern elegance'. After the regicide revolution in France, every kind of gothick imagery is justified and sanctified in order to elevate and protect the image and presence of royalty and nobility. In a civilized society men feel an awed reverence for tradition; acting as if in the presence of 'canonized forefathers', they temper the spirit of liberty with an 'awful gravity' that shames all forms of upstart insolence. Many of the expressions of this awe are external and independent of any personal merit, notably such 'artificial institutions' as inherited orders of chivalry. They have an 'imposing and majestic aspect', as do old monumental inscriptions, armorial bearings, heraldic images, titles, castles, palaces, and ancient country seats.[16]

Such things, rendered into symbolic images, sustain a system of manners and rituals that dignify the processes of social exchange. Burke writes of the 'decent drapery of life' that leads men to regard each other, not merely by the lights of naked reason, but according to a set of prejudices that generate 'pleasing illusions' as to the dignity of monarchs, the integrity of gentlemen, the fairness of judges, the wisdom

of aristocrats, and the virtue of women. The 'coat of prejudice' and the habits of chivalry soften the conduct of power and render civility, and even virtue, habits of mind and not a series of unconnected acts. Duty becomes part of man's nature, and the institutions of civil society are clothed in a manner that secures the willing respect and assent of the general population. In all this Burke was faithful to the principles of his youthful essay *The Sublime and the Beautiful* (1757), in which he had demonstrated close connections between social instincts and aesthetic response. Both beauty and sublimity have a 'social quality' in that the former provokes sentiments of clear affection, and the latter sentiments of admiration, reverence, and respect. There is a desire to be near the object in the first case, and a willing subjection in the other. Chivalry and its associated manners secure in much the same way the general consent of the community by endowing authority with an attractive and respectable form.[17]

The decline of romantic ideas of chivalry and their replacement by reason would not further the causes of peace and justice but those of naked self-interest. Divorced from a sense of tradition, the moral and physical landscape would be left in the hands of the true heirs of the Jacobins, the 'sophists, oeconomists, and calculators'. Superstitions and prejudices that had at least adorned the country would be replaced by a coarseness of taste and manners bound only to deform it. The conventions of the older world had demanded some obeisance, however shallow, to habits of politeness and humility. The political improvers of the new Enlightenment viewed the past as unnecessary rubbish, and would merge all natural and social sentiment in inordinate vanity. The assertive display of personal wealth, cleverness, and everything 'imposing in the appearance' would replace substance and a sense of connection with the community as a whole. Men would wish only to 'rouse attention' and 'excite surprise'. Reversing the basis of men's natural feelings, the desire to find in others, in nature, and in institutions objects of independent reverence or attachment, the new prophets of calculation (one recalls here Hume's 'just calculation') would seek only to draw attention to themselves as an end. Grace and manners, taste and elegance, would give way to pomp and luxury. Men would set themselves up as if to be seen on stage, artificial creatures with painted and theatrical sentiments fit to be seen only by candlelight. In this triumph of vulgarity, the ordinary bonds that attach men to their country as an expression of moral partnership would be steadily dissolved, since for men to love their country, Burke insists, that country ought to be lovely. With the triumph of Jacobinism all the myriad 'little, quiet rivulets' that had ornamented and watered the traditional landscape would be 'lost in the waste expanse and boundless, barren ocean' of cruelty, vulgarity, and 'homicide philanthropy'.[18]

The magnificent country seats of the nobility — the ancient ones, naturally, and not the showier new examples — have an essential part in a landscape of dignified images that sustain tradition, property, and the capacity for self-respect. Ideally, the political aristocracy might converge with the natural through the advantages of permanent property, education, and early experience of habits and responsibilities that 'enlarge and liberalise the understanding'. Even without extraordinary virtues, at least the bulk of the aristocracy would perform a function by representing an inert

or even reactionary force in the community. If members of the nobility chose to disgrace themselves in the 'innumerable fopperies and follies, in which opulence sports away the burthen of its superfluity', this was their own affair: 'We tolerate even these; not from love of them, but for fear of worse. We tolerate them, because property and liberty require . . . that toleration.' Rich men wandering aimlessly round their great estates, caught up in the great machinery of consumption and care, may even become objects of sympathy; their houses, like John Howard's gaols, may be 'mansions of sorrow and pain'. 'Gnawing cares and anxieties' will fill the mental vacuum of 'those who have nothing to do' and will range without limit, 'diversified by infinite combinations in the wild and unbounded regions of imagination'. Such men desperately seek

> something to excite an appetite to existence in the palled satiety which attends on all pleasures which may be bought, where nature is not left to her own process, where even desire is anticipated and therefore fruition defeated by meditated schemes and contrivances of delight; and no interval, no obstacle, is interposed between the wish and the accomplishment.

This problem, which brings to mind, among other images, the improvements of Lords Leicester and Shelburne, does not lead in Burke to a simple resolution of itself in works of benevolence, the redefinition of wealth and improvement. The political economist in Burke sees the fopperies and follies of prolific consumption as inherent in the efficient operation of society. Burke notes that he has frequently reflected, not only on the difficulties of the rich, but on those of the great mass of society, the condition of many of whom is so offensive to feelings of humanity. He has contemplated 'the innumerable servile, degrading, unseemly, unmanly and often most unwholesome and pestiferous occupations, to which by the social oeconomy so many wretches are inevitably doomed.' Such a fate has to be regarded sympathetically but from a position of detachment:

> If it were not generally pernicious to disturb the natural course of things, and to impede, in any degree, the great wheel of circulation which is turned by the strangely-directed labour of these unhappy people . . . [I should be] inclined forcibly to rescue them from their miserable industry . . . I am sure that no consideration, except the necessity of submitting to the yoke of luxury, and the despotism of fancy, who in their own imperious way will distribute the surplus product of the soil, can justify the toleration of such trades and employments in a well-regulated state.

Luxury, as in different ways in Mandeville, Johnson, and Smith, serves the purposes of nature by stimulating production and creating employment; and free-market theory, taken further in Burke than in Smith, determines that nothing, even in a well-regulated state, should seek to regulate the market. Reason and will, reconciliation and composition, so much cultivated in other areas, bow in this field to a different conception of nature, and Burke proposes no system of manners, ethics, or responsibilites to mollify the influence of that nature beyond casual charity. The politician and the man of feeling are equally barred from action. In this context, at

least, the rhetoric of paternal government and protected labour directed against Hastings seems empty. Hastings himself was one of those who recognized a possible discrepancy between domestic and international morality in this regard. In his *Memoirs Relative to the State of India* (1786, pp. 214–15) he quotes the following passage from the *English Review* of that year:

> Indian peculation, and oppression and cruelty, have been common topics of declamation among those patriots in speculation, who are all alive to the sufferings and sensibilities of Gentoos, while they are unjust, cruel, and oppressive, to their own neighbours and inferiors.

For Burke the political economist, the mass of the people live in an economic state of nature, while the mansions of the wealthy, however natural they may themselves be, are occupied by men who, if not noble and decorative, are at least disposed to massive consumption. The poor, miserable in their condition and narrow in their perceptions, look up to the nobility — the 'Corinthian capital of polished society' — and find their pleasures and comforts in that contemplation. The magnificent mansions are closed in upon themselves and, given the limited responsibilities attached to the possession of land even in political activity, many of their owners seem doomed to introspective gloom or endless foppery. The system depends for its survival on separation and obscurity for, as Tom Paine observed, 'once the veil begins to rend, it admits not of repair.' For men of this description, as much as for Burke's candle-lit Jacobins, life is an affair of theatre; it 'degenerates', in Paine's words, into a 'composition of art'.[19]

The capacity of such a culture to resist the assault of sophists, economists, and calculators seems severely limited, especially as the enemy has already occupied strategic elements of the ancient national castle. Contempt for the poor, the common and the rustic links directly such an idea of aristocracy with the essential foundations of political economy as described by Smith and others. The tendency to insist that the pursuit of self-interest is a public service, and the idea that it can be ennobled in a number of senses by incorporation into more or less ancient orders of chivalry or the peerage have been arguments enormously attractive to many calling themselves conservative without any obvious interest in complex ideas of responsibility, nature, change, and improvement. The idea has been so successful, so useful in the conduct of the state, as to have rendered marginal or eccentric those aspects of Burke's thought that looked back to Butler and the Christian moralists and forward to the constructive Toryism of Coleridge and others.

The Constitutional Landscape of the Picturesque

In his *Essay on the Picturesque* (1794) Uvedale Price bases his attack on recent landscape gardening, or what Brown himself had termed the 'levelling Business', on a definition of the picturesque as a category of aesthetic response as important as the sublime and the beautiful so brilliantly described by Burke. The opinions of that 'penetrating and comprehensive genius' are cited throughout the work. Price sent

Burke a copy of the first edition and received an appreciative reply that thanked him for the happy relief it afforded from the reading of political dissertations that taught the art 'not of improving, but of laying waste a Country, and of defacing the Beauties both of nature and contrivance'. In his letter to Price, though not as clearly elsewhere, Burke expressed agreement with the greater part of Price's condemnation of 'Brownism', noting in particular that the 'considerable Effect' first experienced on entering an improved place was soon dissipated, since the observer 'gained nothing upon a further acquaintance', so obvious and limited was the art employed.[20]

When Sir William Chambers had attacked Brown's work in the early 1770s, he had denounced a 'poverty of imagination in the contrivance'. Walks were tedious and shadeless, nothing was offered to curiosity, and all was 'insipid and vulgar'. Brown presented as art only the disgusting rudeness of neglected nature, leaving everything to chance and taking as his ideal the common tedium of a meadow. In this process of rendering everything natural he was destroying many of the old formal gardens, which had been remarkable for their architecture and sculpture as well as for the natural growth of centuries shaped by the art of topiary. All this was being laid waste by a man ignorant of art and refinement, more fitted by birth and training to the simple and mechanical pursuits of a kitchen gardener than to the cultivated skills of the designer of landscape: 'It cannot be expected that men uneducated, and doomed by their condition to waste the vigour of life in hard labour, should ever go far in so refined, so difficult a pursuit.' Only someone familiar with all the polite arts, well travelled, with considerable leisure, and able to converse with the owner of a place on relatively equal terms, in short a gentleman, could hope to be a worthy practitioner of landscape gardening.[21]

Price agreed with much of this, but saw the vulgarity of Brown's work, not in its proximity to nature but in its distance from it, at least as nature could be understood in the relatively wild and romantic landscape of the Welsh borders. Brown's work was neither nature nor real art; it was a cold, settled, regular, and oppressive *system* of laying out grounds, narrow in its conception and constant in its forms, regardless of the peculiarities of a locality in terms of its landscapes and traditions. It was a habit of thought imposed on nature, destructive of character and designed to serve artificial ends, such as the vain display of wealth or the tyrannical appropriation of property, which should have no appeal to the cultivated. Its dominance in the English landscape and its popularity with landowners raised questions less as to the competence or background of Brown himself than of the preoccupations of the culture that had employed him. Price was convinced that many of the habits of improvement were little different from those of the despots condemned in Burke. The threat to England's security was essentially internal, the result of the neglect of ancient constitutional principles and the desire of the wealthy to separate themselves from the rural and the common. In the pursuit of this end, uniformity, narrowness, and vanity replaced the diversity and endless potential of the natural. The picturesque was concerned on the other hand with the blending together of diversity into harmonious images of connection and mutual dependence. The 'family mansion' was natural in so far as it was a composing, unifying figure in the landscape and not its aloof, dominant subject. It was a happy characteristic of the picturesque view that

it could make all the participants in the landscape more content, the owners of the land as well as the poor.

The proper purpose of improvement for Price is to emulate the harmonious variety and intricacy of the natural landscape. It would depend on attentive personal study and reference to the accumulated experience of many generations' observation in the works of great artists. Their models of selection and composition should be the basis of a picturesque style more energetic than the beautiful and having some of the characteristics of that sublimity in nature which was usually associated with effects too great in scale to be emulated by men. This form of improvement, founded in local knowledge, the cultivation of all the polite arts, and a good acquaintance with those aspects of the natural sciences accessible to observation, was more easily carried out by a cultivated class of landowners than by mere passing professionals or new acquirers of land. Based on local knowledge, it was also inseparable from a view of particular, familiar responsibilities. Price always writes, as Burke for example does not, from a position of unassailable respectability and authority as a landowner with substantial connections, who has never been required to ascend to any temple of honour. His father, a parliamentary candidate for his county in the Whig interest in 1754, had been an accomplished musician and water-colourist, and an early pioneer of the taste for alpine scenery. His agricultural improvements were admired by Nathaniel Kent, and his botanical work by Benjamin Stillingfleet, who records Robert Price's activity as a magistrate in what they both took to be a just regulation of the corn market in times of scarcity. He had married a daughter of the first Viscount Barrington, several of whose sons became prominent in various naval, political, legal, ecclesiastical, and antiquarian fields.[*22]

Uvedale Price's account of Brown's system employs a language very familiar from Burke. He had used models of design that seemed fixed and determined by some general contractor in London who sent down pieces to the country, regardless of the particular nature of the object of improvement. He was a narrow-minded mechanic, a quack doctor armed with empyrics and simple nostrums to be applied indiscriminately to every case, an ornamental gardener after the French model, who went about removing all the rubbish of nature and tradition, levelling all landmarks and distinctions, making all places alike. He took away all peculiarities, all wit or fantasy, all unusual and subtle agreements and contrasts, and left only an equality of tameness and insipidity. Against this attempt to force nature into the narrow field of individual perception, Price advocates the stretching of the mind to take in some of the infinite variety of nature. Paintings would aid decisively in this effort of observation. The great artist sees, distinguishes, and feels in nature infinite details and effects of form, colour, light, and shade. He records them in such a manner that

* Uvedale Price's position may be compared with that of the Revd Gilbert White in his *Natural History of Selborne* (1788–9), the greater part of which consists of letters to Price's uncle, the distinguished antiquarian and naturalist, Daines Barrington. White's studies were founded in a prolonged residence in a particular place as an attentive and busy clergyman. Natural history is seen as an undertaking that involves much trouble and difficulty, and is carried out successfully only by those who are active, inquisitive, and 'reside much in the country'. It demands an intricate balance of precise observation and the formulation of general theory, since without system, the 'field of nature would be a pathless wilderness'; but system must be 'subservient to, not the main object of the pursuit' (see White's *The Natural History of Selborne*, ed. R. Mabey, Harmondsworth, 1977, pp. 136, 208).

even the 'common eye' may discover a new appearance of things, a new world of perception, and a thousand interesting objects where previously there seemed 'nothing but ruts and rubbish'. No one who had studied the works of nature — or of Claude, the Poussins, Titian, Gainsborough, among many others — could take as a serious standard the works of a mere Brown. Great paintings, a set of experiments in observation and composition selected and consecrated by long uninterrupted admiration, were the texts of a school in which the mind could be enlarged and its taste refined. Improvement was to be founded on materials extracted from nature and composed from traditional wisdom.[23]

The contempt of past experience manifested in the narrow works of improvement reflected extreme ignorance, vanity, and coarseness of manners, as if the country had been invaded by men without any roots in the past or local connections. Improvement was a false, vitiated taste, tawdry in its shallow refinement and repulsive in its affectation. The naked solitary appearance of many recent country houses arose from the desire of giving an artificial consequence to the mansion. The improver concealed or buried the offices, and cleared a long stretch of grass at the front while planting the sides with clumps or close plantations going off in regular sweeps from the house. He thereby made a formal border to a vast lawn from which the mansion could be seen as widely and uninterruptedly as possible. The planting of clumps of trees on the summits of local hills, often of a species exotic to the country, was a kind of placing of pitchmarks to determine the scale of property. The 'prim squat clump' was 'perked up' on the top of every eminence. If it could make no figure owing to the extent of the ground, it was excessively multiplied and consolidated as part of a series of 'great lumps' stuck about the entire landscape. The improver everywhere forced himself into notice, impudently stared one in the face, and gratified a taste for celebrity by the excitement of vulgar curiosity.[24]

Inordinate vanity led to the appropriation of churches for private use. They were made into sacrilegious 'beacons of taste' by eccentric design and siting or by the whitewashing of mossy, weather-stained, and venerable towers. Churches thus made sophisticated and conspicuous according to a whim of fashion seemed to lose much of their public, timeless, and hopeful significance. The remains of an ancient, castle-like mansion were made to stand in a trim, levelled stretch of lawn so as to have almost the same effect as a modern artificial ruin. Instead of expressing grand and awful ideas to a mind sensitive to the long travails of constitutional history and its patrimony of wisdom, such a ruin assumed a character of littleness and modern polish. A natural stream, unfortunate enough to find itself near an improving place, would be proudly deprived of its liberty and, like some species of domesticated animals, marked as private property by being mutilated. Its 'modest and retired' character was destroyed by the smoothing and levelling of its banks and the artificial determination of its course. In all this an idea of the rural gives way to what is assumed to be a systematic manipulation of the country to serve the gratification of a class of men clearly wealthy but without cultivation.[25]

Price takes over from Cowper and others a sentimental attachment to avenues whose branches had intertwined with each other for ages and whose destruction therefore indicated a want of sensibility. They created walks of shady magnificence

reminiscent of the solemn stillness of a grand Gothic aisle and were places ideally fit for meditation and religious awe. They did not interfere with the country, and from within them one could observe all the intricacy and variety of the different land-scapes beyond. When placed as an approach to a venerable mansion they not only confirmed the impression of age, but the play of light, particularly with the approach of dusk, created romantic effects that seemed to bring to mind the 'pleasing illusions' of chivalry and the greater dignity of ancient manners. Often they were destroyed to make way for, or to be incorporated within, the commonplace Brownian device of a belt — a somewhat shapeless, serpentine arrangement of trees, placed closely together and with little variation in species, which would straddle aimlessly over a wide landscape. To walk through a belt was to be constantly hemmed in and disconcerted by successive waves of trees, usually of the same age and size, and cleared of the undergrowth that would naturally contribute to variety. The repeti-tiveness of the experience, the clear definition of pathways, and the obvious bounda-ries between the belt and the endless lawns beyond, all tended to confirm a sense of artificial contrivance of a low order of skill and the manipulation of the mind by paltry means. The total appropriation of the landscape to this tedious artifice would always seek to eliminate any remaining 'wild sequestered spot' in which the mind could feel a sense of curiosity, uncertainty of direction, and the 'charm of expecta-tion'. Every successive wave would be like the preceding one, a perpetual change without variety which at once irritated and dulled the natural curiosity of the mind. Everything seemed fixed and determined amid a sense that any deviation or wander-ing was forbidden, any independent exercise of taste or judgement eliminated by the complete triumph of an abstract and distant system conceived by the most narrow perceptions of nature and the mechanical skills of a land surveyor.[26]

Such an arrangement was, Price notes, a species of thraldom unfit for a free country; but the other standard Brownian idea, the clump, was if anything worse. Natural groups of trees, random and various in age, species, and disposition of individual parts, are full of openings, hollows, intricacies of light and shade. They change their form and appearance at every step. Clumps, manufactured from parts generally equal in age and size, and often planted at set distances in a circular form, display a regulated formality reminiscent of a compact body of soldiers. From whichever point they are examined, they lack openings, variety, and intricacy. In making a clump the improver cleared away as rubbish, and 'without pity', all the undergrowth and outlying trees which not only add to the beauty of natural groups but protect them against wind and frost. Rendered as clump-like as their 'untrained natures' would allow, groups of trees were made to conform to their model by being mangled, starved, and cut off from all connection. Miserable and alone, they appeared like an 'unhappy newly drilled corps'. Once again, in this maiming of the landscape, the sensitive observer felt not only disgust at the taste involved, but a deliberate assault on his mental freedom, a sense of deprivation through the replace-ment of natural form by personal taste and contrivance. Price imagines a man tethered in a clump or a belt beginning to feel within himself the sameness and insipidity of his surroundings as his natural mental vigour, which requires constant sustenance through the contemplation of variety and intricacy and the sense of

something greater than himself, is frustrated, dampened, and dulled. It is an active curiosity before the works of nature that above all things gives 'free play' to the mind, and is resisted in the despotic landscapes of improvement. If the clump or the belt were to be found in a coniferous plantation, the unhappy victim of taste might well be disposed after a while to hang himself, depressed by the dead, heavy, dull, dismal, and formless shapes of a 'uniform leafy screen'. The parched and blasted soil, and the confusion of apparently lifeless boughs, perplex and harass the mind without refreshing it.[27]

The picturesque is concerned with the maximum amount of stimulating variety consistent with a prevailing sense of harmony; massive intricacy, even confusion, may be present in many parts of a scene, but the general effect will be one of composition. A picture, above all the other arts, embodies the value of connection, the ability to combine together in an easily perceived whole parts which, however interesting in themselves, reveal their real significance and effect through the total composition. Forms, tints, lights, and shadows, in all their contrasts and combinations, agreements and oppositions, are at once subjected to the eye and the quality of the whole perceived in the union, breadth, and harmony of all the diverse effects. The natural sympathy of this form of composition with the mind underlines the role of the improver as a man who at once cultivates variety and 'connects what was before scattered'. In the Brownian system, formalized, lifeless forms were scattered about the landscape without any sense of their common relationship. Streams had smoothed edges adjoining endless, undifferentiated lawns which would eventually meet the clearly defined borders of clumps and belts. There were distinct lines of separation and abrupt transitions of form and colour; objects in themselves smooth and flowing seemed hard and distinct when assembled together. The eye saw, not a connected whole, but a collection of unreconciled parts, with the solitary and insulated mansion the most dominant. The massive clearing of rubbish and the destruction of all the variegated and humble features of an unimproved landscape had removed all the 'bonds of connection'. It was clear that harmonious composition required not mere 'general effects', but single and particular causes naturally linked together in a gradation and dependence of forms. Variety, intricacy, and individuality were essential to picturesque composition.[28]

The creation of an alternative, liberal, and extended idea of improvement would depend on study of the endless variety of scenes afforded the eye in the natural world and in landscapes where human intervention had not created artifice and formality. A true improver would be constantly sensitive to all the processes — historical, geological, botanical, biological and so on — which had tended through endless particular effects to create the character of the whole. Rather than seeking to impose abstract forms, he would be working from all the indications afforded by nature to draw out the particular character of a scene without damaging the internal logic of the diverse constituent parts. Clearly, the process of improvement involves not only long acquaintance with a place but a slow and tempered approach, sensitive to accidental effects or consequences and willing to undo as well as execute. A happy combination of infinite variety and perfect harmony is not uncommon in nature but rarely found in the deliberately or avowedly artificial, particularly in the crudeness

of new work. The picturesque eye is attracted by all that has been mellowed and consecrated by time, and marked by the effects of neglect or accident. The judicious improver, in short, takes advantage of what has been pointed out by nature and will not allow her indications to be destroyed or oppressed by quack remedies and general 'empyricks'.[29]

Price explains his argument by comparing various characteristics of a Herefordshire by-road in its ordinary state — as created by nature and long human use without thought of art — and such a road as it tends to be improved when it approaches a mansion. In the 'dressed lane' every effort of art seems directed against what Price calls the natural disposition of the ground:

> the sides are so regularly sloped, so regularly planted, and the space, where there is any, between them and the road, so uniformly levelled; the sweeps of the road so nicely edged — the whole, in short, has such an appearance of having been made by a receipt, that curiosity, that most active principle of pleasure, is almost extinguished.

In hollow lanes and neglected by-roads left in their 'natural and picturesque' state, the effects of time, neglect, and accident, the free passage of men and animals, and the interplay of vegetation, soil-type, and the passage of water produce an effect of harmonious variety that can never be reproduced by deliberate improvement, but will almost inevitably be damaged by the attempt:

> all the leading features, and a thousand circumstances of detail, promote the natural intricacy of the ground — the turns are sudden and unprepared — the banks sometimes broken and abrupt — sometimes smoothly and gently, but not uniformly sloping — now wildly overhung with thickets of trees and bushes — now loosely skirted with wood — no regular verge of grass, no cut edges, no distinct lines of separation — all is mixed and blended together, and the border of the road itself, shaped by the mere tread of passengers and animals, is as unconstrained as the footsteps that formed it . . . varieties of form, of colour, and of light and shade . . . present themselves at every step . . . some of the most striking . . . owing to the indiscriminate hacking of the peasant, nay, to the very decay that is occasioned by it.

The peasant's passage and his work of clearing are assumed to display a careless, or at least a free and undirected pattern of action that is productive of spirit and animation. It inevitably ceases as one approaches the 'tameness of the poor pinioned trees' near a gentleman's place.[30]

In an article contributed to the *Annals of Agriculture* in 1786 Price had argued that one of the advantages of the 'natural or picturesque' state of trees was the greater availability of fuel for the free and timely use of the poor. In the passage above he seems to be arguing that the picturesque state is in general one of greater utility and liberty for the public. The improver will cut down the old pollards, clear the undergrowth, and leave only the maiden trees standing. He will 'plant up', smooth and level, in a mechanical, commonplace action in which all intricacies, varieties of form, light and shade, every deep recess and bold projection, all the

fantastic roots and winding paths of sheep will be obliterated. The rash hand of false taste will destroy in a moment something that has matured over a great length of time and through a 'thousand lucky accidents'. With the intricacy will disappear also the free and unregulated wanderings of the peasant. The improver will have expressed his taste and expended his funds; he will inevitably seek to regulate access of both men and animals into the denuded landscape. Upstart deformity, without age or any sense of permanency, will replace the random, beautiful, and liberal inequalities of the past to generate a vulgar system of self-regarding monotony.[31]

Improvement had swept through England, obliterating every obstacle, however beautiful or venerable, that stood in its path. The 'blind, unrelenting power of system', however shallow its taste and direction, had led many normally prudent men to the enthusiastic destruction of landscapes with which they had early connections and for which they often continued to feel affection. Their natural feelings had yielded to the prevailing fashion. It was a habit of mind, Price argues, not dissimilar from the abstract mode of thinking that had led men, during the conflict with America, to vote for the destruction of towns and provinces without seeking a spirit of compromise and conciliation. The mind narrowed by system and suppressed in its nature was capable of every folly.[32]

The habits of improvement were clearly contrary to the flexible, unsystematic, and natural approach adopted by the founders of modern constitutional liberty in 1688, when reform had been undertaken through the 'steady, considerate and connected arrangements of enlightened minds'. Free of blind prejudice in favour of antiquity, but with a strong suspicion of precipitate change, the leaders of the Glorious Revolution had been reluctant to destroy old systems or to promulgate new ones. In sharp contrast with this instinct of prudence, Brown and his predecessor Kent had manifested principles in the landscape reflecting those of other low and unenlightened minds in religion and politics. Finding a state of affairs acknowledged to include many 'narrow, inveterate, long-established prejudices' to which men had become attached, however irrationally, they sought to tear down everything and merely succeeded in setting up a new and less tolerant system in its place. Whereas many other ideas had happily coexisted with the old, the new improved systems allowed no other forms than their own. No remnants of the past, however venerable or esteemed, had been suffered to remain. Brown, in particular, had none of the liberal and comprehensive powers of mind that, in art as in politics, enlighten mankind by adding extensive observation and reflection to practical execution, striking out new forms and revelations that exist happily in continuity with the past. He was a man of small practical dexterity, who referred everything to the narrow circle of his own ideas and sought to confine within that circle all the rest of mankind.[33]

England as a whole had shown in all this an illiberal disposition to conformity in which the 'freedom, energy, and variety' of the mind had given way to a general instinct for 'tameness and monotony'. This had manifested itself in the landscape, not only in the levelling of grounds but in an activity reminiscent of some aspects of English foreign policy — the despotic destruction of villages and the dispersal of their inhabitants. It seemed clear that many years of domestic freedom, security, and

peace had induced in the upper and middle classes a set of attitudes that, unchecked, would weaken the country internally and therefore diminish its capacity for self-defence. A careless desire for uniformity and for the oppression of diversity was the product of selfish and narrow habits of mind that could generate, as they had done in France, a countervailing tendency to popular anarchy. The old feudal constitution of England, originally 'meager, hard and Gothic', had been mellowed and softened by long experience and successive trials and had gained in spirit and energy to reach that point of excellence it had attained with the Glorious Revolution. The arts had fallen into a general decline that reflected itself in different ways in the decadence of the Italian mannerists in painting and in the English exponents of improvement. A parallel tendency in government, wedded to systems and neglectful of the complicated nature of its concerns, would have yet more serious and direct consequences.[34]

The defenders of Brown accused Price of rejecting the model of constitutional government embodied in English improvement — a restrained liberty — in favour of Jacobin ideals of anarchy and confusion. To this Price replied that the revolution in France had had its origins in an entire system of laws and manners that had worked to alienate the government from the governed, and that the threat to English liberty, like that to the beauty of its landscapes, also arose from narrow and divisive modes of thought. Improvement, instead of attending to local circumstances, natural processes, and the 'great principle of connection', was itself a 'levelling system' that took away all distinctions and left damage that even time might never repair. No one convinced of the beauty of the ancient constitutional principles of England would advocate either a government or a landscape in which natural indications and effects were counterbalanced to the point of suppression, and opinions and taste were both prescribed. Levelling had many forms, from the popular or democratic to the despotic, and it was clear that he who 'clears and levels everything' round his own 'lofty mansion', obliterating all the works of men and nature, displayed principles of despotism not dissimilar from those of many tyrants abroad.[35]

A good landscape, like a good government, is not laid out as a spectacle of uniformity to serve narrow interests or convenience. It is a complex achievement of connection and picturesque composition,

> in which all the parts are free and unrestrained, but in which, though some are prominent and highly illuminated, and others in shade and retirement, some rough, and others more smooth and polished, yet they are all necessary to the beauty, energy, effect and harmony of the whole.

This grand national harmony is founded in constant reciprocal responsibility. The beauty of the composition and its conformity with the essential order of nature depend on the 'mutual connection and dependence' of all the different ranks and orders of men, and the 'voluntary ties' by which they are 'bound and united to one another'. Using imagery familiar from Burke and Hanway, Price notes that an improved landscape, based on picturesque principles, would be clearly analogous to the true spirit of the ancient constitution of England, improved by long experience and successive trials:

Freedom, like the general atmosphere, is diffused through every part, and its steady and settled influence, like that of the atmosphere on a fine evening, gives at once a glowing warmth, and an union to all within its sphere; and although the separation of the different ranks and gradations is . . . known and ascertained, yet from the beneficial mixture, and frequent inter-communication of high and low, that separation is happily disguised, and does not sensibly operate on the general mind.

Any principle of fragmentation, of alienation between the prominent and the shaded, will destroy the order and harmony of things:

should any of these most important links be broken; should any sudden gap, any undisguised line of separation be made, such as between the noble and [the peasant], the whole strength of that firm chain [will be] broken.

In improvement carried out on picturesque principles the outward face of the kingdom would reflect the true spirit of the constitution, leaving little scope for the undisguised lines of separation between the rough and the polished provoked by the fashions of the recent past. Everything would appear harmonious and balanced, the inevitable and useful distinctions of civil society disguised and blended together by a careful attention to duty on the part of the cultivated and a contented deference on the part of the rougher, but no less meritorious, members of the community. The latter would understand that they gained more in the many advantages of civil society than anything they might imagine themselves to have lost in its inequalities of condition.

What Burke refers to as the 'guiding, governing' part of society had, therefore, to be reconciled with the governed, and the grand chorus of national harmony established on the greater proximity of chieftains and people. In terms of improvement, this meant an end to the 'foolish vanity' of making a parade of property through the appropriation of meadows, public commons, and private enclosures in order to lay together great stretches of territory from which entire villages and many a 'cheerful retired cottage' were spurned, although they interfered with nothing but the 'despotic love of exclusion'. To 'make amends' by building in their place a village *regularly* picturesque' was to do nothing to mitigate a process that was disgusting to all 'whose taste is not insensible or depraved'. It was part of a despotic system of authority that sought to lay everything open, level all that stood in its way, and clear away as rubbish houses, orchards, fields, and gardens in order to extend the bounds of uniformity, monotony, and dreary, selfish pride.[36]

The spirit of the picturesque would instead embrace a pleasure in the rural, strongly influenced by the 'affecting images' of Goldsmith and of Gainsborough, appropriating to itself some of their pleasure in English landscapes often apparently independent of class distinctions. An attentive study of their work and of other great masters would induce a benevolent, humane disposition of mind that would find pleasure in the contented existence of similar persons and objects in nature and therefore in an improved landscape. Whereas a despot thinks every person an intruder who seeks to enter his domain, and wishes to destroy cottages, fields and

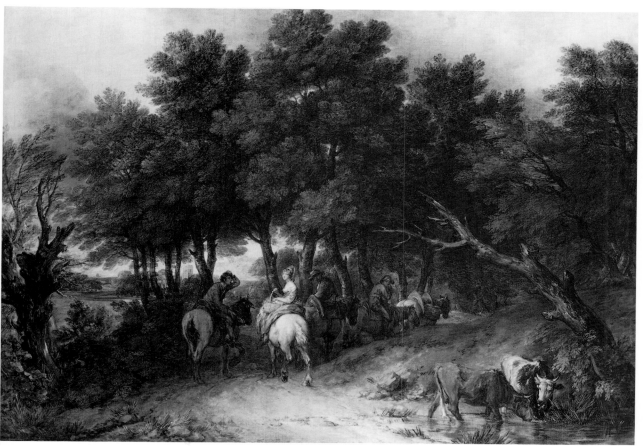

13 Thomas Gainsborough's *The Road from Market* (1767–8) was one of a group of rural scenes commissioned by Lord Shelburne for Bowood while he was employing Lancelot Brown to improve the place. The rather Watteau-like peasant figures included in this image suggest Shelburne's preference at this time for a refined conception of the country rather than an immediate one. Gainsborough's studies of the rural poor, which embrace the elegant, the sentimental, the erotic, and the dejected, are generally capable of interpretation within the broad tradition of benevolence. The poor are usually perceived as well-disposed; they may be agreeably relieved or their accommodation improved, but they do not seem to constitute a threat if left to themselves. In the 1790s, Uvedale Price found Gainsborough's work particularly attractive as he sought, like Lord Shelburne, to redefine the nature of improvement as a means of promoting rather than fragmenting the connections of English society. Price noted that Gainsborough's work tended to humanize the mind in much the same way as the poetry of Goldsmith. The cultivated observer, attentive to their imagery, wishes to observe similar objects in the real landscape and to respond to them with kindness and benevolence.

pathways in order to reign alone, the 'picturesque observer' considers the dwellings of his humbler neighbours and the marks of their intercourse as clear ornaments to the landscape and as cheerful, interesting circumstances of variety, amusement, and humanity. To destroy marks of habitation, industry, and plenty in favour of staring, ostentatious, and unconnected buildings amid a levelled landscape was a choice equally offensive to taste and prudence. It also induced a sense of gloomy detachment comparable in Price's account with Burke's reference to those occupiers of mansions who, submitting to the yoke of luxury and the despotism of fancy, are lost in a strange world 'where nature is not left to her process', and where all desire is given an unhappy fruition in 'meditated schemes and contrivances of delight'. Price refers to the sense of disgust that attends the 'eternal sameness of artificial scenery and manners' in the sham towns made to divert the anxious leisure of the Emperor of China. The various incidents of life were acted by eunuchs, and pointless, spiritless amusements replaced real life and natural feelings.[37]

Instead of undertaking the 'ravages of wealthy pride', the landowner who felt a desire to appropriate a village, hamlet, or farmhouse could combine the improvement of its visual mass and grouping with the promotion of the comforts and enjoyments of the inhabitants. By adorning a real village, as opposed to one artificially constructed, the landowner could sustain or even help to produce 'natural unaffected variety' and rural felicity. The pastoral could in some sense be realized, not independent of the mansion but under its protection, and the cultivated landowner would experience in this process the same pleasures he naturally feels in the presence of the rural in literature and painting. Picturesque paternalism could promote comfort, leisure, and security without the imposition of some external model of design. Its language would be the local vernacular, its success measured in the achievement of an idea of long-established and contented habitation. While respecting intricacy of form, the picturesque would eschew affectation, seeking neatness and simplicity. The buildings would not look as if the purpose of improvement had been a demonstration of the taste, or even of the benevolence of a landowner. All work should be done in the 'style and scale' of the locality, employing its 'common materials' in their 'common method of use'. The presiding monument in a village should be the church, repaired but not sophisticated, acting as a public religious testimony independent of the changing whims of taste.[38]

Price recalls the benevolence of his father and uncle throughout the extensive reach of Foxley, the family estate in Herefordshire. They were constantly attentive to the comforts and happiness of the local inhabitants, and made their 'extensive walks' as much for public use as their own. Such attentive kindnesses, Price notes, were amply repaid by 'affectionate regard and reverence' and were better securities for landed property, and the discouragement of democratical opinions, than any armed militia. In 1796–7, when Price was active in the organization of a county militia to resist the expected French invasion, he emphasized that only a wider sense of connection among the different gradations of society could ensure the defence of the country against external threat and any possible internal rebellion. The revolution in France was an event 'interwoven with the whole of its manners

and government' and with its chief stimulus in the cities amid what Richard Payne Knight had described as

> A rabble long to cruelty inured,
> And harden'd by the wrongs themselves endured.

In Herefordshire no such rabble existed, but the question of the manners of those in authority was a more complicated issue. The labouring poor were generally an honest, 'patient and much-enduring race', whose loyalty could be assumed unless they were driven to despair by sustained ill-treatment. The property of the county should 'watch over them', in terms not only of restraint but of benevolence, particularly in times of scarcity, and consider their welfare as 'intimately connected' with its own. There should be a general and increased attention to the condition of the labourer, securing his 'genuine attachment' not only in an abstract sense of connection but in a degree of participation in property through the wider leasing of cottages with quantities of land. The possession of property, the confirmation of local loyalties, and the pleasure of working land for the direct consumption of his family would inspire in the labourer an increased love of order and dread of confusion.[39]

The security of society did not depend on great concentrations of land, nor on those who were esteemed principally through the 'very natural prejudice' in favour of rank and property. Price silently adapts Goldsmith to his cause by noting that the strength of England must reside in a 'bold yeomanry, their country's pride', as if Goldsmith's peasantry had somehow become merged with those who participated fully in property. The owner of a great estate, whose vast possessions could feed his ambition and decrease his local attachments, was less to be depended on than the cottager with a few carefully tended acres. He was more likely wedded to his spot than the greatest lord to his immense domain. Tensions in society would have their origins in the positive actions or neglect of 'despots' and the growing numbers of rootless urban poor. In the 1810 edition of the *Essays* there emerges a new enemy. Price commented on the increasing number of factories that were 'disbeautifying' once enchanting scenes and contaminating the subtle connections of the landscape in a remorseless logic of profit, convenience, and economy. The picturesque is offered in opposition to all this, to be infringed only in the neatness of 'fine verdure' desirable in the immediate confines of the mansion and in the compromises necessary for farming. Fortunately, agriculture and the picturesque could in some measure coexist; for example, when fine trees were left standing in fields or hedgerows, not only for their beauty, but also for shelter, eventual timber, the production of stakes, and the easy provision of fuel for the poor.[40]

Culture and the Landscape: Richard Payne Knight

The link between agriculture and improvement is emphasized less fully in Price's *Essays* than in the didactic poem *The Landscape*, first published in 1794, the same year as Price's work, by his friend and fellow squire in the Welsh borders, Richard

Payne Knight. There is an apparent paradox here, in that the two engravings by Thomas Hearn attached to the poem seem to contrast a carefully tended image of the landscape with one which appears quite neglected except in the immediate confines of the mansion. Repton, in his *Letter to Mr. Price*, and William Marshall in his *Review of The Landscape*, both of 1795, suggested that the advocates of the picturesque had no interest in the practical but wished, as Repton put it, to turn the country 'into one huge picturesque forest'. Given the political and economic state of England in the mid-1790s, the opponents of improvement might seem to be essentially irresponsible. In the second edition of *The Landscape* (1795) Knight added considerably to the poem and to the notes attached to it in order to allay these charges, naturally insisting at the same time that practical considerations had always been central to his concerns. He offers what he takes to be a balanced image of an ideal landscape in which culture would 'smile upon the haunts of men' and the gentleman's park would connect easily with 'accidental mixtures of meadows, woods, pastures, and corn fields'. The scene would be dotted with farmhouses, cottages and mills, while in the background 'shaggy hills are left to rude neglect'.[41]

Knight omits any church tower from this view. Openly sceptical of Christianity, notoriously arrogant, and the author of an illustrated study of the *Worship of Priapus* (1786), Knight seems a controversial source in a study of conservative ideas of landscape. Anna Seward, the admirer of Shugborough, thought that *The Landscape* expressed a 'jacobinism of taste', in which nature and man would be indulged in 'wild luxuriance'. Horace Walpole denounced Knight as a Jacobin dictator who would 'level the purity of gardens' and 'guillotine Mr. Brown'. Sometimes, particularly in his *Analytical Inquiry into the Principles of Taste* (1805), Knight appears to be tending towards a purely aesthetic idea of taste that concentrates on the impact of images on the senses divorced from any moral or utilitarian considerations. In his notes to *The Landscape* he writes, without any reductive intent, of 'mere visible beauties' and deliberately rejects any analogies between ideas of the picturesque and the state of politics or, as he puts it, between the preservation of trees and terraces and the fate of kingdoms. He seems, in short, to be a spokesman for an idea of the picturesque as completely and happily devoid of any meanings outside itself — a view familiar in Gilpin, which influenced much subsequent discussion of the subject from Ruskin's *The Poetry of Architecture* (1837–8) through to Christopher Hussey's *The Picturesque* (1927), and remains influential in writers as diverse as David Watkin and John Barrell. Landscape gardening, Knight insists, is 'mere elegant amusement' and has nothing to do with the 'nearest and dearest interests of humanity'.[42]

Knight's work is, however, at least as full of analogies as that of Price, with all the wider issues they provoke. In the *Analytical Inquiry*, Knight observes tendencies in the improvement of landscape similar to some found in the development of language and immediately finds himself entering into that broad field which Burke had described as manners. Those who pursue principles of refinement, Knight argues, are constantly being intruded on by the vulgar; in order to survive as such, and remain beyond the reach of vulgarity, refinement must constantly become more refined, that is to say 'affected and constrained'. Only a form of the natural, it is implied, can

avoid this tendency, in which a part of the community is distorted by its determination to separate itself from the common. The idea of fashionable improvement as a false kind of refinement pervades *The Landscape*. Formal gardening, the 'old system against nature' so despised by improvement, had, Knight agrees, manifested frequent absurdities. Its 'prim despots' of topiary and other formality had, however, been a very local phenomenon; they had not 'dared invade' the 'open grounds' of nature happily and freely occupied by the 'roving ox' or the 'browsing deer'. The country as a whole was uncorrupted and the 'ancient forest' left alone in its 'savage pride'. The 'shaggy shrub' and 'spreading tree' pursued their course of 'native liberty' in 'loose and vary'd groups' undisturbed by the 'planter's care'. Equally important, the copse and the 'village pasture' were left to their useful purposes. Modern gardening, on the other hand, was an 'explicit means of gratifying purse-proud vanity' and the 'vain parade' of magnificence. Knight sees such aims entirely in Goldsmith's terms, not, for example, those of Pope's *Moral Essays*, in which magnificence may serve some purpose through the encouragement of economic activity. Knight berates a system of taste in which everything serves to 'announce the owner's state':

> His vast possessions, and his wide domains;
> His waving woods, and rich unbounded plains.

For Knight, what the improver displays is merely 'wealth in land, and poverty in mind'. The landowner sets himself up to appear like everyone else in the narrow circle of improvement, a slave to fashion devoid of any instinct of taste or originality. Wealthy through his grandfather's entrepreneurial success as an iron-master, but now possessed of 10,000 acres and the mansion of Downton Castle, Knight allows himself the indulgence of a strong strain of snobbery. Repton, with whom he had fallen out over picturesque matters, was one of a band of 'mercantile improvers' whose trade was to flatter vulgar pride. His skill was that of the 'prudent mechanic' who, incapable of repairing or embellishing the complex varieties of the past, merely decides to 'take them all away' in favour of his simpler, 'short and easy' method of proceeding. Repton's proposal at Tatton Park of using the family arms on local milestones to convey marks of appropriation seemed to Knight a very inferior idea of dynastic dignity. Downton, built according to Knight's own design, manifests a combination of the picturesque and the practical in being Gothick on the outside, to conform with the country, and Classical within.[43]

The mansion is not to impose itself on the landscape but is to be 'mix'd and blended' with it as a 'mere component part'. Left in 'solitary pride'

> Tis but a lump, encumbering the land,
> A load of inert matter, cold and dead,
> The excrescence of the lawns that round it spread.

Improvement must merge with and contribute to a prosperous agriculture working in a contentedly populated landscape. The second edition of *The Landscape* insists that it is Reptonian improvement, not the picturesque, that threatens to take considerable areas of land out of useful production. Its smooth curves and managed water were best suited to the lowlands and river valleys that were often possessed of the

14 Thomas Hearn's engravings for Richard Payne Knight's *The Land-
scape* (1794) contrast the insipid efforts of Brownian improvement with
the picturesque ideal. In the Brownian image it seems apparent that the
entire country has been designed to conform with and display the el-
egance of the new mansion. In the picturesque version the contrast
between nature and art is less clear, but it is not entirely evident that the
mansion is any less dominant. In the second edition of *The Landscape*
Knight emphasizes the idea of a mansion having a wider public role
that would reconcile more complex ideas of nature, art, and a broadly
defined idea of culture. The mansion and its surrounding landscape
should express and promote a picturesque ideal that emphasizes the
continuity of certain national traditions and a widely diffused idea of
virtuous prosperity.

best agricultural land. Repton's idea of the rural was merely trivial, being often nothing more than the placing of a few cattle in some of his illustrations of improvement. Such cattle, 'harmless and quiet' on paper, might afford unpleasant surprises in reality, as they would be inclined to 'destroy all other enrichment' and 'show themselves in every place, but where they are wanted'. The picturesque was much better adapted to agriculture than a system that sought always to separate land appropriated to pleasure from that devoted to utility. Animal pastures, when enriched with trees, always afford picturesque compositions. Hedgerows generally 'enrich and embellish' the landscape, and even arable land is 'never completely ugly' to the picturesque eye except when left fallow — a practice steadily being discontinued in improved farming methods. Mature trees and old pollards not only enrich the landscape but provide shade for cattle. A landowner need have little difficulty in uniting, in 'just congruity', the delightful with the useful, generating profits and fulfilling the obligations pertaining to his rank. Everything could contribute to the idea of culture that would 'smile upon the haunts of men'. In its purest forms of 'wild obscurity' and 'rude neglect', the picturesque was often associated with the kinds of ground 'least suited to agriculture'. Rarely would it be guilty of 'sacrificing extensive tracts of arable to unproductive lawn'.[44]

The landowner is encouraged to protect his 'native haunts' and 'favourite plants', resisting the selfish pride that wills men to destroy rather than form, to cut rather than plant, and to level rather than diversify. Such virtue is part of a conception of wartime patriotism which insists on the need for efficient production to be reconciled with the defence of ideas that seem to belong particularly to English, as opposed to Continental landscapes. Knight indicates the inappropriateness of a conventional idea of improvement which preferred foreign ideas of perfection to domestic ones. He challenges the habit, practised at Chiswick, Stowe, Stourhead, and elsewhere, of deliberately seeking to impose Italian styles of landscape. Like John Britton in his *Beauties of England and Wales* series (1801–16), Knight points to the unique character of native scenes. The 'cool and watery sky' of England did not display the 'glowing tints of Italy' but it created a foliage singularly verdant and brooks that flowed in 'even currents'. English 'pastures, rich in verdure' better fed the 'martial steed' and produced sheep with 'warmer fleeces'. Her 'native woods' were 'creation's boast and pride'. It was appropriate that the painter should seek to emphasize the 'native graces' of his country, and that the 'planter's skill' should respect its essential character. All these images of England seemed to depend, not on the mansion and its parkland, but on the extensive native landscape that existed in spite of much recent improvement.[45]

The final lines of *The Landscape* offer a hope that 'ambition's wasteful folly' will cease and men will soon cultivate again the 'happy arts of peace'. The folly referred to is that of political and military misjudgement, but it is difficult, in the context of the poem, not to reflect also on the position in all this of the mansion. The idea that England is likely to sink under the weight of selfish folly is a major theme of Knight's didactic poem of 1796, *The Progress of Civil Society*. In an extensive history of civilization, Knight constantly suggests analogies between taste and political systems. He writes, for example, of how 'wealth's dull vanity' manifested itself in the 'senseless pride' of the pyramids. A ruling class of tyrants had erected great monu-

ments to themselves, devoid of public utility and employing an art that stunted the mind. Egyptian design produced shapes 'unknown to nature', wrought by 'patient, dull, mechanic labour', and bound by 'rigid dictates' and 'narrow limits' that crushed all genius, fancy, and 'energy of soul'. Later in the poem Knight writes of the influence of a corrupt, 'selfish pride' that was wasting all the vigour of modern England and, if unchecked, would have its inevitable consequences in a 'despot's, or a rabble's sway'. The poet endeavours to oppose the 'fell spoiler' of his native country; he hopes to save its 'loved waters' and ancient oaks, all sanctified by and giving dignity to a tradition of poetry and painting. The arts, together with the landscape, are threatened by a vulgar principle of gain that destroys all the worth it acquires. 'Vain waste' and selfish individualism devour the strength of the country. They promote 'distrust and discord', with 'avarice and hate', as 'sordid selfishness' extends 'through all'. Recent developments in the balance of town and country created particularly dangerous possibilities. Since 1688, a significant date, the inhabitants of the country had been 'gradually decreasing' and those of the manufacturing towns 'rapidly increasing', giving a 'dreadful momentum' to any future 'popular commotion'. The relation of these developments to the progress of improvement seemed evident.[46]

Knight, like Price, was friendly with Charles James Fox, whose policies in relation to France, at least, he much preferred to those of Burke. The long war with France seemed ill-conceived in terms of its origins and conduct; far from being the salvation of 'Englishness' it seemed likely to accelerate its demise. In his *Monody for Fox* (1807) Knight records the death of the country's last great statesman. He sees England ruled by a conservatism of artificial and received opinions, as simple judgements are imposed on the complex variety of experience by politicians who

> dreading innovation, still pursue
> The beaten track, when all around is new.

The genius of Fox perceived a 'nobler' idea of nature, illuminated by 'Science, Art, and Learning'. His genuine wisdom had unmasked guile, his 'native energy', and a mind 'spontaneous, . . . unforc'd, . . . just' and 'vigorous', had rejected every 'trick of art'. He perceived truths undisguised, in 'native charms adorn'd'. He had marked out 'paths of glory' directed to 'universal good' in a Continent reduced by tyranny and war to 'one wide waste creation'. He had been a true improver in a world of increasingly uniform folly.[47]

Knight's antagonism to uniformity is one of the many preoccupations he shares with John Ruskin, his most distinguished successor in English visual theory. Obvious paradoxes come to mind in linking the two writers, not least the contrast of personality between the free-thinking squire and the moralizing art critic. Many of Ruskin's critical energies were devoted to the denunciation of the picturesque as a superficial manner of observing nature that was wholly inattentive to the condition of humanity in ruined cottages and sublime landscapes. The common interests of the two critics are many, however, and help to underline how the picturesque of Uvedale Price and Richard Payne Knight is very different from that attacked by Ruskin. In his architectural writings, notably *The Stones of Venice* (1851–3), Ruskin carried on the tradition of the critics of improvement in seeing design as an expression of cultural

15 In Knight's work, as in that of Uvedale Price, a broad concept of culture and national tradition coincides with the insistence that the landowner should seek a minimal imposition of proprietorial instincts on the natural landscape. This aspect of the picturesque view is well conveyed in several of Thomas Hearn's drawings of Knight's estate, Downton Castle. The natural is rendered accessible, the bridge and the steps being incorporated into the scene using the materials of nature. A woodland like this may remain exclusively private, for the pleasure of the cultivated, or it may admit local participation, for the pleasure of the landowners' dependants and the gathering of fuel.

values. He is particularly concerned with the importance of the emulation of natural form as a means of developing the creative powers of the makers, observers, and users of objects of design. Ruskin contrasts 'Servile Ornament', in which work is 'mathematically defined' by a superior, with 'Constitutional Ornament', in which the workman has considerable independence of self-expression. The first, practised by the Egyptians, among others, seeks to 'check exertion, to paralyze vitality'; the latter, pioneered under Christian rule, 'confesses its imperfection', but values freedom over perfection. Modern forms of design and methods of manufacturing emulate the servile rather than the constitutional model. Ruskin's economic writings insist on the interdependence of the health and stability of a society with the productive processes it chooses to employ. Political economy displays an 'entire naïveté and undisturbed imbecility' when it proposes that the generation of wealth can be understood as an activity detached from wider moral and social considerations.[48]

In the fifth volume of *Modern Painters*, published in 1860, Ruskin describes the recent history of the depiction of landscape in order to emphasize the distinctive greatness of the art of Turner. He is particularly attentive to the style of classical landscape, perfected in the work of Claude and Nicolas Poussin, which had been enormously fashionable in eighteenth-century England and had formed the ideal of much 'improvement'. For Ruskin it is characterized above all by a deliberate neglect of reality arising from a decline in religious conviction. Sophisticated men, having lost faith in a divine plan, and dismayed by the hopeless perception of ruin and decay, seek relief in attempting to realize a 'perfect worldly felicity' in which all life is to be 'happy and refined'. Even ruin must be ornamental, and such spiritual powers as may be supposed to manifest themselves in the landscape must be

decorative. In this ideal labour has no part, and the humiliation and degradation of the body emphasized by much Christian art are rejected. Private judgement and 'good taste' are more important than an attentive and admiring pursuit of the real. Proud self-sufficiency and concern for the elegant are accompanied by a 'scorn of the helpless and weak'. The entire structure is necessarily dependent on a body of slaves with whom the polite can have nothing to do. Painted seascapes may be dignified by the presence of galleys but would be disgraced by working sailing vessels. Rural labour, hedges, ditches, haystacks, and ploughed fields have no place in a pastoral vision in which men live undisturbed amid elegant architecture, delightful trees, picturesque rocks, and limpid streams.[49]

Ruskin insists that a revulsion from the rural — whether perceived in terms of a traditional hierarchy or in the sturdy independence of Swiss peasants or English 'estatesmen' — would necessarily be accompanied by a vulgarity that would encroach on all forms of social activity. In modern England human relationships are increasingly dominated by pride, fastidiousness, and an instinct of deception, as appearance is valued over substance, sentimentality over emotion, separation over community, prudence over conviction, and clever fraudulence over honest dealing. Modern English manners subvert genuine politeness, sympathy, and affection. The essential reality behind the calm image is a depressed workforce and a destructive competition among the ambitious — 'the selfish struggle of the vain with the vain'. A careful formality in personal relations and in modes of speech, calculated to assert social distinction, coincides with a repulsive precision in design, an accuracy and neatness in 'vile things'. The world of the 'busily base' is one of 'meanness, aimlessness, unsightliness'. Emotional shallowness in relationships is reinforced by the 'dullness and general stupidity' expected in the emerging ideal of the gentleman. Men are reduced in their capacity to see and to judge; absorbed by the notion that civilization is founded in possession and change, they destroy all real beauty in order to 'have large houses and to be able to move fast'. The characteristic modern Englishman, the triumph of commercial improvement, is bound up in an ascetic 'refusal of pleasure and knowledge for the sake of money'; he is a narrow being who consumes rather than experiences or participates.[50]

Part of the greatness of Turner is that he stands in triumphant opposition to such narrowness. The greatest of all artists in the depiction of the loveliness of nature, he is also extraordinarily alive to emotion and experience. His work is achieved through a 'capricious waywardness', an 'intense openness', and a determined regard for justice and truth. Lacking enthusiasm for modern manners, design, and decorum, he occupies himself with the realities of 'common labour' and exhibits a new level of 'understanding and regard' for the poor. The unfortunate paradox is that Turner's revelation of nature is undertaken in an age whose greatest energies are devoted to its destruction. In his late works, particularly in *The Stormcloud of the Nineteenth Century* (1884), Ruskin sees the largely unregulated forces of industrial activity destroying not only the emotional and aesthetic experience of man, but threatening the survival of all earthly life.[51]

4

'Benevolent Ornaments'

Nature is Christian.
Edward Young, *Night Thoughts* (IV. l. 704)

In his essay *The Centaur not Fabulous* (1755) the clergyman-poet Edward Young describes a garden as potentially a 'paradise still extant', unlost amid the general ruin of the world. A garden is uniquely adapted to the improving meditations of a good man; the mind and spirit may be at peace because they see their ideal order reflected in the landscape around them. A garden 'weeds the mind' of 'wordly thoughts' and 'sows celestial seed in their stead'. It awakens gratitude to Heaven, instructs the understanding, betters the heart, and delights the senses. Philosophic and moral sentiments are easily provoked by the verdant walk, the clear stream, the embowering shade, the pendant fruit, and the rising flower. The virtuous man is reminded that religion is the 'natural growth' of the works of God and infidelity an artificial invention of man. A garden is a picture of a good man's happiness and in it he finds every congenial image of culture, order, and fruitfulness. The garden is peculiar in that it is at once independent of man, instructive and essentially divine in nature, and at the same time it is ordered by his hand. It is an image, therefore, of the idea that perfection is forever latent in nature, recoverable by the religious effort of improving, dressing, and keeping both the moral and physical worlds.

Young's remarks, which clearly relate to the analogical tradition, imply that improvement is inseparable from a general benevolence of disposition, but at the same time the garden is perceived as a place detached from the ordinary world. It is secluded and reclaimed from the weeds, wildness, and exposure of a 'common field'. It is like a 'good man compared to the multitude'. Improvement depends, as it does, for example, in Sir William Temple's 'Upon the Gardens of Epicurus', or in the tradition of the *hortus conclusus*, on the essential privacy of the garden, however much it is supposed that public and social virtues will flow from contemplation within it. In order to ensure that a garden will stimulate a man's sense of his wider duties, rather than encourage a sense of self-sufficiency, he must look on the sublimities of a wider nature perceived, as in Young's poem *Night Thoughts*, as an expression of the divine mind. Young's friend, the Reverend James Hervey, had made this point clearly in his popular series of *Meditations and Contemplations*

(1745–7) on life, death, and the wonders of Creation. His 'Reflections on a Flower Garden' notes that all gardens, even if they are on the scale of a Vauxhall or a Ranelagh, are 'puny essays of finite ingenuity' compared with the stupendous works of God. A flower garden may teach important truths — notably that all improvement, every 'rational plantation', will languish without constant care and divine assistance. Wider nature teaches this, and much else, with irresistible force. Hervey's 'Descant upon Creation' and his 'Contemplations on the Starry Heavens' celebrate the 'magnificent economy' of the universe, its astonishing blend of variety, vastness, and precision. He observes the extraordinary diversity and profusion of 'sensitive and intelligent existence' and the 'superabundant liberality' of an 'inexhaustible benevolence'. He sees constant beauties, a 'wild magnificence of prospects', and an 'endless variety of images' making up an infinite number of 'spacious gardens', all replete with joy and harmony. The 'ostentatious scenes' of human endeavour fade into insignificance when a man observes the wonders of Creation, all connected together by the Newtonian principle of attraction. The mind so impressed cannot rest content with a 'single object' of attention but must extend itself into a sympathetic 'diffusive benevolence'. It will feel a 'generous concern' for others and perceive their misery as its own. Enchanted with the benevolent economy and community of nature, the good man will undertake numerous works of generosity, attending in particular to the 'cheerless tenement of poverty'.[1]

The religious desire to reconcile private and public improvement had different practical expressions in John Howard's village at Cardington, Bedfordshire, conceived as a model of beauty, comfort, and morality, and the charitable projects of the Reverend William Hanbury. Planting, religion, and a sense of connection could be brought together in an all-embracing aesthetic and morality of benevolence. The picturesque debate clearly assisted in this process. The writings of Uvedale Price and Richard Payne Knight suggested, albeit from a generally secular point of view, that the improvement of landscape and of society were essentially related. Price also took from the very confused but generally Brownian tastes of William Mason's *The English Garden* the idea that the whole of England might be virtuously improved to resemble a great garden. Price quoted Mason's poem as he looked forward to the day when the 'true spirit' of the British constitution might be progressively realized in the 'outward face of this noble kingdom'

> Till Albion smile
> One ample theatre of sylvan grace

or, as Payne Knight put it, culture would smile on all the haunts of men.[2]

A more religious idea of improvement, looking to embrace the country in a landscape of benevolence, became increasingly favoured in the decade following the picturesque controversy, stimulated perhaps by the dire condition of the country in military and economic terms and by the contemporary religious revival. The threat of scarcity arising from a number of poor harvests, as well as seeming to confirm some prophecies of the imminent punishment of England's luxury, also put into doubt the confident projections of agricultural improvers. The growth of statistical studies, particularly of population, crime, and the living standards of the poor,

quantified and on the whole seemed to enlarge the general sense of the scale of the problems relating to improvement. The rise of political economy appeared to undermine the validity of benevolence, seen as counter-productive interference in the market, and put into general currency, including that of governmental rhetoric and activity, principles that seemed inherently subversive of traditional morality. At the same time, the mushrooming growth of the manufacturing system, to a point where it was clearly about to become the dominant force in the culture, seemed to raise a variety of new issues that intensified the previous discussion of the nature and consequences of change, aesthetic response, regulation, and human control over the external world — in short, of the nature of improvement. This chapter discusses some of the attempts of Christian philanthropy in the 1790s and 1800s to oppose what seemed to be an increasing fragmentation of society with ideas of connection based on the responsibility of the landowner to the moral rather than purely economic improvement of the landscape.

A number of studies of the poor at this time took a very pessimistic view of their condition and of the general state of social relations. In his *History of the Poor* (1793–4) the Suffolk landowner and magistrate Thomas Ruggles gave a detailed documentation of the argument that the poor not only received inadequate wages but that their position relative to prices had long been deteriorating. Improvement, far from being the solution of the problem, had accentuated the divisions of wealth that now created serious dangers of sedition and rebellion. Following Montesquieu, Goldsmith, and others, Ruggles argues that an inherent tendency of the increasing refinement of civil society is to exacerbate both the perceived and the actual disadvantages of the poor. Distress, which in primitive societies may be blamed on the 'order of nature', is aggravated by the 'near view' of the tantalizing contrasts of opulence and luxury, which themselves lead to increases in the price of provisions and therefore worsen that distress. The rigour of the laws created by the opulent to shield their property intensifies the divisions of society as men perceive the low value put on the lives, liberty, and labour of the poor. The growth of the liberal and ornamental arts increases the gap between polite and vulgar culture while subtracting from the time and money available for the customs of hospitality that once distributed 'economic profusion' in a village in which the landlord was a 'constant inhabitant'. Gentlemen perceive it beneath themselves to 'hold conversation with the peasant' whose labour improves or embellishes their domains, unless to utter cursing and dejecting reproaches. General apathy to religion leads to the neglect of those charitable ends once entrusted to the possessors of Church lands. The growth of values founded on 'mere moral convenience' leads to the repeal or putting aside of legislation intended for the protection of the poor, such as the ancient laws against the engrossment of farms. In the place of morality and religion arise narrow theories designed to elevate self-interest into principle and to propose ideas, false in morals as well as in practice, such as the argument that extremity of distress, or dire necessity without prospect of relief, are the best conditions to rouse the poor to labour.[3]

Ruggles argues that the greater harmony of society could be realized only through a more extensive application of the principles of benevolence to oppose the artificial

refinements of improvement. Fortunately, such principles were inherent not only in the British constitution but in the nature of man himself. The now much altered Elizabethan poor laws had been formed from a conspicuous body of 'collected wisdom, observation, and experience' and had insisted that all men have a right to maintenance in times of distress. This principle was founded both in the nature of the social contract and in the divine constitution of human nature. For Ruggles, as for Butler and Hutcheson, it is a principle 'implanted on our minds . . . anterior to, and vastly above all human laws . . . an impulsive duty, as strong in its operations, and as lovely in its effects, as the *storgé* in the animal creation.' The inherent beauty of benevolence encourages Ruggles in the idea that a truly cultivated class of landowners could not rest content in the observation of distress or disorder. In a passage that recalls Hume's citation of Lucretius, Ruggles accepts the idea that abject poverty is repulsive, but argues that it is so, not simply for selfish reasons, but because of a 'natural wish' that all men 'with whom we are connected', by 'intercourse, vicinity or employment', should betray no signs of misery or distress arising out of poverty:

> Some men have supposed, that in a landscape, the pleasing effect upon the mind, of smoke arising from the chimney of a neat cottage, flows from a selfish comparison of one's own situation with that of the cottager — it is pleasant *procul alterius spectare laborem,* — but they must excuse me if I differ with them in opinion; it is a matter of feeling only, — the cottage smoke awakens an idea of comfort; the imagination rushes to the chimney corner, and sees honest labour recompensed by its proper rewards; and the pleasure which is then tasted is of a purer nature; it is pleasant *propé alterius spectare solamen.*

Unfortunately, man's mind is so constituted that this instinct can easily assume a selfish, isolating, tendency. The 'hideous appearance' of distress arising out of chilling poverty inclines the sensitive spectator to turn with anguish from objects whose misery he cannot hope to relieve. Improved sensibilities are particularly vulnerable to this retreat from reality. Men of a poetical and philosophical turn of mind, who leave the town to cultivate a more intimate knowledge of themselves amid happy scenes of rural independence, will flee from the sight of abject misery and abandon estates they might otherwise have improved or embellished to the general good. The more distressed parts of the country will be left to the careless neglect of the hard-hearted. It was the duty of the clear-minded resident landowner to pursue the better part of his nature which will benevolently and pleasurably seek to bring about landscapes that give the justified impression of contentment.

Improvement in this sense, working often against the advancing spirit of the age, but assisted by some general reform of the poor laws in favour of the comfort and security of the labourers, rather than their neglect or punishment, could bring about lovely and equitable landscapes. Such scenes would in turn cultivate a further and more widely diffused instinct of benevolence that would encourage a continued improvement of the country in the direction of a greater connection between the various gradations of society. Self-interest, which on narrowly selfish principles

would tend to the abandonment of the country, would on benevolent principles lead to its cultivation and embellishment. Those who had sought relief from the sight of misery in the construction of artificial and private landscapes, from which reality was excluded, might seek once again to merge their interests with the wider landscape and seek in the improvement of the comforts of its inhabitants their own more natural contentment.[4]

Ruggles's interests, together with those of Price and Knight, suggest how much what may be broadly defined as picturesque theory had changed since the 1770s and 1780s, when the enormously popular 'Observations' of the British landscape by the Reverend William Gilpin (1724–1804) had sought images of decay, roughness, and age to support aesthetic judgements usually independent of, and often in contrast with, the moral observations that accompanied them. In Gilpin's works, which are heavily dependent for their theoretical basis on Sir Joshua Reynolds's *Discourses*, the observer derives his pleasure in landscape according to his skill in looking at nature with the eye of an artist. Nature, however ordered from a cosmological point of view, is in its smaller forms grievously defective in composition. To be enjoyed it must often be rearranged or cast into the narrower compass of human visual capacity. The artist's compositions are simple, harmonious arrangements of form, light, and shade, with a single unifying theme. The landscape is completely at the disposition of the artist; he can take up a tree here, plant it there, he can pare a knoll or make an addition to it, alter or do away with a paling, a wall, a cottage, or any other removable part he finds offensive. The artist is not concerned with the local or the particular. He aims to survey nature in a broadcast style, looking for general themes and not troubling to anatomize matter or record minute details. His works need bear no relation to the scenes he depicts or any other scene; they are true only to themselves, and to the rules of harmonious composition. The principal object in the picture must catch the eye first and engage it most; everything else is an appendage made to correspond with and rank in subordination to it. A principal or master tint must prevail over the whole picture and everything out of key must be excluded. As harmony is difficult to achieve with a variety of parts, the best compositions will admit of but one group of objects. Nothing is to be scattered, separate, or independent; there is to be sufficient contrast of forms to refresh the interest but nothing to detract from the harmony of the whole.[5]

Given Gilpin's ideas of composition and harmony, it is not surprising to note his close relations in the 1770s with the circle of Whately, Walpole, Harcourt, and other admirers of Brown. A great house, Gilpin insists, naturally over time acquires space about it and will stand most nobly on an elevated knoll at the centre of a great park. It is the visual and compositional capital of its own extensive domains, which it should overlook without the interference and inconvenience of neighbours' property. Common objects not conforming to the mansion — cottages and cowsheds, for example — should be placed in sequestered spots at a 'respectful distance' from the house on which they depend. Gilpin writes with approval of the Duke of Argyll's removal of the town of Inverary, which had straggled in front of his view, since it would have been a great nuisance and disgrace to the scene of grandeur planned for the domains of Inverary Castle.[6]

Brown's work is generally taken by Gilpin to be the form of improvement that most clearly followed the path of nature. It is his standard of taste, but by no means perfect, and is indeed sometimes criticized in terms that anticipate Price. Picturesque scenes require a degree of roughness and irregularity rarely to be encountered in the neatness and elegance of improved pleasure grounds. Luxury and convenience are best served by flat, smooth, and regular lines that recall only the tamest of natural landscapes. The more refined a man's observation of nature becomes, the more the forms of such improvement seem insipid and over-finished since they leave nothing to the imagination or intellectual curiosity. At Roche Abbey Gilpin finds too many 'marks of the spade'; Brown had removed all the 'rubbish' that could have connected together the various elements of the landscape and had levelled everything so that the abbey ruins stood as in a neat and newly manufactured bowling-green. The atmosphere of wildness and negligence essential to the character of a ruin had been pared away by Brown almost as much as in the notorious depredations at Fountains Abbey. That sacred relic, which should have been jealously preserved as a trust for posterity, had been appropriated to the puerile, expensive vulgarities of the heir of the Chancellor of the Exchequer who had presided over the South Sea Bubble. At Burghley Gilpin finds himself, almost automatically, approving what he calls the reforms introduced by Brown, notably the destruction of ancient avenues, but at the same time he wonders whether avenues and terraces are not more appropriate adornments of a great house than trim pleasure grounds.[7]

When Gilpin is confronted in his *Observations* with a more or less natural landscape of a scale that would render its improvement practicable, he tends to recommend procedures reminiscent of Brown. In an improved landscape, he notes, it is unpardonable if anything 'disgusting' is presented to the view; elegance has to be absent or to dominate completely. All trees allowed to stand as individuals have to be the most beautiful of their kind, elegant and well-balanced, and all 'offensive trumpery' and 'rough luxuriance' of undergrowth must be cleared away if not absolutely necessary to the connection of specific objects. Describing a lakeside house near Keswick, Gilpin recommends the complete removal of 'rubbish' and wild brushwood to produce an 'elegant neatness' that would be an ideal setting for groves, clumps, well-tended walks, and an occasional ornamental temple. The transitional aspect of the Gilpin picturesque compared with Price's much greater appreciation of variety in landscape is confirmed in Gilpin's discovery of 'wildness and terror' in the Wye Valley and his rejection of Bodmin, Snowdon, and indeed virtually all of Wales as dreary desert and wasteland. His picturesque is found in the gentler uplands of England, where there is clear evidence of human activity but without the formality of tillage.

Gilpin finds the picturesque incompatible with arable activity; the use of tools introduces precision and regularity and the idea of physical labour is low and vulgar. There is nothing picturesque about an industrious mechanic or labourer, whereas a listless and loitering peasant can give dignity and variety to a natural scene. Ruined cottages, ragged children, and perhaps poverty itself may be picturesque, owing to the formal qualities of colour, light, and shade exhibited in old and torn clothes, decaying thatch, and other signs of objective distress. The picturesque, in short, was

a kind of visual abstraction, separate from morality and to be enjoyed in one fairly trivial compartment of human response. The point is well made in Gilpin's account of Drumlanrig, where he found among the Duke of Queensberry's tenants and labourers an unusually developed appearance of comfort and happiness. The third Duke of Queensberry (1698–1778) was friendly with the dramatist John Gay and had quarrelled with Walpole and George II over the banning of Gay's opera *Polly*. His abandonment of Court and political life until the accession of George III gave him ample time to concentrate on his Scottish estates. The Duke had granted leases of his farms and had built many comfortable houses throughout Drumlanrig, many quite close to the mansion. It was a scene, Gilpin reports, that was not at all picturesque, but demonstrated a 'much higher species of beauty' and adorned the country more than the most admired works of taste.[8]

The tensions between Gilpin the moralist and the traveller in search of the picturesque are fairly intricate and were always present in his writings. In his earliest piece, the *Dialogue* on Stowe (1748), a distinction is made between 'natural and moral Beauties'. The former appeal to the imagination, the latter to the 'social Affections', which enjoy 'Views of Plenty and Prosperity in their greatest Perfection'. One admires the picturesque, the other the regular, commodious, and useful. One of the speakers, Polypthon, quotes Pope's observation that ''Tis Use alone that sanctifies Expense' and insists that, favoured with the resources of Lord Cobham, he would turn his estate into a garden, making his tenants his gardeners. Instead of construct-ing useless temples, vistas, and other works of private ostentation, he would build farmhouses and improve roads. The 'Public should partake in my Pleasures', he declares. His friend Callophilus rejects this view as essentially barbaric in that it tends to undervalue art, and goes on to insist that the art of Stowe is itself a major public benefit. It promotes a 'Variety of Trades' and supports the poor in the best possible way by encouraging industry. It feeds the local economy through the 'Money spent in the Neighbourhood' by visitors. It offers a variety of delights for the leisure of busy men of all classes, lifting their minds for a while from the 'Care and Uneasiness' of their labours. It raises the image of England in the opinion of foreigners by fostering an art in which Englishmen are pre-eminent. Stowe is helping to establish a 'just Taste' in a pursuit that is innocent, refined, and elegant, and is encouraging a welcome reformation of former tastes, which were 'formal, aukward, and wretched'. Good taste, Callophilus insists very generally, always improves virtue, and gardening, as much as painting and music, can make men more religious, benevolent, and altogether better. Polypthon is easily persuaded by this reasoning and offers the *Dialogue*'s closing tribute to Stowe as a wonderful 'Epitome of the World', pleasing all tastes and giving 'free Scope to Inclinations of every kind'.[9]

The difficulty of reconciling imaginative, aesthetic, and utilitarian values clearly raises many questions in the history of improvement, but the tensions are even wider than this, and include problems implicit in the whole idea of forming a composition of the landscape. For Gilpin the theologian the world is an astonishing blend of order and disorder, as in Butler and Law. The universe seen as a whole, as by Newton, clearly exhibits an 'appearance of design', but harmony and order are less

apparent in the parts. Few landscapes are completely composed, and as a scene is observed more closely, variety will manifest itself, not only in beautiful forms, but in decay, storms, and weeds. Animal life is characterized by rapine and man himself exhibits a constant 'inclination to evil'. Everything is clearly in a 'fallen state' and can be improved only by faith. The function of Christianity is to compose, to improve the nature of man through a 'mild and peaceable' gospel that will bring about 'scenes of happiness and delight' with nature in 'perfect harmony'. Improvement and the cultivation of nature within and without will re-establish the 'beauty of order', taming man's 'brutal part'. In a fallen world, however, all improvement is an equivocal activity; carelessly undertaken it encourages the introduction of vice, sophistication, and luxury. The improvement of nature to a point of 'genuine purity', of courtesy, love, fellowship, and simplicity, is less easy than the destruction of innocence, in which the natural is 'tricked out' and 'deformed' amid the mere 'gloss of decency'.[10]

The proper task of a virtuous landowner is to seek to achieve within the area of his influence an improved nature in which religion is the 'connecting bond' of 'love and union' and every act a 'public testimony' of religion. He is aware of the risks involved in all intervention in the landscape and knows that the assertion of authority and property may generate as many problems as it resolves. The eye may easily be impressed by a great house dominating deferential landscapes; the Christian, however, must look more attentively and with more concern for religious truths. At the same time it is easy, as in Paley, to be impressed by the realization of abstract, 'regular and proportioned' wholes rather than by more intricate and finely balanced compositions. Sometimes Gilpin seems to present himself as the easy spokesman for a very simple defence of 'religion, liberty, and property' in which the function of the poor is merely to behave 'lowly and reverently' to their betters in the established order. Indiscriminate alms giving is opposed in passages that invoke Townsend and his idea that the suspension of relief would resolve the problem of vagrancy as the undeserving were gradually 'weeded away'. The biblical declaration that 'Charity believeth all things' is amended into the need to credit only what 'can be reasonably believed'. 'Particular cases' and 'partial inconveniences' must give way to the 'general advantage', and are perceived as mere 'imperfections' and 'irregularities' in the order of things which do not detract from the perfection of the whole system. Such Paley-like statements tend to occur in Gilpin's late series of *Dialogues*, written over many years but published in 1807. They take the form of a dialectic between innocent benevolence and sage experience, as if Gilpin was in some degree embarrassed by the implications of the argument. The high form of moral and landscape composition represented by Drumlanrig was particularly attractive in that it seemed to promise the resolution of many difficult issues through a central organizing influence of intelligent benevolence.[11]

In a series of moral writings and sermons written in retirement from the fashionable world as vicar of Boldre in the New Forest, Gilpin sought to depict a number of ideal landscapes improved by morality and benevolence. These works offer an unusually detailed account of the landowner's responsibilities to his dependants and to the community in general, and therefore of the proper nature of

improvement. The landowner is the central, composing figure of a 'large circle' of servants, tenants, and labouring poor who all look up to him and to whom he has a reciprocal responsibility of service that alone justifies his elevated status. His ownership of land is a trust and his role is to protect his inferiors from injury, secure their comforts, and promote morality among them. He gives an example of regularity of conduct, sobriety, good manners, mild behaviour, and other virtues that tend to diffuse a sense of order throughout the neighbourhood. He lives almost permanently on his estate and spends his income locally as an act of restitution to those on whom he depends for his fortune. Gilpin quotes with approval a speech of James I condemning the 'swarms of gentry' who neglect their country hospitality and spend their rents in the capital. Formerly, the King is quoted at saying, it was the honour of the English nobility and gentry above all other countries in the world to be hospitable among their tenants.

The landowner's labourers work temperately in the fields or in the garden grounds he has provided for them, 'uniting health and labour together'. Part of his leisure is occupied in the improvement and embellishment of the estate in ways that combine the practical, the moral, and the ornamental. His park is a place, not of expensive and ostentatious display, but of protected innocence, where children watch lambs and fawns taking 'frolicksome excursions' among the trees. Such a landowner embodies an improved culture that opposes the moral and physical contaminations of London which are constantly spreading along the new roads to the capital and turning places of former innocence into centres of dissipation. He is equally opposed to the provincial grossness of deep-drinking squires who roar glees and catches late into the night and neglect their moral responsibilities.[12]

The clergyman is the other clear 'regulating principle' of this community, particularly among the poor, with whom he prefers to undertake 'convivial intercourse' rather than spend his time in social visiting among the more prosperous. He is knowledgeable in agricultural business and possesses easy manners that allow him to adapt his conversation to all classes without embarrassment. His doctrines are moral rather than litigious, with their origins in the Gospels and such figures as Butler, Lardner, Paley, Law (before his mystical loss of reason), and George Herbert. Of a typical income of £350 — about half that enjoyed by Gilpin himself — he spends at least £50 in direct benevolence.[13]

Gilpin's own sermons reflect in some degree his respect for his ancestor Bernard Gilpin, one of the Reformation clergymen who, like Latimer, had directly chastised the rulers of England in sermons before the Court. Gilpin quotes passages denouncing the 'violence, oppression, and extortion' of those who sought to 'lay field to field' in the creation of vast sheep walks, made to fund a 'vain delight' in sumptuous clothes and 'curious buildings' intended, it seemed, to 'bring Paradise into earth'. These insatiable fancies of the rich were contrasted with the ideal of a virtuous, hospitable, and benevolent nobility that 'spreadeth her beams over a whole realm' in the pursuit of an equitable justice. Although the later Gilpin lacks his ancestor's fluency, he describes for his own audience a similarly demanding station and duties morality. The rich man, he insists, should consider himself not as an individual but as a 'member of the community', whose only pre-eminence is that of being more

extensively useful. All titles and wealth, whether inherited or achieved by independent effort through 'means and opportunities' afforded by providence, are considered purely as a trust. They imply no inherent merit in the possessor, but are, in an expression that clearly recalls Bunyan, a burden. The wealthy are stewards and channels for the distribution of the surplus of society. Only in the performance of these functions can they avoid the corruption of both themselves and their inferiors through the follies and vices induced by a careless prosperity. Even their humours are important. Contempt or violence of language in dealings with the poor lead to confusion, misery, and distress in the cottage through a frustrated expression at home of an anger that the poor dare not display directly to their superiors. The proper relations of rich and poor demand much more than the fashionable virtue of ostentatious charity and include all the 'mutual good offices' that money paid for labour cannot alone supply. The rich are to be 'watchful to wants' in all circumstances of need.[14]

Gilpin generally assumes that the virtuous landowner has inherited a fortune which he seeks to improve through agriculture, since the creation of wealth by commerce is invariably associated with the evils of luxury and the corruption of simplicity and innocence. Commercial endeavour involves all the 'little arts of taking advantage' inherent in dealing and the whole 'system of fallacy' which a tradesman constructs around his activity to fool others and himself regarding his honesty. All competition in trade leads to 'anger, malice, and envy', and is attended with every kind of 'natural mischief' that will follow the exalting or enrichment of a few men at the expense of thousands. Facing his congregation in the periods of scarcity of the mid-1790s, Gilpin's observations reflect his lack of interest in the recently improved science of political economy. Noting the 'heavy judgment' apparently inflicted on the nation by the scarcity, particularly at the time of a 'pernicious war', Gilpin's principal concern, apart from a call to prayer, is to remind his audience that the 'real tenure' by which land is held is not one of legal title but of stewardship. The farmer's duty is not to 'feed the market', but that of 'feeding the country'. He should lower his profit or sell at the market price in small quantities so that the poor could buy without the necessity of paying a retailing profit. For the farmer to keep his corn in the hope of an exorbitant price when the poor are starving, 'as we have lately seen', is a betrayal of trust as surely as 'if the physician is attentive to the rich, and not to the poor — if the clergyman is exact in nothing, but his tythes and dues — if the churchwarden, or overseer contrive to get some little dirty profit out of the parish, by means of his office.' In Gilpin the reader is led to believe in general that most profit is essentially dirty, that wealth is something pleasant to have and to distribute, but corrupting to pursue.[15]

Gilpin writes elsewhere of a farmer who curses his labourers, rails against the poor laws as the ruin of industry, and considers his land, his cattle, and his workmen all in the same light, 'merely to get what he could out of them'. Converted to a religious manner of thinking, he comes to realize that all these things require different kinds of careful attention, and that his own improvement, that of the land, and the manner in which he treats his labourers, and indeed his cattle, are closely related. The idea is developed in *Moral Contrasts: or, The Power of Religion Exemplified under Different Characters*, published in 1798. With help from Richardson, Hanway, and

Cowper, Gilpin describes how different ways of improving an estate may reflect the moral nature of its proprietor. A country baronet, Sir Thomas Leigh, inherits rather more than £10,000 a year after receiving an education more concerned with the accomplishments of polite society than with religion. He immediately has half the workmen of the county employed in ornamental improvements undertaken with a great profusion of expense. He goes about ordering the removal of hills, the widening of river banks, the creation of lakes, and the building of bridges, proceeding in everything without taste and judgement. All is done in 'opposition to nature' and in violence to the landscape. The difficulties he creates for himself — for example, the redirection of water contrary to its natural inclination — mean that he is constantly having to undo his work and remake his plans. The expense and the ambition increase together as Sir Thomas builds stables and other useful buildings wholly out of scale with the mansion. He goes on to erect a Temple of Fame, which costs in excess of £500 and soon becomes known throughout the county as the Temple of Folly.[16]

Leigh's lack of sensitivity in the improvement of nature reflects a character that expresses itself within the mansion in a total lack of order, regularity, and harmony. He takes a mistress who, being vicious, is also ill-tempered. The servants are treated with contempt and ill-governed. The economy of the household is burdened by waste and pilfering. An irregular style of life and intemperance in food and drink undermine the baronet's health and the estate, already mortgaged to fund the improvements, is further damaged by the management of a corrupt steward. Rents are raised, instant payments demanded on pain of seizure, and the game laws are rigorously enforced. Such irregularity, and attempts to impose an unpredictable authority by 'acts of oppression', mean that the farms are badly tenanted or vacant. In ever greater need of funds, Leigh spends £25,000 in an attempt to buy his way into Parliament in the pursuit of a sinecure and, after the failure of this plan, is obliged to cut down all that remains of the patrimonial timber. After twenty years his health and fortune are in ruins and his improvements lie about him abandoned and unfinished in a 'scene of wild, expensive desolation'. The park is a 'mass of confusion' with collapsing temples and absurd artificial lakes into which water has long refused to flow. The estate is sold and Leigh is reduced to the expedient of fleeing to Italy, leaving behind his country and his debts.[17]

Meanwhile the moral Mr Willougby, who has benefited from a religious education at home, away from the corruptions of public school and university, has been slowly improving his estate and his original fortune of little more than £5,000 a year. His first act upon succeeding to his inheritance is to continue his father's practice of awarding pensions to poor widows and superannuated labourers. He is in no hurry to begin his improvements, but makes 'judicious plans' that will follow the pattern of nature in the lengthy course of their progress and in their conformity with the existing disposition of the ground. His plans are to be the amusement of his entire life, a 'growing work' not intended ever to be in a state of completion or perfection. As a convenience to his neighbours, the labouring poor, all extensive works are to be undertaken in the low seasons of agricultural employment. Everything is approached in a mood of propriety and proportion and these virtues are exhibited equally in the conduct and economy of the house and estate. The moral system of the

whole is seen as an orderly society of benevolence and affectionate interdependence. Servants who wish to settle are given the opportunity of taking farms. Cottages are scattered about the whole of the estate, some within the precincts of the park and many within sight of the house. Their style is not of artificial churches, abbeys, and castles but of the plain ornaments of nature. All affectation is similarly avoided in the layout of the park and estate. The emphasis is on 'natural circumstances' such as 'tufted groves' formed from native trees, winding lanes, and the unimproved banks of a river or a stream. As in Price, there is no clear division between the improved and the embellished parts of the estate, between the polite world of a park and the rustic or practical worlds of agriculture.[18]

Within the mansion there is much orderly conversation, a good part of which concerns the relief of the poor and the advancement of their comforts. The house becomes a centre which draws to it the difficulties and distresses of the whole neighbourhood and seeks their resolution. Given an example that tends so much to their improvement, the tenants on the estate exhibit habits of regularity, civility, and prudent attention to the fertility of the soil. They thrive under a benevolent, informed landowner who is attentive to repairs, raises rents only after improvements and due consultation, forgives payments in times of difficulty, makes loans for investment in judicious systems of production, and is liberal in such contentious areas as the management of game. Willoughby's estate naturally becomes increasingly valuable and affords a growing income available for works of benevolence and careful improvement. He plants thousands of trees, many in hedgerows or in the corners of fields, so as to increase the beauty of the estate and its utility for his descendants. For a small outlay he enters Parliament, defeating the desperate and unpopular Sir Thomas Leigh, having recommended himself to the county by his character, as well as his fortune and family connections. He is an independent Member, voting with the government only when measures are compatible with his opinions and conscience. After twenty years his extensive family is healthy, prospering, and useful, and the whole estate is in a flourishing state of improvement administered by careful and elegant judgement.[19]

Moral Contrasts was one of a number of improving books written by Gilpin in the 1790s to provide continuing funds for his charitable endeavours at Boldre, originally financed largely through the publication of the *Observations*. He reports that on his arrival at Boldre in 1777 he had found conditions typical of forest regions, particularly a 'great disorder' founded on easy poaching and smuggling in an area both inaccessible and unfriendly to cultivation. After putting his parsonage in order, he began to try the 'beauties of a little artificial improvement' in his grounds, and the 'much more difficult' task of improving the morals of his parishioners. After twenty years, he reports, there was 'much less disorder'. He had reformed the 'vile, ill-regulated hovel' of a poorhouse, choosing a beautiful situation for the construction of a carefully regulated building designed for the relief of those without any domestic resources. He had built a school, similarly carefully situated, where the boys were taught to read, write, and cast accounts, and the girls to read, knit, and sew. His energies continued to be devoted to the constant management and instruction of the poor. Improvement was a continuous process, its objects, like those in nature, ever

ready to lapse back into the conditions of vice and ignorance from which he had sought to recover them.[20]

In his later years Gilpin was strongly influenced by the much younger Thomas Gisborne (1758–1846), an unbeneficed clergyman of evangelical tendencies who had abandoned a promising political career to seek an improving retirement in Needwood Forest, Derbyshire. With an income in excess of £3,000 a year, he was able to devote himself to his parish, pursue his interests in botany and watercolour painting, and write sermons, poetry, and moral and political tracts. In his *Enquiry Into the Duties of Men in the Higher and Middle Classes*, first published in 1794, the responsibilities of each profession are discussed on the basis of a morality founded in the disinterested fulfilment of almost appointed functions. Most of Gisborne's principles relating to the landowner are familiar — tenderness towards the distresses of the poor, neglect of harsh statutes, encouragement of domestic comforts, reform of the immoral. The landowner is active in agricultural improvement but scrupulous as to the rights of the poor in the promotion or discouragement of bills of enclosure. He favours tillage, since it affords more employment, and opposes the depopulation of the country caused by the engrossment of farms and the transformation of 'half a parish into an immense sheep-walk'. Gisborne has, however, little interest in ornamental improvements; he considers them chiefly as a means of employing the poor in low seasons and as an incentive to residence on an estate. Extended much beyond the gardens, improvement planned for private gratification tends to be associated with a degree of insensibility. He writes elsewhere of young people of fashion vying with each other as to the 'extent of the gardens and of the park at the family mansion', and of the mansion, when 'insulated in its park', as the frequent centre of every kind of haughtiness and malevolence associated with those who confuse rank and fortune with personal merit.[21]

For Gisborne, the gardens should open out quickly into wider nature without the interference of extensive parkland. Improvement should be a social activity comprehending all the landowner's responsibilities and founded, not in the domination of nature but in its contemplation. Gisborne's chosen place of residence was an ancient, as yet unenclosed, forest famous for its great variety of animal and vegetable life. In his poem *Walks in a Forest* (1794–6) he notes that the human influence on Needwood has been confined mainly to the traditional management of the trees at its outer fringes so as to combine utility with the promotion of a natural regeneration. The impact is important but limited and of a kind of mutual service. Man respects the trees; he does not seek to control the landscape, 'nor harasses the wilds, With needless interference'. The forest is valued and respected for its tranquillity, for the inspiring forms of its 'stately growth', for the sensual and intellectual stimulus of an infinite variety of carefully observed, independent, vegetable and animal life, and for the moral and religious feelings it provokes. The 'nice harmony' which blends the whole is contrasted with the garish disharmonies of much painted landscape and such artificial improvements as the 'painted summer-house, or trim alcove'. Only in the cottage gardens of the forest commoners, 'gay with mingled flowers' and 'herbs salubrious', does Gisborne record significant pleasure in landscapes formed by conscious taste.[22]

Gisborne was convinced of what he describes elsewhere as man's 'inherent tendency to evil' and of the need for religious improvement, since the mind in its natural state favours 'the growth of every noxious production'. Improvement does not, however, involve a rigid imposition of authority; as in Berkeley, it is the wilder forms of nature, virtually unmediated by man, that are most improving — at least to an already cultivated mind. Further for Gisborne, as for Butler, attention to human works of improvement distracts men from the observation of meaning in the infinite world of nature.[23]

Gisborne's essentially romantic idea of nature and improvement coincides with a disturbed awareness of the rise of manufacturing as a wholly new form of the commercial spirit. He shows himself to have read Adam Smith with attention and writes of how 'enlarged and liberal principles' of trade might serve to accelerate the improvement and augment the happiness of the whole earth. He saw little evidence, however, that the commercial spirit was suffering from undue restraint; rather he argues a need at once for a greater sense of responsibility and for government regulation. He urges magistrates to seek to regulate manufacturing processes injurious to health and morals, even in the absence of specific statutes. He tries to formulate a principle of 'sufficient, but not immoderate' profit, based on the idea that those involved in commerce have a primary responsibility to seek to advance the 'comforts, the prosperity, the intellectual, moral, and religious improvement' of their employees and of the entire community. Commerce, left to its own course, would have little difficulty in the competitive generation of adequate or even exceptional returns, but its success was not the primary function of civil society, the ends of which, indeed, were often in conflict with those of the unregulated expansion of trade.[24]

Gisborne argues that the introduction of new machines and methods of production should be accompanied by an equally earnest attention to the availability of alternative forms of employment and provision for the relief of the distress inherent in such changes. He calls for legislation to regulate hours of work and standards of safety and to control the 'dense and destructive' clouds of industrial emissions. He calls for workmen to be housed in villages near to places of employment rather than in the confined tenements of manufacturing towns. He demands that masters behave rather like model landowners and magistrates, knowing each employee and being solicitous to particular needs. His call for legal regulation and for the attentions of neighbouring county magistrates reflects the idea that the men involved in the expansion of manufactures were less susceptible to moral appeals than some, at least, of those who controlled country business. They had often risen fast, from 'small beginnings' to 'sudden opulence', and frequently lacked minds improved by 'a liberal education'.[25]

Both Gilpin and Gisborne were involved with the Society for Bettering the Condition and Increasing the Comforts of the Poor, founded in 1796 and directed by Sir Thomas Bernard, a conveyancer turned philanthropist, and by Shute Barrington, Bishop of Durham. Bernard (1750–1818) was a cousin of Uvedale Price and a man of wide interests. In 1799 he was active in moves to establish the Royal Institution, partly as a setting for the researches of Humphry Davy. In 1805 he attended

meetings with Payne Knight, Price, Sir George Beaumont, and Thomas Hope to draw up plans for an Institution for Promoting the Fine Arts. His religious convictions led him to direct the greater part of his energies to philanthropic projects. In a passage published in 1801 he made extensive reference to Burke's praise of John Howard's grand tour of benevolence, obviously seeing some analogy between his own work and that of Howard. His incorporation of principles of taste into his schemes for bettering the condition of the poor answered not only to his own interests but was also designed to make benevolence more attractive to his readers.[26]

The purpose of the Bettering Society was to collect and diffuse a body of 'useful' and 'practical information' regarding the detailed 'circumstances and situation of the poor', in order that 'any comforts and advantages' they 'actually enjoy in any part of England, may eventually be extended to every part of it'. Bernard, perhaps conscious of Burke's dislike of the term 'poor', emphasized that he used it only as a 'general and known term', without implying any 'odious or invidious distinction' either, presumably, between rich and poor, or between idle and deserving poor. In the information to be published he required fact and experience, not speculation. The method of inquiry was to be analogous with the techniques that were extending the 'narrow limits' of knowledge in modern scientific and systematic disciplines. The areas of interest were to include parish relief, friendly societies, workhouses, the provision of cottage gardens, parish mills, ovens, and shops, the supply of fuel, and the 'least exceptionable' modes of relieving beggars. The end of all this was to establish methods of organization and habits of conduct that might eventually 'carry domestic comfort into the recesses of every cottage', and 'add to the virtue and morality of the nation' by 'increasing its happiness'.[27]

The emphasis on fact obviously reflects contemporary enthusiasms in applied science and statistics and, equally important, a desire to enable benevolence to compete on broadly equal terms with political economy, following the recent dismissal of Pitt's proposals for the relief of the poor as loose and sentimental. At the same time it is clear that the once respectable language of 'feeling' and 'universal goodwill' was now widely considered to be tinged with the sentiments of Jacobinism. Hannah More makes this clear when she has her do-gooding and dangerous Mr Fantom go about proclaiming sentimental ideas of 'the reign of universal benevolence' in a way that makes him seem a dupe of foreign sedition. Bernard demonstrates his seriousness by frequent references to statistical work on the poor, such as that of his friend, Frederick Morton Eden, and by naming his Society in a way that brings to mind the work of Adam Smith. The great economist, Bernard recalls, had located the 'master spring' of human endeavour, not in the instinct of benevolence, but in 'the desire implanted in the human breast of Bettering its Condition'. Philanthropy had to make use of this principle and replace casual charity with 'means and opportunities' for the poor to attain a greater degree of independence and prosperity.[28]

In practice Bernard, like Gisborne, found little to enthuse about in the operation of free markets. His advocacy of choice and of self-interest took place clearly within the broad tradition of benevolence, with its language of 'mutual goodwill and connection', of management, regulation, and 'kindness'. Bernard saw men in large

part influenced by the physical and moral conditions of their upbringing, and certainly did not see the bulk of the poor of the 1790s as adequately equipped for free competition in the market-place against the self-interested combinations of masters. Nor, clearly, did he see a general instinct of competition as desirable, since it would interfere with the cultivation of those moral sentiments of benevolently hierarchical community that he valued. His language of benevolence was not designed to break up the existing order of society, but to afford encouragement to those 'good dispositions' of the poor that might afford them some degree of independence from the prevailing uncertainties in which they operated — market fluctuations in commodities and wages, changes in agriculture, and the uncertainties of the poor laws.[29]

Bernard saw the poor of the late 1790s as dispirited and distressed in a way that recalls both Ruggles and the particularly stark images of Berkshire presented by the Reverend David Davies in his important work *The Case of Labourers in Husbandry* (1795). He differs from them in arguing, on the basis of detailed statistics, that the condition of the poor had tended to improve over time, though not of course recently, in terms of diet, health, wages, and life expectancy. Whatever their historical position, it was clear, however, that in a 'country of plenty' the poor were not properly fed, and that their housing was often below a level of comfort and cleanliness 'necessary to life and well-being'. Further, their 'sources of wealth' and domestic economy were increasingly threatened by the taking away of common rights and by the engrossment of farms. As Gilbert had recorded, many of the charitable donations to which the poor were legally entitled had been lost by fraud or inattention. In particular, many educational foundations had been appropriated to fund elections, sustain the parish rate, or serve any corporate or personal interest other than those intended by the 'piety and wisdom of our ancestors'. Amid all this the feelings of the poor were constantly insulted by the wanton profusion of the rich and vain. There was little exemplary in 'our own conduct', Bernard writes, to encourage the poor to practise the virtues that were constantly demanded of them.[30]

The poor laws, after several centuries of alterations designed to treat poverty as a condition that would respond to penal sanctions, were in a state of confusion. Their enforcement left too much to the unregulated discretion of officials who could use them to serve their own local interests or as a supplement for inadequate wages. They provided at best a 'comfortless and hopeless maintenance' that was expensively administered and often granted on terms humiliating and painful to indigent persons of sensibility. They tarnished social relations by obliging the poor to 'look up to the rich' for 'daily alms' in a manner incompatible with the normal principles of social liberty. Constant alterations in the laws and their enforcement led the poor to feel themselves unwilling and unconsulted objects of experiments conducted on their welfare. When the poor were 'farmed' for labour they were deprived of their natural rights and made subject to the whims of workhouse governors who were motivated by the desire to make a profit out of them. In short, the poor laws dealt harshly with those obliged to seek relief from causes founded in the infirmities and calamities incident to nature, and tended to diminish the spirit of independence among many who, if duly encouraged, could provide much better for themselves.[31]

The circumstances of the poor made it impossible to make any easy distinction between the deserving and the undeserving. The charge that they were idle or over-inclined to drink was usually made by men themselves 'little employed'. Bernard had often seen that the 'severe and incessant toil' of the poor, their efforts as well as their privations, were often excessive and frequently fatal. Idleness and drunkenness were in many cases the result of 'hopeless indigence', 'despondency of mind', and 'comfortless habits of life' induced by poverty itself. Unlike Howard, Bernard saw drink as a proper 'domestic comfort' and an enjoyment after labour. The indiscriminate relief of beggars, as advocated by William Law among others, was clearly open to the objection that it substituted the interests of the giver for those of the community and perhaps of the 'artful impostor' himself. The circumstances of life of the poor prevented any adequate confidence. Following the tradition of Chief Justice Hale, Bernard argues that a man 'dare not deny relief' even though some of the Acts relating to vagrancy made it a potential legal offence: 'I forbear to enter into a detail of the evils that attend the encouragement of mendacity. There is no beggar who is not really entitled to compassion.' Child offenders are to be pitied, relieved, and educated, rather than punished, because they are typically reduced to thievery or beggary by wicked masters. Bernard took over from Hanway the campaign against the use of climbing boys, whom he regarded as youthful slaves sacrificed to 'our convenience' and the cruelties of their masters. But the masters themselves, and many criminals, are also seen as victims. They are products of the same sufferings they now inflict, after having been turned out into the world unprotected, unpitied, friendless, and uneducated. In Bernard's rather Butlerian view of the world the horror of neglect, of unfulfilled responsibility, is paramount as it regards both the perceived victims of society and the duties of its rulers.[32]

In his recommendations for bettering the condition of the poor, Bernard underplays the simple proposal made by Davies and others of an immediate and general increase in wages, or the tying of wages to the prices of commodities, arguing that in the difficult economic conditions of the 1790s this would raise prices and unemployment while discouraging individual industry. The relief of the poor needed to be based on two areas of attention — immediate and sustained relief of those in necessity, whether through illness, accident, unemployment, or scarcity, and the encouragement on a local basis of economic circumstances that would allow the poor greater independence and certainty in providing for themselves while offering additional potential rewards for those who were more industrious or able. Bernard's ambition was similar to that of Nathaniel Kent — the creation of a widely diffused cottage economy in which men could achieve some degree of comfortable independence in the country. National plenty or prosperity would be of 'very equivocal' benefit if it left a large part of the population in distress or if — through, for example, the growth of the factory system — it was inimical to the 'comfort and happiness of the great mass of the people'. Without taking it upon himself to define happiness, Bernard at least assumed that the poor should have opportunities for its pursuit in the country before being obliged to make the transformation to an industrial economy.[33]

If the cottage economy of the country was not revived, English society would be

undermined by the rootless worlds of the workhouse and the factory system. Bernard refers to a 1796 pamphlet by Sir William Young in which Young insisted that the State has a duty to concern itself, not merely with its immediate and quantifiable revenues, but with 'another sort of wealth'. 'The wide face of the country', he declared, should be a 'treasury of pure morals and unadulterated happiness'. The country was, however, being 'adulterated by institution' in that Parliament was encouraging the diminution of the number of cottages and small farms and with them the country's best and most faithful subjects. They were a spirited and independent group with deep domestic affections and local attachments that served as the places of endearment from 'whence to stretch the compass of regard' to wider and connected circles of neighbourhood, county, and nation. It was foolish to believe that the cottagers could be replaced by the products of the towns or by men brought up in, or under the threat of, the almost urban contagion and restraint of a workhouse.[34]

The essence of Bernard's system was that landowners would enable the poor to have comfortable cottages with sufficient ground for the keeping of animals and the growth of food, thus enabling them to sustain their own 'system of economy and management'. Providing them with 'increased means and advantages of life' in their own localities would sustain a 'virtuous and thriving peasantry' that would be possessed in some form of a piece of property and the 'means and habits of improving it'. The different gradations of society would be connected in 'brother-hood and affection' and the nation as a whole would gain a 'consolidated and defensive strength'. A better diet and comfortable housing would stimulate a 'cheer-ful, active, prosperous industry' while the encouragement of friendly societies would promote thrift, aid the acquisition of new stock, and assist the further improvement of land, with beneficial consequences to the individual and the property with which he was connected. Co-operative village shops, mills, and ovens would enable savings of at least a fifth in the price of provisions, and the availability of fuel from private estates and parts of commons would reconcile the poor to judicious enclosures of wastelands. Those incapable of looking after themselves and without support in the family or community — the 'friendless' and 'distressed', the 'forlorn' and 'insulated' — would be relieved in their own cottages or, if this was impossible, in a 'clean and comfortable asylum'. To the charge, made by Bentham among others, that this was mere sentimentality and nothing to do with fact, Bernard pointed confidently to the experience of the ninth Earl of Winchilsea at Burley in Rutland and to the Yorkshire estates of Lord Egremont. In the latter case, 'in the true and best exercise of power', Nathaniel Kent had been given *carte blanche* in the management of the tenancies. As a result the poor were reportedly prospering, the poor rates were in decline, and Egremont had the great pleasure of looking out on a landscape of benevolence.[35]

Clearly such a scheme offered considerable scope for a view of improvement that could combine moral and social considerations with those of taste. In a report of the Bettering Society published in 1801, Bernard presented a comprehensive theory of such improvement, drawing widely on the moral tradition of analogy. He argues that the fallen condition of the world, manifested in the deformities of external nature and the moral and physical state of man, is intended by providence to create

a probationary scene of improvement. This was stimulated not only by necessity, but by an innate desire in man for order and even for some type of perfection:

> Vice, indigence, and misery are the noxious weeds, the thorns and thistles, which deform the region wherein we are placed. This world is the scene for the probationary exertions of man. It is the garden which God hath given us, to dress it, and to keep it, impressing us with a desire of perfection, and impelling us to improvement. In proportion as we act in our duty with energy and effect, we attain a more elevated degree of existence and happiness; and we approach nearer to that perfection, which is the only real and rational good, to which our weak and humble nature can aspire.

Inherent in this is a desire for union in the senses argued by Butler and others — both a rational movement towards the protections of civil society, and an emotional desire for bonds and connections of intercourse that make a man's fulfilment dependent on seeing the happiness of others:

> No occupation can be offered to the mind of man, so congenial, so interesting, or affording such real and unmixed gratification to the human heart, as systematic and intelligent benevolence; for independent of the advantage, that by labouring to relieve and benefit others, we always ameliorate ourselves, the experience of human life will teach us . . . that he who contributes to the temporal comfort of the greatest number of his fellow creatures here, and to their eternal happiness hereafter, lives with the most satisfaction, and dies with the greater hope . . .

Bernard notes further that the universe is constituted in such a way that the order of the 'moral world', and the 'beauty and fertility' of the 'natural world', require not only improvement but continuous intervention and maintenance. No system of improvement, in morals or in the landscape, and no political arrangement such as the laws for the maintenance of the poor, can be left to its own workings like an autonomous machine. Order depends on a creative and continuous sense of responsibility that is clearly more akin to Berkeley's conception of God than Burke's idea of the free market.[36]

As regards the benefits to the poor, Bernard writes not only of the sense of attachment to the natal spot, but of all the advantages that would arise from men's occupation of 'their own cottages'. These would be not only activity and providence, but liberty and hope. Bernard argues the importance of a sense of independence, of options and of being a free agent, as the labourer, given the possibility of a secure source of food through his own efforts, could regulate the intensity of labour he undertook for pay. The encouragement of alternative forms of employment in small factories or artisanal trades could further strengthen the position of the poor in the labour market. How the cottage economy would function is not entirely clear, since the forms of tenure are not precisely defined, varying between freehold and different types of leasehold. Obviously it was difficult to imagine the bulk of labourers having affordable freehold cottages, although this was a legitimate goal of industry. Bernard does write, however, of otherwise barren ground being given to labourers 'in fee simple' for 'labourers and their descendants'. Lord Winchilsea, who followed closely

the doctrines of Nathaniel Kent, writes of his goal that his labourers 'acquire a sort of independence'. He reports that upwards of eighty labourers on his Rutland estate were growing prosperous and happy by the renting of cottages and land, and that they remained effective workers. A lot of questions raised here of tenure and independence are difficult to resolve from available evidence. It is clear, however, that benevolent owners were keen to argue that the poor were better placed in their hands than in those of the farmers. Lord Winchilsea complained that the farmers were always jealous of anything that threatened the dependent status of the labourer. As Kent had argued, large concentrations of land in liberal hands were better than any arrangement that allows the land to be monopolized by selfish farmers. The erection of well-built cottages would not offer immediate financial returns, although it would tend eventually to a decline in the poor rates. It was an activity that was part of the responsibility of rank, compensated for by the gratification it would afford, the consolidation of the authority of landed property, and the opportunity to undertake works of taste. Bernard writes, in a manner that recalls Shelburne, of the 'true interest' of landed power, and of the 'general benefit and credit' to an estate and its proprietor's family.[37]

Given that the ills of society required the attentive concern of the wealthy and the cultivated, and that their resolution called for the greater availability of neat and comfortable cottages with land, it was natural for Bernard to seek to combine benevolence with the picturesque as redefined by Price. Landowners could encourage cleanliness, 'regularity, and morality', strengthen the 'bond and connection' of society, and at the same time improve the 'general appearance of the country', by 'adorning the skirts of their parks and paddocks, of their farms and commons, with picturesque and habitable cottages, and fruitful gardens; so as to increase every Englishman's affection for an Island replete with beauty and happiness.' The loveliness of the landscape, the 'frequent communication of kindness and benefit', and the sense of participation in property would attach all Englishmen 'by an indissoluble tie, and by a common interest, to their country, not only as the sanctuary of liberty, but as an asylum, where happiness and domestic comforts are diffused, with a liberal and an equal hand, through every class of society'. Beauty, prudence, stability, morality and benevolence would be united in the landscape. No dependable loyalty could be expected to a constituted order of property which excluded the mass of the people from any principle of possession. A sense of duty on the part of landowners and a generally diffused idea of connection were necessary to create an image of society as a happy and 'harmonious whole'. The calamity of the state of Ireland, and the destruction that threatened it from internal tensions, demonstrated the dire consequences of the separation of rich and poor.[38]

Bernard's phrase 'picturesque and habitable' alludes not only to the inferior form of the picturesque that takes pleasure in hovels and decay but, more important perhaps, to the fashion for buildings of parade. After the publication of Price's *Essay*, Bernard was able to argue with confidence that well-built cottages would 'ornament and enliven the scenery' much more agreeably than the grottoes, 'misplaced Gothic castles', and 'pigmy models of Grecian temples' that 'perverted taste is so busy with', and which were generally 'uninhabited and uninhabitable'. A

landowner seeking a wide field to display his pleasures in taste and 'fanciful improvement' could eschew such schemes of parade in favour of an extended landscape of benevolence. Bernard quotes with a mixture of irony and moral disapproval a passage in which Horace Walpole had mocked those who sought to render landscape gardening subservient to 'benevolent projects' and to make

> every step of their walks, an act of generosity, and a lesson of morality . . . instead of a heathen temple, a Chinese pagoda, a gothic tower, or fictitious bridge, . . . at the first resting place to erect a school; a little further, to found an academy, at a third distance, a manufacture; and at the termination of the park, to endow a hospital.

For Bernard none of this seemed ridiculous; those landowners who had, against the mainstream of taste, decided to undertake such projects exemplified a much higher species of improvement than the one conceived by Walpole:

> let those who have seen Lord Winchilsea's and Mr. Conyers' cottages, the benevolent ornaments of Castle Eden, and the beautifully and romantically situated schools of Mr. Gilpin at Boldre, — appreciate the true value of the *amusements of Strawberry Hill*, the time and abilities of whose benevolent owner deserved better, and more useful occupation.

Being devoted to a moral and improving purpose, 'benevolent ornaments' are a higher form of art and self-expression than landscapes intended, as Walpole had advocated, for 'mere luxury and amusement'.[39] At his estate of Copped Hall in Essex, John Conyers had built cottages in order to encourage the former 'outcasts' and 'deer stealers' of Epping Forest to cultivate the land and 'habits of industry'. At Castle Eden in Durham, Rowland Burdon, an MP for the county, had improved local wastelands and built a model hamlet incorporating a well-regulated cotton manufactory. The land was worked by cottagers with garden ground. Soon a 'bleak and barren country' began to 'assume an aspect of fertility' and the local population greatly increased. Burdon instituted a friendly society to provide for times of illness and the expenses of a surgeon, and to furnish loans for the acquisition of cows. He recorded the rapid improvement of regular habits, foresight, and a sense of connection.[40]

Bernard's position here is very close to that of Ruggles. The sensitive observer is shocked and depressed at the sight of 'wretched hovels' and associates them with disconcerting wretchedness. He is elated at the sight of images of neatness because he associates them with contentment and the due rewards of labour. It is a pleasure that is both comforting to the observer's sensibilities and at the same time a disinterested delight in the happiness of others. Bernard's emphasis on the neat as well as the picturesque suggests a major change, already apparent in Price, from the older idea that the picturesque was inseparable from decay and neglect. In the landscape of philanthropy, neatness and intricacy are carefully to be reconciled; neglect, at least as regards human affairs, is the enemy, not the precondition of this kind of picturesque. The ideally rural, in which the poor are supported in their local and domestic attachments, their independent economy and their uncorrupted man-

ners, depends on the deliberate calculations of the cultivated owners of landed property.

The idea of the picturesque as a kind of active creation of the pastoral is illustrated in some papers of Bernard's friend, the Reverend James Plumtre, a picturesque traveller, author of popular dramas, and conscientious clergyman. In an article published in the reports of the Bettering Society in 1801, Plumtre recommended the system of premiums for excellence of garden produce offered by the third Earl of Hardwicke to his tenants and labourers at nearby Wimpole Hall, where the recent improvements, in addition to the retention of the great avenue, had included the erection of a number of 'very commodious' cottages designed by Sir John Soane. Premiums served to promote the industry, comforts, and morals of the cottagers at the same time as they confirmed local attachments by helping to render the district 'a pleasing scene of rural plenty and happiness', complete with honeysuckle arches to gardens and the laying out of ponds and farm buildings with a view to taste as well as use. It is clear from Plumtre's unpublished papers that Wimpole afforded a marked contrast with his own parish of Hinxton in Cambridgeshire. There the cottagers had recently lost most of their rights of common, had little access to land, and some of the honest and industrious poor were badly fed and clothed. Using his own resources, Plumtre sought to improve his parish through premiums, advice on domestic economy, loans or grants in times of distress, more efficient fire-grates, innoculations, and general moral guidance. In various parts of his journals he inserts passages from Dyer, Rowley, and Goldsmith, offering poetical images of a rural life he clearly hoped in some degree to realize amid the difficult reality of his parish.[41]

At the end of the eighteenth century and the beginning of the nineteenth, a large number of pattern books for rural cottages were published, many of them designed to combine picturesque characteristics with domestic comfort. The texts often have extensive quotations from the picturesque authors, the Board of Agriculture, and the Bettering Society. Introducing what is perhaps the most interesting of them, Joseph Gandy emphasized the importance of good design not only to the practical comforts and morals of the poor but to the welfare of the country in general. The early habit of contemplating fine forms, Gandy notes, elevates men's ideas of beauty and creates a natural good taste. 'Vulgarity and lowness of ideas' are the inevitable consequence of being born and educated among objects 'incapable of exciting any fine impressions'. Good taste, and with it a nobler view of civil society, should be naturalized among the poor as among their superiors.[42]

The fashion for pattern books may be seen as an aspect of the triumph of the principle of picturesque benevolence, but it represents also, as Gandy's remarks suggest, the success of a kind of imposed, artificial view of taste and of the rural that almost always seems to be contracted in London, to use a familiar phrase. The idea of a local process of improvement, based partly on the vernacular and partly on the cultivated whim of the landowner, is replaced by a 'general taste'. Whatever the particular implications of these developments, it is clear that Bernard himself felt increasingly alienated from the progress of English society in the first two decades of the nineteenth century. The 'unmeasured and unregulated extension of our manufac-

tures' meant that the morals, health, and happiness of the great majority of the people were being sacrificed to the 'demon of gain' and to the spirit of speculation that was absorbing so many of the talents and exertions of the country. Only the 'fostering care of government' could be powerful enough to counter the effects of the growth of the factory system. Through his writings and the Association for the Relief of the Manufacturing Poor he founded in 1812, Bernard called for the regulation of the length and conditions of work and the abolition of night labour, opposing in this much of the triumphant doctrine of political economy. At the end of the French wars he complained that the more than doubling of the commerce and manufactures of England had served largely to enhance the power of the 'great and splendid mansion' of the 'funded Capitalist' and 'great land holder', while the peasantry and the poor were increasingly neglected. Direct taxes had been reduced or abolished at the end of the wars because they affected the wealthy; the salt taxes and game laws remained, hurting the poor in particular and forcing many into crime. What made the position seem more difficult than in the 1790s was that the doctrines of narrow self-interest favoured by monopolists had entered into the general currency, making the cause of benevolence seem increasingly adrift from the most improved thought of the time. Only government regulation, opposition to political economy, and the introduction of a universal system of education could hope to counter what was corrupting in the spirit of commerce and satisfy a duty 'to improve for those who succeed us'.[43]

A Note on Hafod

Hafod, the Cardiganshire estate developed by Thomas Johnes (1748–1816) and destroyed by various government agencies shortly after the Second World War, was almost certainly the most important expression of the ideas of landscape discussed in the preceding two chapters. Johnes's improvements, which his friend the botanist Sir James Edward Smith described as a combination of 'goodness, sense, taste, and munificence', occupied most of his energies from 1783 onwards, alongside his positions as MP for Radnorshire, Custos of his own county, and Colonel of the Cardiganshire militia during the invasion threats of the 1790s.[44]

Cardiganshire in the latter half of the eighteenth century was usually described as a wild, mountainous area offering few attractions to the tourist and to the predominantly absentee landowners. It was seen as a region of poor soils, primitive husbandry, bad diets, abject poverty, and widespread immorality. Tenancies were normally insecure and such limited improvement as took place, notably near Cardigan and the increasingly fashionable coast, was observed to damage the poor by depriving them of furze and thorns. The landscape itself had few admirers except for some seekers of the sublime, who found there a British equivalent of the scenes of Salvator Rosa, including his sullen *banditti*. It seems that Johnes — a man of wide interests and sufficient income to finance a passion for building, planting, collecting, and printing (including his own translation of Froissart) — began early to be intrigued by his neglected ancestral estates. His declared intention was to create at

16 J. M. W. Turner's watercolour of Hafod (*c.*1798) conveys the atmosphere of sublimity and wonder often noted by visitors to Thomas Johnes's estate. The Gothick mansion—which bears little resemblance to the actual house—appears to have landed, quite unexpectedly, in the wilds of Cardiganshire. Far from a conventional portrayal of improvement, Turner's image is rather more reminiscent of his picturesque studies of ancient landscapes featuring castles and abbeys. Given the mood of this image, it is not surprising that Turner pays little attention to the practical aspects of Johnes's undertaking.

Hafod a 'Happy Valley' and a paradise of improvement. In his plans he was assisted by Smith, by his cousin Payne Knight, and by Uvedale Price.[45]

The nature of the landscape, much wilder than that of the Welsh borders, enabled the creation at Hafod of what became the most widely admired picturesque landscape of its period. It generated a large and detailed body of descriptive writing in which almost all observers were inclined to contrast its romantic and enchanted wonder with the tame sterility of Brownian improvement. What was not done was as important as what was attempted; the mountainous landscape, naturally obdurate in its character, was simply rendered accessible. The works of habitation and agriculture disposed on the lower parts of the hills represented judicious and modest attempts to 'graft convenience and improvement' onto the landscape without 'fighting tastelessly against its character'. There were no commonplace exhibitions of artificial management, no attempts to refine the rudeness of nature, and no ornamental buildings of parade in exotic styles. There was no defined plan to which the landscape was intended to conform and no expectation of a point of completion. Commentators often referred to the changing and 'growing improvements' of scenes as the landscape absorbed or rejected Johnes's efforts.[46]

The most extensive work at Hafod was that of planting — between 1796 and 1801, for example, Johnes is reported to have ordered the planting of 2,065,000 trees, of which 400,000 were larch and the rest a mixture of alder, beech, ash, oak, birch, and elm. The bulk of this work, in which 'science and taste' were said to 'go hand in hand', was on the higher stretches of the hills around the valley of the Ystwyth near Devil's Bridge. Formerly naked hills, usually described by tourists as desolate and dreary and as a dull uniformity of waste fatiguing to the eye, were turned into 'rich and productive forests'. Paths were made through the new woods to connect the tops of the hills with the valley bottom and to join with walks running through the older woodlands on the lower sides of the valley. Observers noted not only the extensive trees but 'wild and tangled' underwood, dramatic waterfalls, cataracts and rivers 'foaming impetuously' over rocks. There was a constant change of outlook from enclosed woods to distant scenes of 'endless variety' and 'unrivalled wilderness'. The imagination was left at liberty to wander, making its own compositions and ideal creations amid an endless 'picturesque inequality'. Every variety of sentiment seemed ready to be enjoyed, including the sublime, as the observer noted the natural glooms of woods, the tremendous height of the hills, and the terrifying precipices of river cliffs.[47]

The real purpose of Hafod was, however, inseparable from the project of incor-

17 The agricultural improvements at Hafod, which merged easily into the wider landscape, are noticed in one of 'Warwick' Smith's fifteen watercolours, executed about 1792 and engraved for James Edward Smith's *Tour to Hafod* (1810). The artist's difficulty in conveying the wild nature of the place is evident in the somewhat Brownian drawing, including the rather clump-like woods.

porating an idea of improvement into the lives of the local poor, beginning with the transformation of the agricultural possibilities of the area. A 'principal ornament' of the place was an obelisk to the late Duke of Bedford, the 'judicious and munificent promoter of the National Agriculture'. In the lower reaches of the hills areas of land laid to pasture, and 'neat and commodious' farmhouses and cottages sheltered by rising groves began to appear, bringing an 'air of comfort and cheerfulness' to the scene. Lower in the valley, land was improved for tillage, using some of the most advanced techniques researched by those associated with the Board of Agriculture. In 1800 Johnes published for the instruction of his tenants a volume of extracts from the 'most improved' writers on agriculture, with a preface in which he writes of the long attachment between his family and theirs, the 'natural connection' that should exist between landlord and tenant, and his long and earnest desire of improving their condition. He notes his confidence that he needed only to point out the best methods to induce his tenants to follow them, and makes it clear that any who insisted on the practice of such unimproved methods as 'paring and burning' would not receive assistance and support. With the aid of some Herefords provided by Payne Knight, Johnes radically improved the quality of the local cattle and at the same time encouraged the cottagers to keep cows and other useful animals. In the general scarcities of the 1790s he felt justified in claiming that he had twice saved his area of the county from famine, chiefly through his improvements, but also in the bringing of a ship-load of corn from Bristol to be distributed below the market price. Johnes's robust dislike of some aspects of political economy is well conveyed in a letter of 1801: 'I hope the *old* Corn Laws will now be renewed, and all Adam Smith's doctrines & of such speculators be annihilated and that we shall trust to experience & fact alone.'[48]

High in the hills, and announcing 'a new order of things in the wilds of Cardiganshire', Johnes built a new church, designed by Wyatt with an altarpiece by Fuseli. All services were held in Welsh. Although the church seemed to be placed in its situation to be 'enbosomed' in tufted groves as Price, following Milton, advocated, the site was that of an ancient church long since abandoned into ruin. One of the approaches was over a wooden footbridge with one rail; it was described as picturesquely overhung with a luxuriant oak and as crossing a 'deep-bedded, black, and rocky mountain brook'. From the church, through a 'natural lattice-work' of intervening groves, the observer could see the whole variety of the valley, with mountainous hills and woods, naked sheep-walks, and 'picturesquely circumstanced' areas of cultivation intermixed with the 'wild beauty'.[49]

Johnes's mansion was a peculiar blend of the Gothick of Batty Langley or Sanderson Miller and the 'Hindoo' of Sir William Chambers; it was designed by Thomas Baldwin of Bath, with a later octagonal library by John Nash. Despite its exotic design, it stood in a common meadow and was so placed as not to be an object in the landscape except from very near; the carriage road gave a view of it only at the last moment. The house was described as the centre of an extensive hospitality that comprehended both the 'liberal and elegant' and the local and traditional: Johnes's habit of holding his estate dinners within the house itself was clearly not a common practice at the end of the eighteenth century. From the

18 The invigorating land-
scape of Hafod is well evoked
in the series of lively pencil
sketches made by Thomas
Stothard, mainly in 1805 and
1810. He spent a number of
months at Hafod as drawing-
master to Johnes's highly
accomplished daughter,
Mariamne. Stothard also
painted a series of chivalric
scenes for the octagonal
library, which was recon-
structed after the fire of
1807.

mansion he worked at being 'paternal in the care of dependants' in the manner
recommended by the advocates of benevolence — ameliorating manners, improving
diets and housing, providing medical assistance, instituting pensions and friendly
societies, adopting liberal attitudes to rents and the game laws.[50]

Hafod itself, and the extensive documentation it received, clearly assisted the
process in which the country house, after its literary and controversial unpopularity
in the age of Brownian improvement, tended at the turn of the century to be seen
once again as the centre not only of civilized but of moral values. This is an idea of
improvement perfectly expressed in 1807 by the antiquarian Richard Fenton in an
account of Stourhead. The author of a poem on 'The Genius of Hafod', Fenton
found Stourhead a similarly enchanting landscape, in which the natural and the
cultivated were perfectly blended:

> as little of nature as possible sacrificed to ostentation, . . . such an air of tranquil-
> lity over the whole, and so many happy human faces occurring everywhere,
> . . . even the unreclaimed tenants of the wild mixing in your path, fearless and
> tame, as in Eden ere sin had entered . . . you see every morning a hundred pheas-
> ants, intermixed with hares, playing their gambols with a confidence and famili-
> arity that is delightful . . . there is no satiety, and you fancy yourself in a better
> world.

Fenton makes it clear that the discovery of these sentiments at Stourhead, once famous for its profusion of temples, Chinese and rustic bridges, and other eccentricities, depended on the character and more recent improvements of Sir Richard Colt Hoare. He had removed many of the 'fantastic' deformities, leaving only the 'most elegant and classic models of art' and 'chaste imitations of nature'. Fenton contrasts the 'august' monument to King Alfred, the founder of English liberty, with the ostentatious tower that 'unmeaningly' crowned the summit at neighbouring Fonthill. The entire landscape, formerly smoothed and levelled in many places, had been rendered more natural with banks of 'grotesque growth' and woods of a 'wild and entangled appearance'. The picturesque variety and cheerfulness of Stourhead — its 'improving on the outline of nature', according to Colt Hoare — contrasted delightfully with the bleak and barren part of Wiltshire that surrounded it.[51]

The grounds were so disposed as to 'mix with the village' which, together with the cottages and farms of the wider estate, had received much attention in the manner advocated by Price — the interiors made commodious, the structures repaired, and the exteriors rendered more picturesque with jasmine, roses, and honeysuckle. Colt Hoare himself who, according to Fenton, presided 'providently and methodically' over 'every part of his establishment', referred to Stourhead as a 'wilderness converted into a paradise'. For this role he was well suited by disposition and study; he had bought a number of Gainsborough peasant scenes and his library included Mackenzie, Crabbe, Langhorne, and Richardson (*Sir Charles Grandison*), the picturesque writers — Gilpin, Price, and Payne Knight — Hanbury's *History*, Cumberland's *Attempt to Describe Hafod*, Burke's *Reflections*, Coxe's *Stillingfleet*, and several of the publications of the Bettering Society, including a pamphlet on cottage and garden economy.[52]

5

'A Noble Estate'

We tolerate even these; not from love of them, but for fear of worse. We tolerate them, because property and liberty require . . . that toleration.

Edmund Burke

In a letter published in the *Annals of Agriculture* in 1803 the Reverend George Lawson, vicar and physician of Heversham in Westmorland, complained that the great increase in travelling in search of the picturesque had done little to increase the general understanding of the real condition of men in different parts of the country. Authors of county histories, topographical works, and guides taught little regarding what should be the central concern of all benevolent men, that of understanding and improving the civil and moral condition of the poor. In a passage that recalls Bernard and his citation of Burke on Howard, Lawson called for a detailed local geography of the poor to supplement more familiar works:

> The historian of a county necessarily as such confines his views and researches to that, and his business is to speak, as does the tourist, of magnificent buildings and extraordinary scenery only, and of the great men and great events which it has given rise to; whilst the mass of the people have been seldom thought of, or contrasted with others of worse or happier lots elsewhere.

What was required was a mass of details that would show how different circumstances — local social arrangements, types of cultivation, tenure of land, and so on — tended to influence the condition of the poor. From his personal experience Lawson compared the counties near London, notably Hertfordshire, Essex, and Surrey, with the area of the Lakes. In the London counties there had been much more accumulation of the land into large farms than in Cumberland and Westmorland, and as a consequence, Lawson argued, the poor there were worse fed, clothed, and housed. In the Lake counties the land continued to be divided among a great number of independent cultivators and the poorest cottager was aware of the possession of land in some part of his family. He could see some prospect, however distant, of himself owning land and this hope supported his pride, industry, and local attachments. There were many 'estatesmen' with twenty or thirty acres trans-

mitted in their family, who were able to provide well for their families and educate their children with ease. Lawson's eventual conclusion is a recommendation to 'Give, therefore, to every labourer in husbandry a little farm of his own.' Although the significance of 'give' is uncertain, it seems that a primary source of land for the purpose would be derived from the enclosure of waste lands. The end of the process is quite clear, it is the creation of a peasantry that would be a 'happy set of men, the strength and admiration of the nation'.[1]

Lawson's argument that such a goal seemed to require ownership rather than renting of land is part of a very broad debate as to the best means of attaching the poor to the soil, and of the best way to structure the tenure of land in order to satisfy the needs of agriculture and the welfare and industry of tenants and labourers. Clearly, as can be perceived from the *Annals*, from Bernard's *Reports*, and the *General Views* of the Board of Agriculture, there was no complete or simple answer. The question depended, among other things, on local circumstances and levels of improvement, the structure of society existing or desired, the sense of responsibility to the fertility of the soil and to posterity, the view taken of the power of the landed interest, the preferred price of land, and, not least, calculations of human nature. Thomas Lloyd, in his *General View* of Cardiganshire (1794), took a fairly simple view, but one clearly influenced by the obdurate and unimproved state of the county:

> It cannot be expected that a tenant will go to much expense in marling, or any lasting improvement, with a short or uncertain possession: if the tenure is in years, the three or four last may be employed to the great injury of the land. Security for life gives energy to action, and as few men live so long as they wish or expect, improvements are carried on to the last; hope comforts the tenant, uncertainty the landlord.

Every such simple statement is debatable in terms of its own internal logic and different points of view; the question was unresolved and probably incapable of resolution. It was always clear, however, that there was a marked difference between a system of leaseholds, whatever the length of the term, and one of freeholds, because the latter were more easily traded, and therefore subject to the irony that the purest form of property could also be the most unstable.[2]

The Lakes had long been felt to be different from the rest of England. Some older, less divided form of civilization seemed to have survived among the mountains, while the rest of the country became increasingly commercial and more aware of class and property distinctions. Picturesque travellers in the 1760s and seventies, such as Gilpin and the poet Thomas Gray, had noted with enthusiasm an economy of independent farmers who were self-sufficient and content, hospitable, honest, and moral. Gray recorded an ideal rural picture of productive fields and comfortable houses in a landscape undisturbed by the 'flaring' red tiles of a gentleman's house or garden wall. He found peace, rusticity, and 'happy poverty in its neatest, most becoming attire'. Inevitably, as Gilpin noted, the discovery of such contented innocence led to its corruption. In his *Remarks Made in a Tour from London to the Lakes* (1792) Adam Walker, himself a native of Patterdale born in 1730, used language to describe his birthplace that recorded in large part the values of Gold-

smith. Patterdale had been until recently a happy valley, a seat of mirth, innocence, hospitality, independence, and liberty. It had been corrupted by vices and diseases introduced by miners and by the 'false ideas of happiness' brought with them by tourists. In England as a whole, Walker noted, the introduction of turnpike roads had destroyed all provincial manners, dialects, and customs; everywhere was now 'only London out of town'. Yet in this general levelling the Lakes continued to retain some virtues and peculiarities left from the ancient Catholic culture that had permeated all aspects of religious practice, economic relations, manners, and even the local music. The 'Mountain Spirit of Liberty', the inheritance of many years of border conflict, would yet take time to eradicate. Many virtues remained, although the 'generous spirit' of the people was constantly subject to the 'baneful prostitution' of commercial habits and of 'aristocratic influence'. Only reason, honesty, and time could cure such ills, Walker notes, as he turns from the 'hateful disease' to view the 'Grand and sublime of Nature' and despise the 'littleness of human systems, and petty competitions'. The happy virtues seemed doomed like those of Auburn, partly by the strength of the alien forces attacking them, but partly also because simple men, ignorant of the real nature of luxury and commerce, could not perceive, as Goldsmith and Walker were able to do by experiencing them, that the benefits were illusory. In this process, as Wordsworth was to note, the existence of small units of private property might delay the process of absorption into the larger commercial world, but certainly could not prevent it.[3]

There has been a tendency in criticism of Wordsworth, and more markedly of Coleridge, to assume that their work is best clarified by the identification of increasingly arcane sources. This has been particularly evident in the extensive investigation of a body of contemporary German philosophical writing not always remarkable for its clarity of meaning. Coleridge's own claim that his mature thinking predated his reading of Schelling, Fichte, and others, and was independent of their work, has not discouraged this process. Scholarship has sometimes laid conceptual man-traps around its enclosures to frighten off those who might be considered unqualified to enter. Critics often emulate Coleridge in his habit of obscurity. One, for example, notes that for Coleridge 'Art symbolizes the immanence of the Absolute, the power constitutive of phenomena, literally "embodying" the "aeternitas mundi" of the civil ideal.' Another critic argues that the integrity of Wordsworth's poems 'depends on their holding together of the polymorphous or antithetical predications of passion without reducing the play of that polymorphousness'. This reading is backed up by quotations from Fichte, Schopenhauer, Nietzsche, and others. In this scholarly process some simpler, more obvious, and possibly more provincial influences may be felt to have been neglected, such as, for example, the broad tradition of the picturesque. Discussion of this tradition is often confined to accounts of Wordsworth's very early poems, notably 'An Evening Walk' and 'Descriptive Sketches', which few admirers of his work will wish to read often. This neglect may be considered rather anomalous, given the importance in Wordsworth's poems of issues of property and perception, of how man sees nature, and how the poor are observed by those of more independent means.[4]

Wordsworth's poetry has always been perceived by some critics as a political

undertaking. Francis Jeffrey, writing from the liberal position of the *Edinburgh Review*, thought that the *Lyrical Ballads* shared Tom Paine's ambition of spreading 'disaffection and infidelity'. William Hazlitt argued that Wordsworth's muse had levelling ambitions founded in a variety of false premises. The sentiments of his work were absurd because the country, lacking the civilizing influence of 'vanity and luxury', was a place of hatred, envy, selfishness, and stupidity almost on the level of 'savages or animals'. Many modern critics have assumed that the *Lyrical Ballads*, and especially their preface, embody a Jacobin or communistic conception of society, or at least a radical point of view strongly influenced by the English Commonwealth tradition. The idea that Wordsworth's conception of language was popular or communistic has not discouraged such critics from their attachment to 'polymorphousness' and the 'immanence of the Absolute'. Such interpretations sometimes suggest a very simple division of ideas among the educated of the 1790s between revolutionaries and Church and King reactionaries. They also tend to neglect those aspects of English radicalism that were themselves somewhat narrow and intolerant. Wordsworth's own youthful republican tract, his *Letter* of 1793 to Richard Watson, Bishop of Llandaff, contains several examples of these characteristics. A Marxist critic, Michael Friedman, has found in it 'an aversion to the common people' and a simple faith in free-market economics. Certainly the *Letter* is full of ideas, often derived from Rousseau, which Wordsworth was to find repellent later in his career. Liberty, he writes, must be forsaken in revolutions because the poor are rightly in a 'state of war' with their oppressors. Politics must come before morals, and the 'general will', which is sacrosanct because it is founded in utility, must prevail over the desires of a 'few refractory individuals'. The process through which Wordsworth abandoned his republican ideas and came to emphasize the values he manifests in *The Prelude* (1805–6) is, of course, a complicated one. It is clear, however, that the picturesque was a much more interesting discourse to the cultivated, often landed circles in which he increasingly mixed than the 'general will'.[5]

In *Tintern Abbey* (1798) and elsewhere, Wordsworth describes his early, sensual response to nature, an appetite and passion for colours and forms that had nothing to do with thought 'or any interest Unborrowed from the eye'. His desire to compose and understand experience at first sought assistance in the writings of David Hartley and Rousseau, but they soon proved inadequate to the task. James Chandler has emphasized the growing importance for the young Wordsworth of the work of Edmund Burke. He shows the poet, in the intensely creative years of 1797–8, anxious to experiment and explore ideas, refusing to think 'formally and systematically', and attentive to those manners and actions that are the 'result of our habits'. Wordsworth came increasingly to read the landscape as a memorial of experience, reflecting on 'traditionary' tales and on the 'moral properties' of objects in influencing and recording events and emotions. At the same time, the poet's desire to comprehend experience reflected itself in a new kind of separation from the reality of suffering and injustice as a revulsion from narrow political systems expressed itself in other forms of abstraction. In the republican *Salisbury Plain* (1793–4) there is a simple sense of evil forces in the moral and political landscape — the sway of the

mansion over the cottage, oppression, and superstition. In 'The Ruined Cottage' (1797–8), and elsewhere, an often closely perceived distress is resolved in a manner somewhat reminiscent of Crabbe's *The Village*. All men are vulnerable, and must yield to natural processes and 'unforeseen misfortunes'. Sad experience supplies materials for meditation and a 'wise passiveness'. Much of human hope is an 'idle dream', and men must learn the 'sweet and tender lesson' of suffering and joy that can only be understood as part of a providential plan. Combined with a Christian sense of human vulnerability there is sometimes a rather Malthusian conception of nature. Chandler makes an interesting comparison between *The Old Cumberland Beggar* (1797) and Burke on scarcity, pointing to the preference for local charity over political systems, and to the idea of nature as a general provider or withholder of benefits in a world in which much is left to manners. Chandler's account is distorted by a very anaesthetized interpretation of Burke's economic writings, which does not convey their elements of ruthlessness and denial of community. It can hardly be doubted, however, that Wordsworth was alive to the contemporary debate regarding the poor, and that his work reflects its difficult and contradictory aspects. Later, of course, Wordsworth came to insist on the importance of moral activity, and of the State, in the correction and improvement of manners and of nature. In *The Excursion* he denounces false ideas of equality, noting, rather weakly perhaps, that the 'smoke ascends' to heaven as lightly from the cottage as the mansion; but he also argues that the State has obligations to the cottage. In the same poem he demands that the people should be 'taught and trained', partly so that evil should be 'rooted out'; but he insists that much of the purpose of education is to allow men to defend themselves from the onslaught of commerce. The balance of ideas in Wordsworth, between growth, freedom, control, and composition, is as complex as it is in the general tradition of conservatism he expresses, and readers have long been obliged to pick and choose between the more and less congenial aspects of his work, in which brilliance of perception is intermixed with a quality that Coleridge noted in Burke, 'an apparent versatility of the Principle with the Occasion'.[6]

In the *Biographia Literaria* (1817) Coleridge describes Wordworth's sympathy with those he depicts as that of a 'contemplator, rather than a fellow sufferer or co-mate (*spectator, haud particeps*)'. Sometimes Wordsworth is like the picturesque travellers noted by Lawson, who take a general view of a landscape and pass on, hardly noticing the human elements in the scene. Sometimes his sympathy is affected by his own social ambiguity, his fears of solitude, poverty, 'pain of heart', and labour — all things important in the poetry, and often associated, at least in others, with deep and noble sentiments. Few images are susceptible of simple analysis. Reading the *Lyrical Ballad* 'Simon Lee', for example, the reader discovers a quaintness, a sensitivity of insistent and careful observation, and a Gilpin-like dwelling on the marks of decay:

> And he is lean and he is sick;
> His body, dwindled and awry,
> Rests upon ankles swoln and thick;
> His legs are thin and dry.

In the fourth book of *The Prelude*, Wordsworth describes an evening walk along a public road and his encounter with an old soldier:

> He was alone,
> Had no attendant, neither Dog, nor Staff,
> Nor knapsack; in his very dress appear'd
> A desolation, a simplicity
> That seem'd akin to solitude.

The strangely vivid description, realized through the absence of things, is given a kind of decorative aspect in the emphasis on the quality of simplicity. Wordsworth is constantly manipulating his objects of perception and his point of view in order to define them in relation to a private world. It is, after all, 'my own, I made it'. In this expression there is an echo of the Psalmist's celebration of the divine authority over nature — 'The Sea is His, and He made it'. Wordsworth might not have intended to suggest that his powers were equal to those of God, but he certainly manifests a proprietorial interest in the admission of men and women into his mental landscape.[7]

Although Wordsworth's background was in what he termed the 'happy equality' of the Lakes, his own point of view is rarely one of equality with its inhabitants, any more, of course, than was Goldsmith's at Auburn. He would like to be part of a community, but for various reasons the community eludes him. He tends to write, as do the proponents of benevolence, from a position of detachment. The principal focus is on 'our' duties and pleasures relative to men of lesser information and cultivation. Lacking, however, the confident and clear social basis of a Price or a Bernard, Wordworth's employment of analogical and picturesque modes of thought does not always lead to a clearer point of view. The apparent promise in the early work of a breakthrough into a more comprehensive manner of observing the landscape and its inhabitants is seldom fully realized. Part of the stated purpose of the early poetry is to use the language of the poor to reinvigorate that of the polite. Wordsworth sees himself building on the work of Bishop Percy's *Reliques of Ancient Poetry* and showing that popular forms of expression can display livelier language and deeper sentiments than those current among most of the educated. The poor, Wordsworth seems to be arguing, are not only objects of sympathy or contempt; they are men from whom the polite have much to learn. Starting off as a claim of realism replacing artifice, it soon becomes clear that the sympathetic images of the poor that emerge are still being used, as in picturesque theory, to ends which include a way of elevating certain forms of the rural over the commercial, the urban, the falsely improved, and of course what might be called the democratic.

In the critical comments associated with the *Lyrical Ballads* Wordsworth notes that the language and sentiments of a large part of the population have been significantly influenced by the gathering of men into cities, the development of uniform habits in occupations (a consequence of the division of labour), and the distillation of great events through popular journalism. Men think more alike and question less; some older, more comprehensive and immediate mode of thinking is being lost, the powers of discrimination blunted, and a craving for the sensational is

replacing that of a tranquil effort of understanding. The purpose of poetry, and increasingly for Wordsworth of political discourse, is to define or highlight values that are durable and essential. He writes of the inherent and indestructible capacities and qualities of the mind and of the 'great and permanent objects' of nature and emotion that act upon men. The poet retrieves and keeps alive everything that gives meaning to experience and defines its ends, potential, and means of fulfilment. He focuses on strong and committed feelings, loyalties to persons, objects, or places, which are not the product of prudent self-concern but of intense and real emotions. Like the painter — and Wordsworth here cites Reynolds's *Discourses* — the poet combines long thought and attentive study to the 'best models' in order to perceive and illustrate what Wordsworth describes as images that are permanent, more 'consonant to nature', to 'the great moving spirit of things'. His goal is a comprehensive and 'natural delineation of human passions' that men can set against their narrow 'pre-established codes of decision'.[8]

Wordsworth's debt to the tradition of analogy is made yet clearer as his language increasingly tends to call to mind Butler and Burke. The poet 'binds together by passion and knowledge the vast empire of human society'; he is the 'rock of defence for human nature', the 'upholder and preserver' of instincts that connect men through time, common sentiment, and a spirit of sanctity. While undertaking to 'look steadily' at the subject in every particular case, he expands his mind to all the variety that confronts him and makes the individual example relate images of 'general, and operative' truth in 'men and nature'. He rectifies men's emotions and gives them new compositions of feeling that are healthy, pure and more in equilibrium with nature.[9]

The lower orders of men employ simple and forceful expressions that are the genuine outgrowth of their emotions. The narrowness of their circle of intercourse lessens their exposure to the endless, artificial distractions, compromises, and politeness of a more commercial society. Their constant experience of the works of nature increases their sense of the just proportions of things, the folly of deception and disguise. Wordsworth cites the example of idiot children, who in the 'false delicacy' of polite society are hidden away, but whom the poor easily accept, care for, and even regard as in some ways a blessing. The natural sympathies of men are stronger than conventional ideas of the acceptable and the ugly. The polite tend to display a want of comprehensiveness of thinking and feeling that contrasts with the greater strength of sentiment, grandeur of love, and depth of sympathy often found among the lower orders. The latter have not been corrupted by narrow systems of manners or by modern principles of moral philosophy founded on prudent self-interest. They do not set ideas of just calculation above the emotions belonging to the particular and the concrete. Adam Smith, Wordsworth notes, had a hatred for common language and any forms of speech diverse from that of the gentleman. His own narrow understanding of experience coincided with a period of equally shallow conception among a generation of poets who had been much less successful in painting the feelings and manners of men than the 'elder writers'.[10]

Wordsworth himself writes as a gentleman and addresses others in 'our rank in life'; he makes it clear that for the simple and natural feelings of the poor to be of

service in giving greater amplitude to the emotions of the polite they must be mediated and improved. Incidents from 'common life' and the language really used by common men are to be given a 'colouring of imagination' to make them more interesting and appetizing and to clarify the poet's conception of their meaning. Like the proponents of benevolence, Wordsworth also wishes the poor to be seen in a sympathetic light; the realism is thus to be pastoralized or purified by the removal of the low and over familiar. The vulgarity and meanness commonly found in 'ordinary life' might be 'causes of dislike or disgust' in the reader, who wishes, for his own gratification and benevolence of feeling, to see the poor as in some ways happier or more innocent than himself. The reader is not expected, as Ruggles puts it in describing the duties of a landowner, to 'hold conversation with the peasant' until the peasant has been taught his manners.[11]

In his writings on the improvement of landscape, Wordsworth's approach is broadly similar to that of Price. In an extensive piece written in 1805 regarding the proposed improvement of Coleorton, the seat of their common friend Sir George Beaumont, Wordsworth was especially anxious that the mansion should be incorporated into the wider landscape. The house, he writes in a manner recalling Switzer, should belong to the country and not the country to the house. In earlier, feudal times, there might have been something imposing to the imagination and useful to the purposes of civil society in demonstrating the dependence of a whole country on its chief. In the event, of course, such formality rarely extended much beyond the house and immediate gardens. An imposition of style on nature was, however, clearly inappropriate in post-feudal society; indeed, it seemed a substitution of little things for great when a country was dressed in a modern nobleman's livery. It was more becoming for men of rank and property to show that they had not been spoiled by good fortune, become detached from humble human feelings, or lost pleasure in the sight of the beauties of an independent nature. The great landowners should devote themselves to improvements that combine public utility and intellectual culture by seeking to create the most graceful of all landscapes, those in which tenants live in happy-looking houses amid flourishing fields. In the areas marked out as pleasure grounds, all improvement should seek to be adopted by nature; the mansion might be the 'chief figure' of a composition but it should not try to dominate the rest of it. The chief end of art beyond the immediate gardens should be to make nature accessible in a manner that avoids artificial and weedless paths in favour of walks possessing some of the unpredictable wantonness of a river or a living creature. The improver should aim only to assist nature in moving the affections by discreet guidance to particular places or images; he should not seek the gratification of an individual landowner or his class. In the midst of the sadder realities of life he should endeavour to enjoy the happiness and harmony of creatures living at ease with themselves.

It follows that the removal of cottages, or any 'unqualified expulsion' of human beings, is to be avoided as tending to the selfish 'poverty of solitude'. It cannot be ruled out, however, if some figures in the landscape do not conform to the model of contentment to which the improver aspires. It is legitimate to exclude the gross and offensive by character or occupation, since unwelcome and uncontrollable intru-

sions on the improved landscape would subvert its purposes. The end of improve-
ment is to seek opportunities for the human heart, 'under the direction of the divine
Nature', to confer value on the 'objects of the senses' by associating them with the
joys and permanent values of life. This purpose, part of the end of which is the
cultivation of benevolence, requires a considerable degree of discrete privacy and
control for its achievement. The gross and intractable are to be dealt with humanely
outside the park paling, where the general public functions of a respectable land-
owner such as Beaumont will supply ample opportunities to meet them. The end of
improvement, like that of poetry, is to distil and compose, to render feelings more
sensitive and, through a conception of the ideal, to increase a man's capacity to
manage the real. A discretionary power over limited private landscapes will tend to
stimulate such benevolence rather than diminish it.[12]

Although the language of benevolence was not necessarily as appropriate for the
Lakes as for Leicestershire, Wordsworth's *Guide to the Lakes*, first published in
1810, applies to that area many of the values of the picturesque. He acknowledges
that the traditional inhabitants of the area had achieved various effects attractive to
the painter without any apparent need for gentlemanly principles of composition;
but this, of course, was no more than a reader of Price would expect. The long-
frequented country lane is always more picturesque than that made by a self-
conscious improver. The chief enemy in the Lakes, as in Price, is the new, the
metropolitan, the commercial, and the vulgar — the half-educated or half-bred.
Wordsworth does not need to dwell too much on the possible wider political
implications of the relations of rural happiness and 'happy equality' because the
system is very localized and is anyway under threat from the same forces of
innovation that threaten the morals and beauty of the rest of England.

The Lakes were until very recently the home of an innocent and pure common-
wealth of almost perfect equality, in which independent shepherds and cultivators
were generally the proprietors of their land and were able to keep a number of cows.
Their lives had been shaped more by the landscape than it by them. They were in
large degree subservient to its powers and processes or, to put the issue more
favourably, incorporated into 'the bosom of the living principle of things'. Their
buildings had many of the same characteristics. They grew over many years reflect-
ing different necessities, changing family needs, and adaptations to the elements.
Their characteristic and picturesque recesses and projections, for example, were
intended for shelter against the obdurate elements. Their forms, the native materials
used, and the quick growth of lichens, flowers, and other vegetation on the roofs,
created bold, harmonious, and intricate effects of light and shadow that merged
naturally with the surrounding woods and fields. Well tended orchards, gardens,
and frequent cheese presses added to the air of proud but comfortable independence
and a harmonious relationship with the natural world. Simple virtues were sup-
ported by an ancient religious culture centred in small, humble, and robust churches
that displayed the 'all-pervading and paternal care' of a 'venerable Establishment'
appreciative of the particular circumstances and local needs of its people. These
churches represented the principal impact of the national culture, since Wordsworth
at this time attaches little importance to the few ancient manorial estates that could

be found in the area. It seemed that the benefices of the Church, the quality of the soil, and the pleasures of a scattered local squirearchy were insufficiently attractive to encourage the ambitious in religion, farming, or proprietorship.[13]

The Lakes had, however, long lost that complete absence of glare described by Gray; the whole area was in transition in both social and aesthetic terms. In 1805 Wordsworth had commented in a letter on the improvements undertaken by a 'wretched' attorney named Crump, who had sullied the simple and 'sweet paradise of Grasmere' with a 'temple of abomination' that stared everyone in the face. In the *Guide* he mentions numerous showy houses staring in snow-white splendour amid trim lawns and newly planted firs. The process of change that increasingly replaced the ancient and simple inhabitants with the showy and selfish was ironically accelerated by the system of private tenure. Fluctuations in prosperity during the long period of war, together with vigorous improvements undertaken in other parts of the country, had undermined the local agriculture at a time when the economy of the area was becoming increasingly connected with that of the entire nation. Similarly, the mechanization of spinning by the factory system was rendering obsolete the tradition of cottage industry which had been an important supplement to income from farming. The small divisions of property in the Lakes would quickly bring about the transformation of the area into a resort for pleasure. Wordsworth is obliged therefore to end his *Guide* with an appeal for a better taste to prevail among the new landowners in what should really be regarded as 'a sort of national property'. It was clear, however, that selfish and financial considerations would determine the future of a landscape under the control of neither the peasantry nor cultivated landowners. All that could be hoped for was an artificial system of taste to make the new conform, in some superficial degree, with the character of a traditional landscape quickly losing its tradition of creative adaptation to nature. Wordworth was invoking for the Lakes a new idea of the picturesque committed almost entirely to the preservation of external form.[14]

The more traditional picturesque expressions and habits of thought pervade much of Wordsworth's work, in both the prose, including the political writing, and in the poetry. In *The Prelude* (1805–6), for example, he offers a childhood memory of a brook, an 'unruly child of mountain birth', that had been 'box'd Within our garden' and thus left without effort and will in a 'channel paved by the hand of man'; all this was, of course, an emblem of his own condition. The passage, in some ways redolent of Price's manner of seeing improvement, also suggests some of the major differences of Wordsworth's approach. He is concerned with the mountains, not Herefordshire, and the implication, at least in part, is that the more sublime regions of nature are incapable of improvement and therefore in some way more essentially natural. The thought here is clearly concerned with self, not the general order of polite society, and the use of the term 'emblem' perhaps suggests an older, more spiritual, form of analogy between the condition of nature and of man.[15]

To some extent the differences between Price and Wordsworth may be highlighted by the contrast between the poet's admiration of the abundant variety of Hafod and his disappointment with Foxley. On a visit in 1811 Wordsworth found the place surprisingly lacking in variety, as if Price, endlessly seeking a perfection of compo-

sition, had fastidiously reworked his landscapes to a point at which they seemed subject to his control. In the process nature seemed impoverished and rendered somewhat monotonous. Wordsworth records a feeling of melancholy and a want of the 'relish of humanity' that he associated above all with mountain scenery and which depends on humanity being either absent or incorporated within the landscape. Aside from being, perhaps, a more acute observer than Price, Wordworth was more committed than the worldly squire to the broad traditions of religious analogy and natural theology, and the idea that man realizes his moral nature in the observation of the sublimities created by the divine nature. The external world, while infinitely greater than man, ultimately exists for moral and therefore human ends under the direction of God; it can serve those ends, naturally enough, only if it is uncontrolled and uncontaminated.[16]

Through the experience of a sublime nature, man discovers the essential constitution of things, the divine forms and ideas that should regulate existence. The mind is the 'mirror of the fairest and most interesting properties of nature'. Man's destiny, his nature, his comfort, and his home depend on a sense of infinitude, of hope, effort, expectation, admiration, and love based, to use Berkeley's phrase, on the 'seeking after something more spiritual'. The focus and emblem of all these instincts or desires is external nature, since observation and thought reveal the reconciliation of constant movement, decay, and renewal in the parts, with realities that are permanent, unchangeable, and immeasurable in the whole:

> The immeasurable height
> Of woods decaying, never to be decay'd,
> The stationary blasts of water falls
> . . . the sick sight
> And giddy prospect of the raving stream,
> The unfettered clouds and region of the Heavens,
> Tumult and peace, the darkness and the light —
> Were all like workings of one mind, the features
> Of the same face, blossoms upon one tree;
> Characters of the great Apocalypse,
> The types and symbols of Eternity,
> Of first, and last, and midst, and without end.*

The awesome grandeur of such landscape can shape the 'measure and the prospect of the soul' to majesty, raise it above the trivial, and transform its sense of the

* Compare this with a passage in Burke's *Reflections* (p. 79) showing, according to the 'spirit of philosophick analogy', how English constitutional policy conforms to the 'pattern of nature':

> The institutions of policy, the goods of fortune, the gifts of Providence, are handed down, to us and from us, in the same course and order. Our political system is placed in a just correspondence and symmetry with the order of the world, and with the mode of existence decreed to a permanent body composed of transitory parts; wherein, by the disposition of a stupendous wisdom, moulding together the great mysterious incorporation of the human race, the whole, at one time, is never old, or middle-aged, or young, but in a condition of unchangeable constancy, moves on through the varied tenour of perpetual decay, fall, renovation, and progression. Thus, by preserving the method of nature in the conduct of the state, in what we improve we are never wholly new; in what we retain, we are never wholly obsolete.

relative value of things. The 'changeful language' of natural processes amid 'forms Perennial' demonstrates movement and complexity within order and relation in such a way that the hills embody virtue and thoughts for the sensitive mind. The 'Spirit of Nature', the 'Soul of Beauty and enduring life', can become to such a mind 'present as a habit' in the same way as Burkean manners — they condition observation, response, and a sense of priorities without further thought.[17]

In London, by way of contrast, Wordsworth finds men enslaved by low and trivial pursuits and occupied with a perpetual flow of vulgar sensations that tend to leave their minds melted and reduced to one uniform identity without particular significance or clear ends. The poet is able to perceive this without succumbing to the low sensations because his eye has been trained by nature, that most complete form of an education dedicated to 'comprehensiveness and memory'. He 'looks In steadiness' and sees the true nature of human activities, finding in all things an 'under-sense' of meaning. He sees the parts of the composition of life clearly but has a feeling for the whole. He perceives a complete 'picture' whose interpretation would be unmanageable to the untrained eye. There has been instilled in him a habit of comprehension and composition that sees through the lines and colours of experience, the mass of contradictory, self-destroying, and transitory sensations, to grasp an essential 'Composure and ennobling Harmony'.[18]

In the attainment of this comprehensiveness of perception, the poor, particularly that uniquely natural figure the shepherd, have their due part. Wordsworth notes with gratitude that it was such men who 'did at the first present themselves' to his youthful, untaught eye, 'purified, Remov'd, and at a distance that was fit'. They stood in the picturesque composition distilled of their vulgar dimension in a separation presumably due to class distinction. The virtues of the poor were seen unalloyed and were enhanced by their beautiful setting, being observed through objects that were 'great or fair'. The poet and the poor accordingly 'commun'd' with each other and nature; all seemed in perfect harmony. From an early age Wordsworth was able to see life clearly, comprehensively, and aloof from the mean and selfish cares and coarse manners of the ordinary and crowded world in which 'we traffic'.[19]

From this vantage point Wordsworth had no difficulty in perceiving the 'utter hollowness of what we name The wealth of Nations' and of the entire commercial world. He prefers to see the dignity of individual man elsewhere than in the unnatural abstractions of modern political and moral philosophers. Such men, seeing humanity by artificial lights and determined to level truth for the sake of system, merely flatter the self-conceit of a wealthy few with pictures designed to emphasize all the 'outward marks' and differences by which society has parted men from each other. Rejecting such a wealth, Wordsworth sees among the lower classes living in the country at a level that is neither luxurious nor necessitous — the ordinary peasantry of the Lakes — an independence from vulgar preoccupations, a developed sense of community, honour, values, and skills, that enable men to live more contentedly and harmoniously with the natural order of things. As such qualities seem to diminish with wealth, it seemed clear that improvement past a certain level of comfort tends to be contrary to the fulfilment of humanity and the

moral ends of civil society. With this conclusion in mind, redolent at once of Goldsmith and Mandeville, and so contrary to the logic of political economy, Wordsworth undertook in his youth a sustained inquiry into how much real worth, genuine knowledge, and true power of mind may be found in those living by bodily labour in settled communities. The poet sought to find all those depths that may exist in souls that appear to vulgar eyes to have none, but rather to be failures, victims of prejudice, or instruments in the play of economic and political forces.

The answer takes various forms and is complicated by the fact that men can no longer live independent of the wider economic change and improvement that are constantly altering, and often diminishing, the choices open to them, particularly in the country. It seems clear, however, that for Wordsworth the traditional complaint against luxury is justified, but also that men's virtues depend on a level of material comfort and labour that is by no means one of oppression. The balance of prosperity is difficult to fix because accident or temporary distress may transform a certain level of comfort into one of despair. The inquiry is further complicated by the peculiar circumstances of the Lakes and by Wordsworth's growing conviction that the virtues of humble life are strongly conditioned by the 'grace Of culture' received from religion, and therefore from the national Church.[20]

The people of the Lakes were not as they were, or at least had been, because they lived in some 'state of nature', but because they had maintained an ancient religiously based culture that had managed to survive uncorrupted in the mountains. In 'Home at Grasmere' (1800–6), the 'true community' of the Lakes is based on complete seclusion. Each family has its mansion 'appropriate to itself'. Men are 'divided from the world', and their 'legislative Hall' is the local church. By the time of *The Excursion* (1814), however, Wordsworth's sense of this division from the world had altered somewhat. In the valley in which much of the poem is set a 'popular equality' is said to reign, but the attention is drawn to the largest house, a 'turreted manorial hall', which is the home of a gentlemanly clergyman and represents some 'sweet civility' in 'rustic wilds'. The ancient and well-maintained gardens display the

> consummate harmony serene
> Of gravity and elegance, diffused
> Around the mansion and its whole domain.

The clergyman is at once a 'genuine Priest', an offspring of a 'knightly race', and the 'father of his people'. He loves his spot of native soil and the ancient manners of the people. He admires their 'feelings unsuppest' and undisguised, and their capacity for 'strong and serious thought'. These are virtues that those in humble life may share with a cultivated landowner and priest. As Burke had put it, 'the more a man's mind is elevated above the vulgar the nearer he comes to them in the simplicity of his appearance, speech, and even not a few of his Notions.' The church, of massy, not nice proportions, and built for 'duration', is full of texts, heraldic shields, and monumental inscriptions that stimulate the collective memory and, like the humbler tombstones described in the third *Essay on Epitaphs* (1810), serve to feed local attachments, the essential tap-root of patriotism. The church itself, as always in

Wordsworth, combines ornamental interest with deep significance as a principal means for the diffusion of pious sentiment, human charity, and social love. In *The Prelude* Wordsworth expresses his sense of isolation from English society in the early years of the war with France by recording how he had felt 'like an uninvited Guest' as he sat silent in church while the simple worshippers prayed for victory. Only those who 'love the sight of a Village Steeple' as he does could understand this loneliness, to be happily resolved by his decreasing sympathy with France.[21]

The influence of the Church, the sublimity of nature, and the tenure of land in small parcels were all essential constituents of the virtuous humble life of the Lakes. Private property created domestic circumstances in which the other two influences could be most effective since, in keeping with a very broad tradition of eighteenth-century constitutional thought, the occupation of small units of property was almost always a moralizing influence. In 1801, in a letter to Fox, Wordsworth described a general decay in England of the domestic affections and of local attachments which he blamed, like Bernard, Sir William Young, Ruggles, and others, on the rise of manufactures, workhouses, houses of industry, and the discrepancy of wages and prices; he added to this list the rise of soup-shops and heavy taxes on postage. He noted how the spirit of independence, so much in decay in the increasingly landless poor of England, was in some degree preserved in the Lake counties through the system of independent proprietorship. Repectably educated men laboured daily on a tract of land that served as the permanent rallying place for their affections, memories, and hopes for the future. In *Michael* (1800), to which these remarks partly relate, the eponymous shepherd is engaged in 'endless industry'; he is strong, intense, frugal, and watchful, all to the end of working those fields and hills that are his property and which to a large extent have taken him over — they constitute the 'pleasure which there is in life itself'. There is no apparent criticism in this; in *Repentance* (1804) those who sell their property come to realize that they have lost the birthright of freedom; without their native spot they lose the unfettered sense of life that can only derive from the use and possession of land.[22]

Independence can generate a certain kind of dependence on property but, whether or not the observer considers it has been taken too far, it is principally the problem of the owner; it releases the observer of much moral responsibility. If the independence is of a different kind, a refusal to be dependent on the community, as in *Resolution and Independence* (1802), the response is of admiration and emulation. A beggar, in some ways dependent, can be valued as independent because he may retain a clear integrity of spirit and freedom and at the same time have a positive moral effect on the community. In *The Old Cumberland Beggar* (1797) the old man is seen as entirely worthy of respect and not as a social problem; the poet calls for statesmen, in the restlessness of their wisdom, not to pursue too far the desire to rid the world of nuisances. The beggar, like all the natural forms in the plenitude of nature, has a use that may be beneficial and is in any event 'inseparably linked' to the rest of creation. He is not to be 'cast out of view' like a worthless implement. He is a constant record and inspiration of acts of charity; he keeps alive kindlier moods and checks a latent selfishness that would be strengthened without objects to relieve. In language that once again recalls Butler and Burke, Wordsworth notes that the

'mild necessity of use' compels to acts of charity as 'habit does the work Of reason'. The poor benefit from the compassionate feelings they experience on relieving the beggar and from the enhanced sense of their own situation that derives from the ability to give charity to someone even poorer than they. The prosperous and unthinking benefit from a 'transitory thought Of self-congratulation' in their gift and from the stimulation of a social sense in their own lives, often sheltered in a 'little grove Of their own kindred'. The beggar's dependent position, although it carries risks, is clearly better than the real loss of independence that would arise from being a captive in a house of industry, where 'life-consuming sounds' break the 'natural silence of old age'.[23]

In *Beggars* (1802) the gypsy character is a creature 'beautiful to see' and a 'weed of glorious feature'. In the 1817 sequel to that poem, Wordsworth writes of 'wanton' vagrants displaying in all they do qualities of wit, frolic, and mirth. His beggars, like his independent proprietors, can be studied at a fit distance, meditated on, and perceived as being in some sense incorporated into the nature of things. The real problems, poetical and political, arise when the position of the poor is dependent and ambiguous, as in ordinary rural life or in the anonymous, uncontrolled confusion of the manufacturing towns. In the former case there is no equivalent in Wordsworth's poetry to the week by week supervision and relief of the poor noted, for example, in a letter of 1808 regarding the lack of wisdom of giving large sums in individual charity, since this would excite envy and 'unkindly feelings' among the many who deem themselves equally needy and deserving. It would encourage 'irregular and romantic' expectations in 'distressed persons' and lead to the recipients feeling a 'vanity and pride' above their station. It was better for everyone if the poor could be in some sense independent to resolve among themselves the distribution of scarce resources.[24]

Any problem existing in the country was likely to be exacerbated in the towns by the lack of religious sentiment, the absence of the sublime effects of nature, and the dependent status of most of the poor. Manufacturing civilization, it soon became apparent, was incapable of any picturesque composition or fit distancing between the population and the cultivated observer. The entire spirit of political economy, with its sense of man independently pursuing his self-interest, may have been systematic, but it was clearly not comprehensive in the sense that clear meanings and patterns could be detected which elevated man's sense of the ends of life. By taking away principles of order and virtue it seemed to reduce all social exchange to envy, vanity, and pride. Wordsworth's poetical and political career after *The Prelude* is increasingly concerned with an attack on political economy on one hand and somewhat uncomplicated appeals to ideas of tradition on the other.

In his pamphlet on *The Convention of Cintra* (1809) Wordsworth takes the heroic resistance of the Spanish peasantry against the French as evidence that humble men, in a great national emergency, instinctively understand the real significance of public events, while politicians and calculators of expediency merely flounder. The peasants, deeply attached to the soil of which they are themselves a growth, have an intellectual range that is confined but has the merit of never seeking to stretch itself to take in systematic forms of belief. They 'trust in nature' and their 'social inherit-

ance' of real experience. A material progress undirected by any ends but its own chases away imagination and sensibility as the determining sources of opinion and replaces them by 'Good Sense', which, while claiming to be an improved form of wisdom, is merely some men's calculation of presumptuous expediency. It involves a neglect of ends, ideas, and principles in favour of the pursuit of short-term advantage and accommodation. It replaces a broad sense of responsibility with the pursuit of sectional interest and immediate popularity.[25]

In *The Excursion* the 'proud complacency' of political economy is denounced for sacrificing many clear, ancient, and resilient values in favour of an ill-digested idea of future general prosperity of which the only sure consequence is the enrichment of a few at the expense of the sufferings of many. It is a 'bondage lurking under shape of good'. The new industrial worker is generally a slave, bound not only by economic necessity but by a strict uniformity and discipline that destroy the finer susceptibilities of the mind and body. Nature, the basis of every kind of human need, is carelessly laid waste. As factories and pollution grow, 'hiding the face of earth', and blocking out the sky with the 'smoke of unremitting fires', the issue is not merely one of taste. Disease, unhealthy air, unremitting labour, and artificial light mean the 'outrage done to nature' is comprehensive. The great difference between this form of deprivation and cruelty and those existing in the country, where many are 'vassals of her soil, Following its fortunes like the beasts', is that the rural slavery, as well as being probably less intense and unhealthy, is capable of reform within the theoretical morality of the State. The injustices are well-known, actively discussed, and often mitigated.[26]

The industrial system, as long as it was accompanied by the simple maxims of the political economy that claimed to have given it birth, was inherently destructive and could only exacerbate the ills of society the more it grew. Its entire philosophy was based on the spiritual and mental degradation of man, the perception of him as a mere insulated instrument of gain, production, and consumption:

> An offering, or a sacrifice, a tool
> Or implement, a passive thing employed
> As a brute mean, without acknowledgment
> Of common right or interest in the end;
> Used or abused, as selfishness may prompt

Such a system unnaturally denied that 'active Principle' which, like Butlerian benevolence, declares that no man can be said to be fully alive if he exists independently of others and without a sense of responsibility, purpose, affection, and a link with futurity.[27]

With no clear ends but its own expansion, the industrial system could be made to serve human nature only through direction and regulation. As this was against its natural course, a power out of itself would be required which could only reside in the State. Wordsworth reaches this conclusion by insisting, with Adam Smith, that the perceived interests of merchants and men of commerce are almost always different from the real interests of the community as a whole. To counterbalance the commercial system required not only regulation, but the introduction of a scheme of

universal education that might give each man a chance of a fuller participation
in civil society. Without 'timely culture' men would be left to drudge through
life without 'intellectual implements' or to fall into 'wild disorder'. Wordsworth
assumes as a 'law of life'

> That when we stand upon our native soil,
> Unelbowed by such objects as oppress
> Our native powers, those powers themselves become
> Strong to subvert our noxious qualities:

Clearly this natural process of improvement becomes more difficult the more
that men are absorbed within the commercial system. Education grows in impor-
tance as that system expands, in order to counterbalance its depressing, narrowing
tendencies.[28]

A clearly progressive scientific spirit, capable of directed improvement and the
increase of the charms and comforts of life through some 'intellectual mastery' over
'brute matter', had to be prevented from being a mere instrument of the commercial
system in its constant pursuit of new wants. The system itself had to be made an
instrument to serve genuine need and the traditional moral law. Left to itself it
would destroy every natural and traditional virtue — old domestic morals, pure
water, pure goodwill, honest dealing, hospitable cheer, and any joyous forms of life
'Breathing fresh air, and treading the green earth'.[29]

Casting about for a rallying point to oppose the onslaught of the commercial
spirit, Wordsworth naturally looks to the 'national property' of the English land-
scape and the instincts and experience deriving from it. As the moral and physical
landscapes were under equal threat, the object of politics was to identify those
elements in society that could defend all the 'happy images' of England: 'a green hill
over a rich landscape diversified with Spires and Church Towers and hamlets' or 'the
green-fields of Liberty in this blessed and highly-favoured Island'. By the time of *The
Excursion* Wordsworth had clearly made the clamorous decision, following Burke,
that the only sufficiently powerful safeguards lay in the great accumulations of
landed property, the remnants of what he called the 'feudal frame' of society. The
peasantry and the yeomanry were increasingly cut off from the land, and in the
Lakes the system of private tenure had become so unstable that only the aristocracy
could be seen as the sure defenders of large tracts of 'native soil'. Wordsworth's
aristocracy is conceived in ways that recall both Smith and Burke — deeply rooted
in the past, immobile, inattentive to vulgar commercial considerations and disin-
clined to many forms of improvement. Lord Lonsdale becomes the central figure in
the landscape as it is discovered that the Lakes somehow depend for their survival
on Lowther Castle, recently rebuilt in a style of symmetrical Gothic. Starting out
from a background of 'happy equality', Wordsworth comes to a position very
similar to that of Bernard and Lord Winchilsea, for example, in which the landed
interest is the proper defender of the poor and of the essential values of English
society.[30]

In their *History of Westmorland* (1777) John Nicholson and Richard Burn had
noted the remorseless increase of the Lonsdale estates, using an image familiar from

Goldsmith. Vast stretches of country continued to be 'drawn within the vortex of the house of Lowther, from age to age purchasing, and never selling again'. For Wordsworth this vortex had now become the bulwark and chief defence of English liberty. In marked contrast with such men as Bernard and Winchilsea, the 'fear of worse' doctrine of political thinking regards the evil of the innovations in society as justifying an uncritical attachment to certain other, supposedly countervailing interests. Accuracy of thought, careful analysis of constitutional principles and a rigorous criticism of the conduct of landed power, the administration of local justice, and the general state of social equity have to be put aside in order to present a solid front of opposition to change. As a result, the traditional language of constitutional and moral criticism of authority is inevitably debased, as Wordsworth draws nearer to his image of Lord Lonsdale and hopes to place not only the Lakes, but much of England, in a nobleman's livery.[31]

In 1808 Wordsworth had argued that the monotony of manufacturing employment and the crowded and stressed conditions of industrial life rendered stimulus more difficult, but also more urgent. Men without local attachments would seek change and there would be widespread 'contact with new notions'. By 1814 this understandable tendency had become a motive for a kind of panic; writing to Lonsdale in that year, Wordsworth calls for the whole island to be covered by an armed yeomanry and for the press to be curbed. The poor laws needed to be reformed, in a manner undefined, and the industrial towns assisted by the building of churches and other improvements. In 1817 Wordsworth complained of the dissolution in the previous thirty years of the 'vital and harmonious dependence' of farmer, landlord, and labourer. Everything was now settled by mere selfish calculations of profit and loss, by 'quickened self interest', and the replacement of old habits and prejudices by the maxims of financiers and economists. As in Burke the rhetoric is confused, since Wordsworth goes on to complain of the appalling weight of the poor rates on landed property, apparently ignoring the argument of many previous commentators that relief might be regarded as a mere substitute for just wages. In his *Addresses to the Freeholders of Westmorland* (1818) Wordsworth offers a completely uncritical account of the conduct of landed power by the Lonsdale family and, by extension, of the aristocracy in general. The aristocratic influence so lamented by Adam Walker as a baneful prostitution is now to be the salvation of the country.[32]

Wordsworth, explicitly following Burke, argues that the rural and the humble must depend on the magnificent, embodied in the 'sedentary power' of large estates maintained in ancient families. He employs the language of landscape gardening to endorse a traditional image of England that carefully ignores the rage of improvement undertaken in the previous sixty years by a large part of a landed interest now valued for its sedentary beauty. The rights of the people are most safe, he argues, under the shade of rank and property. The competent improver, whether in landscape or politics, considers every object he finds, however deformed, as having a prejudice in its favour. He strives to render the offensive ornamental by some slight alteration of its appearance. Too many modern improvers, however, reverse this maxim; they regard mere existence as a warrant for destruction. The ancient law of

England may be a stately oak in decay or a magnificent building in ruins, but it continues to be worthy of respect, admiration, and emulation. The great estates represent not only opulence, rank, station, privilege and distinction, but intellectual culture, protection, succour, guidance, example, dissemination of `knowledge and, of course, introduction of prudent improvements.

Burke's natural aristocracy suddenly resides completely in the political, but not as a mixed quantity that includes everything from distinguished men such as Lords Fitzwilliam and Rockingham to fops whose only function is to consume. It is offered as a uniform embodiment of prudence, elegance, and wisdom. Wordsworth confirms the point by a kind of appeal to market forces. The press is so powerful, and the nobility so visible, that any gross defects in the class would be quickly exposed to public observation. Wordsworth seeks an honourable return to 'time-honoured forms of subordination' that promote gratitude and attachment without servility, and habits of deference that enrich the heart without offending the understanding. The only cure for 'universal habits of rapacious speculation' is to see the entire nation as a great estate in which the stock of ancient virtue may be impaired, but can be given new birth by manuring and pruning under the direction of wise and cultivated improvers who are the unquestioned owners of the estate.[33]

One of the consequences of this point of view seems to be the confirmation of Burke's attempt to elevate the *idea* of nobility in such a way that it has value quite independent of personal merit; providing its external forms are magnificent it can be said to serve its purpose. The capacity of such an idea to resist the commercial spirit, except by snobbery, seems somewhat limited. The landscape it promotes may be that of islands of magnificence amid increasing squalor, in sharp contrast with the central picturesque idea of a populated and improving landscape spread romantically through the country as a whole. The works of Wordsworth and Southey after about 1810 make it clear that the idea of growing population was itself becoming a matter of great concern. However much they despised Malthus and his morality, they appear to have accepted the logic of his arguments to the extent of being proponents of emigration and colonial settlement. The sage in *The Excursion* is made to announce that Britain must 'cast off Her swarms' and seek the spread of universal civilization directed by her traditions of culture and liberty. Imperialism is not, of course, an activity always accompanied by accuracy of thought, and Wordsworth's position and Mandevillian imagery here is identical with that of such utilitarians as Robert Torrens. In his *Paper on the Means of Reducing the Poor Rates* (1817) Torrens called on his fellow countrymen to

> avail ourselves of the resources placed in our hands by the vast extent of unappropriated colonial territory . . . The hive contains more than it can support; and if it be not permitted to swarm, the excess must either perish of famine, or be destroyed by internal contests for food.

Torrens was taking up imagery used by his master Jeremy Bentham in the *Manual of Political Economy*, mainly written in the 1790s. Bentham generally took the view that overseas possessions were harmful both to indigenous populations and to colonial proprietors. It was nevertheless clear to him that the interests of mankind

as a whole would be best served by the colonial activity of the British rather than less civilized nations. It was desirable that emigrants

> should go forth from the nation whose political constitution is most favourable to the security of individuals; that the new colonies should be swarms from the most industrious hive; and [that] their education should have formed them to those habits of frugality and labour which are necessary to make transplanted families succeed.

Wordsworth and the utilitarians both contributed to the process in which the intense scepticism regarding overseas adventures that characterized the major literary minds of the second half of the eighteenth century gives way in the early part of the nineteenth to a vaguely defined idea of expansion and therefore of 'appropriation' on an unprecedented scale.[34]

* * *

When not discussing colonial issues, Robert Southey, who was generally much less insistent than Wordsworth on the originality and universal significance of his work, was perhaps more successful than the latter in linking his political theory to recent traditions, such as the philanthropic movement of the 1790s. His *Letters from England* (1807) are a comprehensive account of change that may be easily dismissed as the politics of the picturesque, but they have a coherence from drawing upon a large body of criticism of improvement in which the visual and the moral had long been perceived as inseparable. At Durham he was horrified at the levelling of the Cathedral churchyard — ordered, incidentally, by Bishop Barrington — insisting that the new, smooth lawn was the creation of a sacrilegious taste that destroyed every feeling of the mind connected with reverence, death, and immortality. At Trinity College, Oxford, he was delighted by the ancient yew hedges, so perfect in their curious art and so striking for the growth and care of generations, but feared that they would fall victim to the modern rage for the destruction of the old without any comparable ability to create objects of beauty. At Birmingham he was appalled at the iron furnaces, not only because they were ugly, but because men seemed to be sacrificed body and soul in infernal occupations and surroundings that left them looking as if they had been created for nothing better. He described landscapes rendered hideous, black, smoking, and so blasted that they seemed to have been made incapable of any improvement or any purpose that could elevate humanity.[35]

The domination of the landscape by factory chimneys, rather than by the traditional and adorning steeple, and the replacement of cottages by blackened brick hovels, seemed to offer a very curious idea of improvement. Southey saw men and women destroyed in health by pollution and overwork and injured by machines in circumstances that seemed cut off from the legal and moral regulations that might mitigate the effects of greed in rural society. Above all, he was horrified by the sight of large numbers of children being employed throughout the night to take advantage of their low cost and manual dexterity, their hands 'playing' in the machinery. Outside the towns nothing was escaping a dramatic spirit of change in which every rank of society seemed to be becoming commercialized, as customs, dress, speech,

and manners became more uniform and more concerned with the expedient and the temporary. Many estates were being bought by speculators and money men without local attachments, family customs, or any 'feeling connected with times and seasons'. They preferred their new poplars to the oaks they had cut down or never thought to plant. Many of the older gentry were happy to join in this spirit of improvement, sacrificing their elm avenues and yew hedges to the general love of uniformity.[36]

In his subsequent work, notably in the long essays *On the State of the Poor* published in 1812 and 1816, Southey developed his criticism of political economy without seeking to deny the difficulties of rural England. The discussion centres on the real nature of wealth, a theme which had been central to Bernard's work and was to be taken up more familiarly by Coleridge. Southey admits that an unregulated industrial system, founded on greed, looseness of principle, and half-knowledge, could be expected to expand national prosperity, activity, and enterprise, and generate whole classes of rich men, but it would be at the cost of a considerable increase in vice, poverty, and disaffection. Indeed, it would leave many in civil society in a worse state than out of it, subject to law without benefits and alienated by the sight of others' prosperity. This was the likely effect, not so much of improvement or even of the manufacturing system, but of the view of things promoted by vulgarized versions of the work of Adam Smith, in which the success of the nation was identified with the profits of money men. Southey was, for example, insistent on the need to improve machinery in order to replace all child labour, but doubted if an unregulated system of greed would consider this an early priority. The chief problems of society were connected with the dominance of an idea of man, not as a moral being, but as a manufacturing animal, an instrument of gain, worth what can be extracted from him and therefore valuable in inverse proportion to his human cultivation.

The rural is the only generally available counterbalance to commerce owing to the potency of its customs and local attachments, and because in the country men can see in the order of nature, and in ancient institutions such as the church and churchyard, ideas relating to a wider sense of tradition and human responsibility. Southey is emphatic regarding these values, even though he is very clear that a modern spirit of speculation had entered into agriculture before the recent growth of the manufacturing system, expressing itself in the conduct of enclosures, the engrossment of farms, and the virtual destruction of the peasantry. With references to such sources as Kent, Bernard, and Lord Winchilsea, Southey emphasizes the distressed state of that most useful and respectable class of men, the cottagers or, as he describes them, the yeomen, now reduced to day labour. Improvement had increased total output, but it was not clear whether the markets were better stocked as to quality and variety of produce. For some products, including corn, there was less competition and more withholding. A good deal of effort and money had been devoted to the self-indulgent and cruel breeding of miserable and monstrous animals. These 'triumphs of art over nature' required constant attention until they were mercifully butchered. The improvement of man was, however, totally neglected, and with the decline of cottages the number of gaols, workhouses, and houses of correction was inevitably increasing.[37]

The more enterprising part of the rural population was being detached from the soil and many of those that remained, notably the day labourers, saw their children entailed into an inheritance of poverty. Their income was barely sufficient to keep them from the workhouse and certainly would not allow them ever to farm independently. In one of the classic images of the Tory view of landscape, Southey notes that the 'crooked hedge-rows' of traditional agriculture had disappeared along with the 'children of the soil'. Both were cut down like old timber and the moral scene was as injured as the landscape. The old, independent class of yeomen, who had often been enabled through the grammar schools to educate their children into taking some of the most important functions of the community, was sacrificed to the commercial spirit.[38]

Southey's wider view of rural improvement clearly distinguishes him from Wordsworth and his sense of a remedy, at least at the time of his 1816 *Quarterly Review* article, is a little more concrete than blind dependence on a branch of the aristocracy. He appeals to the same principles as Bernard, hoping that the commercial spirit could be regulated by the State and that the country could be reinvigorated by the application of the cottage and cow approach to the rural economy. If made general, such a plan would have the advantage of making the 'very face of the country' both wealthier and more picturesque. Southey's position, like Bernard's, was becoming increasingly difficult. The diverse radicalisms of the day, notably those of Thomas Spence and William Cobbett, were talking of ways of redistributing the land and altering the basis of society through programmes of revolutionary action or parliamentary reform. In Southey's view, such forms of action would simply accelerate the rate of change and general decay. With the emotional hatred of change he shared with Cowper and Burke, Southey felt obliged like Wordsworth to consider the country as an ancient estate. He writes of men whose 'names and families are older in the country than the old oaks upon their estates' and 'who possess the habitual and hereditary respect and confidence of all about them'. This link with the past, however tenuous, was encouraged by the beauty of the estates and by Southey's acquaintance with landowners such as Lord Winchilsea, who could be supposed to share his ideas of improvement.[39]

<p style="text-align:center">* * *</p>

Acquaintance with Bernard and Winchilsea also influenced the opinions and imagery of Coleridge, who, like Wordsworth, emphasizes the importance of a creative perception of political issues. The true statesman possesses a capacity for deep philosophical understanding comparable with that of the poet, whose genius, according to the *Biographia Literaria* (1817), 'reveals itself in the balance or reconcilement of opposite or discordant qualities'. It 'blends and harmonizes the natural and the artificial', but 'still subordinates art to nature'. In an important body of work published between 1809 and 1818, Coleridge confirms a tendency to appropriate the political landscape of England to an ideal of the country house. At the same time, he points to an imaginative understanding of the State as the most important embodiment of national values and the central point of balance and reconciliation of the

opposing interests of an increasingly fragmented social order. The following account is based on *The Friend*, first published in 1809 and extensively revised in 1818, on articles in *The Courier* of 1811 and 1814, and most important, on the *Lay Sermons* of 1816 and 1817. The first of the *Lay Sermons*, 'The Statesman's Manual', was addressed to the 'Higher Classes' as the traditional rulers of England; the second, based on the text 'Blessed are ye that sow beside all waters!', was addressed also to the middle classes.[40]

'The Stateman's Manual' was sent, with a philosophical covering note, to the Prime Minister, Lord Liverpool, who seems to have tackled Coleridge's work but confessed that 'I can not well understand him.' The pragmatic Liverpool — Disraeli's 'Arch-Mediocrity' — must have been seriously taken aback by Coleridge's romantic conception of the English nation. The State and its ancient institutions are to be considered as a richly planted and noble estate, inherited from brave and vigorous ancestors and strongly fenced about by their sinewy arms and dauntless hearts. The image, influenced clearly by the long experience of war, is intended to suggest a continuity of tranquillity within the confines of the park. The skills required for the management of the estate are quiet duties; constant care, gradual improvement, the cautious, unhazardous, experienced labours of the industrious and contented gardener. He is full of traditional wisdom and practical knowledge in pruning, grafting, and removing from the leaves and fresh shoots the slug and the caterpillar. The country house is the central idea in a State in which the reciprocal dependence of crown, aristocracy, and minor proprietors creates and sustains an unbroken chain of connection that preserves the national union. The people live under the noble, delightful, and attentive shade of the ancient oaks of the estate. They are perceived, as in Burke, as most contented and harmonious in connection with their natural chieftains, whom they respect and to whom they are happy to defer. The proprietors of the estate are in turn elevated and softened in their manners by this regard and by the sense of responsibility it promotes.[41]

For this image to have any hope of being sustained, and of embracing the entire State rather than being a merely ornamental relic of its past, it was clear that the commercial spirit had to be held in check. In particular, political economy had to be regarded as a theory of production and distribution rather than as an image of civil society. Coleridge goes further than Wordsworth and Southey in arguing that economic theory had been of considerable value by demonstrating the general imprudence of State intervention in the setting of market prices. The cost of commodities essential to human existence was, in the great mass and in normal circumstances, best regulated by the mere instinct of self-interest seeking to supply the market at the highest price. By spreading the dearness of provisions over a larger space and time, such self-interest could prevent the degeneration of scarcity into famine which had been the not uncommon fate of 'our less commercial forefathers'. The ancient moral prejudice against corn holding was in many cases merely mischievous, but Coleridge, prepared to allow no merit whatsoever to Adam Smith, argues that this was no modern discovery but had been demonstrated shortly after the 1688 Revolution by Sir Josiah Child. It was right, in short, that England should aspire to be a busy commercial nation. It should, however, also seek to be something better

than that. The more complex ends of the State and of humanity could not only not be realized through political economy but were indeed usually in conflict with its principles.[42]

Groups of men, or indeed a whole culture, seeking merely commercial ends and talking a language based on the vulgarization of political economy, would fail to achieve even their own limited purposes. A market created by men of little general information and unimproved morals would be subject to great cyclical fluctuations through a general ignorance of the history and nature of cycles of supply and demand. Large quantities of capital would be foolishly lost and many skills dissipated in the sudden failure of industries. Many citizens, feeling themselves victims of fraud and folly, would be alienated from civil society. The constant observation of unprincipled and ignorant speculation, and the vanity and expense accompanying apparently successful folly, would undermine men's sense of the value of honesty and industry. It would weaken established institutions, charities, the landed interest, and all those living off their capital, offering the temptation, or the virtual necessity deriving from increased prices, of participation in the general rage of speculation. A spirit of easy gain would become incorporated into the national character, lower the quality of judgement, and discourage a prudent concern for the future. Such a spirit would contaminate even the powers of imagination necessary to creativity, not only in the liberal arts but in the applied sciences.[43]

The skills of organization and of reconciliation of differences between the various groups in society would be undermined by a predominant spirit of self-interest divorced from a sense of the public good. Greed, presumption, and a repulsive seriousness of purpose mixed with an underlying levity of spirit, would enter into all forms of manners and social exchange. The decay of a sense of connection would give free reign to disorder and crime, unchecked by any general morality, religion, or respect for old institutions. The endless proliferation of new wants, and expectations exceeding the consistent productive capacity of an increasingly cyclical economic system, would generate constant tensions. Ignorance of history and the habit of thoughtful collation of past, present, and future would undermine the prediction of consequences of actions, the capacity to assimilate change, and indeed all attitudes serving a well-founded and consistent idea of improvement.[44]

Coleridge argues that the habits of commerce, involving a kind of appropriation of the outward world to the purposes of sensation, appearance, and fleeting enjoyment, are contrary to the finer nurture of humanity that seeks common ground between nature and man, finding in nature an image and source of permanence, identity, and connection. Man, inherently disturbed and restless in his nature, 'sallies forth' into external nature to perceive the originals of the forms innate in his own intellect — powers of harmonious organization and the realization of the individual part through conceptions of dependence and unity. The comprehension of 'nature in himself', the laws of his own existence, is inextricably related to the recognition of 'himself in nature'.[45]

The destruction of external nature is an aspect of a whole system of misconception that dominates the commercial mind — the confusion of wealth and well-being, the reduction of political discourse to statistics and the 'despotism of finance', the

substitution of vanity for manners, cost for value, and value for worth. A heartless sentimentality and empty nostalgia coincide with an ignorant contempt for antiquity and a neglect of moral self-discipline. Knowledge, whenever it is intricate, contradictory, and of no immediate utility, is destined for 'plebification', and civilization, seen as the triumph of mechanism over nature, subverts cultivation.

The ends of cultivation and real improvement cannot be realized by a government directed by the narrow maxims of political economy. Coleridge seeks to define countervailing, humanizing forces in the community and finds them, as had Burke, in certain prejudices and instincts not easily subject to rational analysis. The most important is Christianity, with which the values of political economy can have little to do. Among the other most important are traditional customs, local attachments, and family loyalties. Coleridge, pursuing the image of the 'noble estate', includes with these latter ideas the 'ancient feeling of rank and ancestry' and 'willing reverences, and habits of subordination almost naturalized into instinct'. Another essential counterbalance is a learned and philosophic public occupied with serious discussion of ends and the unmasking of all kinds of presumptuous assertion of private interest as public good. A philosophic public is necessary to the commitment of at least some part of civil society to permanent and universal values, and a sense of historical continuity that sees the rights and duties of citizens as social and hereditary privileges and obligations. These are not to be subject to the whim of any particular age, but valued as a consistent link between generations.[46]

The purposes of the State and of positive law go beyond those allowed by the vague determinations of political economy, such as national defence, justice, and public works. The State has a function of reconciliation and composition in checking the free expansion of the commercial system. It must seek to oppose the encroachment of that system on what is its own 'inalienable and untransferable' property — the health, strength, honesty, morality, and 'filial love' that are to be considered the natural rights of men in civil society. The spirit of the State must be strong enough to be able to enlighten and counteract the spirit of commerce, which must consent to regulation and be made responsible to the State in terms of duties and trusts. The State must ensure a level of subsistence and comfort necessary for health, and a degree of independence sufficiently ample for poverty or ignorance not to be involuntarily entailed on any of its citizens. It must occupy itself with the cultivation through education of its members, including their instruction in rights and duties. It must discourage those opinions and interests that equate riches with well-being and the domination of nature with enlightenment. It must defend what Coleridge terms the 'Nationalty' — all those institutions and national properties, including the Church, which further its own ends and require its sustenance. It must resist the tendency of wealth to accumulate in unwieldy masses through monopoly, the undue favouring of the commercial interest over the public, and the mismanagement of public and private credit, particularly in the incompetent use of the resources of the banking system.[47]

The ends of the State, which had depended on a strong landed interest, had been undermined by the great commercial cycle that had expanded during the European wars and collapsed after their end. The vast generation of wealth, in circumstances

in which apparent necessity and economic theory had acted together to reduce the level of regulation of the productive system, had its usual consequences in folly, presumption, extravagance, and a blind passion of speculation. Much of the landed interest, including some of its humbler members, had fallen into expensive habits in seeking to maintain their position within their class and relative to the money men. The natural tendency of the landed interest to decline had been accelerated by the distance between their ambitions and their acuity. The commercial men, having more knowledge and talent in the aggregate, had increased their relative strength in the community. The countervailing capacity of the country had been further weakened by the decline of the peasantry. In language that recalls the whole tradition of anti-improvement, Coleridge writes of those who regard the beauty of their prospects as deformed by the sight of another's property, a meadow not their own, or a field being ploughed by its 'humble owner'. Such men, overawing bidders at auctions, promote those large farms which, from grandiloquent notions of self or calculations of profit, create a country of landless labourers sustained by the parish.[48]

In common with other observers, Coleridge was not clear whether such calculations were justified even on elementary principles of accounting, taking into the reckoning poor rates, land values, and the quality and quantity of production. Politically, however, they were clearly disastrous, as they undermined the real strength of the landed interest and the morals and well-being of a great part of the population. Unfortunately, there was no alternative compatible with the rights of property, other than encouraging the better sort of landowners to regard the short-term marketable growth of their estates as subordinate to the 'living and moral growth' that should remain on the land and be seen in a 'healthful, . . . high, and warm-hearted tenantry'. Once again the argument looks to Kent, Bernard, and Lord Winchilsea, who, as a major and intelligent landowner, was able to show that his methods of improvement were fully compatible with reasonable rents. Coleridge quotes Winchilsea's complaint of the dislike of farmers to rent out land to labourers, since it tended to make them more difficult to control. Accordingly, Winchilsea notes, the social ladder had been broken and with it the hope that separated the industrious labourer from the slave. This reluctance was a clear argument for large quantities of land remaining in more liberal hands than those of the farmers.

Coleridge summarizes the argument by insisting that the only security of respectability and political influence for the landed interest was the repopulation of the landscape and its management on a long-term basis of considered improvement. If they chose to compete with the money men on the latter's own terms they would simply weaken and demoralize themselves. Seeking ever-higher returns to support an artificial style of life, they would become the dupes of projectors, jobbers, and speculators in property. On the other hand, a landed interest practising a rural economy that ensured the continuing attachment of a large body of skilled and respectable tenants and labourers would have interests identical with those of the State. It would feed its citizens, improve their condition, preserve their morals and independence, and encourage the development of all the faculties essential to a

rational and cultivated humanity. The noble estate of England would be picturesque, contented, and under the clear influence of its traditional proprietors.[49]

The 'True Picture of England'

The idea of the 'noble estate' developed by Wordsworth, Southey, and Coleridge was formulated during a long period of war characterized, among many other things, by an intermittent effort to repress political dissent on the part of successive British governments. All three writers had felt themselves, at various times in their careers, possible victims of attention by the legal authorities; the vigour of their conservatism was not, therefore, entirely disinterested. A series of Ministers had sought to limit the political freedoms of many of their fellow citizens at the same time as they liberalized many of the constraints on commercial men. They had relied for their legitimacy in the mind of the public on such texts as William Paley's *Reasons for Contentment*, addressed to the 'Labouring Parts' of the community, or on the moral tracts of Hannah More, whose honest labourers go about singing

> I'm apt to believe the distress which is sent
> Is to punish and cure us of all discontent.[50]

In the political climate of invasion threats and conspiracies even Hannah More could, at one point, be suspected of Jacobinism. British governments from Pitt to Lord Liverpool hardly represented an ideal value that could be defended with absolute moral conviction. Tories persuaded themselves that they were defending ancient constitutional values which had rarely been fully embodied in particular politicians. To some extent they were playing the familiar game of much eighteenth-century constitutional writing, in which the lavish praise afforded to the idea might serve as a criticism of the practice. At the same time, governments and landowners offered incentives as well as threats — sinecures, respectability, and comfortable accommodation. The 'fear of worse' doctrine was also an important factor, not only because of a possible French invasion, but in terms of the perceived nature and consequences of evolving Whig and radical ideas. A large part of political discourse was occupied by the platitudes of political economy and some ideas being diffused among the people seemed dangerous, in both the short and the long term. The increasing dominance of political and economic theories based on the destruction of all traditional power seemed to make it necessary for Toryism to become, in some ways, simply conservative.

Many radical insights were not particularly new, as when Thomas Spence likened landowners to the giants 'in Romances' who spread 'Terror and Destruction' all around. Even Tom Paine's central observation that in English society the bulk of men were 'degradedly' thrown into the background of a 'human picture' dominated by the 'puppet-show' of state and aristocracy only serves to identify, from a different viewpoint, something clearly acknowledged by Burke. The unpolished style of argument and imagery in his *Reflections*, much noted by contemporaries, served in some ways to accentuate the distance between political discourse and the

'Corinthian capital' that is the central image of Burke's idea of aristocracy. He sees much of public life as a puppet-show in front of a sublime edifice of tradition. The problem of radical writing for the Tories was that it seemed to make easy deductions from the contradictions of tradition in favour of a simple idea of change as being inherently beneficial.[51]

Much radical writing displayed progressive certainties not unlike those of the vulgarizers of political economy. In the early 1760s Joseph Priestley had published two grammatical treatises in which he argued that the 'best forms of speech' will always establish themselves 'by their own superior excellence' in precisely the same way as a 'manufacture' for which there is a 'great demand'. Market selection will bring both to 'all the perfection of which they are capable'. This kind of language permeated a large part of radical thought in the next half-century. In *Political Justice* (1793) William Godwin announces that 'Sound reasoning and truth . . . must always be victorious over error . . . The vices and moral weakness of man are not invincible: Man is perfectible, or in other words susceptible of perpetual improvement.' In an essay 'On English Style' (1797) Godwin insists that all English before Johnson was written in a 'relaxed and disjointed style', more resembling the 'illiterate effusions' of the rustic than a man of 'delicate perception and classical cultivation'. Men must acknowledge and reject the Gothic prejudices that limit their freedom in favour of a modern enlightenment which, despite the allusion to Johnson, eschews conventional religious and social ideas. Liberal principles of commerce and free exchange of enlightened opinions will bring about social justice and eventually abolish even death. Tom Paine, in the second part of *The Rights of Man* (1792), was equally convinced of the importance of free trade in the eradication of prejudice:

> If commerce were permitted to act to the universal extent it is capable of, it would extirpate the system of war, and produce a revolution in the uncivilized state of governments. The invention of commerce has arisen since those governments began, and is the greatest approach towards universal civilization that has yet been made by any means not immediately flowing from moral principles.

The rhetoric here merges very clearly with that of political economy.[52]

Radical plans for the redistribution of land did not seem much more attractive, from the point of view of either their goals or the methods needed to realize and sustain them. Like Paine and Godwin, they assumed a rational nature in man which could be discovered by political activity that exposed the follies of the traditional order. When William Ogilvie had published his plan for a nation of 'independent cultivators' in 1781 he had not looked to 'great and sudden changes' but for a 'gradual progressive innovation' which would eventually mean that 'each individual of mature age shall be possessed of an equal share of the soil.' The wealthy would concur in this as they came to perceive deepening social antagonisms and would be 'awed into wisdom and humanity by the impending gloom'. The programme of Thomas Spence was more openly revolutionary. The very Christian-sounding goals of 'perpetual and perfect Peace' and 'perfect Freedom and Felicity' required the complete destruction of the authority — cultural, economic, and political — of the landowners. Spence's popular audience was to recognize that the 'scene of Oppres-

sion and Woe' in which they suffered could be ended only by the abolition of private property in land, which was an arbitrary power with its origins in violent 'conquest or encroachment' on the 'common Property of Mankind'. The tyranny of the landowners was not mitigated by any virtues associated with their opportunities for leisure, any 'arts and callings useful in Society'. The leisure merely provided opportunities for conspiracies against the people. Being founded in violence, the authority of the landowners could be preserved only through systems of oppression. Land must be appropriated by the people and vested in democratically controlled parishes. Men of all classes would have to forget the idea that the 'completion of all earthly felicity' consists in the 'possession of Landed Propriety' or of a 'snug Estate'. Spence was not very clear as to how equality would be achieved or sustained, except through some vague goodwill and use of a higher reason. Political circumstances would be altered and then influence human nature in their favour.[53]

William Cobbett was perhaps a more complex figure than any of his predecessors. Southey, writing on parliamentary reform in the *Quarterly Review* in 1816, saw Spence as a foolish but wholly honest idealist who had been absurdly hounded by Government; Cobbett, on the other hand, was a wilier, more mischievous, figure. Southey's point may be clarified in a reading of Cobbett's 'Address to the Journeymen and Labourers', written in the same year. It is in part a very traditional document, more so than Southey in its rejection of the idea of emigration as a cure for domestic social ills: 'No: you will not leave your country. If you have suffered much and long, you have the greater right to remain in hope of seeing better days.' The threat of Jacobin confusion, so dear to the rhetoric of establishment politicians, was not a real risk in England and never had been, because, unlike the French, the English had 'settled principles' of government. 'We have great constitutional principles and laws,' writes Cobbett, 'to which we can refer, and to which we are attached.' When Cobbett reminded the labourers that the country would be a wilderness without the 'assistance of their hands' he was declaring something fairly moderate compared with the clergymen and poor-law pamphleteers of the eighteenth century who had described all wealth as having its origin in those hands. The great difference in Cobbett's position was that such men were talking among themselves, addressing the polite. Cobbett was seeking to communicate directly with the labourers, and in that way trying to establish a new mode of politics. In May 1816 Cobbett described how he had been studying a volume entitled 'A Picture of England' which, with its 'views of Country Seats and of fine hills and valleys', would once have afforded him great pleasure. He had come to despise such images in favour of the 'true' picture of England, that of the 'great body of the people', the real 'English nation'.[54]

Cobbett's work on grammar argues that a popular culture must replace the classical artifice of 'our insolent, high-blooded oppressors'. Conventional grammar, as taught in the English educational system, merely served to 'inculcate passive obedience and softly promote the cause of corruption'. Existing language and landscapes had to be deconstructed, and history rewritten to reveal a popular truth. Cobbett's *History of the Protestant 'Reformation'* (1824–6) offers a version of the hospitality myth in which the great monasteries were centres of equity and support

for the poor until they were dissolved and their lands appropriated for private use. Landed property is seen as iniquitous in its habits and its origins; it could not, therefore, offer any resistance to oppression, either of a traditional kind or in the newer forms arising from the expansion of the commercial system and the values of political economy. Only democratic activity could serve those ends, and would inevitably do so once it was organized.[55]

In much of *Rural Rides* (1830) Cobbett confirms a rejection of benevolence in favour of a democratic viewpoint. The apparently differing opinions and values among the ruling classes were in reality all 'tarred with the same brush', all conspiring in the cruel, unfeeling yoke imposed by lords, gentlemen, and clergy. The answer was not improvement of the established order, but political and constitutional change — 'felling the tree' of the system. Yet Cobbett's attitude to the different landscapes he describes is complex, as he reflects on the appearance of villages, the quality of cultivation, the relations of landlord, tenant, and labourer. It was clear to him that the situation of the labourer was at its worst in areas of rich fertility devoted almost entirely to corn. High returns had encouraged the maximization of private interests and the grasping of the entire country by a few. Cobbett's taste for more ancient, mixed landscapes was founded in a conviction that the labourer was more comfortable where there were woods, forests, and wild places, hedges, commons, and grassy lanes. A diverse and well populated country also encouraged domestic manufactures and horticultural activities, including some private walled gardens, which depended on a ready local market.[56]

Cobbett was not dogmatic as to the nature of new proprietors of estates, for sometimes they were very clearly an improvement on the old. He delighted, however, in exposing the ignorance and pride of those, such as the banker Alexander Baring, who imagined that plantations could be made to yield as readily as the funds. Baring had planted his trees too large and they were dying off, sterilizing the soil, and displaying a 'shocking want of taste'. Cobbett's contentment when he finds estates occupied by old families 'worthy of possessing' them emphasizes the Tory aspect of his radicalism. He had particular praise for the exertions of the Duke of Richmond and Lord Egremont in Sussex. Like Gilpin at Drumlanrig, he delighted in an unusual 'appearance of comfort' among labourers sustained by the benevolence of a great landlord; the cottages were comfortable and the gardens well-stocked. Such scenes sometimes encouraged Cobbett in the belief that there might be the basis in England of a 'coming back' to the old system, even to the 'ancient small life and lease holds and common-fields'. In a phrase borrowed by Ford Madox Ford a century later, Cobbett takes comfort in noting that 'the land remains' and imagines a return to a mode of life that existed before the 'shutting out of the labourers from all share in the land'. The greatest threats to this felicity were an economic system based on paper credit and a set of proprietorial attitudes that expressed themselves most violently in increasingly savage game laws. With the help of quotations from Blackstone, Cobbett insists that these laws had reached such a point of oppression, both in the letter and in the application, that they now undermined a good proportion of the ancient constitutional rights of Englishmen.[57]

The tension in Cobbett's work between democratic and traditional values remained until the end, and was perhaps accentuated in the last full year of his life, 1834, under the influence of his extensive tour of Ireland and the passing of the New Poor Law. Both experiences seemed to underline the increasing lack of concern among Britain's rulers for the rights of their fellow citizens. He was astonished by the potential abundance of Ireland, imagining there the creation of scenes of felicity comparable with some that could still be found in various parts of England. Such scenes, he proudly declared, appealed to the vulgar rather than the improved taste; they were of 'coppices, trees, corn-fields, meadows, . . . gardens, flowers, neat houses' and a people 'well fed, well dressed, and able to work'. Intelligent husbandry and a more equitable use of resources could realize such landscapes throughout Britain without requiring the expensive improvement of unproductive land and invading the rights of 'the grasshoppers, the efts and the lapwings'. A widely diffused cottage economy would encourage the growth of an intelligent, moral population who would never be ignorant, even if they were illiterate, owing to the great variety of skills they would practise and the wisdom they would receive from nature and tradition. Like the Tories, Cobbett lamented the disappearance of the once 'happy yeomanry' who had regarded their landlords with gratitude, veneration, and 'willing and cheerful obedience'. He regretted equally the passing of what he terms the 'small country gentlemen', who had influenced for the better the manners and morals of the 'common people' and exhibited a 'standard of character' which all men could 'look up to'. They were the 'natural magistracy' of the country and exercised a 'parental sway'. Now 'all is changed', and force and social competition have replaced 'traditionary respect', 'consideration one for another', and 'ties of mutual benefit and kindness'.[58]

This was a very familiar language and, like many of his predecessors in its use, Cobbett would have liked to believe in the role of aristocracy as a counterweight to the innovations that had undermined the old social order. He writes of exposing the mere placemen while giving honour to those 'to whom honour is due'. He hoped that intelligent noblemen such as Lord Radnor could be cured of their flirtations with the new through an appeal to their 'good sense and benevolent disposition'. Many had given credit to the theorists of political economy through a submission to intellectual fashion rather than conviction. Unfortunately, Cobbett's visit to Ireland suggested, even more than in England, the limitations of benevolence among some at least of the great landowners. Even Lord Egremont, an admirable landlord in England, appeared to be a careless absentee in Ireland.[59]

The failure of the House of Lords to reject the New Poor Law seemed to Cobbett to be an act of constitutional dissolution, since it meant that his fellow citizens were henceforth to be deprived of the ancient right of maintenance described by such legal theorists as Hale and Blackstone. Lord Brougham, the chief promoter of the New Poor Law, was fond of declaring that the ownership of land implied no duties and the mere state of citizenship no economic rights. Cobbett argued that without such rights, effectively ensuring each individual an interest in the wealth, security, and stability of the country, civil society was dangerously unstable. It was, as

Wordsworth was to argue in his 1835 *Postscript*, both morally and constitutionally absurd for the government to demand allegiance in exchange for fewer advantages than could be anticipated in a state of nature.

Cobbett had devoted much of his career to assaults on the power of the money-men, but the acquiescence of the Lords in measures of oppression led him to write of the necessity of a 'general confiscation' and even to encourage popular support for the commercial interest against the landed in order to restore older laws. His position was contradictory and unstable, as his critics were keen to point out, but it was difficult for it to be otherwise. Like Bernard, he was certain that traditional institutions and social bonds were being deliberately destroyed by those in authority. Cobbett's *Legacy to Labourers*, published towards the end of 1834, was probably the most radical or democratic of his works.[60]

Rural Rides appeared in the same year as Coleridge's *On the Constitution of the Church and State*, in which values that may be described as Tory are seen as a necessary check on virtually every increasingly fashionable mode of thinking, including Cobbett's. The emergence of a wholly commercial civilization, the appeal of which had corrupted much learned thought, threatened to destroy all traditional culture, including those popular virtues on which Cobbett based his views. It could not be opposed lightly or by a simple appeal to democracy, particularly as 'the People' were increasingly located in the industrial towns, where they had known few values other than those imposed on them by their commercial masters. Opposition to the civilization of political economy would require an extraordinary renewal of energy in all those institutions in which some powers of cultivation, continuity, and community had always existed in England, almost independent of the will of many in authority — the Church, the landed interest, and the constitution. Any hopes for the improvement of English society would depend on a clear separation of traditional institutions from the entire logic of the commercial spirit that had corrupted them. It was becoming increasingly apparent, however, that such a revival of older virtues was highly unlikely. It will be noted later how Coleridge's Toryism, like that of Cobbett, tended towards the end of his life to imply the need for new checks and balances in the community. By 1834, the year of his death and of the New Poor Law, Old England had largely ceased to exist.

6

The View of Donwell Abbey

No one knows the labourer.
 George Sturt[1]

With England seen as a noble estate and the landed interest in general as its ancient defenders, the image of a country house amid old plantations and well-managed farms easily comes to convey a wide range of sentimental and political meaning. It seems to represent the real England, besieged by ugly, alien, and inhuman forces of change. The Tory view of landscape, which uses a traditional moral and constitutional language to support an order under assault, seeks to convey the old arrangements in ever more attractive terms. The distortion or moral improvement of the old becomes a patriotic duty for fear of worse, and the traditional country house is increasingly portrayed as an ancient centre of order, cultivation, and disinterestedness. Its sentimental importance naturally increases as its real power declines, and as the country and its symbols are increasingly appropriated by the ambitious commercial interest. Ironically, perhaps, the Burkean insistence on the value of outward form as the essence of social control facilitates this appropriation, since a country house and chivalric orders, titles, and armorial bearings can all be acquired, and manners and habits can be emulated, at least in the second generation. In the early decades of the nineteenth century, the inexorable rise of the commercial interest coincides with an increasingly diffused snobbery regarding trade and a devaluing of knowledge of the arts and sciences in favour of complacent ignorance and attachment to country sports, the preference often being for shooting rather than the risky and skilled activity of hunting. The gamekeeper is as much a representative of Victorian values as the workhouse and the factory clock. At the same time cottages become more picturesque, whether built for the wealthy or for the poor, as many estates cultivate a chivalric and long-established image. They are designed to convey ideas of benevolence and rustic contentment in a landscape in which most men, not only the poor, are now decisively detached from the land.

The interplay of taste and social mobility becomes increasingly complex, but it seems clear that the Tory idea seeks to emphasize a natural picturesque in a set of images that convey ancient rootedness in a place, as opposed to an artificial picturesque that suggests the conscious improvement of landscape and social relations.

In the development of this image 'Capability' Brown, and a large part of late eighteenth-century improvement, are quietly forgotten, as if to avoid the need to acknowledge that much of the landed interest had been gripped by a desire for showy innovation and the pursuit of quick profit rather than the determined care of their patrimonial acres. The intention is to allow an easy contrast between the old and the new, as if improvement and innovation were features in a landscape created by some sudden emergence of the commercial spirit. In Jane Austen's novels, in particular, absence of improvement is normally an indication of dignity, sensibility, and responsible attachment to a past threatened by new manners that combine superficial politeness with coarseness of spirit.

The symbols and images that accompany this view of change are full of irony and contradiction, as George Crabbe makes clear in *The Borough* (1810). An old man in the workhouse laments the passing of Old England; in former days, Benbow regrets, men were happy to 'fight and drink', but now they are determined to 'read and think'. The old squire used to live without pretentions, leading a hospitable life close to his servants and tenants. He was happy to see his park used for general amusement and even the taking of game:

> He never planted nor inclosed — his trees
> Grew like himself, untroubled and at ease:
> Bounds of all kinds he hated, and had felt
> Choked and imprison'd in a modern belt,
> Which some rare genius now has twined about
> The good old house, to keep old neighbours out:

The squire's son, who has succeeded to the estate, is formal, proud, and unsocial, and is therefore a keen improver and encloser. The use of Brownian vocabulary many years after the master's death, and the suggestion that all this rage for improvement is something new, contribute to the ambiguous nature of the contrast of new and old. The clear sense in Crabbe's late work is that Benbow's position, albeit debatable in its terms, is essentially correct and that progress has done nothing to remedy the ills of the past. It has, on the whole, merely introduced new habits of confident inattention and proud alienation, of which the workhouse itself may be considered an aspect. Obviously the progressive mind finds the past rough and perhaps picturesque; at the same time there is no clear indication that the new habits of reading and thinking do much to expand human sensibility. Behind the passage is a keen scepticism before the triumphant 'march of intellect' and its rejection of the absurdities of the past.[2]

Humphry Repton, who was always ready to base his theories on the demands of the market, tried increasingly after the controversies of the 1790s to distance himself from Brown and to emphasize picturesque elements in his work. In praising Repton's *Fragments on the Theory and Practice of Landscape Gardening* (1816), the *Quarterly Review* took it as given that the real English style in gardening, and indeed England herself, were typified by mature parks, dignified mansions, and gentlemen benevolently overlooking flourishing landscapes with as much interest in the con-

tentment of the tenantry as their own. Landscape gardening was a subject insepara-
ble from patriotic sentiments; it was a field of endeavour 'entirely English':

> The very name, the *English garden*, suggests ideas of cheerfulness and comfort
> unknown in every other country. Indeed the heart-enlivening prospect, over the
> pleasure ground, the park, the woods, and the well tenanted farms surrounding
> the country residence of an English gentleman, gives a favourable impression of
> the spirit of freedom and independence of its possessor.

On these attributes of the landowner, embodied in his estate, depend the liberty and
integrity of the country as a whole. Price's ideal has become the norm of the
established order of things. The province of the improver comprehends not only
the exterior effect of the mansion and pleasure grounds, but all that relates to the
employment and comforts of the local inhabitants, everything that makes the gentle-
man the protector of his dependants and the friend of his neighbours.[3]

Repton's own position in the *Fragments* is more complicated than the *Quarterly
Review* makes out. His point of view is more reactionary than conservative in that
he presents himself as an aged and invalid witness of the passing of a better England.
The old culture of hospitality and reciprocal assistance, in which improvement
would include groups of comfortable cottages ornamented by jasmine, rustic
benches, and maypoles, and the cheerful 'moving scene' of an active humble life, has
given way to a general instinct of greed, typified in the conduct of enclosure bills, the
workhouse, locked park gates, and the setting up of man-traps to scare what remains
of the peasantry. In the early days of Repton's practice it had seemed that all
England might become a comely, contented, and well-managed garden; but now all
beauty is being laid waste for profit. New money has bought up estates, the
patrimonial timber has been cut and pasture land ploughed up. The old landed
interest, fearful of losing its former pre-eminence, is often itself tempted into ruin
by undertaking various forms of 'sordid improvement'. Poplars, firs, larches, and
spring-guns have replaced ancient oaks, shady glades of elm and beech, and
footpaths left open for public use. One of Repton's illustrations, simply entitled
'Improvements', shows a picturesque by-road running past an easily accessible park
with deer frolicking among ancient trees. After improvement, the road has been
transformed into a highway; on one side it adjoins a modern plantation, cheaply but
aggressively fenced off, and on the other a ploughed up enclosure. This image is
admirably analysed by Stephen Daniels in his 1988 essay 'The Political Iconography
of Woodland'.

Repton does not dwell on his own part in the development of improvement and
his former constant calls for vigorous assertion of the appearance of private prop-
erty. In fact his instinct for appropriation survives intact even in the *Fragments*. In
the illustration of his own 'humble Cottage' in Essex before improvement, an open
space is shown beyond the narrow confines of his garden and a one-armed, one-eyed
man, possibly a casualty of the wars, is officiously seeking alms over the hedge. In
the improved version the open space has been appropriated to a very suburban-
looking garden and the old man has been moved on, perhaps to the model work-

IMPROVEMENTS

19 In the illustrated 'Red Books' that Humphry Repton prepared for prospective clients he offered images of places before and after improvement. In this late illustration of new and old public roads, simply entitled 'Improvements', the order of the illustrations suggests, not only the irony he could now associate with the term, but the practical impossibility of reversing such changes. Ancient trees cannot readily be replaced, and a view of property that expresses itself in a sign notifying the passer-by of the laying of man-traps cannot easily be reconciled with an idea of social harmony. Old England—slow, dignified, shaded, and beautiful, with the public wandering freely through a variety of landscapes—has given way to the modern world of assertive privacy, ugliness, utility, and tension.

VIEW FROM MY OWN COTTAGE, IN ESSEX.

VIEW FROM MY OWN COTTAGE, IN ESSEX.

20 and 21 Repton is hardly free of some of the modern instincts he often condemns in his late work. The improvement of his 'humble cottage' in Essex is designed, like some of his grander projects, to distance the owner from anything vulgar or intrusive, or at least to screen him from such nuisances.

house, with its odd combination of rusticity and regimentation, illustrated in the same volume. Repton's proposals for country houses continued to seek to disguise churches, remove cottages, and place shrubberies in churchyards to counter the disgusting images of mortality. In his scheme for Harleston, the Northamptonshire mansion often identified with Jane Austen's Mansfield Park, Repton illustrates an old, relatively modest house with a castellated wing and rather rustic barn-like structures nearby. In the improved version the house has been transformed, as if after a sudden and substantial inflow of funds; there are grand wings, bridges, and stables, all evidently designed to impress. Despite Repton's apparent conversion to Old England, there is clear justification for his doubtless rather wounding portrayal in *Mansfield Park* as the hireling practitioner of new and showy ideas of improvement whose ends appear quite unlike those assumed in the *Quarterly Review*. The choice of surname for the novel's heroine, Fanny Price, is a striking one, given the treatment of Repton.[4]

In Jane Austen's work the theme of improvement is treated with increasing seriousness as the novels succeed each other until it has become one of the central ideas of *Mansfield Park*. In *Emma* and *Persuasion* the treatment is more economical, with an increasingly unambiguous desire to contrast Old England with the new uniformity of a shallow, urban-inspired sophistication. *Mansfield Park* (1814) is, among other things, a distillation of fifty years' debate regarding improvement in which many of the characters are esteemed in inverse proportion to their desire to improve established landscapes. A scrupulous editor of the novel would have no difficulty in footnoting virtually every remark regarding the landscape with a source in the long debate. It is consistent with the old/new idea that it is discussed in essentially Brownian terms. Fanny, the chief critic of change, quotes Cowper, and the proponents of improvement talk essentially as if the picturesque debate had never taken place. The conversation is devoted to the widening of prospects, the enhancement of approaches as objects of display, the removal of nuisances associated with the rural and the religious, and the demolition of avenues. It is implied that none of these things is particularly controversial even among the fashionable amateurs of taste. The direction of the argument is clearly designed to suggest that improvement is a new and simple idea, and to portray the country house as an essentially moral institution under threat by a new generation of proprietors. They have inherited estates which they are anxious to improve out of their picturesque rusticity into grand places to attract general notice. It is significant here that Fanny, who describes herself as a 'by-stander' at Mansfield, and yet values it more fully than anyone else, has a relationship to the polite world perhaps similar to that of Jane Austen herself. She is well connected but without an independent fortune; only through marriage can she attain a secure social position and a permanent enjoyment of the pleasures of a country house.

The principal character in the novel is probably the house itself, well placed and screened in a park five miles around — modern, comfortable, and airy, but not showy. It is presented, to use Adam Smith's language, as a perfectly constructed machine apparently designed for happiness and harmonious order. Its potential is to some limited extent realized in its occupation by the Bertram family, but it helps to

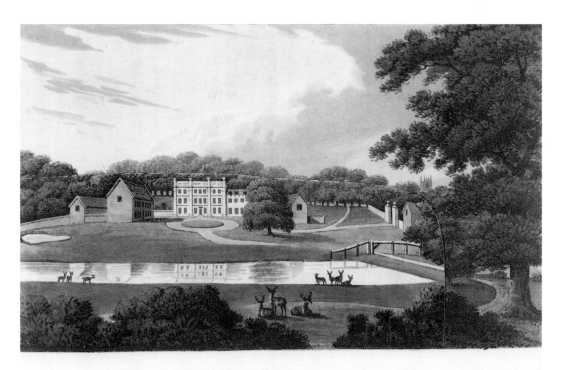

SOUTH FRONT OF HARLESTON PARK, NORTHAMPTONSHIRE, F. ANDREWS, ESQ^R

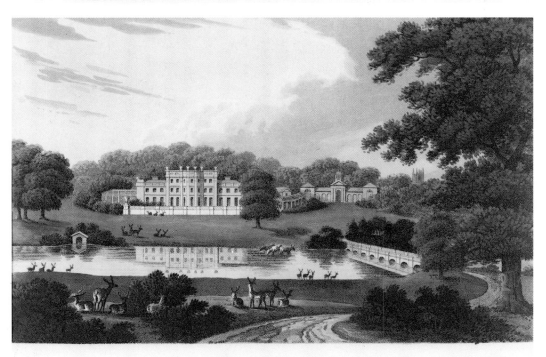

SOUTH FRONT OF HARLESTON PARK, NORTHAMPTONSHIRE, F. ANDREWS, ESQ^R

22 and 23 Repton's illustrations of Harleston Park show how an apparently natural style of gardening may accompany considerable sophistication, as the residence of a provincial squire becomes a place worthy of a free-spending man of fashion, keen to be recognized as such.

make few of them moral and happy amid its expensive comforts. Its owner, Sir Thomas, is obliged to undergo hardship and stress in the management of the West Indian estates on which his fortune appears to be based in some considerable degree. Fanny appreciates the value of the house, having known the distress of living in conditions of noisy confinement in which nobody is 'in their right place'. She admires its clearly composed hierarchy and its 'elegancies and luxuries'. She prefers its generally pampered inhabitants to her often more honest and considerate family at Portsmouth. Poverty and clumsiness, made additionally insufferable by small rooms and thin walls, are offensive to a sentiment that has been nourished amid the accommodations of Mansfield Park. Exposed once again to the horrors of Portsmouth, Fanny craves for the comforts of her real home at Mansfield and, in a striking example of how the 'fear of worse' leads to a reappraisal of the established order, the frequent insensibilities and vulgarities of the inhabitants of the mansion are minimized. She sees only the greater beauty and order of the setting and the perfection of the machine itself. Mansfield Park is elegance, propriety, harmony and, above all, peace and tranquillity. There is a 'regular course of cheerful orderliness', everybody has their due attention and importance, everybody's feelings are consulted, and good sense and breeding compensate for an occasional lack of tenderness. There is, in a phrase that recalls Burke and Southey, a 'consideration of times and seasons' completely lacking in a crowded house. Mansfield Park is perfected nature and Portsmouth is unimproved, gross, offensive, and low.[5]

The house comes to be seen in terms that recall Grandison Hall or an ideal mansion in Gilpin or Gisborne, and of course in the end the conversion of some of its inhabitants to better ways may confirm this view. The mansion may become what it has not been before — a cultivated and benevolent centre of authority to its neighbourhood, perhaps relieving those whom Fanny calls the poor and oppressed. The management of the domestic estates receives much less attention in Jane Austen than in such predecessors as Smollett and Richardson. The primary interest is in the harmony and comfort of the mansion and its immediate parkland, not in the large community of an agricultural estate. The point is underlined in certain ways by the funding of the harmonious economy of Mansfield by slavery rather than farming. The relations of master and dependant are hardly a moral issue in the book, except in the clear implication that Sir Thomas is at once too stern and too uninvolved in the general welfare of those who depend on him at home. The slave theme raises a number of moral issues without really clarifying them; for example, the name of the house clearly recalls Lord Mansfield and the legal question of slavery in England. In 1772 Mansfield, as Lord Chief Justice, had decided that, because slavery could never be considered legal on British soil, a foreign slave once landed in Britain instantly became free, whatever the inconveniences to property. Certain of Jane Austen's favourite writers, notably Cowper and Gisborne, were active in the campaigns against slavery. Further, quite apart from any moral concerns, the emphasis on West Indian estates may be felt to imply an air both of trade and of instability, given the uncertain prospects for slavery in the second decade of the nineteenth century.[6]

Slavery in *Mansfield Park* manages at the same time to be a central issue and no issue at all. Sir Thomas is said to be guilty of mismanagement of the moral economy

of the mansion in that he has neglected the promotion of active principles of morality. It is implied that he might have made the house a more complete machine of harmonious order, as well as something felt by each member of the family to be a home in the deep sense said to be experienced by Fanny. Sir Thomas's daughters, in particular, lack any discipline of self-denial and humility. They are without a sense of religion, duty, understanding, and manners sufficient to 'govern their inclinations'. They are unimproved in short, and so prone to every whim of their natures. Sir Thomas's absence in the West Indies removes the atmosphere of restraint and allows the unbridled expression of natures which resist every limitation of their freedom. The daughters rebel against a mixture of moral neglect and daily severity just as it was feared the rather less pampered African slaves would do, once unchained. To this extent the sources of the funding of the mansion may be said to influence the conduct of its inhabitants. Yet there is equally no doubt that the maintenance of order and harmony requires considerable financial resources, and in *Mansfield Park* it is considered better not to inquire too deeply into these things.[7]

The discussion of new ideas of improvement of the landscape is relatively uncomplicated, given the clear link between morality and a feeling for the past. Mrs Norris, who likes activity, expense, and style, declares that she would always choose to be 'planting and improving'. She notes that if her husband the clergyman had lived they would have made a plantation around the parsonage to shut out the churchyard, just as the present incumbent has done. Henry Crawford is selfish and lacks delicacy and regard for others. He wants feeling and principle to supply as duty what is deficient in his heart. He dislikes permanence of abode or limitation of society and above all things loves 'to be doing'. He sees difficulties nowhere and, by his own account, never inquires or stops to ask the way. He is a landlord who has never seen many of his tenants and cottagers. He knows his duty in theory and is gratified by its occasional performance, particularly as this can be expected to earn the regard of Fanny, but he lacks fixed principles. However inadequately improved he is in a moral sense, Crawford regards himself as a 'capital improver' of landscape, who sees quickly, resolves his plans, and acts without hesitation.[8]

During a game of Speculation, Edmund discusses with Henry the capabilities of the parsonage at Thornton Lacey, which he is to occupy after taking orders. He mentions the need to move the farmyard that lies at the approach to the parsonage in order to give the house more the air of a gentleman's place. He is reluctant, however, to undertake heavy expense and hopes to rely more on existing beauties than deliberate ornament. Edmund is clearly a half-hearted improver. Henry, on the other hand, sees 'work for five summers'. The terrible nuisance of the yard must be cleared away entirely and the blacksmith's shop disguised by a new plantation. The house must be turned to face the east and a new approach made through the old garden. The meadows beyond the new garden front must all be laid together, and are to be acquired for this purpose if they do not form part of the glebe-lands. Through such changes the house may be transformed into a place worthy of a respectable old family spending £2,000–£3,000 a year. It will appear to be the seat of a gentleman of education, good connections, and modern manners. Every creature travelling the road will perceive the proprietor as the biggest landowner of the parish. Improve-

ment will enhance an image of 'privilege and independence' through heavy expenditure, designed so that the place may be seen more clearly and with greater respect as it is distinguished from the local, the common, and the rural. Edmund half concurs with all this despite his theoretical sense of the high value of the clergyman's calling as the representative of the national Church and as the guardian and exemplar of morals, religious principles, manners, and conduct.[9]

Fanny is seen to be improved in a broad moral sense; her naturally good qualities have been formed by the care of the essentially kindly and literate Edmund. She has also had the advantage of early discipline and hardship arising from her ambiguous social position. Her transfer to the mansion fills her with a sense of gratitude towards a 'charitable kindness', and the inhabitants of the house are happy constantly to encourage this sense of obligation. All this has somehow made her a person innocent of deceit and without need for 'future improvement'. Through her qualities of goodness and calm insight she will eventually reward by marriage Edmund's attention, as he comes to perceive the superiority of her natural improvement to the artificial sophistication of Mary Crawford. It is uniquely Fanny who comprehends the real value of the 'view and patronage' of Mansfield Park and who understands, with the help of Cowper, the folly of fashionable improvement.[10]

With the assistance of Edmund, Fanny has learnt to admire nature, to see in the contemplation of its infinite variety a sense of the greatness of things, and to find even in its commonest productions scope for a 'rambling fancy'. Nature is, as in Cowper, something best perceived within the park walls. Indeed, the improved landscape is sometimes a substitute for nature. It is from the comfort of the house that Fanny appreciates the infinite loveliness, solemnity, and harmony of the night sky, imagining for a time, like Fenton at Stourhead, that there could be neither 'wickedness nor sorrow in the world' or, at the least, that such evils would be much less if men were taken out of themselves by the contemplation of such scenes. She delights in the mysterious vegetable processes of nature in the glory of the woods within the park and in the growth and beauty displayed in the shrubbery. She finds in her walks quiet simplicity, liberty, freshness, fragrance, and verdure. All are in sharp contrast with the noisy, ugly, public world of Portsmouth, where nature is not only unimproved but debased. This sensibility is at one with her romantic, gothic, tendency — her liking for old chapels, chivalry, nobility, and 'warm affections' in literature. Unlike the legal inheritors of many country houses, her mind is instilled with a sense of history, time, and continuity between generations. She perceives the importance of memory as a regulating principle in morals. Like other bystanders, including Burke, she reminds the privileged at once of their duties and the importance of forms and images in the preservation of their authority.

Within Mansfield Park — and the park is at least as important as the house — Fanny pursues, as Mrs Norris says, an 'independent walk'. She 'likes to go her own way' on a path that is at once more natural and more improved than those taken by the other inhabitants of the house who, naturally enough, seem to make much less use of the park. It is one of the ironies of *Mansfield Park* that a clear expression of anti-improvement should take place in a setting that seems to resemble mid-Repton in its blend of the natural and the artificial. Given the perfection of the park, and the

near perfection of the house, Fanny's marriage to Edmund and the reformation of Sir Thomas and his heir to less selfish manners, may bring about a more perfectly harmonious composition of setting and inhabitants. Perhaps the house will become much less insulated from its neighbourhood; but this is a very incidental consideration in the novel.[11]

Sotherton Court, the Elizabethan mansion inherited by the inane Mr Rushworth, is generally viewed, not for its traditional qualities, which include residual images of hospitality and moral seriousness, but for its potential for showy improvement. Miss Bertram, who has a particular interest in the place as a reward of marriage, regrets its low and 'dreadful' situation, so unhelpful to prospect-seeking from within and the display of grandeur from without. She laments the inadequate dignity of the approach to the house along a rough road that passes through a village containing an old almshouse and gives a clear sight of cottages whose appearance she takes to be a 'disgrace'. She is thinking, presumably, less of the comforts of the inhabitants than of a lack of expensive decorum and a sense of appropriation to a wealthy place. She is grateful, however, that the old-fashioned habit of siting the house near the parish church had not been adopted at Sotherton, given the inevitable annoyance of the bells.[12]

Rushworth is keen to transform Sotherton because a friend had recently had his own place, Compton, laid out by Repton to produce what Rushworth describes as a 'most complete thing'. It is wonderfully and thoroughly altered, and now the admiration of the entire country, with an approach artfully contrived to give a most surprising view of the house. Compton, a mere 100 acres, cannot hope to compare with an improved Sotherton, where Rushworth is prepared to make 700 acres available for improvement, even without counting the water meadows. He fully expects the place to be transformed. Fine old trees will be cut down to open prospects and the old avenue will most likely be destroyed. Fanny thinks this a pity and inevitably thinks of Cowper. Edmund smiles agreeably and regrets, with his sister, that the low position of the house is so unfavourable for improvement. He thinks, however, that the stream might be 'made a good deal of' and that it is perfectly correct to give the place a 'modern dress'. His less artificial side leads him to comment that in Rushworth's place he would prefer his own personal and progressive beauty to that instantly offered by a professional improver with only a fleeting acquaintance with the landscape.[13]

Mary Crawford comments at this point that she would be happy to purchase beauty from Repton, or indeed any other competent improver, though wishing not to be troubled until the work was completed. Her interest in the country is generally confined to comfort, shrubberies, flower gardens, and rustic seats, all to be kept in order without her care. She is dedicated to what she terms her London manners, believes that all pleasures can be bought, and is shocked at the sturdy independence of the country people in refusing to rent out a cart during hay-making. She is described as inattentive to nature and occupied only with the intrigues of men and women in a certain kind of 'light and lively' society. Hearing that the custom of daily chapel has been left off at Sotherton, and disgusted at Edmund's intention to take orders, she notes pleasantly that 'every generation has its improvements.' Fanny, on

the other hand, regrets the passing of a valuable part of older times. Mary Crawford shares with Fanny a pleasure in going her own way, but her independence is based on a dislike of all restraint, obligation, and 'cold prudence'. Like her brother she is constantly active; resting fatigues her and she constantly aspires after the new. In the emblematic wilderness that is to be found amid the more conventional improvements of Mansfield Park — a strange area, more formal than wild, and consisting of a two-acre wood of larch, laurel, and beech cut down, all laid out with 'too much regularity' — she leads Edmund on what she describes as a 'very serpentine course' amid formal paths. The more natural landscape of the park itself seems to bore her except where it is seen through a closed iron gate. This presents an enforced restraint that stimulates her attention and her desire to transgress.[14]

In *Mansfield Park* the great majority of the well-born characters, however congenial the settings in which they were brought up, are foolish, amoral, and innovative. They are ignorant and careless of the culture they inherit; their principle virtues, it seems, are that they are usually not noisy, and that they occupy houses infinitely more agreeable than themselves. The conservatism of the book is based partly on 'fear of worse' and partly on a faith that such people are falling off from something finer in the past, which survives precariously in places, language, and morals. What is valuable is old, what is new destructive. There is a kind of reactionary hope for continuity with a past perceived nostalgically and distorted by the suggestion that improvement is somehow a new force in society. Civilization as embodied in Mansfield Park is saved to a large extent by a clearer commitment on the part of its inhabitants to values that seem natural to Fanny. It is capable of being saved because the great houses are testimonies of a more ample, older culture that manages to survive amid the new, narrowing sentiments of individual interest and showy display.

A similar theme is explored in a less ambiguous form in *Emma* (1816), which contains in its prospect of Donwell Abbey one of the most familiar images of the Tory view of landscape. The prospect is part of a celebration of 'English manners', embodied in Mr Knightley, which express themselves in a steady, calm, frank, plain, unaffected, and open address. Such manners sometimes seem near to indifference, but they conceal a firm and disinterested attachment more durable and more essentially delicate towards the feelings of others than the showy floridity of foreigners. Knightley's character is reflected in the appearance of his ancestral home, and both together represent the essential or real England, the charms of which consist in a total absence of fashionable improvement. The name of the house and of its owner express, without too much subtlety, achievement, age, and of course chivalry. The style and size of the Abbey are 'respectable', not showy; its situation is 'suitable, becoming', and 'characteristic', in being 'low and sheltered'. Its ample gardens stretch down to unimproved meadows washed by a stream, but the Abbey, 'with all the old neglect of prospect', has scarcely a sight of this beauty. The park, which is barely differentiated at its margins from the country, has an 'abundance of timber' in rows and shady avenues which 'neither fashion nor extravagance had rooted up'. The house is 'rambling and irregular', picturesque in Pricean terms because of its dignity, age, gradual evolution, and respect for previous work. It is unmistakably

the residence of a family of 'true gentility', 'untainted in blood and understanding', independent in spirit, and bowing to no one in ideas of respectability or fashion. The house is, even more than Mansfield Park, a natural feature of the English landscape, an achievement of a unique culture that has expressed itself as perfectly in the landscape as in manners and constitutional arrangements. The contrast between Milton Abbey and Donwell Abbey hardly needs to be emphasized.[15]

Having established the principal figure in the composition, Jane Austen broadens the view to include the wider estate:

> The considerable slope, at nearly the foot of which the Abbey stood, gradually acquired a steeper form beyond its grounds; and at half a mile distant was a bank of considerable abruptness and grandeur, well clothed with wood; and at the bottom of this bank, favourably placed and sheltered, rose the Abbey-Mill Farm, with meadows in front and the river making a close and handsome curve around it.

The Hafod principles of the picturesque — steepness, abruptness, grandeur, and ornamentation by well-distributed woods — convey the idea of a landscape in which beauty, nature, and cultivation exist happily together. The word 'placed' recalls the language of picturesque composition, but at the same time it is clear that the siting of the farmhouse has been determined by natural considerations of soil, weather, and the availability of water and wood.

The whole prospect of the Abbey and the farm is used by the novelist to embody the essential idea of England herself: 'It was a sweet view — sweet to the eye and the mind, English verdure, English culture, English comfort, seen under a sun bright without being oppressive.' England, as most men knew in the eighteenth and early nineteenth centuries, and indeed before, was a country uniquely favoured in the temperate nature of its climate, its constitution, its manners, and its agriculturally based wealth. Comfort coincided with virtue, beauty, liberty, and easy social relations in a landscape in which the old country house is the centre of the happy composition. The prospect of Donwell may be thought to be essentially the perfection of the idea of England offered by Price's version of 'Albion', and by Payne Knight's image of a landscape in which culture smiles on all the works of men.[16]

The passage also brings to mind the *Quarterly Review* theme of the uniqueness of English comfort and its foundation in the happy proximity of landlord and tenant. The *Review* quotes from Thomas Gray the familiar idea that the national skill in the laying out of grounds was something unique to England and indeed the only proof of original talent in matters of pleasure. This apparent confession of the limitation of artistic imagination is counterbalanced, of course, by the sense that improvement is in some way the highest form of art in its reconciliation of beauty, equity, and use. Many years of generally isolated but triumphant resistance to Napoleon had clearly confirmed national pride and the preference for what the topographer John Britton describes as the English culture of 'rural simplicity' and 'chartered wilderness' above any idea of landscape founded on 'foreign associations'. Gilpin had noted many years before that England was unique in its verdure because 'velvet turf', close and rich in texture, was, together with the English oak, the essential feature of improved

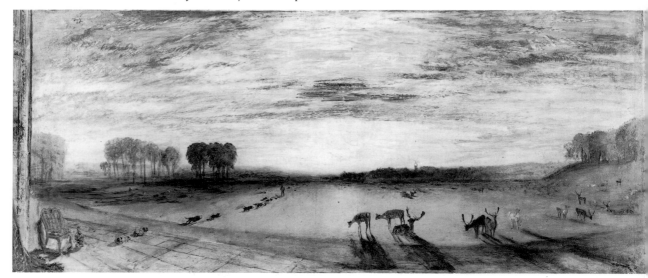

24 J. M. W. Turner's views of Petworth Park have sometimes been represented, as simple tributes to the landed power of his friend and patron, Lord Egremont. In addition to being a sympathetic supporter of the artist's work, Egremont was an improving landowner whose efforts were admired by Sir Thomas Bernard and William Cobbett, among others. He was also an aristocrat who drew sufficient general conclusions from his own sense of responsibility to make him a steady opponent of constitutional change. A study of the image illustrated here (painted *c.*1828) may suggest how little Turner was interested in portraying a narrow idea of property and improvement. In a good number of his pictures of country houses, especially commissioned ones, Turner makes the mansion and its park almost insignificant elements in the scene—*Brightling Park* and *Tabley House* are particularly good examples. At Petworth the artist's affection for a particular place and a liberal patron does not lead to a simple tribute to landed power. The characteristic flatness and dullness of the Brownian park make it the perfect mirror of the sublimity of the sky. Improvement is not absorbing nature but being re-transformed by it. The painting may be seen both as an affectionate image of a place and as a criticism of a tradition of improvement that seeks to emphasize the triumph of the artificial and private over a much wider idea of human cultivation.

national landscape. While drawing on this tradition of observation and prejudice, Jane Austen also qualifies it. As in Payne Knight, the verdure, which is both beautiful and productive, and the 'native woods' ('creation's boast and pride', according to *The Landscape*) are seen as clearly flourishing before the conscious efforts of improvement and likely to be threatened by its progress. The natural qualities of the country house are, as in Burke, clearly under assault.[17]

Observed from a nearer vantage point, Abbey Mill Farm is seen as being quite as picturesque as the mansion itself amid 'all its appendages of prosperity and beauty, its rich pastures, spreading flocks, orchard in blossom, and light column of smoke ascending.' The picturesque tradition is confirmed in the preference for the pastoral and the horticultural over the arable, and the identification notable in Ruggles — after Milton's *L'Allegro* — of a flourishing chimney with rural contentment. Robert Martin, the occupier of Abbey Farm, is an equally ideal figure who reads both the

25 Turner's lack of interest in conventional images of the country house is underlined by
Ruskin in *Modern Painters*. The artist, brought up in a poor part of London, was innocent
of automatic habits of deference, and depicted the distress and sadness that often character-
ized the labour of the poor. The point is well illustrated in *A Frosty Morning* (1813). As John
Barrell has pointed out in *The Dark Side of the Landscape*, pastoral conventions are laid
aside, and work depicted as a narrowing necessity. An easy distinction between rural and
mechanical labour, made in favour of the former, is eschewed. Work and poverty are seen
in terms that cannot easily be resolved, even by benevolence.

Agricultural Reports and such sound literature as the *The Vicar of Wakefield*. He is
initially dismissed by Emma because he is part of the yeomanry. This is a class too
low to notice socially, but too high for those useful offices that express Emma's
compassionate attentions to the poor and at the same time 'do one good' in terms
of gratifying sentiments. Improved by Mr Knightley into a more just and natural
way of thinking. Emma comes to respect Robert Martin's character and his capacity
to offer Harriet Smith 'security, stability and improvement'.[18]

Mr Knightley, as landowner, magistrate, and man of sense, is seen as the recon-
ciling, regulating, moralizing force of the real England. He has a frank and open
relationship with Robert Martin, in which their common interests and gentlemanly
instincts are seen as virtually eliminating the perception of difference of rank. They
embody together an economic and moral system that is productive but uncompeti-
tive, at ease with nature and without tensions induced by commerce. The reader
assumes that both 'hold conversation with the peasant' in an agreeable manner, but
this is a theme hardly developed. The pastoral landscape, after all, requires little in
the way of day labour except during hay-making. Gisborne, it may be recalled, had
seen arable farming as the preferred use of land because it provided greater oppor-

tunities of employment. Repton's image of 'Improvements' tends to regard the plough as an image of vulgar utility, destroying a picturesque harmony, but in *Emma*, published in the same year, the reader may feel that the picturesque is unduly favoured over the productive. Divorced from 'conversation with the peasant' it is, after all, difficult to perceive how the view of Donwell can remain an image of the real England. It seems doomed to be a nostalgic idea or one relatively easily appropriated by a commercial interest that has learned to merge into the country with some discretion, at least as regards its interests within the park walls. The major difference between Donwell Abbey and Grandison Hall is the contrast between a relatively private world and one considered in a certain way public. This difference is in turn influenced by the idea that Grandison Hall is an exceptional but hopeful image of how existing social relations might work in England, whereas with Donwell Abbey the reader and the novelist are both aware that the larger world and its balance of social forces have changed fundamentally. Jane Austen, like Burke, undermines her vision by making it exclusive, and therefore participates in the evil she attacks.

Persuasion (1817) confirms the pattern of an increasingly simple opposition of new and old, the traditional and the improved, a real historical feeling and a mere reliance on rank and title. The problem of improvement, as in *Mansfield Park*, is not an external danger arising from a distinct commercial spirit, but a lack of principle in the landed interest itself, a readiness to embrace new manners or to substitute manners alone for substance. Once again the houses and the inherited landscape are the only completely reliable witnesses of an idea of tradition. Jane Austen describes the village of Uppercross as being, until recently, in the 'old English style', with only two houses much superior in appearance to those of the yeomen and labourers — the squire's Great House and the Vicarage. Uppercross has now 'received the improvement' of a farmhouse elevated into a 'cottage' as the residence of the squire's son, a house contrasted with the more 'consistent and considerable aspect' of the Great House. The Musgrove family has undergone a similar improvement from the 'old English style' of the parents — not much educated or elegant, but friendly, hospitable, and with real delicacy of feeling — to the shallow confidence of the son, whose choice of a cottage is determined by fashion rather than sentiment. As in Crabbe, the break with the past is hardly an unequivocal gain.[19]

The past is superficially respected, but really mocked by Sir Walter Elliot. His interest in armorial bearings, lineages, and family pride is accompanied neither by intelligence nor by a sense of responsibility. Because in many ways he undermines the past even more than the forces of clear innovation he is treated with little short of contemptuous hatred. He is completely unworthy of the dignified, gothically named Kellynch Hall. Once again in the politics of the picturesque, however, there is hope as long as the house remains. The mansion is more important than its owner, and may be tainted by him. After Elliot has rented the house to Admiral Croft, who is enterprising and efficient in the naval rather than the commercial manner, the comment is that they had 'gone who deserved not to stay', and that the house has fallen into 'better hands than its owner's'. Sir Walter is a 'foolish, spend-thrift baronet' without principle or sense enough to maintain himself in 'the situation in

which Providence had placed him'. This observation implies not only that the title has confirmed and nourished Elliot's natural stupidity, but that the title itself is rather snobbishly mocked. The implication is surely that respectable country gentlemen living quietly and usefully on their estates are, as in the case of Knightley, often simply 'esquires'; if they have entered into national life they may well have become peers. The title of baronet may carry an air of mediocrity, recalling its origins in Jacobean intrigue and money-raising.[20]

The hope for England seems to lie in gentlemanly naval officers and a number of respectable county families as yet untainted by stylish improvement. As always in Jane Austen, it is difficult to separate snobbery, social insecurity, fear of vulgarity, and principle. In a fairly unsubtle passage in *The Watsons* (1804), she had contrasted a home 'where all had been comfort and elegance' with the prospect of being a mere 'addition in an house, already overstocked, surrounded by inferior minds with little chance of domestic comfort, and as little hope of future support'. The problem is much the same as the one noted by Adam Smith; the machines of happiness are in many cases occupied by the unworthy, and the process of achieving prosperity is normally degrading. At the same time, the worst situation in which the sensitive can find themselves is the actuality or prospect of the lack of comfortable accommodation. Although there is a Butlerian element in Jane Austen, there is also a revulsion from the poor and the common reminiscent of the political economists. The threat of relative poverty or, more accurately, lack of wealth, exists of course in a moral world in which it is pleasant to have money but vulgar and corrupting to think about making it. Mr Knightley would not be himself if his mind was occupied with commerce. It is a regular, albeit fluctuating, income from farming an estate, whose financial origins or original basis are not in discussion, that is the primary basis of English respectability.[21]

Sanditon (1817) is a considerable break from Jane Austen's earlier work in that she attempts to understand something of the commercial mind, with its promises of universal comfort and improvement through the pursuit of novelty and self-interest. Her response is unsurprisingly sceptical. Parker, the projector behind the development of the future seaside resort, is a man of 'imagination and quick feelings' whose 'superfluity of sensation' expresses itself in enterprise, independence, and vigorous self-confidence. His instinctive feeling that by pursuing his own path of prosperity he is also serving the cause of the public has been confirmed by a knowledge, albeit limited, of the new political economy in its usual version of vulgarized Adam Smith. In *Sanditon* the reader encounters the authentic language of modern Conservatism, accompanied by various kinds of irony. Not only does Parker seem to the novelist a man whose motives are confused by self-deception, but the reader of *The Wealth of Nations* will also recall Smith's superior amusement when noting the determination of projectors to elevate their self-interest into a florid language that talks of noble schemes to ornament the country, increase comforts, and distribute every kind of improvement.

Parker's scheme provokes opposition from Mr Heywood on the basis that anything that stimulates economic activity in the area will simply raise the price of provisions and 'make the poor good for nothing'. This is perceived in the novel as

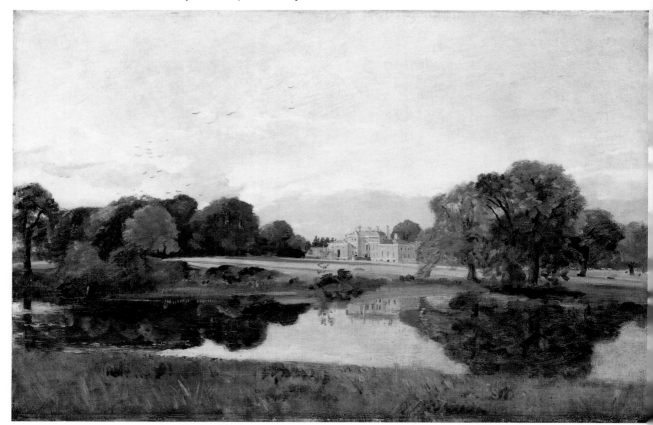

26 John Constable's *Malvern Hall* (1809), like his *Wivenhoe Park* (1816), offers an improved, private image of the country house. In both paintings, the mature groups of trees suggest the separation of the house from a wider conception of rural relationships and a particular locality.

a narrow language that in its clear and limited class orientation does nothing to challenge the force of change, indeed almost moralizes it, making it seem fresh, exciting, and productive of greater liberty. Yet the difficulty with Parker is not so much his project as his articles of faith; he talks a simple language of 'growth' incompatible with older ideas of the term. What he hopes will be a 'profitable speculation' is presented as a public good because 'growth' will stimulate 'demand', excite 'industry', and everywhere 'diffuse comfort and improvement'. No patriot or man of feeling could therefore oppose it. The nature of this growth, in opposition, for example, to older ideas such as cultivation, is that it is at once undirected and infinitely self-generating in the endless demand for 'all the useless things in the world that could not be done without'. Economic activity, it is clear, will soon cease to be a means but the end of life itself. Parker worships at the altar of money as if the projector and the speculator were fully realized examples for humanity. Rising prices are seen as good since they are the indicators of an inevitable future prosperity. The 'diffusion of money' by West Indians and the increasing wealth of tradesmen, far from being of any possible disadvantage to the public welfare, are to be

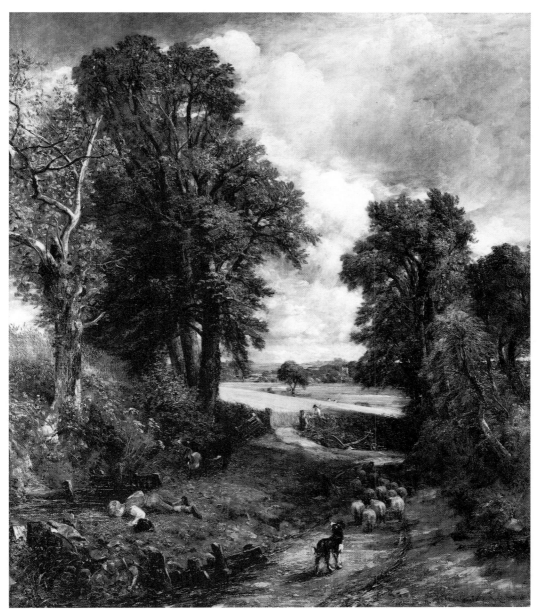

27 The very familiar portrayals of England made by Constable in his maturity, such as *The Cornfield* (1826), often appear to represent a patriotic conception of the landscape which is, in many ways, as ordered as the country-house image but much wider in its reach. These pictures are sometimes reminiscent of Wordsworth's understanding of the meanings attached to a 'rich landscape diversified with church towers and hamlets' or Jane Austen's tributes to a national culture that expresses itself as much in the landscapes of southern England as in its language and social conventions. Some of the underlying tensions in such versions of Toryism may be detected in Constable's imagery. The artist clearly feels obliged to make the picturesque dominate over the productive, so that the cornfield is almost an adjunct to the landscape. Property and social relations are left undefined. The labourers are few, quiet, solitary, and apparently unconnected, and any sauntering that may be supposed to occur would seem quite joyless.

welcomed, as they will provoke higher rents and increase the 'value of our houses'.[22]

The acceptance of this language necessarily means a society in rapid and undirected change. Just as the reader, and Jane Austen herself, know that Donwell Abbey is not the actual England, however much it may be the real expression of tradition, so it is difficult not to regard Parker as the genial side of an increasingly dominant commercial culture. The new culture will be irresistible because of its self-confident and apparently convinced equation of the public interest with the expansion of trade, and its absolute belief that the ideas of political economy carry with them enlightenment and the resolution of historic problems. The intricate and contradictory moral landscape of the past, hopelessly distorted by an impotent obeisance to ideas of nature, will be transformed by a wave of enterprise and improvement that has achieved a scientific and philosophic understanding of the uses of nature. Growth supplied by the free play of market forces and the ambition of enterprising individuals will become the dominant ideology of English society to such a point that total respect for the commercial system will eventually be presented as the basis of conservatism. In these circumstances the Tory idea of landscape, like the picturesque, becomes an easy target for dismissal as reaction and nostalgia.

In his novel *Melincourt* (1817) Thomas Love Peacock, writing from a very cultivated position within liberal ideas, describes a Mr Forester and a Miss Evergreen who are, as their names adequately suggest, protagonists of Old England. He treats them sympathetically, as being good-natured, but he also sees them as innocently youthful and hopelessly out of touch with the reality of either the past or the increasingly businesslike future. Mr Forester, who is a young squire, looks at the growing towns and is horrified by their ugliness and disorder. He detects an increasing gap between what the rich and cultivated see and experience and the cramped squalor of the accommodation of the industrial workers. In the new he sees only distress:

> our swarming hospitals — our overcharged workhouses — . . . those narrow districts of our overgrown cities, which the affluent never see — where thousands and thousands of families are compressed within limits not sufficient for the pleasure-ground of a simple squire.

On his own estate he follows the example of a father who estimated his riches, not by his rent roll, but by the number of 'simple and happy beings' he could maintain. The estate is divided into little farms, the working of which enables the cottagers to supply current needs and put something aside for old age and accident. All this creates an image of how England used to be before the age of spurious improvement: 'the clean-tiled floor, the polished beechen table, the tea-cups on the chimney, the dresser with its glittering dishes.' Rustic contentment has been replaced by factories and large farms. Miss Evergreen notes that 'you may go over vast tracts of country without seeing any thing like an *old English cottage*.' England has been taken over by 'the imaginary riches of paper-credit, of which the means are delusion, the progress monopoly, and the ultimate effect the extinction of the best portion of national population, a healthy and industrious peasantry.' Later on a genial peasant, Mr Hawthorn, laments that Squire Openhand, afflicted by war taxes and the

inflationary tendency of paper money, has had to abandon his paternal acres. Hawthorn, who speaks in the bluff, manly, picturesque style of the past with a heavy, if unspecific, dialect, notes that after the estate was sold,

> every now and then came a queer zort o' chap dropped out o' the sky like — a vundholder he called un, — and bought a bit o' ground vor a handful o' paper, and built a cottage-horny, . . . and had nothing to do wi' the country-people.

New shrubberies surround the *cottage ornée*, replacing the oak plantations of the former squire.[23]

Peacock was amused by all this for good liberal reasons. He wished to believe in a clear tendency to improvement, which would replace the discretionary and uncertain benefits of Old England with the greater independence and prosperity afforded by a modern commercial system. This could gradually resolve its own problems and generate a higher level of culture as the industrial system was perfected. Peacock was an employee of the India Office, involved in the training of an efficient and honest class of administrators to govern an important colony. He was in a position to feel confident that improvement and better management could resolve the chaos of the past. The picturesque prejudices of romantic observers could therefore be regarded with a genial tolerance as men awaited the vastly expanded possibilities of civilized commercial life. In *Melincourt* Southey appears as Mr Feathernest, a mere lackey of reactionary forces, and Coleridge as Mr Mystic, well-intentioned but quite incomprehensible. The march of mind is leaving them and Old England behind. In *Crotchet Castle* (1831) the feudalist Mr Chainmail is an advocate of 'kindly feeling' between the classes, small communities, nature, simplicity, and picturesqueness in a world become as 'artificial and as complicated as our steam-machinery'. The 'way to keep the people down', he declares amid the threat of Captain Swing riots, is through 'kind and liberal usage'. Whatever the inadequacies of progressive thinking, Peacock was determined to suggest that no serious prospect for society could be successfully constructed on a romantic appeal to the past.[24]

7

'A Sort of National Property'

Let culture smile upon the haunts of men.
 Richard Payne Knight

The Tory view of landscape seemed increasingly out of date at the end of the Napoleonic wars, stuck in an impasse between its theoretical benevolence and its fear of democratic, levelling impulses. The essential elements in the happy composition of the old society — a responsible, cultivated, landed interest and a contented peasantry — appeared increasingly elusive. As Thomas Love Peacock suggests, one Tory response to the triumph of the commercial culture was to seek comfort in forms of chivalry and nostalgia. An expression of this was the establishment of Young England and Lord John Manners's call for gentlemen to play cricket with the working classes and lay out parks for their recreation. Such ideas were not, however, the whole of the Tory view. An important part of its future lay, as Macaulay perceived, in an increasing attachment to a romantic idea of the State as the essential promoter and defender of national continuity and social equity. The importance of such ideas has already been noted in the writings of Sir Thomas Bernard. He saw a paternal State as the only hope for the regulation of the immense energies and greed that were generating the expansion of manufacturing industry, apparently without regard to its consequences for the welfare of the nation as a whole. In the mature work of Wordsworth, Southey, and Coleridge the State is both a force for regulation and an imaginative extension of the idea of the 'noble estate'.

The increasing complexity of Tory discourse is hinted at in Wordsworth's idea of the Lakes as a 'sort of national property', whose integrity is more important than individual property rights, and it has one of its fullest expressions in the 'Postscript' of 1835. Coleridge came to insist on the importance of nationalized institutions and ideas (not economic activities), and of the setting aside of a 'national reserve' to fund the cultivation of the nation. A declining conviction that the welfare of the community could be entrusted to the discretion of benevolent individuals, or of a particular social class, confronted an influential body of opinion that sought to leave such things to the market. Tory values had to be redefined and embodied in an idea powerful enough to regulate that market and challenge the preponderance of particular interests. Change had to be managed into a concept of beneficial improve-

ment that could balance progression and permanence. The emerging emphases of Toryism probably have their most important expression in Coleridge's *On the Constitution of the Church and State* (1830). In an apparently reactionary work, written to denounce the risks associated with careless attitudes to Catholic emancipation and parliamentary reform, Coleridge is obliged to recognize that the historic balances of English society have been so radically put out of joint as to necessitate a much broader basis of consensus in the nation as to what should constitute its essential character, and what values, duties, and rights might promote its security and continuity.

The Tory idea of the State is in part a form of compromise between the values of benevolence and the rising demands of democracy. While it was clear that power would come to be spread more widely, it was also evident that many beneficial aspects of traditional culture would be under threat in that process. The political ambiguity of Tory attitudes to the people emerges very clearly in this argument. In his pamphlet on the Convention of Cintra, Wordsworth had insisted that the instinctual sentiments of the common people were generally finer than those of their leaders. It was clear, however, that this superiority was partly a result of their having no direct political power. Politicians are removed from insight because they live in 'a situation exclusive and artificial', more occupied with knowledge of material things than genuine sensations. Wordsworth described the Spanish peasantry naturally and spontaneously rising up against 'a new world of forces', embodied in Napoleon, which were utterly without 'restraints of morality' and constrained only by the extent of their own power. As Michael Friedman points out in his study of Wordsworth's 'Tory Humanism', there is much in the poet's work to suggest that he identified very similar evils in the rise of unregulated commerce. In many ways, of course, economic invasion could be perceived as much more insidiously threatening than military, because it corrupted and narrowed the energies of the common people rather than consolidated them into moral action. Wordsworth did not, however, tend to identify his challenge to commerce with the need for democratic struggle.[1]

Coleridge was also reluctant to abandon a system of hierarchical order, but he found that the order had, in a sense, abandoned him. The conservatism of *Church and State* is more complex than that of the *Lay Sermons*. It is possible, as Nigel Leask has suggested, that Coleridge's exposure after 1825 to the writings of Giambattista Vico allowed him to qualify his pessimism. Vico's work on the science of history had identified a cyclical pattern in which monarchy, aristocracy, and democracy naturally succeed each other, with democracy destined to give way eventually to monarchy. In any event, Coleridge's *Church and State* confronts the problem of conservatism soon to be defined in Disraeli's novel *Sibyl* — if the market was left to itself, there would quickly be nothing left to conserve.[2]

Coleridge depicts an England in a state of self-evident fragmentation. The rural population had become in large part pauperized. Industrial workers were being regarded merely as means to an end, 'mechanized into engines for the manufactory of new rich men'. The increasing quantitative wealth of the nation was being built out of the wretchedness, disease, and depravity of those who should constitute its major strength. The real 'weal and happiness' of England were being sacrificed to

expediency as its landscapes — 'Sea, and Land, Rock, Mountain, Lake and Moor' — were subjugated to utility. 'Idealess facts' were substituted for principled insight, and men without a feeling for the past were increasingly bereft of any clear foresight for the future. The idea of a nation as a historical continuity and community, with 'generation linked to generation' by common values, had given way to the 'superstitions of wealth and newspaper reputation'. Government was occupied merely by considerations of finance, social intercourse was ruled by personal vanity, and economic relations were determined by presumption and hardness of heart. The 'landed interest' was no longer a diverse group of men whose welfare could be considered as inseparable from that of the nation itself, but an 'imposing name' for a few major proprietors who showed their sense of community in an assiduous commitment to the game laws and corn laws.[3]

Coleridge suggests that many of the historic functions of landed property must be increasingly replaced and extended by what he terms 'nationalized' institutions. In particular, the cultivation and 'harmonious developement' of individuals and of the community as a whole are entrusted to the clerisy, a body of teachers endowed by the nation. Individual members of that body are to constitute the 'resident guide, guardian, and instructor' of different communities and to be so widely distributed that the inhabitants of 'even the smallest integral part or division' of the country will be assisted in the means of personal cultivation, enhanced knowledge, and a clear understanding of the rights and duties that bind them to the community as a whole. Coleridge's argument sometimes sounds like a more organized version of eighteenth-century ecclesiastical benevolence, and raises a number of questions. It is not clear, for example, how individual members of the clerisy are to relate to local structures of authority. It is uncertain how the widely diffused cultivation promoted by the clerisy is to be reconciled with the higher, often more individual, intellectual activity of a nation in which knowledge is becoming ever more specialized. Further, it is unclear what safeguards exist to stop falsely motivated members of the clerisy from threatening to corrupt, rather than cultivate, the tastes and inclinations of ordinary men and women.[4]

There were, of course, other problems in understanding the influence of the clerisy in a nation whose freedom and growth had always depended, according to Coleridge, on a complex balance of permanence and progression. In 1830 Coleridge was still keen to insist, as he had in the *Biographia Literaria* (1817) and elsewhere, that the educated should plead for the 'poor and ignorant' rather than to them. The widespread honesty and intuitive understanding of issues manifested by many of the people was an effect of the long influence of a national Church operating throughout the country. Most men lacking 'artificial cultivation' or 'original sensibility', or both, were unlikely to be improved by rural life; the scenes of nature are often, to the ignorant, 'pictures to the blind', and a 'want of stimulants' in the country can leave men 'selfish, sensual, gross, and hard-hearted'. In the towns, on the other hand, the stimulants are often too many, of the wrong nature, and counterbalanced by the drudgery of repetitive toil. By 1830, however, it was clear to Coleridge that those who were most powerful and influential in English society were becoming decreasingly likely to offer an improving example to the people in general. Indeed, the

people seemed, on the whole, less touched by the prevailing spirit of selfishness than their masters. A monopolistic landed interest could hardly be relied upon for a very fruitful expression of permanence, and a manufacturing class devoted to short-term gain was unlikely to be consistently progressive. It seemed that English society was in need of wider principles of balance and composition than had served in the past. Coleridge, like Wordsworth, Southey, and other Tories, was inclined to seek for fully realized examples of humanity among some of those who could be broadly described as aristocratic, but at the same time to assume that sound values, and even 'pure morality', are more often the 'hereditary property' of the 'hovel and the work-shop' than the mansion or the counting-house. Perhaps order, continuity, and the independence of the clerisy had somehow to be entrusted to the whole community rather than to narrow classes of men. From this conclusion is derived the Tory enthusiasm for the State as a focus of education and regulation.[5]

It could be argued that the 'Tory democracy' of Disraeli, and his decision in the 1860s to 'dish the Whigs' by enfranchising the industrial working classes, were fruits of this line of argument, but in its practice the Conservatism of Disraeli had little more interest in the cultivation of mankind than that of Lord Liverpool and Sir Robert Peel. Coleridge's idea of the State as a national community of balanced rights and duties had its chief intellectual enemy in the traditions of liberalism. It is difficult not to think of Coleridge's clerisy when reading Macaulay's denunciation of an order of society, such as the one he associated with Southey, in which there is a 'Lady Bountiful in every parish, a Paul Pry in every house, spying . . . relieving, admonish-ing'. Coleridge's idea of the State as 'beneficent and humanizing' was as alien to the young Macaulay as Southey's conception of the picturesque. Victorian liberalism was described by John Stuart Mill, in his essay on the 'Claims of Labour' (1845), as inspiring an age whose 'whole spirit' was that it 'instigates every one to demand fair play for helping himself, rather than to seek or expect help from others'. The sentence hints perfectly at Mill's ambiguous sense of the ruling ideology of England — a response which led him to a serious flirtation with socialist ideas and must have encouraged his self-exile in France. Many Tory observers, among them Richard Oastler and John Ruskin, found that their attachment to ideas of tradition and community imposed on them a constant revulsion, not only from explicitly liberal ideas, but from most forms of institutionalized conservatism. Mill noted that the values and interests of Conservatives made them, 'by the law of their existence', much 'the stupidest party'. It seemed to many that Conservatives had abandoned any endeavour after accuracy of thought in favour of a conception of life based, in Coleridge's words, on 'flattering the envy and cupidity, the vindictive restlessness and self-conceit' of the 'half-witted vulgar'.[6]

Some of the difficulties of being a Tory within the Conservative Party are illus-trated in the career of the seventh Earl of Shaftesbury (1801–85), who was, in many ways, the most prominent successor of Sir Thomas Bernard. He insisted that the 'Legislature ought to interfere' in the improvement of working conditions and public health. He argued that the Christian politician should spend much of his time in 'intercourse with vice and misery', understanding the real distresses of his fellow citizens in order to ease them. In the management of an estate, he assumed that

'ancestral feeling' should express itself in the promotion of a 'well-inhabited well-cottaged prosperity'. Improved housing, schools, and gardens would connect the landlord with his dependants, and they would share a common 'enjoyment of the old park of my ancestors'. Shaftesbury condemned a model of industrial growth in which man's 'loftiest faculties, when not prostrate, are perverted, and his lowest exclusively devoted to the manufacture of wealth'.[7]

Shaftesbury insisted that successful improvement would depend on a high level of 'inspection and care' in which private commercial activity must be made answerable to a broad idea of the public interest. He inevitably earned the antagonism of a wide variety of political allegiances. Many philosophical radicals were as opposed to the interfering spirit of 'gratuitous humanity' as those wealthy men whose mere selfishness made principle inconvenient. Shaftesbury offended a good proportion of his Party when he described the agricultural labourers as 'generally ill-treated in houses and wages' and oppressed by those who 'roar out about Protection' and the 'superhuman excellence of landlords'. He found little consistent sympathy in the more progressive Conservatism of Sir Robert Peel, a man to whom 'cotton is everything, man nothing', and who was often inclined to 'succumb to the capitalists'. In 1840 Shaftesbury met with hostility among what he described as the 'Conservative(!) Peers' in his plans for the protection of climbing boys. Lord Beaumont, who had designed his mansion in such a way that the chimneys were extraordinarily long and narrow, denounced the 'pitiful cant of pseudo-philanthropy'. In 1841 Shaftesbury 'blessed God' that he was not part of Peel's new government, fearing that it would abandon his plans for the improvement of public health. In 1842 he observed among his colleagues an extraordinary 'display of selfishness', a 'frigidity to every human sentiment', and a 'ready and happy self-delusion'. Later in his career he was repelled by the 'military, despotic, offensive' air of Disraeli's imperial schemes, perceiving them as showy distractions from domestic issues supported by a Party that was 'servile' and 'without principle or patriotism'. It is curious to find that David Willetts's celebration of *Modern Conservatism*, published in 1992, seems to regard Shaftesbury as 'one of us', particularly as his book chooses to portray Peel as a wholly admirable pioneer of opposition to the authority of the State in commercial and social relations.[8]

8

The Nature of Toryism

Meer Enthusiasm is the All in All! Bacon's Philosophy has
Ruin'd England. Bacon is only Epicurus over again.
William Blake, *Annotations to Reynolds*[1]

If the Tory idea of landscape remains somewhat elusive or confused this is not, perhaps, surprising given the uncertain and changing characteristics of Toryism itself. In 1776 Tom Paine wrote that 'servile, slavish, self-interested fear is the foundation of toryism.' He was referring to Americans loyal to colonial rule, but his language recalls, not only Lord Shaftesbury in 1878, but similar remarks made by Robert Harley in 1701. Having joined the 'country Tories', Harley described those whom he elsewhere called 'the gentlemen of England', as 'naturally selfish, peevish, narrow-spirited' and 'envious of any ability in others'. In his book *Revolution and Rebellion* (1986) the historian Jonathan Clark, whose views are clearly conservative, occupies himself with the reputation of those gentlemen. He complains of the way that John Brewer, a historian he takes to have been strongly influenced by the radical spirit of the late 1960s, describes sections of the Tory landed interest of the first half of the eighteenth century. According to Clark, Brewer 'caricatured a bumbling squirearchy' when he wrote passages such as the following:

> Paternal, reactionary, resisting the growth of market relations, and bent on reform only as a means of turning the tide of 'history', these bucolic creatures seem, at least, to have squared ideology and interest and to have behaved as every *Marxisant* historian would wish.

Brewer's rather loose language, itself redolent of a certain kind of modern conservatism, is answered by Clark as follows:

> However conformable to *Marxisant* expectations, any such parody of the gentry does not survive the evidence presented [in recent studies that demonstrate] their extensive involvement in agricultural and industrial entrepreneurship. Inconveniently, this was especially the case of the *Tory* gentry . . . Sir Roger Newdigate, 5th Bt (1719–1806) . . . was a leading Warwickshire entrepreneur in coal mining, canals and turnpikes, and a reader of Richard Watson's *Chemical Essays*.

It seems that even a conservative historian has to suggest that Tories are admirable in so far as they conduct themselves in the same manner as the most progressive of the Whigs, or even according to the lights of the modern enterprise culture. The qualities valued would seem to be much the same in the work of the conservative as the 'Class of '68' historian. The point of the reference to Richard Watson is unclear; whatever the merits of the popularizing *Chemical Essays*, the very Whig Bishop Watson has perhaps been chiefly remembered for Wordsworth's outrage at his contemptuous references to the perversity and stupidity of the English labouring poor, and for Blake's disgust at the politically partial nature of his religious works.[2]

In *Landscape and Ideology* (1986) the *Marxisant* art historian, Ann Bermingham, dismisses Uvedale Price as a reactionary, if often unconscious, lackey of capitalist oppression, both as landowner and theorist of design. The picturesque, in all its forms, was a mere refinement of a system of domination in which property and nature were made to seem indistinguishable. The landscaped park was the private nature of a ruling class that was completing the expropriation of public nature through enclosure. By disguising the real essence of ruling power through paternalism, Price was a more insidious enemy to libertarian standards than the cruder proponents of improvement. In *The Search for the Picturesque* (1989) a literary historian, Malcolm Andrews, continues the theme of progress and reaction, but with a different emphasis, perhaps more suited to recent political history. The aesthetics of Price are denounced as 'reactionary' and 'anti-utilitarian' in that he preferred a pastoral ideal of England to the progressive impulses represented by industrialization and enclosure. His works were hostile to the 'engineering of social change' and the superior insights offered by emerging 'liberal humanism'.[3]

According to the art historian David Solkin, the eighteenth-century writer John Shebbeare was a 'rabid Tory and a Jacobite' in that he took pleasure in the feudal oppression of the Welsh peasantry, their 'remains of ancient vassalage' and unquestioning 'obedience to their landlords'. For the historian of philanthropy F. K. Brown, Sir Thomas Bernard was a vindictive and aloof Tory MP who vigorously opposed every measure for the 'betterment of the lower orders'. For Michael Ignatieff, on the other hand, Bernard was a servile follower of Bentham who wished to undertake a 'scientific' distinction between the 'deserving and undeserving poor' in order to facilitate the 'profitable exploitation' of the labour of both. In a much quoted passage, E. P. Thompson may be taken as implying that Bernard's ideas were little different from those of Burke's *Thoughts on Scarcity*, and yet he writes admiringly of the later Tory Richard Oastler, whose values on the whole strongly resembled those of Bernard. Thompson, clearly a writer of *Marxisant* tendencies, is generally sympathetic in his work to Tories, particularly in the eighteenth century, seeing them as defenders of traditional, albeit paternal values, in contrast with the grasping and vulgar selfishness of the 'Whig oligarchy'. Conor Cruise O'Brien, on the other hand, quoting a passage of 1796 in which Burke describes himself as one of a set of 'Tory geese' warning of the Gallic threat, is anxious to point out that in no other place does Burke so demean himself as to regard himself as Tory; he is clearly being 'facetious'. 'Tory sensibility' is associated in O'Brien's mind with Lord Shelburne, whom he detests, and is coupled with Shelburne's sin of 'religious bigotry'.[4]

A consistent definition of Toryism may be as elusive as the identification of the golden age of rural England, whether conceived as a period of happy equality or as a time of landowners living hospitably on modest estates amid a contented peasantry. When William Gilpin quoted James I's complaints regarding the decline of hospitality he did not feel he had to apologize for repeating them, essentially unqualified, in his own day. James Ibbetson was outraged at the wanton tyrants who 'lay field to field' until there is no place for the poor, just as Bernard Gilpin and Bishop Latimer had been in the sixteenth century, and the author(s) of the Book of Isaiah had been in Old Testament times. Every age seems to have a tendency to conspicuous accumulations of capital at the apparent expense of the poor. The language of protest, it appears, has to be reinforced in every generation in an attempt to make history a continuous dialectic of power and morality rather than a process of simple and unchallenged appropriation. Whether Toryism is best considered as a principle of oppression or as a moral assertion of responsibilities, and whether its ends are best served by an appeal to ancient rights or by the liberalization of markets, remain questions of opinion as much as definition.

Toryism, as conceived in this study, is taken to have been informed by a strong sense of responsibility in the management and distribution of scarce resources, to be attentive to its own ideas of social cohesion, and to assume continuing obligations to the past and the future. Among its obvious weaknesses was a limited interest in many of the processes by which material wealth is created and may be expanded. One of the ways this expressed itself was in an antipathy to political economy, generally seen as a shallow, undifferentiated doctrine of radical greed that must be uniformly, and often uncritically, opposed. These remarks may serve to underline how little Tory thought has in common with those branches of modern conservative argument that assume the primacy of simple free-market theory in virtually all human affairs. Many expressions of this argument claim to draw confirmation from Classical economics, and in particular from Adam Smith. The extent of their proponents' understanding of Smith's work is, however, often rather dubious. It may be that Toryism and much modern conservatism are united only in their weakness for titles and their very partial comprehension of the values of political economy. In neither of these characteristics are they alone, of course. It is striking, for example, to note that Ted Honderich's conception of Adam Smith in his denunciation of *Conservatism* (1991) is essentially identical with that of David Willetts in his celebration of *Modern Conservatism* (1992). Perhaps the perceived interests of both right and left have been served by suggesting that Smith took a simple view of the nature and consequences of free markets. It is unfortunate that some of those who seek an alternative idea of political economy, such as Richard Douthwaite in his stimulating work *The Growth Illusion* (1992), should also allow themselves to promote this view.

Those who spend much of their time occupying themselves with the past do not necessarily gain particular insights into the present, but they may be of some value in pointing out cases in which a partial view of history is used to confuse their contemporaries. Discussion of the historical landscape continues, after all, to influence values, attitudes, and sometimes decisions. It is widely believed in Ireland that

the country was covered with rich woods until the seventeenth century, when the increasing dominance of alien power brought about their alleged destruction. A similar myth was once important to certain conceptions of Old England. It is still sometimes argued in Britain, regardless of historical evidence, that hedgerows were largely a product of eighteenth-century enclosures. Such a view is of course useful to those who wish to grub up hedgerows, and whose concern for this alleged truth may be their only expression of interest in the past. Some supporters of field sports argue that the traditional landscape of England was created almost entirely to answer the needs of sportsmen. This argument, like the one relating to hedgerows, can become tortuous, as hedgerows and coverts may become symbolic images for a wide variety of political positions. It is sometimes forgotten that field sports were in many ways more controversial in the eighteenth and nineteenth centuries than in the twentieth. Enclosures are still sometimes discussed, particularly by critics of art and literature, as if it were possible to make simple generalizations regarding their local consequences. Arthur Young's *General Report* of 1808 makes it abundantly clear that such generalizations are often ill-advised, and that the effects of enclosure differed markedly according to particular circumstances and the character of those who supervised the process. All these issues, and many others, continue to influence the perception of parts of the landscape and of the social influences alleged to have formed them.[5]

A simple contrast of Tory and Whig views of landscape, which has been used in this study, may be helpful in trying to define a tradition, but hardly does justice to the complexity of progressive ideology, particularly in the eighteenth century. It is possible, however, that a more accurate account of the history of political economy would enhance a critical sense not only of Tory views but of the modern landscape of ideas. It has been noted earlier in this study how most advocates of free-market theory in the eighteenth century were completely candid regarding the kinds of society that they expected their ideas to promote. Townsend and Malthus, in particular, leave the reader in no doubt of the difficulties of improvement. Malthus's work after the publication of his first *Essay* was in some ways more optimistic than his original thesis, but it does not offer the reader an easy prospect of human felicity. He became convinced that the rising demand for labour brought about by economic growth would increase wages in the short term and limit the negative effects of an increased population. After a certain level of affluence had been reached, men would be so keen to protect and even enhance the comforts and pleasures they derived from new clothing, comfortable accommodation, and good food that they would delay marriage and therefore lessen the rate of procreation. The darker prognostications of the first *Essay* could be avoided and society might continue to sustain itself. All that was required to achieve this happy result was the complete liberalization of markets, the diffusion of an unbridled competitive instinct, and aggressive incentives to improvement in the form of personal consumption. This in turn required the end of benevolent intentions in the poor laws — far from generating a sense of security, they must humiliate and punish. Every failure of the economy to expand and generate full employment seemed to imply an over-indulgence in the systems of relief. By the 1820s Malthus was urging the widespread destruction of cottages and

the withdrawal of all parish assistance from those born after a specified date. Everything, including the possible starvation and depopulation of the country, must be undertaken to stimulate economic activity. The attractiveness of Malthus's vision of society may be debated, but he makes no attempt to disguise the nature and risks of his idea of improvement.[6]

Malthus may be considered a somewhat eccentric figure, and an aberration from the more positive tradition of economic theory represented by Adam Smith. It has, after all, suited many commentators of very diverse persuasions to portray Smith's work as an uncritical celebration of the effects of leaving market forces to themselves. As Smith is such a dominant figure in the English landscape, it may be of some interest to the study of conservative as well as Tory opinion to qualify this view. As noted earlier, Smith sees improvement as founded in man's natural desire to better his condition and to emulate wealth and pre-eminence. Unfortunately these dispositions, so essential to economic ambition, are defined by Smith as the 'great and most universal cause' of the 'corruption of our moral sentiments'. They distort every perception. Men who can be indifferent to the distresses of the poor may be indignant at the sufferings of the great, as if pain intensified with rank. The lower orders of society are in a state of constant awe of rich men of inane understandings and trivial accomplishments, whose only recommendation is pre-eminence. Ambitious men, always anxious that their talents be brought into public view, engage in any deceptions to this end, even at the risk of civil disorder. Those who have risen to prominent positions in politics or commerce will have done so amid the conniving, jealousy, and contempt of their colleagues and will have acquired habits of meanness themselves. Only in some of the professions, where success may be acquired by patience, industry, and the respect of equals, can men who seek their way in the world hope to avoid such corruption. The ambitious poor man's son who finds his father's cottage insufficiently commodious, and seeks his fortune in commerce, will undertake a long and corrupting course of aspiration after a dubious contentment. Aiming after an uncertain and artificial 'elegant repose' amid the 'machines' of prosperity, he will sacrifice a 'real tranquillity' in favour of a journey that will leave him exhausted and galled by a thousand injuries and disappointments. Improvement, in Smith, is almost always perceived as an equivocal undertaking.[7]

Anxious journeys in the pursuit of the machinery of happiness stimulate all improvement. Philosophical wisdom might suggest that real happiness would be found among those who are healthy, clear in conscience, and possessed of sufficient funds to supply basic needs and occasional indulgences (a competence, in eighteenth-century terms). Smith describes this condition, perhaps rather optimistically, as the 'natural and ordinary' state of mankind, and one that offers a level of contentment to which the highest prosperity can add little. Yet men are so fearful of being overlooked, and so persuaded that wealth will increment their 'means of happiness', that they sacrifice their real comforts for material ambition. It is this deception that

> rouses and keeps in continual motion the industry of mankind. [It prompts us] to cultivate the ground, to build houses, to found cities and commonwealths . . . to

invent and improve all the sciences and arts which ennoble and embellish human life . . . [and all the energies] which have entirely changed the whole face of the globe, have turned the rude forests of nature into agreeable and fertile plains, and made the tractless and barren ocean a new fund of assistance.

This appropriation of the external world to material improvement is one of the aspects of generic political economy that especially repelled Wordsworth, Coleridge, and others, but Smith never suggests that it is without adverse consequences or offers easy guarantees of contentment or social peace.[8]

A reader of Ruskin and William Morris, or indeed other writers who emphasize how the division of labour leads to the fragmentation of the personality of the workman as well as of his tasks, might assume that Smith's central account of mechanization in *The Wealth of Nations* is an uncritical celebration of the process. It is clear, however, that while Smith regarded the division of labour as an inevitable accompaniment of improvement, he also perceived it as a highly destructive phenomenon. In this he concurred with several of his Scottish philosophical colleagues. John Millar, for example, worried that men might come to emulate the machinery they attended, lapsing into a 'habitual vacancy of thought' that was unenlivened by wider prospects. The rise in national improvement would tend to make such men the 'dupes of their superiors', the degraded consumers of a received culture. Adam Ferguson worried that the exaltation of a few rich men would 'depress the many', both economically and intellectually. The advocacy by Smith and others of much increased public investment in education was not designed to train up specialist operatives to work machines, but to encourage a mental stimulus increasingly denied by the conduct of labour. Smith was convinced that the general level of skills required of workmen would tend to decline and threaten the impoverishment of individual personality. Education was to serve a cultural rather than a utilitarian purpose. In the rural economy such a provision was regarded by Smith as hardly necessary, since men derive ample stimulus from the variety of their experience. In rural labour, for example, it is typical for men to vary their work and tools many times in a single day. Even those who are slothful and careless tend to learn a large number of skills and are obliged to 'invent expedients for removing difficulties'. Smith insists that the successful practice of agriculture requires a 'variety of knowledge and experience' exceeded only in the fine arts and liberal professions. The new industrial tasks, on the other hand, deliberately seek to involve the entire attention of the workman in a single, partial object and to exclude invention and initiative. The torpor of mind that results tends to exclude rational thought and conversation, 'generous, noble, or tender sentiment', and the understanding of personal and social interests. The material improvement of society is increasingly acquired at the expense of the mental degradation of the mass of the people. The growth of child labour perpetuates, and indeed accelerates, the process, as men and women are brought up to labour that is 'simple and uniform', constant, and severe. As Adam Ferguson suggests, 'ignorance is the mother of industry as well as superstition'. Sentiment and reason, reflection and fancy, are hardly wanted by a system that sees human beings as parts of machinery.[9]

The transition from a rural to an industrial economy would be accompanied by other difficulties. Smith's extensive celebration of country life in *The Wealth of Nations* has a number of polemical intentions, of which one of the most important is to underline the inherent instability of a social order increasingly dominated by the greater energies of commercial life. Smith's enthusiasm is not, in general, for the great landowners. Such men tend to neglect their extensive estates, concentrating on the expensive improvement of the land around the mansion at a cost that can never generate an economic return but subtracts from useful investment. Many of the great estates are remnants of a feudal order that had flourished when the rich had few objects of luxury on which to expend their surplus and exercised a 'prodigious influence' over vassals. This role, useful in its time and often accompanied by a tradition of general hospitality, had been to a large extent abandoned as the rich concentrated increasingly on personal consumption and the construction of fashionable houses and gardens. Smith attaches greater moral and political importance to smaller proprietors of land, celebrating a secure, independent, and respectable yeomanry who know every inch of their land and derive much of their pleasure from its cultivation and adornment. He praises also the utility of the country gentlemen and the extraordinary pleasures that their social position and style of life may afford. Their real interests, Smith argues, are always identical with those of the community as a whole and they are altogether less fractious and more dependable as a class than the money men. They are less inclined to monopoly, and 'have no secrets', being generally fond of communicating with their neighbours regarding, for example, the benefits of new farming practices. They generate their revenues almost 'independent of any plan or project of their own' and enjoy a life characterized by the ease and serenity of their situation and a leisure extensive even to the point of indolence. In agriculture, Smith further suggests, nature 'labours along with man'; he directs and regulates, rather than animates, the 'active fertility' of the natural world. The quantity and quality of productive labour employed in agriculture, and the value added to the wider benefit of society, render it the investment of resources most useful, in every sense, to the community.[10]

In contrast, as commercial rates of return often tend to decline with the expansion of the national economy, and as money men take a narrowly selfish view of investment, their interests are, Smith argues, always different from, and often opposite to, that of society as a whole. They seek to widen their markets while limiting the competition. They deceive and oppress the public and falsify the common language by attempting to elevate the 'sneaking arts of underling tradesmen' into grand maxims of politics, morality, and taste. The reality is that commercial capital has no interest in morality, justice, or principles of taste. Unlike agricultural investment, which must reside in the society, in a 'precise spot', it has no 'fixed or necessary residence' but will travel to where it sees the highest return. Its tastes, morals, and politics will be equally pragmatic. Commercial men will always be disposed to seek markets that they can most easily manipulate, where they can select their own rules of conduct and find the cheapest materials and workers.[11]

Given this line of argument, and the declaration that the worst kind of government would be one undertaken by men of commerce, it will be apparent that Smith's

idea of the State is more complex than is often suggested. He was clearly concerned to reject the principle of assiduous intervention recommended, for example, by Sir James Steuart. Steuart's *Principles of Political Oeconomy* (1767) had imagined statesmen 'systematically conducting' every part of government so as 'to prevent the vicissitudes of manners, and innovations, by their natural and immediate effects or consequences, from hurting any interest within the commonwealth'. Smith argues that the bulk of politicians being, like other ambitious men, mainly occupied with the fine art of being seen, clearly do not have the competence for the effective administration of such a task. The State, as an expression of the common good, can clearly not afford to become too involved with the processes of improvement, given the moral corruption always involved in their pursuit. Smith's idea of what the State ought to be is not particularly clear, but his analysis of the duties of the national government does not suggest a particularly narrow focus. He discusses at length the government's duties in defence, public education, public works not profitable to individuals, and the administration of justice. As justice, rather than benevolence, is the basis of civil society and is essential to its morality, order, and real improvement, and as government must look to defend every citizen from the 'injustice or oppression' of 'every other member' of the community, it can hardly be supposed that Smith favours the withering away of the State. Further, rather like Steuart, Smith sees government as constantly obliged to take what he terms an 'extensive view of the general good' by consistently opposing the 'clamorous importunity of partial interests', most notably those of merchants and manufacturers. Such men are assumed to be unprincipled, ignorant, and fond of putting their own immediate self-interest, imaginary or real, before the interests of society as a whole and their own shareholders, associates, or employees. Accordingly, governments are in a constant state of tension with the changing demands and the 'clamour and sophistry' of men of commerce, operating internationally and often seeking to make the public authorities their own instruments or property.[12]

A rapidly improving society is, in Smith's view, threatened throughout by fragmentation and discontinuity. The bulk of the population is made into operatives, their minds narrowed by their daily tasks. Technical changes and commercial decisions regarding the uses of capital are always threatening the stability of employment. New energies are constantly required to sustain an inherently cyclical productive machine. Traditional forces of stability, such as the landed interest, are losing their influence. In order to try to balance the opposing forces in society, Smith looks not only to government but to the existence of a class of men whose precise nature he does not define in detail. They might be taken to be a kind of administrative élite or the basis of what Coleridge describes as a 'philosophic public'. Smith insists on the need for a group of men in the community who, like himself of course, are assumed to be disinterested spectators and critics of the public good. Although improvement narrows particular tasks, it tends to expand the sum of total activity amid an 'infinite variety' of competing interests. There is a need for men who are 'acute and comprehensive' in their understandings, capable of 'endless comparisons and contemplations' that will enable them to understand the common good. Such men are to be 'placed in some very particular situations' that will ensure their

independence from partial interests. They are to be educated as comprehensively as possible — presumably as comprehensively as Smith himself, with his extensive combination of interests in law, literature, science, and philosophy. Who is to select such men, and where they are to be placed, is not entirely clear. It is evident, however, that Smith, like others in the analogical tradition of which he was a part, believed in the vital importance of the composition and balance of opposing forces, whether in nature, art, or civil society. A community abandoned to market forces would become disagreeable, inefficient, corrupt, and destined to self-destruction.[13]

If Smith was misjudged by Tories such as Wordsworth and Coleridge, his recent instrumentalization by Conservatives has surely been more destructive and absurd. The Tories at least rejected him in favour of a social ideal that Smith would, in a large degree, have respected. The frequent use of the writings of Edmund Burke by modern Conservatives is only a little more convincing than that of the work of Adam Smith. The elements of Burke's thought appropriate for this purpose are chiefly those passages of the mid-1790s in which his mind seems least engaged — the celebration of market forces and the elevation of external pomp over moral and intellectual substance. Burke's Butlerian emphases — the sense of continuity and connection, the responsibility of one generation to another, the valuing of community over dogma — are clearly much more difficult to relate to simple free-market values. There is hardly a phrase of Burke's, when he is operating at his full powers, that is not an effective criticism of modern Conservatism. To dignify the latter by tracing its intellectual roots in the eighteenth century is as unrewarding a task as performing the same exercise for such characters in Dickens as Messrs Bounderby, Merdle, Podsnap, and Pecksniff. Reflections on these personalities, and on the economic writings of Townsend, Burke, Malthus, and even Mill, might suggest that certain influential traditions of economic and moral liberalism seem generally to reflect the absence or the fear of emotional sympathy, coupled with a strident but uncertain, sense of personal identity. This is a theme that has been explored, with reference to modern Conservatism, in the plays of David Hare.

Perceiving the landscape merely as a setting for an 'enterprise culture', modern Conservatism has little room for subtle notions of responsibility, continuity, and balance. A narrow view of the market seems in large part to exclude thought, creativity, and stability, and seeks to conserve nothing but itself. Its rejection of Tory values is well conveyed in an interview, given in January 1991, in which a former Conservative Minister, Geoffrey Howe, complains that many of Britain's problems arise from persistent literary ideas and what remains of traditional landscape. Those problems centre, of course, on a low level of economic growth. The fault lies in the writings of 'people like William Blake',

> who contrasted the dark, satanic mills with England's green and pleasant land. There has been a kind of cultural gap between educationalists, who want to remain green and pleasant, and our entrepreneur-industrialists, who work in dark, satanic mills.

Fortunately, however, 'We are bridging that gap now, finally. It is a long, long, deep-seated process.' The 'bridging' depends on an increasing commitment to specialist

technical education and the spreading of a culture of enterprise in which individuals dismiss out-dated prejudices and boldly pursue the conquest of new markets. Literature and the landscape may have been decorative aspects of the past, but they are irrelevant to a more enlightened future.*[14]

In some ways Howe pays an extraordinary, if doubtless undeserved, compliment to the power of literature in England. It would be hard to imagine a senior politician in France, Italy, or the United States, for example, citing a great poet and artist as an enemy of economic growth. That Blake should be singled out for this argument may be unsurprising, but it is not especially candid. Jane Austen, for example, would have done as well for this purpose as Blake, but might have provoked the potentially embarrassing thought that it would be difficult to name a major writer or artist who could be plausibly argued to be sympathetic to Conservative values. The contrast between landscapes corrupted by greed and those that serve the public interest, even when they are private, is a familiar enough theme in English literature and painting. Works of art may, however, be more resistant to banishment than the landscape, and to that extent, at least, may represent a more serious barrier to a spirit of innovation and enterprise.

That enterprise has no interest in the past is a favourite theme of *The Economist*, a publication founded by men of liberal inspiration in 1843. Its purpose was to take part in a 'severe contest between intelligence, which presses forward, and an unworthy, timid ignorance obstructing our progress'. A survey of the British economy published by *The Economist* in October 1992 regrets a pervasive 'preoccupation with the past' that continues to thwart the arrival of a future that is to be 'brand new, . . . bigger, brighter, more efficient'. What remains of the past must be 'torn down'; British society must learn to 'scrap and build', vigorously 'bulldozing away' everything tainted with tradition and prejudice. Change must be 'fast and furious' and nothing is to be left 'untouched'. Only on this rather Jacobin *carte blanche*, it seems, can a new ethic of energy, sacrifice, vision, and duty be established. Opposing all this is the 'meddlesome nature' of government and regulation. An observer of the British landscape may be forgiven for supposing that a great quantity of tearing down has already occurred, certainly more than in many other countries that are, strangely enough, more successful economically. It can hardly be said of England at the end of the twentieth century that 'the land remains', as Cobbett believed in the 1820s, and Ford Madox Ford imagined a century later. Other articles in *The Economist* have, however, confirmed that the pursuit of continuity is an unhealthy

* In his important study, *Charles Babbage, Pioneer of the Computer* (1982), Anthony Hyman outlines the evidence from Babbage's career that the decline in international competitiveness of British industry can be traced back at least as far as the 1830s. By that time it had developed many of its familiar habits of waste, low investment, contempt for the workforce, and complacent neglect of scientific research. It would be interesting to explore how much of this pattern of attitudes could be related to the fashion for simple notions of political economy. The conviction that the short-term interests of businessmen are identical with those of society does not necessarily promote an intelligent use of resources. Babbage, a man of extensive cultivation, appears to have received much more support from the reactionary Duke of Wellington than his more businesslike political successors, and to have failed almost entirely to attract the interest of private entrepreneurs. Babbage dedicated his *Reflections on the Decline of Science* (1830) to an anonymous nobleman, whom Hyman argues to have been the future Lord Shaftesbury, a serious amateur mathematician and astronomer who was devoted to traditional Tory social values.

distortion of the proper operation of the free market. Policies that seek to take account of the future are to be regarded with suspicion since they assume some knowledge of the 'unknown preferences of the unborn'. Every generation is to pursue its own idea of self-interest and not to assume that such a choice may limit the freedom of its descendants. An interesting confirmation of *The Economist*'s conception of time horizons occurs in an article on budgetary policy published in March 1993, in which the fiscal year 1994–5 is perceived as the 'medium term'.[15]

In a lecture given in March 1990, a former Conservative Environment Minister, Chris Patten, made an attempt to formulate an approach to the traditional land-scape, and to the future, more delicate than those of Geoffrey Howe and *The Economist*. He was concerned with what he called the 'protection of the environ-ment' and looked to a distinguished figure from the past as a point of reference. His speech goes back, indeed, to the sixteenth and seventeenth centuries and cites Francis Bacon as the 'first champion of sound science as a basis for politics for managing the environment'. What the argument is trying to establish is, unfortunately, unclear, but it seems that the 'management of nature' is to be left largely to the market and to follow Bacon's insistence that men must 'trust science and human ingenuity'. Since Bacon was perceived by Blake as a spokesman of a philosophy that had ruined England, and Blake is a dangerous enemy of the enterprise culture, Patten's comment is provocative and interesting. It is not necessarily helpful, especially since Bacon is one of those great thinkers who may be quoted on various sides of difficult disputes. Patten cites the doctrine, repeated many times in Bacon's *Novum Organum* (1620), that men can only 'command nature by obeying her'. He does not point out that this statement, itself rather ambiguous, occurs within an argument that emphasizes that all arts and sciences exist to furnish means, usually mechanical, by which men will 'establish and extend' the power, dominion, and empire of the human race over the universe. Science will recover the right over nature that belongs to men by 'divine bequest' and which was lost with the Fall. Bacon's language suggests the idea of men assuming divine or diabolical power over the elements that in Bacon's lifetime had occupied Christopher Marlowe, among others, not always offering the prospect of happy results.

Bacon has a very simple sense of the moral implications of such power over nature; once given, its exercise will be governed by 'sound reason' and 'true religion'. His idea of nature, formulated before Newtonian physics, not to cite subsequent developments, is quite uncomplicated. Nothing exists in nature, Bacon writes, besides bodies performing 'pure individual acts according to a fixed law'. Nature appears to have little connection with man except as the object of experiment. Animal life exists to be used, moulded, dissected, and made the object of trials in which colours, shapes, and natures are transformed purely for the pleasures of experiment. Bacon several times uses the image of 'inquisition' for scientific enquiry, making it clear that in many cases the object of a trial is to demonstrate a point, such as the effects of pain, rather than to uncover the essential nature of the thing being investigated. The experiment, Bacon writes, is itself the judge of the object. Scien-tists, who undertake a purely inductive review of experience, are perceived as men innocent of values and presuppositions; they have 'purged and swept and levelled the

floor of the mind'. The entire undertaking assumes a violent rejection of authority and received wisdom. The reader of Bacon may well recall that the motto of the Royal Society for Improving Natural Knowledge, founded in 1660 and strongly influenced by Bacon's work, is *Nullius in verba*. How all this would be appropriate to the management of nature in the late twentieth century is not at all clear, although it might be taken as an incentive to the abolition of all regulation. It may be that Patten's account of Bacon is as partial as his understanding of Edmund Burke and Adam Smith, two other distinguished writers he has used in the defence of Conservative doctrine. Both would have found Patten's conception of 'the environment' essentially meaningless.[16]

Smith and Burke, together with David Hume, are among the major heroes of *Modern Conservatism* (1992), written by the Consultant Director of the Conservative Research Department, David Willetts, in order to give intellectual and moral respectability to recent policies by demonstrating that all the pleasures of human society, including a 'sense of community', are rooted in competition, and that the essence of Conservatism lies, of course, in constant change. 'Community', it appears, derives from a 'robust understanding of what is in our own interests'; it is 'co-operation' among 'self-interested individuals'. The reader is informed that the founders of modern Conservatism in the eighteenth century seem to have regarded 'all historical change' as 'equally welcome'. Adam Smith invented dynamic market economics and Burke realized his own greatness in being a 'free-market follower' of Smith. Burke's *Thoughts on Scarcity* and his *Reflections* were brilliant vindications of the idea that 'free-market economics' and a 'sense of community' are easily reconciled. Major contemporaries, such as the 'essayist' Johnson, demonstrated that commerce automatically led to 'refinement of the arts' as well as community. This radical understanding of free trade as the basis of human felicity was grasped by Lord Liverpool and Sir Robert Peel, who were both responsible for a 'bold project' to 'roll back the frontiers' of the nineteenth-century state. Unfortunately, these great men were criticized in the novels of Disraeli, who distorted Conservative traditions by depicting 'boot-faced mill-owners'. The true values of Conservatism were understood by Disraeli as Prime Minister, however, and expressed themselves in his invention of the British Empire. Sound Conservative values were sustained by Lord Salisbury, but fell into decay after his death until they were revived in the 1954 discussion document *Change is Our Ally*, which insisted that the emphasis of Party policy must shift from 'stability to change'. Recent Conservative governments have triumphantly vindicated this insight, and 'Adam Smith, Friedrich Hayek, Margaret Thatcher convey the spirit of the age.' The latter's genius has been to perceive that all human virtues have their foundation in private enterprise and that governments are most effective when they realize that the financial markets are wholly efficient, that interest rates are the 'main tool for managing the economy', and that the motives for which economic activity are undertaken are not their concern. Clearly the historical Adam Smith has managed to become rather lost amid the spirit of the age. On the basis of free markets and 'sound money' emerges a society, which only modern Conservatives will detect in contemporary England, in which every virtue may flourish, and which manifests, in the words of Hayek, 'tolerance of the different

and queer, respect for custom and tradition, and healthy suspicion of power and authority'. Occasionally, Willetts acknowledges, the modern Conservative feels some sense of the tragic, some regret at the passing of the familiar. In these moments he turns to the poetry of Philip Larkin or Michael Oakeshott's 'beautiful' essay 'On Being Conservative', which movingly laments the impermanence of life, the death of friends, the retirement of a favourite clown, and a storm which 'sweeps away a copse and transforms a favourite view'. These are, however, phenomena that may be relegated to the merely natural cycles of life; Willetts does not suggest that regret concerning such changes would be legitimate if, for example, the copse and the view were altered by economic activity. The environment is, after all, to be managed by the market.[17]

The thoughts of Howe, Patten, and Willetts may be considered something of a betrayal of Anthony Quinton's argument in *The Politics of Imperfection* (1978) that the Conservative Party exists above all to promote excellence. A social order in which excellence is 'enabled to develop and become effective' is to be valued above any 'conception of justice, . . . desert or merit', and any idea of 'equality or need'. It is certainly more important than any 'ancient constitutional pieties' that may be invoked to perpetuate competing values from the past. Conservatism is, it seems, to be regarded as the heir of Lord Macaulay's Whig conception of a free exchange of ideas naturally generating improvement. Unfortunately, after more than a decade of Conservative rule it is extraordinarily difficult to identify many areas in which excellence is on the increase in England; hence, presumably, the Malthusian argument that the destruction of the past must be stepped up in order to complete the emancipation of society. It is curious how the absence of excellence manifests itself in areas in which the free competition of ideas may be assumed to be at its most intense — in the appointment of the managerial class. Yet *The Economist* consistently argues that this class is so bad that the only salvation for British industry will lie in its continuing acquisition by overseas interests. Such defects have often been blamed, as by Geoffrey Howe, on an alleged preponderance of reactionary and anti-commercial attitudes in education. It would, however, be difficult to imagine men more emancipated from traditional cultivation than the British managerial classes and their political representatives. One recalls that Lord Macaulay, and indeed the founders of *The Economist*, assumed that the free debate of ideas would be founded on a broad achievement of knowledge and wisdom, not on a market defined by ignorance. One recalls also that Macaulay, despite his rhetorical antagonism to Tories, was an outspoken promoter of specific acts of legislation, such as the Ten Hours Bill, which obliged capital to be more careful in its use of resources, and encouraged men generally to be 'healthier, and wiser, and better'.[18]

In the historical vacuum of modern Conservatism residual images of the Tory view of landscape survive in a form that is normally absurd and is probably best considered alongside such phenomena as the heritage industry and the architecture of Quinlan Terry. A good example may be found in an issue of *The Spectator*, published in August 1992, in which Nigel Nicolson describes ways in which it is always clear from the air when the landscape below is part of England, and not 'some foreign country'. This has little to do with the market, but is partly a function

of planning. England, the reader may be astonished to discover, is free of the 'incongruous development' one would find 'in America, in France, or Italy'. Further, the layout of the fields is an unmistakable indicator of Englishness — it is a 'neat patchwork' formed by hedges and ditches, 'some brown, some green', but mostly 'patines of bright gold' in the 'harvest sunlight'. This glowing image is part of the astonishing evidence of a unique social system:

> the nuclear village with its manor-house, its church, its parsonage and cottages, the 18th-century park being a refinement of the surrounding fields and its lake the village pond writ large, all settled into folds of the low hills without fuss and a minimum of arrogance.

The politics of the picturesque rediscover themselves and perish in an atmosphere of complacency and absolute lack of interest in historical developments, struggles, and controversies. The partially perceived external character of a wholly unrepresentative fraction of the landscape is not only made to stand for the whole, but is read without inquiry, doubt, or any serious concern for the past or the future. Such a concept of heritage co-operates with simple notions of political economy in the moral, intellectual, religious, and aesthetic blindness of modern Conservatism to produce a landscape in which glamourized remnants of the past are left standing amid vast stretches of debilitating mediocrity. The perfect triumph of the narrowly commercial mind has expressed itself, as Ruskin forecast, in 'meanness, aimlessness, unsightliness'.[19]

Notes and References

Introduction

1 Ford, *No More Parades* (1963 ed.) pp. 178, 247, 256. *A Man Could Stand Up* (1963 ed.) pp. 339, 369, 421–2.
 Report of the Roskill Commission, (1968–70) pp. 1501, 1736, 1765.
2 Southey, *Sir Thomas More: or, Colloquies on the Progress and Prospects of Society* (1829); the reference to 'liberal opinions' is in vol. I, p. 35.
3 Macaulay, 'Southey's Colloquies' in *Critical and Historical Essays* (1854) vol. I, pp. 206–55.
4 Wordsworth, 'Postscript' (1835) in *Poems*, ed. T. Hutchinson (1923) pp. 959–66.
5 K. D. M. Snell, *Annals of the Labouring Poor* (1985) pp. 9, 101, 106–12, 120–3, 136, 381.
6 C. Woodham-Smith, *The Great Hunger* (1991 ed.) pp. 65, 72, 120, 133, 177, 374–5.
7 *Mill On Politics and Society*, ed. G. L. Williams (1985) p. 246.
 On Malthus and Smith see chapter 8.
8 Mill, *Principles of Political Economy* (1848) vol. I, pp. 9–11, and Book III. The phrase 'aesthetic branch' is from Mill's 'Inaugural Address' as Rector of St Andrews University (1867).
9 Ruskin, *Works*, vol. XVII, p. 81.
10 Barrell, *The Dark Side of The Landscape* (1980) pp. 67, 81–6, 156; *The Political Theory of Painting from Reynolds to Hazlitt* (1986) pp. 259, 339; *The Birth of Pandora* (1992) pp. 1, 104.
11 On 'revolutionary' insights see, for example, Carole Fabricant 'The Literature of Domestic Tourism' in *The New 18th Century*, ed. F. Nussbaum and L. Brown, (New York, 1987) pp. 254–75.

1 The Perception of Improvement

1 Linda Colley, *In Defiance of Oligarchy* (1982) pp. 9–10, 85, 99–100, 162–3, 195, 217, 274.
2 Ibid., pp. 147–9, 159–60, 289.
3 A. Enaudi, 'The British Background of Burke's Political Philosophy', *Political Science Quarterly*, 49, 1934, pp. 576–98.
 Newton, *Opticks*, (4th ed. 1730) Book III, pp. 380–2.
4 Geoffrey Cantor, *Michael Faraday: Sandemanian and Scientist*, (1991) pp. 172–3.

Christopher Lawrence, 'Humphry Davy and Romanticism' and Simon Schaffer, 'Genius' in *Romanticism and the Sciences*, ed. Andrew Cunningham and Nicholas Jardine (1990) pp. 90–2, 216.
5 Mandeville, *The Fable of the Bees* (1970 ed.) pp. 201–2.
6 Butler, *Works* (1820) vol. I, pp. 87, 172–3, vol. II, pp. vi, ix, xi, 15, 147, 176, 254.
7 Ibid., vol. I, pp. 144, 282, 310, vol. II, pp. 253, 276, 313, 445.
8 Ibid., vol. I, pp. 87, 237–8, vol. II, pp. 87, 229, 237, 253–4.
9 Ibid., vol. II, pp. 87, 92–3, 411–12.
10 Ibid., vol. II, pp. 216, 313–4.
11 Ibid., vol. I, p. 267, vol. II, pp. 14–15, 345–6, 445.
12 Berkeley, 'Principles of Human Knowledge' (1710) and 'A New Theory of Vision' (1709) in *Philosophical Works*, ed. M. R. Ayers (1975) pp. 51–2, 87, 101, 109.
13 Ibid. and 'Three Dialogues Between Hylas and Philonous' (1713) in *Philosophical Works*, pp. 166–7.
14 Berkeley, 'An Essay Towards Preventing the Ruin of Great Britain' (1721) in *Works*, ed. A. C. Fraser (1871) vol. IV, pp. 323–7, 'A Sermon Preached Before the Society for the Propagation of the Gospel' (1731), ibid. p. 395, 'The Querist' (1735–50), ibid. pp. 423–7, 431–6, 459, 'A Discourse Addressed to Magistrates' (1736) ibid. pp. 487–8.
15 Hutcheson, *An Inquiry Concerning Beauty, Order, Harmony, Design* (1725) ed. P. Kivy, (1973) pp. 25, 41–2; *Illustrations on the Moral Sense* (1728), ed. B. Peach, (1971) p. 111.
16 *Inquiry*, pp. 51–2, 89, 92–3; *Illustrations*, pp. 110, 176, 209.
17 *Inquiry*, pp. 55–7, 78, 93.
18 Law, *A Serious Call* (1729) in *Works* (1892–3) vol. IV, pp. 8, 13, 18, 84, 109, 181.
19 Law, *The Spirit of Love* (1752) *Works*, vol. VIII, pp. 19, 83; *An Appeal to all that Doubt* (1740) *Works*, vol. VI, pp. 65–6, 115–17, 123; *The Way to Divine Knowledge* (1752) *Works*, vol. VII, p. 242.
20 *The Spectator*, 1 March 1711.
21 Maynard Mack, *Alexander Pope* (1985) pp. 368–9.
22 Fielding, *Tom Jones*, ed. R. D. C. Mutter (1966)

pp. 58–9, 113.

23 Mack, *Pope*, p. 765.
 Tom Jones, pp. 262, 365, 545; *Joseph Andrews*, ed. A. Humphreys (1973) pp. 219–20, 261.
 Malcolm Andrews, *The Search for the Picturesque* (1989) pp. 21–2.

24 *Tom Jones*, pp. 72, 724; *Jonathan Wild*, ed. D. Nokes (1982) pp. 213, 216.

25 *Tom Jones*, pp. 72, 172, 552, 572, 724, 862.

26 *Amelia*, ed. D. Blewett (1987) pp. 118–19, 367, 539.

27 Ibid., pp. 467–70, 493, 534, 544.

28 Hume, *A Treatise of Human Nature* (1739–40) ed. E. C. Mossner (1969) pp. 243–4, 308–10, 435, 539–40, 643–4; *An Enquiry Concerning the Principles of Morals* (1751) ed. J. B. Schneewind (1983) pp. 19, 59–61, 79; *Essays*, ed. E. F. Miller (1985) pp. 191, 264, 270, 298, 303, 512–14.

29 Beccaria, the Italian philosopher of the law, has an interesting variant on this link between improvement and gravitation. He refers to 'quella forza simile alla gravità, che ci spinge al nostro ben essere', which is also linked to 'quella fortissima attrazione che spinge l'un sesso verso l'altro; simile in molti casi alla gravità motrice dell'universo, perché come essa diminuisce colle distanze'. The link between sexuality and improvement was to be central to the tradition of political economy represented by Malthus. Cesare Beccaria, *Dei Delitti e Delle Pene* (1764); ed. A. J. Jemolo (1981) pp. 73, 132.

30 Smith, *Essays on Philosophical Subjects* (1980) pp. 66–7, 104, 177–8, 205; *The Theory of Moral Sentiments* (1976) pp. 85–8.

31 *Moral Sentiments*, pp. 9, 35–6, 45–56, 61–3, 181–2; *Essays*, p. 183; *The Wealth of Nations* (1976) pp. 190–2.

32 *Moral Sentiments*, pp. 181–5, 232–5; *Wealth of Nations*, general introduction, p. 47; text, pp. 343, 663–4, 758.

33 *Wealth of Nations*, pp. 91, 100, 140–5, 245, 264–7, 312, 363–4, 385–6, 412–25, 462, 470–2, 493, 622, 640–4, 684–8.

34 Smith, *Correspondence* (1987) pp. 337–76, 404.

35 From Johnson, *Selected Writings*, ed. M. Wilson (1965), 'A Journey to the Western Islands' (1775) p. 737; 'Review of Jenyns' (1757) pp. 527–9; 'The Adventurer' nos 67, 99 (1753) pp. 262–4, 276; 'Rasselas' (1759) p. 368; 'Preface to Dictionary' (1755) p. 325; 'The Idler' nos 22–3 (1758) pp. 285–7; 'Sermons' 23–4, in *Works*, vol. XIV, pp. 238–50.

36 Paley, *Principles of Moral and Political Philosophy* (1785) 1817 ed., pp. 267–77, 301–2; *Natural Theology* (1802) pp. 36, 117–118; *A Charge Delivered to the Clergy of Carlisle* (1790) p. 28.

37 Malthus, *Essay* (1966 ed.) pp. iv, 6, 85–6, 97, 286, 312–3, 377–8.

38 Young, *Autobiography* (1898 ed.) pp. 212–13, 257.

39 Burke, *Works* (1815–27) vol. VII, pp. 376–9, 382–5, 390, 397, 404, 413–18.

2 *The Whig Idea of Landscape and its Critics*

1 Nikolaus Pevsner, *Studies in Art, Architecture and Design* (1968) vol. I, pp. 84–101; Christopher Hussey in Dorothy Stroud, *Capability Brown* (2nd ed., 1975) pp. 30–2; and Rudolf Wittkower, *Palladio and English Palladianism* (1974) pp. 179–90, quote Addison, Thomson, and Shaftesbury. Among many other expressions of the idea may be cited Lord Kames, *Elements of Criticism* (11th ed., 1840) pp. 429–33, and William Mason, *The English Garden* (1767–81).
 Defoe, *A Tour Through the Whole Island of Great Britain*, ed. G. D. H. Cole and D. C. Browning (1962) pp. 1, 167, 252.
 Thomson, *The Seasons*, Winter, ll. 371–84, 1046–69.

2 See, for example, David Watkin, *Thomas Hope and the Neoclassical Idea* (1968) and *The English Vision* (1982); Kerry Downes, *Vanbrugh* (1977).

3 Mason's 'Sonnet xii' (1795) in *Works* (1811) vol. I, p. 133.
 Marshall, *Planting and Rural Ornament* (3rd ed., 1803) vol. I, p. 283.
 Walpole, 'On Modern Gardening', in *Works* (1798) vol. II, pp. 534, 537, 542.
 Whateley, *Observations on Modern Gardening* (Dublin, 1770) pp. 182–5.

4 Repton (1795), in *Landscape Gardening*, ed. J. C. Loudon (1840) pp. 84–5, 88, 92–5.
 Christopher Hussey, *The Picturesque* (1927; 1967 ed.) pp. 163, 171.
 Mason, 25 Aug. 1776, in Reynolds, *Letters*, ed. F. W. Hilles (1929) p. 244.

5 Throsby, *Select Views in Leicestershire* (1789) pp. i–iii.
 Marshall, *Planting and Rural Ornament*, pp. 287–8, 320–1.
 Mason, *Works*, vol. I, pp. 367–8.
 Blair, *Lectures on Rhetoric* (1965) vol. II, pp. 336–44.
 Watson, *A Sermon Preached Before the Stewards of the Westminster Dispensary* (1793) pp. 26–7.

6 Reynolds, *Discourses*, ed. R. W. Wark (1975) pp. 15, 44–5, 58, 110, 127–34, 192.

7 Ibid., pp. 15–16, 126, 134, 147–50, 192, 248–9, 254.
 John Barrell, *The Political Theory of Painting from Reynolds to Hazlitt* (1986) p. 31.

8 Watkin, *The English Vision*, pp. 9–10.
 Stebbing Shaw, *A Tour To the West of England* (1789) pp. 65–6.
 William Bray, *Sketch of a Tour* (2nd ed., 1783) pp. 17–18.
 A New Display of the Beauties of England (3rd ed., 1776) vol. I, pp. 276–81.
 Lawrence Whistler, *Stowe* (1956) p. 17.
 John Britton and Edward W. Brayley, eds, *The Beauties of England* (1801–16) vol. I, p. 293, vol. XII, pt. II (1813) pp. 278–86.

9 John Martin Robinson, *Shugborough* (1989) pp. 19–21.
 Mavis Batey, 'Nuneham Courtenay', *Oxoniensia*, 33, 1969, pp. 108–24.

William Angus, *Seats of the Nobility and Gentry* (1787) pl. xxxviii.

10 Watkin, *The English Vision*, p. 14.
 Peter Willis, *Charles Bridgeman* (1977).
 Gilpin, *A Dialogue upon the Gardens at Stow* (1748) pp. 8–12, 52.
 J. D. Hunt, *William Kent* (1987), chapter 3.

11 Willis, *Bridgeman*, pp. 19–24.

12 Ibid., pp. 18, 40, 59, 78–88, 100–3.

13 Ibid., pp. 18–19, 25, 135–8.

14 Richard Hewlings, *Chiswick House* (1989) pp. 25–6.
 G. B. Clarke, ed., *Descriptions of Stowe* (1990) pp. 88–93, 107–8.
 Whistler, *Stowe*, pp. 12, 17, 20, 30–1.
 Gilpin, *Dialogue upon Stow*, pp. 19–21.

15 G. B. Clarke, *Stowe*, pp. 180–5.

16 Ibid., p. 188.
 Hunt, *Kent*, p. 91.

17 W. Shenstone, 'Unconnected Thoughts on Gardening' in *Works* (1768) vol. II, pp. 117–18.
 Hunt, *Kent*, p. 62.
 Clarke, *Stowe*, pp. 72, 111.
 See also Britton, *Beauties of England*, vol. XV (1814) pp. 280–4, Hoare *The History of Modern Wiltshire* (1822) vol. I, pp. 44, 63, 73–6.

18 The complex history of Stourhead and its imagery is discussed in Kenneth Woodbridge's *Landscape and Antiquity* (1970) and in the National Trust guides.

19 A general account of these gardens is given by Watkin in *The English Vision* (1982).

20 These arguments are discussed in K. D. M. Snell's *Annals of the Labouring Poor* (1985) and Oliver Rackham's *The History of the Countryside* (1986).

21 Yorke's letter, which was written to William Warburton, is reprinted in the latter's *Letters to Richard Hurd* (2nd ed., 1809) p. 499; see also p. 508.

22 Michael Rosenthal, *British Landscape Painting* (1982) pp. 22–8.

23 *The English Reports*, vol. I, p. 692; vol. II, pp. 700–4.
 J. Hutchins, *History of Dorset* (2nd ed.) vol. IV, p. 220.
 H. Pentin, 'Old Milton Abbey', *Proceedings of the Dorset Field Club*, 25 (1903) pp. 1–7.
 T. Perkins and H. Pentin, *Memorials of Old Dorset* (1907) pp. 110–14.
 John Harris, *Sir William Chambers* (1970) p. 60.

24 *Royal Commission on Historical Monuments: Central Dorset*, p. 197.
 Harris, *Chambers*, pp. 60–1.
 Fanny Burney, *Journals* (1972) vol. I, p. 23.

25 Britton, *Beauties of England*, vol. IV (1803) pp. 484–7.
 Robert Fulke Greville, *Diaries*, ed. F. McKno Bladon (1930) p. 354 (23 September 1794)
 Arthur Oswald, 'Market Town into Model Village', *Country Life*, 29 September 1966, p. 765.
 F. M. Eden, *The State of the Poor* (1797) vol. II, p. 148.
 Fanny Burney, *Journals*, vol. I, pp. 24–5.

26 Pentin, 'Old Milton Abbey'; Perkins and Pentin, *Memorials of Old Dorset*.

Public Record Office, Chancery Decree C33/443 pt 2 ff. 553–7.
Journals of the House of Lords, vol. XXXVII, pp. 118–19.
Journals of the House of Commons, vol. XL, pp. 316–17, 1011.
Nicholas Carlisle, *Concise Description of the Endowed Grammar Schools in England and Wales* (1818) vol. I, p. 375.

27 Bingham, *Biographical Anecdotes of the Rev. John Hutchins MA* (1785) pp. 9–10, *Bibliotheca Topographica Britannia*, vol. 6 (1790) pt 34 (Cambridge University Library L1.12.22).
 Hutchins, *History of Dorset* (1774) vol II, p. 433.
 Hurd, *Moral and Political Dialogues* (2nd ed., 1760) pp. 131–3.
 In the eighth of his *Letters on Chivalry and Romance* (1762) Hurd may hint at a political interpretation of fashionable improvement in landscape. He notes that in the older or 'Gothic' method of design in gardening a wood or a grove was often cut into 'separate avenues or glades' with distinct walks, destinations, and terminal objects. The diversity of the whole was, however, 'brought together and considered under one view' by the relation of the parts to 'their common and concurrent centre'. In the new system, objects were disposed and grouped into an 'entire landscape' without any appearance of art. This taste seemed truer to nature and was certainly simpler; the old 'manifest regard to unity' had been much admired, however, and its design and beauty' might eventually return to favour. (See J. D. Hunt, *William Kent: Landscape Garden Designer*, 1987, p. 99.)

28 Fulke Greville, *Diaries*, p. 353.
 Britton, *Beauties of England*, vol. IV, pp. 485–6.
 Perkins and Pentin, *Old Dorset*, p. 113.
 Richard Burn, *Ecclesiastical Law* (2nd ed., 1767) vol. I, pp. 236, 317–18.
 James Hervey, *Meditations and Contemplations* (1816) pp. 1–64.
 Revd George Huntingford, 'Address at the Consecration of a Churchyard' in *Works* (1832) pp. 499–501.
 Revd George Horne, 1784, in *Works* (1831–43) vol. III, p. 388.
 Rt Revd Thomas Secker, 1753, *Eight Charges* (1769) pp. 178–9.
 Butler, 1751, in *Works*, vol. II, p. 445.
 Petition, 22 August. 1786, Milton to Bishop of Bristol, Bristol Diocesan Archives, Consecration Papers.
 Hoare's Bank, *Letter Books* (1786, 1795, 1797) especially 23 September 1797.

29 Locke, *Two Treatises on Government*, ed. P. Laslett, (1960) pp. 281, 301, 401, 410–11.

30 Blackstone, *Commentaries on the Laws of England*, ed. R. Burn (9th ed., 1783) vol I, pp. 5–12, 125–31, 144, 472; vol. II, pp. 2–11, 15, 201, 214; vol. III, pp. 265–8, 325–7; vol. IV, p. 343.

31 Ibid., vol. I, pp. 360–5, 472; vol. III, pp. 265–6, 325; vol. IV, pp. 17, 371.
 Sir John Davies, *Report des Cases* (1615) preface.

32 Johnson, 'Preface to Dictionary' *in Selected Writings*, ed. M. Wilson (1965) pp. 325–6; *The Plan for a Dictionary* (1747) pp. 10, 17–19, 25; 'The False Alarm' (1770) in *Political Writings*, ed. J. P. Hardy (1968) pp. 46–8.
 Bentham, *A Fragment on Government* (1776) and *Principles of Morals and Legislation* (1780), ed. W. Harrison (1967) pp. 3, 19, 31, 125.

33 Blackstone, *Commentaries*, vol. II, pp. 273–4; vol. III, pp. 216–17, 427–8; vol. IV, p. 32.

34 Ibbetson, *A Sermon Preached Within the Peculiar of Nassington, October 1777* (1778) pp. 4–5, 8, 11–13, 16–20.

35 John Howlett, *An Enquiry Into the Influence which Enclosures have had upon the Population of this Kingdom* (2nd ed., 1786) pp. 36–7. The quotation from Mason's *The English Garden* is on Howlett's title-page.

36 Oliver Goldsmith, *The Deserted Village*, ll. 2, 8, 63, 74, 103–4, 214.

37 'The Citizen' xvii (1762) in *Selected Works* (1967) p. 318. 'A Comparative View of Races and Nations' (1760), in *Works*, ed. A. Friedman (1966) vol. III, p. 66. 'The Revolution in Low Life' (1762), ibid., pp. 195–8. 'The History of a Poet's Garden' (1773), ibid., pp. 207–8. *History of England* (1771) *Works*, vol. IV, p. 382.

38 Goldsmith, *The Deserted Village*, ll. 56, 310–12, 424; *The Traveller*, ll. 335–48, 387–9; 'Low Life', pp. 195–8; *The Vicar of Wakefield* (1766) ch. xxvii.

39 Goldsmith, *The Traveller*, ll. 335–60; *The Deserted Village*.

40 Goldsmith, *The Deserted Village*, ll. 37, 49, 66, 254–60, 276, 298, 306–8.
 Montesquieu, *L'Esprit des Lois* (1748) Pt 1, bk 5, ch. 14; Pt 3, bk 15, ch. 13; Pt 3, bk 19, ch. 18.

41 Goldsmith, *The Deserted Village*, l. 39; 'Low Life', p. 197; 'Some Original Memoirs of the late famous Bishop of Cloyne' (1759–60) *Works*, vol. III, p. 37.

42 Johnson, *The Idler* (1761) vol. II, pp. 160–4.
 Clarkson, *An Essay on the Slavery and Commerce of the Human Species* (1786) pp. 21–3, 77, 126–7, 219, 248.
 Warburton, Sermon of 1766 in *Works* (1788) vol. V, p. 334.
 Peckard, *Am I Not a Man? And a Brother?* (1788) pp. 47–9, 50–9, 71; *The Neglect of a Known duty is Sin* (1790) p. 11; *Justice and Mercy Recommended* (1788) pp. 21, 28–32.

43 Peckard, *Piety, Benevolence, and Loyalty Recommended* (1784) pp. 8–9, 12, 16, 17–18; *The Nature and Extent of Civil and Religious Liberty* (1783) p. 27; *National Crimes the Cause of National Punishments* (1795) pp. iv–v, 11–12, 18–20; *The Neglect of a Known duty is Sin*, pp. 23, 26, 28; and *Justice and Mercy*, pp. 25–32; *Am I Not a Man?* pp. 93–5.

44 Mackenzie, *The Man of Feeling*, ed. B. Vickers (1967) pp. 17–18, 25, 87–8, 101.

45 Hastings, *The Present State of the East Indies* (1786) pp. 40–1, 67–8, 91.
 G. S. Rousseau, 'The Pursuit of Homosexuality in the 18th Century', in *'Tis Nature's Fault*, ed. R.

P. Maccubbin (1987) pp. 157–8.
 Samuel Foote, *The Nabob* (1778) pp. 4, 13, 50.
 Colin Maclaurin, 'Ode Inscribed to the Conquerors of the East', in *Poetical Works* (1812) vol. II, pp. 97–9.
 William Hickey, *Memoirs*, ed. A. Spencer (1913–25) vol. II, p. 308.
 Richard Cumberland, *The Observer* (1791) vol. I, pp. 32–4, vol. IV, pp. 30–3.
 Conor Cruise O'Brien, *The Great Melody* (1992) p. 285.

46 *Humphry Clinker*, ed. L. Rice-Oxley (1925) pp. 142, 259, 351–4, 403–4, 423–4.

47 Cradock, *Literary and Miscellaneous Memoirs* (1828) vol. IV, pp. 3, 6, 8–9, 16–17, 29, 37–9, 48, 65.

48 Burgess, *An Essay* (2nd ed., 1782) pp. 27–9.

49 'The Task', bk I, ll. 251–65, 338–49, 733–5; bk II, ll. 206–9; bk III, ll. 742–4, 764–810.
 'Charity' (1781) l. 93.

50 'The Task', bk I, ll. 109–10, 173–5, 338–49; bk III, ll. 292–305, 320–1, 640–74.
 Letters, 18 November 1782, 3 July 1784, 9 September 1792, in *Verse and Letters*, ed. B. Spiller (1968) pp. 676, 720, 968.
 Cowper's remarks of 1792 recall a speech of 1777 in which Lord Shelburne sought a reduction in the Civil List that would permit lower taxes on the poor, notably for soap, candles, and salt. Such a reform would 'let in the light by day, and be the cause of cheering the lonely, miserable, dusky mansions of the poor labouring part of the community by night . . . instead of corrupting the morals of all ranks, of influencing parliament, and of furnishing means to the idle, extravagant, and profligate, of wallowing in vice, riot, luxury and dissipation.' (quoted in J. Norris *Shelburne and Reform* (1963) pp. 103–4).

51 John Scott, *Critical Essays* (1785) pp. 276–8.

52 Whately, 'Considerations on the Trade and Finances of this Kingdom' (1765) in *A Collection of Scarce and Interesting Tracts* (1787–8) vol. II, pp. 322, 342–3.
 Scott, *Essays*, pp. 277–8.
 Langhorne, *Poetical Works* (1804) vol. II, p. 82.

53 Lord Kerry, 'King's Bowood Park', *Wiltshire Archaeological and Natural History Magazine*, 42, (1922–4), pp. 18–38.
 Lord Fitzmaurice, *Life of William, Earl of Shelburne* (1876) vol. II, pp. 351–4, 363.
 Alison Olson, *The Radical Duke* (1961) p. 155.

54 Kent, *Hints to Gentlemen* (ed. 1799) pp. 95–100, 184–99, 285.

55 Ibid., pp. 202–14, 234–41, 285.

56 Ogilvie, *An Essay on the Right of Property in Land* (1781) pp. 27–30, 38, 105.

57 Kent, *General View of the Agriculture of Norfolk* (1794) pp. 29, 37.
 J.M. Robinson, *Georgian Model Farms* (1983) p. 109.

58 *An Account of the Scots Society in Norwich* (2nd ed., 1787) pp. 12, 32, 89.
 James Yorke, *A Sermon Preached at St Clement Dane* (1775) p. 17.
 John Jebb, *The Excellency of the Spirit of Be-*

nevolence, *A Sermon, December 28 1772* (2nd ed., 1782) pp. 9, 16.

Thomas Price, *The Life, Voyages and Adventures of Bampfylde-Moore Carew* (1785) pp. 16–17.

For radical or egalitarian treatments of the poor law issue see, for example, Ogilvie, *Essay*, Thomas Spence, *The End of Oppression* (2nd ed., 1795) and William Belsham, *Remarks on the Bill for the Better Support and Maintenance of the Poor* (1797).

59 John Aikin, *A View of the Character and Public Services of the late John Howard, Esq.* (1792) pp. 27–9.

Malachy Postlethwayt, *The Universal Dictionary of Trade and Commerce* (1774) s.v. 'Poor'.

John McFarlan, *Inquiries Concerning the Poor* (1782).

Isaac Wood, *Some Account of the Shrewsbury House of Industry* (2nd ed., 1791).

William Sabatier, *A Treatise on Poverty, its Consequences, and the Remedy* (1797).

60 Kames, *Sketches of the History of Man* (1774), 1788 ed., vol. III, pp. 101–7.

Townsend, *A Dissertation on the Poor Laws* (1786) ed. A. Montagu (1971) pp. 23–9, 35–8, 61.

Clarkson, *Essay on Slavery*, pp. 22–3.

61 Gilbert, *A Scheme for the Better Relief and Employment of the Poor* (1764) pp. 6, 10–12, 14–18; *Considerations on the Bills for the Better Relief and Employment of the Poor* (1787) pp. 30, 35–45.

Reports from Committees of the House of Commons, vol. IX, 1803, p. 733.

62 Burn, *Observations on the Bill ... for the Better Relief and Employment of the Poor* (1776) pp. 49–50.

T. Rutherforth, *A Sermon Preached [at] Addenbrooke's Hospital June 27 1771* (1771) p. 7.

Philip Thicknesse, *An Account of the Four Persons Found Starved to Death, at Datchworth* (1769) pp. 1–2.

Robert Potter, *Observations on the Poor Laws* (1775) pp. 3, 20.

John Scott, *Observations on the Present State of the Parochial and Vagrant Poor* (1773) pp. 25–34.

Langhorne, *Works*, vol. II, pp. 53–73.

An Account of the Scots Society in Norwich, p. 32.

63 Thicknesse, *Four Persons*, p. 1.

Langhorne, *Works*, vol. II, pp. 53–73.

John Scott, *Observations*, pp. 17–18.

Burn, *The History of the Poor Laws* (1764) pp. 210–11.

64 Warren, *A Sermon Preached [at] Addenbrooke's Hospital June 27 1776*, (1776) pp. 4, 8–10.

Burn, *History of the Poor Laws* (1764) pp. 137–8.

Langhorne, *Works*, vol. II, pp. 49–51.

65 Langhorne, *Works*, vol. II, pp. 50–3.

Potter, *Observations* (1775) pp. 53–4.

66 Richardson, *Sir Charles Grandison*, ed. J. Harris (1986) vol. III, pp. 464–6.

Tillotson quoted by Norman Sykes in *Church and State in England in the XVIIIth Century*

(1934) pp. 258–9.

Langhorne, *Letters on the Eloquence of the Pulpit* (1765) p. 39.

67 Richardson, *Grandison*, vol. I, pp. 279, 361; vol. III, pp. 124, 263, 348.

68 Ibid., vol. I, p. 361; vol. III, pp. 272–3.

69 Ibid., vol. II, pp. 160–1, 167; vol. III, p. 272.

70 Ibid., vol. II, pp. 477–8, 544, 629; vol. III, pp. 28, 96, 285, 288, 438.

Goldsmith, *The Vicar of Wakefield*, ch. xix.

71 Smollett, *The Life and Adventures of Sir Launcelot Greaves*, ed. P. Wagner (1988) pp. 58–61, 76–7, 99, 143.

72 Ibid., pp. 58, 113–15, 244.

73 Ibid., pp. 135, 233, 247.

74 Hanway, *Virtue in Humble Life* (1774) vol. I, pp. xxviii, 54–7, 61.

75 Ibid., p. xxix; *A Sentimental History of Chimney Sweepers* (1785) pp. x, 20, 49, 166; *The Defects of Police* (1775) pp. 27, 119–21; *An Earnest Appeal for Mercy to the Children of the Poor* (1766) pp. 7, 17.

76 Langhorne, *The Effusions of Friendship and Fancy* (1763) vol. I, p. 172.

Hanbury, *An Essay on Planting* (1758) pp. 8–10, 17–35; *A Complete Body of Planting and Gardening* (1770–1), vol. I, pp. iv, 1–2, 5–8, 17, 23, 67–71; *A History of the Rise and Progress of the Charitable Foundations at Church-Langton* (1768) p. 205.

77 Hanbury, *Complete Body*, vol. I, pp. 67–70.

78 John Nichols, *History and Antiquities of the County of Leicester* (1795–1815) vol. II, pp. 685–91.

John H. Hill, *The History of the Parish of Langton* (1867) pp. 92–6, 100–19, 139–46.

Hanbury, *History*, pp. 12–13, 211–12, 421, 436–7, 445–66.

79 Crabbe, *The Village*, bk 1, ll. 5, 37–8, 60.

80 Ibid., bk 1, ll. 67, 112.

81 Ibid., bk 1, ll. 42, 135–8, 160, 259, 284, 326; bk 2, ll. 20–7, 35.

82 Ibid., bk 2, ll. 119–22, 188, 205.

83 Crabbe, *A Discourse, Read in the Chapel at Belvoir Castle, after the Funeral of His Grace the Duke of Rutland* (1788) pp. 11–12.

3 The Mansion and the Landscape

1 *Speech at Bristol Previous to the Election, 1780* (4th ed., 1781) pp. 25, 45, 63.

2 Burke, *Works*, vol. XIII, pp. 65, 80, 159–64; vol. XV, p. 210.

3 Ibid., vol. XV, pp. 99, 339–40, 346–8; vol. XVI, pp. 145–7, 174, 275, 389; 'Speech on Mr Fox's East-India Bill' (1783) *Works*, vol. IV, p. 24; 'Speech on the Nabob of Arcot's Private Debts' (1785) *Works*, vol. IV, p. 295.

Conor Cruise O'Brien, *The Great Melody*, p. 324.

4 Burke, *Speech on Conciliation with America* (1775) pp. 3, 8, 11–12, 32–8, 43–69, 87–88, 98–101; Burke's image of rust is a deliberate reproach to such enlightened thinkers as Beccaria, who had

written of the need for 'i cittadini illuminati' to undertake the difficult task of stripping away 'la venerata ruggine di molti secoli' (Beccaria, *Dei Delitti*, p. 125). *A Letter to the Sheriffs of Bristol* (1777) pp. iii, 182.

5 Burke, *Two Letters Relative to the Trade of Ireland* (1778) pp. 3, 26–8; *A Letter to Sir Hercules Langrishe, Bt* (1792) pp. 54–5, 71; *Correspondence*, ed. T. W. Copeland et al, (1958–70) vol. IX, pp. 117, 120, 165.

6 Burke, 'Letters On the Proposals for Peace with the Regicide Directory of France', *Works*, vol. VIII, pp. 178–9; 'An Appeal from the New to the Old Whigs', *Works*, vol. VI, pp. 85, 202–3, 217–19, 265.

7 Burke, 'Reflections on the Revolution in France', *Works*, vol. V, pp. 187, 285, 293, 311–12, 328, 352.

8 Burke, 'A Letter to a Noble Lord', *Works*, vol. VIII, pp. 18–20; 'Reflections', pp. 75–8, 81–2, 168, 184.
 C. Cruise O'Brien, *The Great Melody*, p. 390.

9 Burke, 'Reflections', pp. 304–7.

10 Burke, 'Regicide Peace', *Works*, vol. VIII, pp. 183, 251–2; 'Reflections', pp. 81–2, 306–7, 434.

11 Burke, 'Reflections', pp. 93–4, 343–7.

12 Burke, *Two Letters on the Conduct of our Domestick Parties* (1797) p. 5; *Correspondence* vol. IV, p. 107; 'Thoughts on French Affairs' (1791) vol. VII, pp. 19–22.

13 Burke, 'A Letter to a Noble Lord', p. 66; 'Reflections', pp. 96–7, 123–5; *Substance of a Speech on the Army Estimates 9th February 1790*, (2nd ed. 1790) pp. 18, 22, 27.

14 Burke, 'Reflections', pp. 105–8.

15 Burke, *Third Letter On A Regicide Peace* (1797) p. 30; 'Letter to a Noble Lord', p. 20, *A General Reply to the Several Answers of a Letter Written to a Noble Lord* (1796) pp. 31, 44–6, 49–50, 'An Appeal', pp. 85, 202–3, 217–21, 265.
 Writing to the Duke of Richmond in 1775, Burke argues that the people are not to blame for their complacency regarding the American crisis, since 'God and nature never made them to think or to Act without Guidance and Direction'. They depend on 'their Natural Leaders' to instruct them, those qualified by 'their Rank and fortune . . . the goodness of their Characters, and their experience in their affairs' (*Correspondence*, vol. III, pp. 217–19). The concepts to the 1790s were not new, but their emphases were notably so.
 Scott, *Familiar Letters*, ed. D. Douglas (1894) vol. I, pp. 429, 435.

16 Burke, *Speech on Oeconomical Reformation 11th February 1780* (3rd ed., 1780) pp. 22, 38; 'Reflections', p. 80.

17 Burke, 'Reflections', pp. 151, 167–8; 'On the Sublime'.

18 Burke, 'Reflections', pp. 149–55, 308–9.
 C. Cruise O'Brien, *The Great Melody*, p. 609.

19 Burke, 'Reflections', pp. 90–4, 193–4, 255, 291–4.
 Paine, 'The Rights of Man Pt I' (1791) in *Political Writings*, ed. B. Kuklick (1989) pp. 64, 120.

20 Burke, *Correspondence* vol. VII, pp. 547–8;

'Tabletalk', *Miscellanies of the Philobiblion Society*, no. 5, pp. 42–3.
 D. Stroud, *Capability Brown* (2nd ed., 1975) p. 93.
 Price, *Essays on the Picturesque* (new ed., 1796–8) vol. II, p. 235.

21 Chambers, *A Dissertation on Oriental Gardening* (1772) pp. ii–iii, v–x.

22 William Coxe, *The Literary Life of Benjamin Stillingfleet* (1811) vol. I, pp. 174–6.
 William Cooke, *History and Antiquities of Hereford* (1892) p. 191.

23 Price, *Essays*, vol. I, pp. xi–xii, 3–5, 11–12, 28, 38–40, 248–9, 257, 260–4, 277–8, 375; vol. II, pp. 156–7; *A Letter to H. Repton, Esq.* (1795) pp. 37, 112.

24 Price, *Essays*, vol. I, pp. 21, 175–80, 294–9; vol. II, pp. 105, 215–20, 307–10.

25 Ibid., vol. I, pp. 175–80, 294–9; vol. II, pp. 219–20, 306–10.

26 Ibid., vol. I, pp. 272–82, 378.

27 Ibid., vol. I, pp. 267–70, 281, 291, 302–5.

28 Ibid., vol. I, pp. 152–67, 169–71, 185–6, 235, 263, 274–82; vol. II, pp. 121–3; *A Letter*, pp. 9–14, 30–1.

29 Price, *Essays*, vol. I, pp. 32–6, 277–8.

30 Ibid., vol. I, pp. 28–36, 267–8, 281–2.

31 Ibid., vol. I, pp. 28–36, 267–9, 280–3; 'On the Bad Effects of Stripping and Cropping Trees, *Annals of Agriculture*, 5, (1786), pp. 341–50.

32 Price, *Essays*, vol. I, p. 35; vol. II, pp. 143, 152–3; *Letter*, p. 93.

33 Price, *Essays*, vol. I, pp. 35–6, 277–8; vol. II, pp. 172–6; *Letter*, pp. 92–4.

34 Price, *Letter*, pp. 150–61.

35 Ibid., pp. 92–4; *Essays*, vol. I, pp. 40, 298–9, 378–9.

36 Price, *Essays*, vol. I, pp. 39–40, 298–9, 378–81; vol. II, pp. 328, 352, 400–5, 428; *Letter*, pp. 159–62.

37 Price, *Essays*, vol. I, pp. 380–1; vol. II, pp. 352, 400–3, 428.

38 Ibid., vol. II, pp. 328, 397–8, 400–4, 409, 419–20.

39 Ibid., vol. I, pp. 379–80; *Thoughts on the Defence of Property* (Hereford, 1797) pp. 4, 14–15, 18–20, 27–8.
 Payne Knight, *The Progress of Civil Society* (1796) p. 145.

40 Price, *Essays*, vol. I, pp. 248, 298–9, 315–6, 322, 327, 378–80; vol. II, pp. 86–7, 352; *Essays* (1810) vol. I, p. 198.

41 Payne Knight, *The Landscape* (2nd ed., 1795) pp. 41–2.

42 Stephen Daniels, 'The Political Iconography of Woodland', in D. Cosgrove and S. Daniels *The Iconography of Landscape* (1988) pp. 43–82.
 Payne Knight, *The Landscape*, pp. 23, 101–4.

43 *Analytical Inquiry* (4th ed., 1808) p. 444.
 The Landscape, pp. vi, 12–13, 32–33, 42, 100–3.

44 Ibid., pp. 16, 40–5.
 Analytical Inquiry, p. 220.

45 *The Landscape*, pp. 40–1, 86–7.

46 Ibid., p. 93.
 The Progress of Civil Society (1796) pp. 88–93,

142–9, 152–4.

47 *A Monody on the Death of Fox* (1807) pp. 6–11.

48 Ruskin, *Modern Painters* (1843–60) vol. V., p. 348; *Works*, vol. X, ch. 6 ('The Nature of Gothic').

49 *Modern Painters*, vol. V., pp. 246–50.

50 Ibid., pp. 269–80, 299, 329–32.

51 Ibid., p. 293.

4 *'Benevolent Ornaments'*

1 Young, *The Centaur Not Fabulous* (1755) pp. 83–5.

 James Hervey, *Meditations and Contemplations* (1816) pp. 102, 114–15, 215, 232–3, 240, 251–7, 294–5, 320.

2 Price, *Letter to Repton*, pp. 160–1, quoting Mason's Bk i, ll. 560–61.

3 Ruggles, *The History of the Poor* (1793–4) vol. I, pp. 11–12, 23–33, 46–60; vol. II, pp. 69–77, 90, 127–8.

4 Ibid., vol. I, pp. 59–60, 79–80; vol. II, pp. 61–2, 178–9.

5 Gilpin, *Three Essays* (1792) pp. ii–iii, 26, 44, 67–8, 70; *An Essay on Prints* (4th ed., 1792) pp. 2–4, 8, 11; *Remarks on Forest Scenery* (1791) vol. I, p. 250; *Instructions for Examining Landscape* (MS. Fitzwilliam Museum, Cambridge), pp. 1–3, 13–14; *Observations . . . Cambridge and Wales* (1809) pp. 174–6.

6 Gilpin, *Remarks*, vol. I, pp. 181–2, 186; vol. II, p. 205; *Observations . . . on the Mountains and Lakes of Cumberland and Westmorland* (1786) vol. I, p. 61; *Observations on the Western Parts of England* (1798) pp. 14, 128; *Observations . . . on the High-Lands of Scotland* (1789) vol. I, pp. 186–8.

7 Gilpin, *Observations . . . Cumberland*, vol. II, pp. 180–8; *Observations . . . Scotland*, vol. I, pp. 7–8, 22–4; vol. II, pp. 6–9; *Three Essays*, p. 57.

8 Gilpin, *Observations . . . Scotland*, vol. II, pp. 93–4, 159–70; *Three Essays*, pp. iii, 14; *Instructions*, p. 2; *Observations . . . Cambridge*, pp. 155–9; *Observations . . . River Wye* (5th ed., 1800) pp. 40, 78, 192; *Observations . . . Western Parts*, pp. 328–31; *Observations . . . Cumberland*, vol. II, pp. 43–6, 252–3; *Remarks*, vol. I, pp. 183–4.

9 Gilpin, *A Dialogue upon the Gardens at Stow* (1748) pp. 5–6, 45–59.

10 Gilpin, *Lectures on the Catechism* (5th ed., 1799) pp. 19–21, 130; *Sermons*, vol. I (1799) pp. 30, 113, vol. III (2nd ed., 1804) pp. 141–2, 352–4, 425; *Dialogues on Various Subjects* (1807) pp. 42, 241; *The Lives of Reformers* (new ed., 1809) vol. I, p. 315; *Moral Contrasts* (1798) pp. 224–25.

11 Gilpin, *Lectures*, pp. 101, 139–40; *Sermons*, vol. I, pp. 187–8; *Dialogues*, pp. 484, 515–20, 525–6.

12 Gilpin, *Dialogues*, pp. 112–13, 165–6, 208–10, 214–5, 267; *Sermons*, vol. III, p. 105.

13 Gilpin, *Dialogues*, pp. 323–4, 343–4.

14 Gilpin, *The Lives of Reformers*, vol. I, pp. 396–7; *Lectures on the Catechism*, pp. 169–71; *Sermons*, vol. I, pp. 102–3, 109, 130–7, 282; *Sermons*, vol. III, pp. 119–20.

15 Gilpin, *Sermons*, vol. I, pp. 139–40; vol. II (1800) p. 394; vol. III, pp. 8, 115–19, 121–3, 128.

16 Gilpin, *Dialogues*, pp. 492–3; *Moral Contrasts*, pp. 19–20, 31–9, 58, 75–6, 85–93.

17 Gilpin, *Moral Contrasts*, pp. 19–20, 34–9, 58, 75–8, 84–93.

18 Ibid., pp. 1, 6–7, 18, 24, 33–6, 42–4.

19 Ibid., pp. 44–7, 55–60, 67–71, 92–5.

20 Gilpin, *Memoirs of Dr. Richard Gilpin*, ed. W. Jackson (1879) pp. 136–7, 140–1; *Two Sermons* (1788) pp. 48, 51, 59–60.

 Sir Robert Harvey, 'Extract from an Account of Two Schools founded by the Rev. Mr. Gilpin at Boldre' in *Reports of the Society for Bettering the Condition of the Poor* (1798–1814) vol. I, p. 279.

21 'A Letter to the Rev. W. Green', *Gentleman's Magazine*, LXXXIX, pt II, (July 1819), p. 504.

 Gisborne, *An Enquiry* (7th ed., 1824) vol. II, pp. 396–410, 479; *Enquiry into the Duties of the Female Sex* (1796; 7th ed., 1806) pp. 92, 215.

22 Stebbing Shaw, *History and Antiquities of Staffordshire* (1798–1801) vol. I, pp. 65–7.

 Gisborne, *Walks in a Forest* (2nd ed., 1796) pp. 22–3, 32–3, 61, 65–6, 80, 112.

23 Gisborne, *Duties of the Female Sex*, pp. 46–7.

24 Gisborne, *An Enquiry*, vol. II, pp. 188–201, 261–74.

25 Ibid., pp. 375–82, 391.

 For a somewhat earlier attempt to absorb the new and alien culture into the notional values of the old, see Revd Sir William Clerke, Bt., *Thoughts upon the Means of Preserving the Health of the Poor* (1790).

26 James Baker, *The Life of Sir Thomas Bernard, Bt.* (1819) pp. 1, 77.

 Gentleman's Magazine, LXXXVIII, pp. 82–3.

 Reports of the Bettering Society, vol. III (1801) p. 44.

 Theological Works of the First Viscount Barrington, ed. G. Townsend (1828) vol. I, p. xliv.

27 *Reports*, vol. I (1798) pp. iii–vii, 15–17; vol. II (1800) pp. 8–9, 13.

28 More, *The History of Mr. Fantom*, pp. 8–9.

 Reports, vol. I, pp. vi–vii.

29 *Reports*, vol. I, pp. i–v.

30 Ibid., vol. II, pp. 14, 22, 146–7, Appendix p. 47; vol. VI (1814) pp. 56–60.

31 Ibid., vol. I, pp. vii–x; vol. III, pp. 20–8.

32 Ibid., vol. I, pp. viii–x, 64, 148–55; vol. III, pp. 11–12, 17–23.

 Richard Burn, *History of Poor Laws*, pp. 137, 205.

33 *Reports*, vol. II, pp. 2–4.

34 Young, *Considerations on the Subject of Poor-Houses* (1796) pp. 16–20.

35 *Reports*, vol. I, pp. xii–xvi; vol. II, pp. 4–6; vol. V (1808) pp. 50–2.

36 *Reports*, vol. III, pp. 36–8.

37 *Reports*, vol. I, pp. 130–9; vol. II, pp. 4, 250, Appendix pp. 54–7; vol. V, pp. 48–50.

38 Ibid., vol. II, pp. 22–7, 30–1, 168–9, 259–60.

39 Ibid., vol. III, pp. 37–8, Appendix p. 53.

40 Robert Surtees, *The History and Antiquities of Durham* (1816–40) vol. I, pp. 44–5.

 Britton, *The Beauties of England*, vol. V (1803)

pp. 125–7, 430–1.
 Reports of the Bettering Society, vol. I, pp. 13–15.
41 *Reports*, vol. III, pp. 113–15.
 James Plumtre, *A Journal of a Tour to the Source of the River Cam made in July 1800* (Cambridge University Library Add. MS 5819) p. 31; *An Account of the Parish of Hinxton, 1802* (Add. MS 5821) pp. 3, 23, 57.
 Plumtre letters, Add. MS 5864: 219 and 5861.
42 Gandy, *Designs for Cottages* (1805) pp. vi–vii; 'On the Philosophy of Architecture', *Magazine of Fine Arts*, vol. i, (1821) pp. 289–93, 370–9.
 M. McMordie, 'Picturesque Pattern Books and Pre-Victorian Designers', *Architectural History*, 18 (1975) pp. 43–59.
 For references to Price and Knight see, for example, D. Laing, *Hints for Dwellings* (1800) p. iv, and James Malton, *An Essay On British Cottage Architecture* (1798) pp. 1, 6. For references to Bernard and the Board of Agriculture see, for example, Gandy *Designs for Cottages*, pp. iii, vi. The introduction to the *Views of Picturesque Cottages* (1805) of William Atkinson, who worked at Castle Eden, is often a paraphrase of Price. It includes detailed emphasis on comfort and cleanliness and their effect on character.
43 *Reports*, vol. II, pp. 370–1; vol. IV, pp. 5–6; vol. V, pp. 50–1.
 Bernard, *Spurinna, Or, The Comforts of Old Age* (1816) pp. 145–8; 'On the Supply of Employment and Subsistence for the Labouring Classes', *The Pamphleteer*, X, (1817), pp. 174–5, 188; *Case of the Salt Duties* (1817) pp. 21–3.
44 E. Inglis-Jones, *Peacocks in Paradise* (1950) p. 132.
45 Thomas Green, *Extracts from the Diary of a Lover of Literature* (1810) pp. 152–3.
 Thomas Rees, *The Beauties of South Wales* (1815) dedication and pp. 399–406, 416–18, 436.
 Richard Warner, *A Walk Through Wales* (3rd ed., 1799) p. 72.
 George Lipscomb, *A Journey Into South Wales in 1799* (1802) pp. 126–7.
 Thomas Lloyd, *General View of the Agriculture of Cardigan* (1794) pp 14–17, 21–7.
 Inglis-Jones, *Peacocks in Paradise*, pp. 103, 171.
46 George Cumberland, *An Attempt to Describe Hafod* (1796) pp. vii–viii, 22–4.
 Rees, *South Wales* p. 417.
 Lipscomb, *South Wales*, pp. 127–8.
 Benjamin Heath Malkin, *The Scenery, Antiquities, and Biography of South Wales* (2nd ed., 1807) vol. II, pp. 20, 55–65, 87.
47 Green, *Diary*, pp. 151–4.
 Malkin, *South Wales*, pp. 55–68, 88–9.
 Rees, *South Wales*, pp. 399–400, 416–7, 432–40.
 Lipscomb, *South Wales*, pp. 128–34.
 Richard Warner, *A Second Walk Through Wales* (1799) pp. 148–52.
48 Malkin, *South Wales*, p. 68.
 Inglis-Jones, *Peacocks in Paradise*, pp. 127, 132, 180.
 Rees, *South Wales*, p. 400.
 Johnes, *A Cardiganshire Landlord's Advice to His Tenants* (1800) pp. 3, 19, 74; R. J. Moore-Colyer, *A Land of Pure Delight* (1992) p. 155.
49 Malkin, *South Wales*, pp. 56–62, 92.
50 Malkin, *South Wales*, pp. 35, 55–69, 93.
 Rees, *South Wales*, p. 418.
 Inglis-Jones, *Peacocks in Paradise*.
51 Fenton, *A Tour in Quest of Genealogy* (1811) pp. 205–7, 214–16.
 Colt Hoare, *The History of Modern Wiltshire* (1822) vol. I, pp. 44, 73–6.
52 Britton, *Beauties of England*, vol. XV (1814) pp. 280–4.
 Fenton, *Tour*, pp. 179, 206, 215–16.
 Colt Hoare, *History of Wiltshire*, vol. I p. 63.
 Catalogue of the Hoare Library (1840).

5 'A Noble Estate'

1 *Annals of Agriculture*, XL, (1803) pp. 50–69.
2 Lloyd, *Cardigan*, p. 17.
3 Gray, *Works*, ed. E. Gosse (1884) vol. I, pp. 265–6.
 Gilpin, *Observations . . . Cumberland*, pp. 63–9, 197–8.
 Walker, *Remarks* (1792) pp. 80–5.
4 Nigel Leask, *The Politics of Imagination in Coleridge's Critical Thought* (1988) p. 132.
 David Simpson, *Wordsworth and the Figurings of the Real* (1982) p. 122.
5 Leask, *Politics of Imagination*, pp. 12–14, 226.
 James K. Chandler, *Wordsworth's Second Nature* (1984) p. 146.
 Michael Friedman, *The Making of a Tory Humanist* (1979) pp. 98–101, 197.
6 Chandler, *Wordsworth's Second Nature*, pp. 81–91, 122–34, 151, 231–7, 276.
7 Coleridge, *Biographia Literaria*, ed. A. Symons (1907) p. 255.
 Friedman, *A Tory Humanist*, pp. 30–8.
8 Wordsworth, *Literary Criticism*, ed. N. C. Smith (1905) 'Advertisement to Lyrical Ballads' (1798) pp. 1–2; 'Letter to Wilson' (1800) p. 7; 'Preface to Lyrical Ballads' (1800) p. 17.
9 Ibid., 'Preface', pp. 18, 25–9.
10 Ibid., 'Advertisement', p. 2; 'Letter', p. 8; 'Preface', p. 14.
11 Ibid., 'Advertisement', p. 2; 'Letter', p. 6; 'Preface', pp. 13–14, 21.
12 Wordsworth to Sir George Beaumont, 17 October 1805 in *The Early Letters of William and Dorothy Wordsworth* (1935) pp. 523–8.
13 Wordsworth, 'Guide to the Lakes', *Prose Works*, ed. W. J. B. Owen and J. B. Smyser (1974) vol. II, pp. 200–6.
14 Wordsworth, *Early Letters*, p. 441; and 'Guide', pp. 207–10, 221–4.
15 Wordsworth, *The Prelude*, ed. E. de Selincourt (1926) bk IV, ll. 35–55.
16 Wordsworth to Beaumont, 28 August 1811; Wordsworth's *Letters: The Middle Years* (1937) vol. II, p. 467.
17 Wordsworth, 'Preface', p. 27; and *The Prelude*, bk VI, ll. 538–9, 556–8, 564–72; and bk VII, ll. 721–40.

18 Wordsworth, *The Prelude*, bk VII, ll. 695–740.
19 Ibid., bk VIII, ll. 427–70.
20 Ibid., bk XII, ll. 69–111, 145–219.
21 Wordsworth, 'The Excursion', in *Poetical Works*, bk v, ll. 96–170; bk VI, ll. 20–41; bk VIII, ll. 538–40; and *The Prelude*, bk x, ll. 264–75; 'Essay on Epitaphs' in *Literary Criticism*, p. 141.
 Simpson, *Wordsworth*, p. 134.
 Chandler, *Wordsworth's Second Nature*, p. 276.
22 Wordsworth, *Early Letters*, pp. 260–2; 'Michael', l. 77; 'Repentance', l. 10.
23 Wordsworth, 'The Old Cumberland Beggar', ll. 67–132, 179–97.
24 Wordsworth, 'Beggars', l. 18; 'Sequel', ll. 1–5; *Middle Years*, vol. I, pp. 191, 214.
25 Wordsworth, *Prose Works*, ed. A. Grosart (1876) vol. I, pp. 182–5.
26 Wordsworth, *The Excursion*, vol. VIII, ll. 121–6, 151–5, 310; vol. IX, ll. 177–205.
27 Ibid., bk IX, ll. 1–43, 115–19.
28 Ibid., bk IX, ll. 129–32, 254–335.
29 Ibid., bk XIII, ll. 196–251, 276–96.
30 Wordsworth, *Middle Years*, p. 734; and 'Convention of Cintra', p. 126.
31 *The History and Antiquities of Westmorland and Cumberland* (1777) vol. I, p. 441.
32 Wordsworth, 'Letter to Archdeacon Wrangham', *Prose Works*, ed. A. Grosart. vol. I, p. 337; and *Middle Years*, pp. 585, 783–4, 792–3.
33 Wordsworth, 'Two Addresses' in *Prose Works*, ed. Owen and Smyser, vol. III, pp. 158–60, 170–3, 183–7.
34 Wordsworth, *The Excursion*, bk IX, ll. 368–82.
 Torrens quoted in K. D. M. Snell, *Annals of the Labouring Poor* (1985) p. 112.
 Bentham, *Works*, vol. IX, p. 53.
35 Southey, *Letters from England*, ed. J. Simmons (1951) pp. 40, 177, 197–211.
36 Ibid., pp. 203–11, 362, 367–9.
37 *Essays, Moral and Political* (1832) vol. I, pp. 79–154, 173–220, 259–68; vol. II, pp. 22–4.
38 'On the State of the Poor', *Quarterly Review*, April 1816, pp. 197–8.
39 Ibid., pp. 217–18; *Essays*, vol. I, pp. 11–12.
40 Coleridge, *Biographia Literaria* (1817), ch. xiv.
41 Coleridge, *The Friend* (1809; revised 1818) 1850 ed., vol. I, pp. 80–1.
 Essays on his own Times (1850) vol. II, p. 742, pp. 893–4; *Lay Sermons*, ed. D. Coleridge (3rd ed., 1852), pp. 84–6.
 'The Statesman's Manual' in *Political Tracts of Wordsworth, Coleridge and Shelley*, ed. R. J. White (1953) p. 80 and 'Introduction', pp. ix–xi.
42 *Essays*, vol. II, pp. 917–8.
 Lay Sermons, pp. 214–17.
 Statesman's Manual, pp. 80–2.
 See also an article in the *Morning Post* (1800) in *Essays*, vol. I, pp. 273–4.
43 *Lay Sermons*, pp. 178–81, 215–17, 237–8, 245–6.
44 Ibid., pp. 10, 80, 188–91, 214–17.
45 Ibid., pp. 184–92.
46 *The Friend*, vol. I, pp. 153–4; vol. III, pp. 101–2, 167, 186.
 Lay Sermons, pp. 80, 187–91.
47 *The Friend*, vol. II, p. 27.

48 *Lay Sermons*, pp. 248–52, 264–6.
48 *Lay Sermons*, pp. 178–81, 214–18, 245–52, 262–6. See also *Essays*, vol. II, p. 314.
49 *Lay Sermons*, pp. 244–57, 263–6.
50 Quoted in Olivia Smith, *The Language of Politics* (1984) p. 93.
51 Ibid., pp. 36–50, 101.
52 Priestley quoted in J. Barrell, *An Equal, Wide Survey* (1983) p. 162.
 Godwin, *Political Justice* (1946 ed.) vol. I, pp. 85–7.
 O. Smith, *Language of Politics*, p. 18.
 Paine, *Political Writings*, p. 196.
53 Ogilvie, *Right of Property*, pp. vi, 31, 105.
 Spence, *The End of Oppression* (2nd ed., 1795) pp. 3–10.
54 Southey, *Quarterly Review*, XVI, pp. 225–78.
 Cobbett's Political Register, XXX, cols. 613–14, 18 May 1816.
 James Sambrook, *William Cobbett* (1973) pp. 105, 132.
 O. Smith, *Language of Politics*, pp. 9, 192.
55 Ibid., pp. 227–31.
56 Cobbett, *Rural Rides*, ed. G. Woodcock (1985) pp. 99, 178, 206, 265, 321, 394.
57 Ibid., pp. 44, 100, 125, 313, 372, 433.
58 *Cobbett in Ireland*, ed. D. Knight (1984) pp. 37–8, 89–90, 145, 225, 233, 267.
59 Ibid., pp. 127, 217.
60 Ibid., pp. 116–7, 131, 226.

6 *The View of Donwell Abbey*

1 Quoted in Snell, *Annals*, p. 6.
2 *The Borough*, 16, ll. 61–4, 80–5.
3 *Quarterly Review*, XXXII, (1817) pp. 417, 423–4.
4 *Fragments*, pp. viii, 96, 191–2, 205, 229–37.
5 Jane Austen, *Mansfield Park*, ed. Tony Tanner (1966) pp. 80, 346, 363, 376, 381, 384.
6 For Lord Mansfield see *A Complete Collection of State Trials*, ed. T. B. and T. J. Howell (1809–26) vol. XX, col. 82.
7 *Mansfield Park*, pp. 216, 448, 450.
8 Ibid., pp. 84–8, 252–3.
9 Ibid., pp. 249–52.
10 Ibid., pp. 455–7.
11 Ibid., pp. 139, 222–4, 323.
12 Ibid., p. 111.
13 Ibid., pp. 84–8.
14 Ibid., pp. 88–9, 110, 115, 119–24, 251.
15 J. Austen, *Emma*, ed. G. Hough (1980) p. 284.
16 Ibid., p. 286.
17 Gilpin, *Observations . . . Cumberland*, pp. 10–11.
 Britton, *Beauties of England*, vol. XV, pp. 280–4.
18 *Emma*, pp. 24–5, 72, 286, 384.
19 J. Austen, *Persuasion*, ed. J. Davie (1971) pp. 38–42.
20 Ibid., pp. 119, 234.
21 J. Austen, *Lady Susan, The Watsons, Sanditon*, ed. M. Drabble (1974) p. 151.
22 Ibid., pp. 159–62, 178–80, 198.
23 Peacock, *Melincourt*, ed. D. Garnett (1963) pp. 191, 251–3, 285.

24 Peacock, *Crotchet Castle*, ed. R. Wright (1969) pp. 205, 252.

7 *'A Sort of National Property'*

1 Friedman, *A Tory Humanist*, pp. 271–6.
2 Leask, *The Politics of Imagination*, pp. 167–8.
3 Coleridge, *On the Constitution of Church and State*, ed. J. Barrell (1972) pp. 47, 50–3, 73–6.
4 Ibid., pp. 33–4, 53.
5 Ibid., pp. 59–61.
 Biographia Literaria, ed. A. Symons (1907) pp. 93, 182.
6 Macaulay, *Critical and Historical Essays*, vol. I, p. 229.
 Coleridge, *Church and State*, p. 99.
 Mill, *On Politics and Society*, p. 297.
 Coleridge, *Biographia Literaria*, p. 113.
 D. Willetts, *Modern Conservatism* (1992), p. 193.
7 J. L. and Barbara Hammond, *Lord Shaftesbury* (1923) pp. 86, 125, 174, 199.
8 Ibid., pp. 60, 80, 98, 107, 113, 157, 199, 220–3, 264–5.
 Willetts, *Modern Conservatism*, p. 12.

8 *The Nature of Toryism*

1 Blake, *Complete Writings*, ed. G. Keynes (1969) p. 456.
2 Paine, *Political Writings*, p. 44; Gilmour, *Riot, Risings, and Revolution*, p. 40.
 J. C. D. Clark, *Revolution and Rebellion* (1986) p. 29.
 On Watson see Wordsworth, 'A Letter to the Bishop of Llandaff' (1793) in *Prose Works*, ed. Owen and Smyser, vol. I, and Blake, 'Annotations to Watson's *Apology for the Bible*' (1798) in *Complete Writings*, pp. 383–95.
3 M. Andrews, *The Search for the Picturesque* (1989) pp. 65–6, 236–7.
 A. Bermingham, *Landscape and Ideology* (1986) pp. 66–74.

4 D. Solkin, *Richard Wilson: The Landscape of Reaction* (1982) p. 101.
 F. K. Brown, *Fathers of the Victorians* (1961) pp. 87, 91, 375.
 M. Ignatieff, *A Just Measure of Pain* (1978) p. 76.
 E. P. Thompson, *The Making of the English Working Class* (1968) p. 160.
 C. Cruise O'Brien, *The Great Melody*, pp. 237, 552.
5 Most of these issues are discussed in Richard Mabey's *The Common Ground* (1980) and Oliver Rackham's *The History of the Countryside* (1986).
6 Alan Macfarlane, *The Culture of Capitalism* (1987) pp. 26–35, 151–7.
 K. D. M. Snell, *Annals of the Labouring Poor* (1985) p. 112.
7 Smith, *Theory of Moral Sentiments*, pp. 55–63, 181–4; *The Wealth of Nations*, p. 190.
8 *Moral Sentiments*, pp. 9, 35–6, 45–50, 181–4.
9 David Simpson, *Wordsworth*, pp. 148–50.
 The Wealth of Nations, pp. 143–4, 782–8.
10 Ibid., pp. 145, 265–6, 363–4, 385–6, 412–25, 462, 622, 684.
11 Ibid., pp. 144–5, 265–6, 363, 462, 472, 687–8.
12 Ibid., pp. 144–5, 265–6, 343, 363, 462, 472, 663–4, 687–8, 758.
13 Ibid., pp. 781–4.
14 *International Herald Tribune*, 17 January 1991, p. 2.
15 *The Economist*, 9 May 1992, p. 91; 24 October 1992, 'Britain Survey', pp. 6–7, 19–20; 20 March 1993, p. 14.
16 *The Times*, 12 March 1990, p. 14.
 Bacon, *Physical and Metaphysical Works* (1894) pp. 383, 415, 428–36, 446–9, 497, 567; *Selected Works* (1965) pp. 310, 317, 367, 374–7, 450.
 Stephen Clark, *The Nature of the Beast* (1984) p. 9.
 Michael Polanyi and Harry Prosch, *Meaning* (1975) pp. 184–5.
17 Willetts, *Modern Conservatism*, pp. 7–12, 17, 32, 37–40, 88, 96–107, 135, 181.
18 T. Honderich, *Conservatism* (1991), p. 219.
 J.L. and B. Hammond, *Lord Shaftesbury*, p. 116.
19 *The Spectator*, 29 August 1992, p. 42.

Bibliography

The place of publication of printed sources is London, unless otherwise stated.

Manuscript Sources

Bristol Archives Office: Presentation and Nomination Records for Milton Abbas, Ref. EP/A/3/230.

Cambridge University Library:

Gilpin, William. Letter to James Plumtre, 3 February 1801. Add. MS. 5864:220.

Plumtre, James. An Account of the Parish of Hinxton and of its Inhabitants. Add. MS. 5821.

—— A Journal of a Tour to the Source of the River Cam made in July 1800. Add. MS. 5819.

—— Letter to William Gilpin, 22 January 1801. Add. MS. 5864:219.

—— Memorandum taken during a Five Weeks Tour in the summer of 1800. Add. MS. 5818.

—— A Narrative of a Pedestrian Journey through some parts of Yorkshire, Durham and Northumberland to the Highlands of Scotland, 3 vols, 1799. Add. MS. 5816.

—— Notebook of Expenses. Add. MS. 5861.

Fitzwilliam Museum, Cambridge: Gilpin, William. Instructions for Examining Landscape.

C. Hoare and Co., 37 Fleet Street, London: Ledgers and Letter Books relating to the account (1762–98) of Joseph Damer, Baron Milton and Earl of Dorchester.

Public Record Office: Decree in Chancery Case, Attorney General at relation of Lord Milton v. Gundry and Others, ref: C33/443 pt. 2 ff. 553–57.

Examinations in this Case: ref: C12/1536/4.

Wren Hall, Salisbury: Consecration Papers, Milton Abbas, 1786.

Primary Printed Sources

Account of the Scots Society in Norwich. 2nd ed., Norwich, 1787.

Adam, R. and J., *Works in Architecture*. 3 vols, 1773–1822.

Addison, Joseph, *The Spectator Papers*, ed. D. F. Bond. 3 vols, Oxford, 1965.

Aikin, John, *A View of the Character and Public Services of the late John Howard, Esq.* 1792.

Albermarle, Lord, ed. *Memoirs of the Marquis of Rockingham*. 2 vols, 1852.

Alison, Archibald, *Essays on the Nature and Principles of Taste*. Edinburgh, 1790.

Angus, William, *Seats of the Nobility and Gentry*. 1787.

Atkinson, William, *Views of Picturesque Cottages*. 1805.

Austen, Jane, *Emma*, ed. Graham Hough. New York, 1980.

—— *Mansfield Park*, ed. Tony Tanner. Harmondsworth, 1966.

—— *Persuasion*, ed. John Davie. Oxford, 1971.

—— *Lady Susan, The Watsons, Sanditon*, ed. Margaret Drabble. Harmondsworth, 1974.

Bacon, Francis, *Selected Works*, ed. S. Warhaft. Toronto, 1965.

—— *The Physical and Metaphysical Works*, ed. J. Devey. 1894.

Bagot, Lewis, *A Sermon Preached at the Cathedral Church in Norwich, August 21, 1783*. Norwich, 1783.

—— *A Sermon Preached at St. Mary's Church in Oxford, on Thursday, July 1, 1779*. Oxford, 1779.

—— *A Sermon Preached in the Cathedral Church of St. Paul, On Thursday, June 5, 1788*. 1788.

Baker, James, *The Life of Sir Thomas Bernard, Bt.* 1819.

Banks, Sir Joseph, 'Economy of a Park', *Annals of*

Agriculture, XXXIX, 1803, pp. 550–55.

Barber, W., *Farm Buildings; or Rural Economy. Containing Designs for Cottages, Farm-Houses, Lodges, Farm-yards*. 1802.

Barrington, Daines, 'On the Progress of Gardening', *Archaeologia*, VII, 1785, pp. 113–30.

—— 'On the Sudden Decay of Several Trees in St. James Park', in *Miscellanies*, 1781, pp. 170–73.

Barrington, Shute, *Sermons, Charges, and Tracts*, 1811.

Bartell, E., Jr., *Hints for Picturesque Improvements in Ornamented Cottages, and their Scenery*. 1804.

Beattie, James, *Dissertations Moral and Critical*. 1783.

Beccaria, Cesare, *Dei Delitti e Delle Pene*, ed. A. C. Jemolo. Milan, 1981.

Belsham, William, *Essays, Philosophical, Historical, and Literary*. 2 vols, 1789–91.

—— *Remarks on the Bill for the Better Support and Maintenance of the Poor, now Depending in the House of Commons*. 1797.

Bentham, Jeremy, *A Fragment on Government and Principles of Morals and Legislation*, ed. W. Harrison. Oxford, 1967.

—— *Works*, ed. J. Bowring. 18 vols, Edinburgh, 1830.

Berkeley, George, *Philosophical Works*, ed. M.R. Ayers. 1975.

—— *Works*, ed. A.C. Fraser. 4 vols, Oxford, 1871.

Bernard, Sir Thomas, 'An Account of a Supply of Fish for the Manufacturing Poor', *The Pamphleteer*, I, 2nd ed., 1813, pp. 432–44.

—— *Case of the Salt Duties*, 1817.

—— *The Life of Sir Francis Bernard, Bt*. 1790.

—— *The New School*. 1809.

—— *On the Repeal of the Salt Duties*. 1817.

—— 'On the Supply of Employment and Subsistence for the Labouring Classes', *The Pamphleteer*, X, 1817, pp. 174–212.

—— *Spurinna, Or The Comforts of Old Age*. 1816.

Bernard, Sir Thomas, ed., *The Reports of the Society for Bettering the Condition and Increasing the Comforts of the Poor*. 6 vols, 1798–1814.

Bickham, G., *The Beauties of Stowe*. 1750.

Bingham, George, 'Biographical Anecdotes of the Reverend John Hutchins' (1780), *Bibliotheca Topographica Britannia*, VI, 1790.

Blackburne, Archdeacon, *A Serious Enquiry Into the Use and Importance of External Religion*. 1752.

Blackstone, Sir William, *Commentaries on the Laws of England*. 9th ed., ed. R. Burn. 1783.

—— *A Treatise on the Law of Descents in Fee-Simple*. Oxford, 1759.

Blair, Hugh, *Lectures on Rhetoric and Belles Lettres*. 2 vols, Carbondale, 1965.

Blake, William, *Complete Writings*, ed. Geoffrey Keynes. 1969.

Bolingbroke, Lord, *Works*. 4 vols, 1844.

Britton, John and Edward Wedlake Brayley, eds. *The Beauties of England and Wales*. 26 vols, 1801–16.

Buck, Samuel, *Antiquities*. 3 vols, 1774.

Burgess, Thomas, *An Essay on the Study of Antiquities*. 2nd ed., Oxford, 1782.

Burke, Edmund, *Correspondence*, ed. Thomas W. Copeland et al. 9 vols, Cambridge, 1958–70.

—— *A General Reply to the Several Answers of a Letter Written to a Noble Lord*. 1796.

—— *A Letter to the Sheriffs of Bristol*. 1777.

—— *A Letter to Sir Hercules Langrishe, Bt*. 1792.

—— *Speech at Bristol Previous to the Election*. 4th ed., 1781.

—— *Speech on Conciliation with America*. 1775.

—— *Substance of a Speech on the Army Estimates*. 2nd ed., 1790.

—— *Two Letters on the Conduct of Our Domestick Parties*. 1797.

—— *Two Letters Relative to the Trade of Ireland*. 1778.

—— *Third Letter on a Regicide Peace*. 1797.

—— *Works*. New ed., 16 vols, 1815–27.

Burn, Richard, *Ecclesiastical Law*. 2nd ed., 4 vols, 1767.

—— *The History of the Poor Laws*. 1764.

—— *The Justice of the Peace, and Parish Officer*. 14th ed., 4 vols, 1780.

—— *Observation on the Bill . . . for the Better Relief and Employment of the Poor*. 1776.

Burnet, Thomas, *The Sacred Theory of the Earth*. 2 vols, 1684–90.

Burney, Fanny, *Journals*, ed. J. Henlow. 2 vols, Oxford, 1972.

Butler, Joseph, *Works*. 2 vols, Oxford, 1820.

Carlisle, Nicholas, *A Concise Description of the Endowed Grammar Schools in England and Wales*. 2 vols, 1818.

Castell, Robert, *The Villas of the Ancients Illustrated*. 1728.

Chafin, William, *Anecdotes and History of Cranbourn Chase*. 2nd ed., 1818.

Chambers, Sir William, *A Dissertation on Oriental Gardening*. 1772.

Clarke, G. B., ed., *Descriptions of Lord Cobham's Gardens at Stowe (1700–1750)*. Buckingham, 1990.

Clarke, James, *A Survey of the Lakes of*

Cumberland. 1789.

Clarkson, Thomas, *The History of the Rise, Progress and Accomplishment of the Abolition of the African Slave-Trade*. 2 vols, 1808.

—— *An Essay on the Slavery and Commerce of the Human Species*. 1786.

Clerke, Sir William, *Thoughts upon the Means of Preserving the Health of the Poor*. 1790.

Cobbett, Wiliam, *Rural Rides*, ed. G. Woodcock. Harmondsworth, 1985.

—— *Cobbett's Legacy to Labourers*. 1834.

—— *Cobbett's Political Register*. 89 vols, 1802–35.

—— *Cobbett in Ireland*, ed. Denis Knight. 1984.

Coleridge, Samuel Taylor, *Conciones ad Populum*. 1795.

—— *Biographia Literaria*, ed. A. Symons. 1907.

—— *Essays on his Own Times*. 3 vols, 1850.

—— *The Friend*. 3 vols, 1850.

—— *Lay Sermons*, ed. Derwent Coleridge. 3rd ed., 1852.

—— *On the Constitution of the Church and State*, ed. J. Barrell. 1972.

—— *Political Tracts of Wordsworth, Coleridge and Shelley*, ed. R. J. White. Cambridge, 1953.

Combe, W., *The Tour of Dr. Syntax in Search of the Picturesque: a Poem*. 1812.

Cowper, William, *Poetical Works*, ed. H. S. Milford. 1934.

—— *Verse and Letters*, ed. B. Spiller. Cambridge, MA, 1968.

Coxe, William, ed. *The Literary Life and Select Works of Benjamin Stillingfleet*. 2 vols, 1811.

Crabbe, George, *A Discourse, Read in the Chapel at Belvoir Castle, After the Funeral of His Grace the Duke of Rutland*. 1788.

—— *Poems*, ed. A. W. Ward. 3 vols, Cambridge, 1905.

Cradock, Joseph, *Literary and Miscellaneous Memoirs*. 4 vols, 1828.

Cudworth, Ralph, *The True Intellectual System of the Universe*, ed. J. Harrison. 3 vols, 1845.

Cumberland, George, *An Attempt to Describe Hafod*. 1796.

—— *A Poem on the Landscapes of Great Britain*. 1793.

—— *Some Anecdotes on the Life of Julio Bonasini*. 1793.

—— *Thoughts on Outline*. 1796.

Cumberland, Richard, *Character of the Late Lord Viscount Sackville*. 1785.

—— *The Observer*. 5 vols, 1791.

Dallaway, James, *Anecdotes of the Arts in England*. 1800.

Davies, David, *The Case of Labourers in Husbandry*. Bath, 1795.

Davies, Sir John, *Report des Cases*. Dublin, 1615.

Davies, Walter, *General View of the Agriculture and Domestic Economy of South Wales*. 2 vols, 1814.

Defoe, Daniel, *A Tour through the Whole Island of Great Britain*, ed. G. D. H. Cole and D. C. Browning. 2 vols, 1962.

Dodsley, R., *Descriptions of the Leasowes*. 1764.

Eden, Sir Frederick M., *The State of the Poor*. 3 vols, 1797.

Elsam, R., *An Essay on Rural Architecture*, 1803.

English Reports. 176 vols, 1900–30.

Falconer, William, *An Essay on the Preservation of the Health of Persons Employed in Agriculture*. Bath, 1789.

—— *Remarks on the Influence of Climate, Situation, Nature of Country, Population, Nature of Food, and Way of Life, on the Disposition and Temper, Manners and Behaviour, Intellects, Laws and Customs, Forms of Government, and Religion, of Mankind*. 1781.

Felton, Samuel, *Gleanings on Gardens*. 1829.

—— *On the Portraits of English Authors on Gardening*. 1828.

Fenton, Richard, *A Tour in Quest of Genealogy*. 1811.

Ferguson, Adam, *An Essay on the History of Civil Society*, ed. D. Forbes. Edinburgh, 1966.

Fielding, Henry, *Amelia*, ed. David Blewett. Harmondsworth, 1987.

—— *Jonathan Wild*, ed. David Nokes. Harmondsworth, 1982.

—— *Joseph Andrews and Shamela*, ed. Arthur Humphreys. 1973.

—— *Tom Jones*, ed. R. P. C. Mutter. Harmondsworth, 1966.

Fitzmaurice, Lord, ed. *The Life of William, Earl of Shelburne*. 2 vols, 1912.

Foote, Samuel, *The Nabob: A Comedy*. 1778.

Ford, Ford Madox, *Parade's End*. 2 vols, 1963. (First published 1924–6.)

Forsyth, William, *Observations on the Diseases, Defects, and Injuries in all kinds of Fruit and Forest Trees*. 1791.

Gainsborough, Thomas, *Drawings*, ed. John Hayes. 2 vols, 1970.

—— *Letters*, ed. Mary Woodall. 2nd ed., Ipswich, 1963.

Gandy, Joseph, *Designs for Cottages, Cottage Farms, and Other Rural Buildings*. 1805.

—— 'On the Philosophy of Architecture', *Magazine of Fine Arts*, I, 1821, pp. 289–93, 370–79.

Garrett, Daniel, *Designs, and Estimates, of Farm Houses*. 1747.

Gessner, Salomon, *On Landscape Gardening.* 1796.

Gilbert, Thomas, *Considerations on the Bills for the better Relief and Employment of the Poor.* 1787.

—— *A Scheme for the Better Relief and Employment of the Poor.* 1764.

Gilpin, William, *A Dialogue upon the Gardens of the Rt. Hon. Lord Cobham at Stow.* 1748.

—— *Dialogues on Various Subjects.* 1807.

—— *An Essay on Prints.* 4th ed., 1792.

—— *Lectures on the Catechism of the Church of England.* 5th ed., 1799.

—— *Life of William Baker.* Dublin, 1795.

—— *The Lives of Reformers.* New ed., 2 vols, 1809.

—— *Memoirs of Dr. Richard Gilpin*, ed. William Jackson. 1879.

—— *Memoirs of Josias Rogers, Esq.* 1808.

—— *Moral Contrasts: or, The Power of Religion Exemplified under Different Characters.* Lymington, 1798.

—— *Observations on Several Parts of the Counties of Cambridge, Norfolk, Suffolk and Essex.* 1809.

—— *Observations on the Coasts of Hampshire, Sussex, and Kent.* 1804.

—— *Observations on the River Wye.* 5th ed., 1800.

—— *Observations on the Western Parts of England.* 1798.

—— *Observations, relative chiefly to Picturesque Beauty, Made in the Year 1776, on several Parts of Great Britain: particularly the High-Lands of Scotland.* 2 vols, 1789.

—— *Observations, relative chiefly to Picturesque Beauty, Made in the Year 1772, On Several Parts of England: particularly the Mountains, and Lakes of Cumberland, and Westmorland.* 2 vols, 1786.

—— *Remarks on Forest Scenery.* 2 vols, 1791.

—— *Sermons Preached to a Country Congregation.* Vols I–II, Lymington and London, 1799–1800, vol. III, 2nd ed., 1804.

—— *Two Sermons.* 1788.

—— *Three Dialogues on the Amusements of Clergymen.* 1796.

—— *Three Essays.* 1792.

Gisborne, Thomas, *An Enquiry into the Duties of Men in the Higher and Middle Classes of Society.* 1794, 3rd ed., 2 vols, 1795; 7th ed., 1824.

—— *An Enquiry into the Duties of the Female Sex.* 1797; 7th ed., 1806.

—— *Poems, Sacred and Moral.* 2nd ed., 1799.

—— *Principles of Moral Philosophy.* 4th ed., 1798.

—— *Remarks on the Late Decision of the House of Commons Respecting the Abolition of the Slave Trade.* 1792.

—— *Sermons.* 1802.

—— *The Testimony of Natural Theology to Christianity.* 2nd ed., 1818.

—— *Walks in a Forest.* 3rd ed., 1797.

Godwin, William, *Caleb Williams*, ed. D. McCracken. 1970.

—— *Enquiry Concerning Political Justice*, ed. F. E. L. Priestley. 2 vols, Toronto, 1946.

Goldsmith, Oliver, *Collected Works*, ed. A. Friedman. 5 vols, Oxford, 1966.

—— *Poems*, ed. Roger Lonsdale. 1969.

—— *The Vicar of Wakefield*, ed. J. H. Plumb. New York, 1961.

—— *Selected Works*, ed. R. Garnett. 1967.

Gray, Thomas, *Works*, ed. E. Gosse. 4 vols, 1884.

Green, Thomas, *Extracts from The Diary of a Lover of Literature.* Ipswich, 1810.

Greville, Robert Fulke, *Diaries*, ed. F. McKno Bladon. 1930.

Hale, Lord, *The History of the Pleas of the Crown.* 2 vols, 1736.

Hanbury, William, *A Complete Body of Planting and Gardening.* 2 vols, 1770–1.

—— *An Essay on Planting, and a Scheme for making it conducive to the Glory of God, and the Advantage of Society.* Oxford, 1758.

—— *The History of the Rise and Progress of the Charitable Foundations at Church-Langton.* 1767.

Hanway, Jonas, *The Defects of Police The Cause of Immorality.* 1775.

—— *An Earnest Appeal for Mercy to the Children of the Poor.* 1766.

—— *A Sentimental History of Chimney Sweepers.* 1785.

—— *Thoughts on the Plan for a Magdalen-House.* 1758.

—— *Virtue in Humble Life.* 2 vols, 1774.

Harford, John S., *The Life of Thomas Burgess*, 1840.

Hastings, Warren, *Memoirs relative to the State of India.* 1786.

—— *The Present State of the East Indies.* 1786.

History of the Trial of Warren Hastings, Esq. 1796.

Herbert, George, *The English Poems*, ed. C. A. Patrides. 1974.

Hervey, James, *Meditations and Contemplations.* Bungay, 1816.

Hickey, William, *Memoirs*, ed. A. Spencer. 4 vols, 1913–25.

Hill, John, *Eden: or, A Compleat Body of Gar-*

dening. 1757.

Hoare, Sir Richard Colt, *The History of Modern Wiltshire.* 6 vols, 1822–44.

Hogarth, William, *The Analysis of Beauty.* 1753.

Horne, George, *Works*, ed. William Jones. 4 vols, 1831–43.

Howard, John, *State of the Prisons.* 1777.

Howlett, John, *An Enquiry into the Influence which Enclosures have had upon the Population of this Kingdom.* 2nd ed., 1786.

—— *Enclosures, A Cause of improved Agriculture, of Plenty and Cheapness of Provisions, of Population, and of both private and national wealth.* 1787.

—— *The Insufficiency of the Causes to which the Increase of our Poor, and of the Poor's Rates have been commonly ascribed.* 1788.

'Humanus', *Considerations on the Present State of the Poor in Great Britain.* 1773.

Hume, David, *An Enquiry Concerning the Principle of Morals*, ed. J. B. Schneewind. Indianapolis, 1983.

—— *Essays Moral, Political, and Literary*, ed. Eugene F. Miller. Indianapolis, 1987.

—— *A Treatise of Human Nature*, ed. Ernest C. Mossner. Harmondsworth, 1969.

—— *Philosophical Works.* 4 vols, Edinburgh, 1826.

Hunter, Alexander, *Georgical Essays.* York, 1777.

—— *Outlines of Agriculture Addressed to Sir John Sinclair, Bart.* York, 1795.

Huntingford, George, *Thoughts on the Trinity, Charges, and other Theological Works.* 1832.

Hurd, Richard, *Dialogues on the Uses of Foreign Travel.* Dublin, 1764.

—— *Letters on Chivalry and Romance.* Dublin, 1762.

—— *Moral and Political Dialogues between Divers Eminent Persons of the Past and Present Age.* 2nd ed., 1760.

Hutcheson, Francis, *Illustrations on the Moral Sense*, ed. B. Peach. Cambridge, MA, 1971.

—— *An Inquiry Concerning Beauty, Order, Harmony, Design*, ed. P. Kivy. The Hague, 1973.

Hutchins, John, *The History and Antiquities of the County of Dorset.* 2 vols, 1774; 2nd ed., ed. Richard Gough and John Bowyer Nichols, 4 vols, 1796–1815.

Hutchinson, William, *The History and Antiquities of the County Palatine of Durham.* 3 vols, Newcastle, 1785–94.

Ibbetson, James, *A Sermon Preached Within the Peculiar of Nassington, in the Month of October 1777.* 1778.

—— *The Heinous Nature of Rebellion, A Sermon Preached in the Cathedral Church of York, on Thursday, August 21, 1746.* 1746.

Irwin, Eyles, *Saint Thomas's Mount. A Poem.* 1774.

Jebb, John, *The Excellency of the Spirit of Benevolence, A Sermon Preached Before the University of Cambridge, on Monday, December 28, 1772.* 2nd ed., 1782.

—— *Thoughts on the Construction and Polity of Prisons, with Hints for their Improvement.* 1786.

Johnes, Thomas, *A Cardiganshire Landlord's Advice to His Tenants.* Bristol, 1800.

Johnson, George, *A History of English Gardening.* 1829.

Johnson, Samuel, *The Idler.* 2 vols, 1761.

—— *Political Writings*, ed. J. P. Hardy. 1968.

—— *Selected Writings*, ed. Mona Wilson. Cambridge, MA, 1965.

—— *Plan of a Dictionary of the English Language.* 1747.

—— *Works*, ed. A. T. Hazen and others. 16 vols, New Haven, 1958–90.

Jones, William, *The Theological and Miscellaneous Works*, ed. W. Stevens. 6 vols, 1810.

Journals of the House of Commons.

Journals of the House of Lords.

Kames, Lord, *Elements of Criticism.* 11th ed., 1840.

—— *The Gentleman Farmer.* 3rd ed., Edinburgh, 1788.

—— *Sketches of the History of Man.* 4 vols, Edinburgh, 1788.

Kent, Nathaniel, *General View of the Agriculture of the County of Norfolk.* 1794.

—— *Hints to Gentlemen of Landed Property.* 1775, new ed., 1799.

Knight, Richard Payne, *Alfred: A Romance in Rhyme.* 1823.

—— *An Analytical Inquiry Into the Principles of Taste.* 4th ed., 1808.

—— *The Landscape, A Didactic Poem.* 2nd ed., 1795.

—— *A Monody on the Death of the Rt. Hon. Charles James Fox.* 1807.

—— *The Progress of Civil Society: A Didactic Poem.* 1796.

Laing, D., *Hints for Dwellings.* 1800.

Langhorne, John, *The Effusions of Friendship and Fancy*, 2 vols, 1763.

—— *Letters on the Eloquence of the Pulpit.* 1765.

—— *Poetical Works.* 2 vols, 1804.

La Rochefoucauld, François de, *A Frenchman's Year in Suffolk*, ed. N. Scarfe. Woodbridge,

Suffolk, 1988.

Law, William, *Works*, 9 vols, 1892–3.

Leslie, Charles R., *Memoirs of the Life of John Constable*. 1951.

Ley, Charles, *The Nobleman, Gentleman, Land Steward, and Surveyor's Compleat Guide*. 1786.

Lipscomb, George, *Journey into South Wales*. 1802.

Lloyd, Thomas, *General View of the Agriculture of the County of Cardigan*. 1794.

Locke, John, *Two Treatises of Government*, ed. Peter Laslett. Cambridge, 1960.

Lolme, Jean Louis de, *The Constitution of England*. 1775.

Lugar, Robert, *Architectural Sketches for Cottages, Rural Dwellings and Villas*. 1805.

Macaulay, Aulay, *Essays on Various Subjects of Taste and Criticism*. 1780.

—— *The History and Antiquities of Claybrook*. 1791.

Macaulay, Thomas Babington, *Critical and Historical Essays*. 3 vols, 1854.

McFarlan, John, *Inquiries Concerning the Poor*. Edinburgh, 1782.

Mackenzie, Henry, *The Man of Feeling*, ed. B. Vickers. Oxford, 1967.

—— *Works*. 8 vols, Edinburgh, 1808.

Maclaurin, Colin, *Poetical and Dramatic Works*. 2 vols, Edinburgh, 1812.

McPhail, James, *Remarks on the Present Times, Exhibiting the Causes of the High Price of Provisions*. 1795.

Malkin, Benjamin Heath, *Essays on Subjects Connected with Civilization*. 1795.

—— *The Scenery, Antiquities, and Biography of South Wales*. 2nd ed., 2 vols, 1807.

Malthus, Thomas, *An Essay on the Principle of Population*. Facsimile ed. J. Bonar. New York, 1966. (First published 1798.)

Malton, James, *An Essay on British Cottage Architecture*. 1798.

—— *Collection of Designs for Rural Retreats*. 1802.

Mandeville, Bernard, *The Fable of the Bees*, ed. Phillip Harth. Harmondsworth, 1970.

Marshall, William, *On the Management of Landed Estates*. 1806.

—— *On Planting and Rural Ornament*. 3rd ed., 2 vols, 1803.

—— *A Review of The Landscape*. 1795.

Mason, George, *An Essay on Design in Gardening*. 1795.

Mason, William, *Works*. 4 vols, 1811.

Mathias, Thomas, *The Pursuits of Literature: A Satirical Poem*. 8th ed., 1798.

Matthews, John, *A Sketch from The Landscape, A Didactic Poem, Addressed to R. P. Knight, Esq*. 1794.

Maton, William, *Observations relative chiefly to the Natural History, Picturesque Scenery, and Antiquities of the Western Counties*. 2 vols, Salisbury, 1797.

Meyrick, Samuel Rush, *The History and Antiquities of the County of Cardigan*. 1810.

Middleton, Charles, *Picturesque and Architectural Views for Cottages, Farm Houses, and Country Villas*. 1793.

Mill, John Stuart, *Mill on Politics and Society*, ed. Geraint L. Williams. 1976.

—— *Mill on Bentham and Coleridge*, ed. F. R. Leavis. 1967.

—— *Principles of Political Economy*. 2 vols, 1848.

Montesquieu, Baron de, *L'Esprit des Lois*. Geneva, 1748.

More, Hannah, *Works*. 6 vols, 1834.

Neild, James, *An Account of the Rise, Progress, and Present State, of the Society for the Discharge and Relief of Persons Imprisoned for Small Debts*. 1802.

—— *State of the Prisons*. 1812.

New Display of the Beauties of England. 3rd ed., 1776.

Newton, Sir Isaac, *Opticks*. 4th ed., 1730.

Nichols, John, *The History and Antiquities of the County of Leicester*. 4 vols, 1795–1815.

Nichols, John Bowyer, ed., *Catalogue of the Hoare Library at Stourhead, Co. Wilts*. 1840.

Nicholson, John, and Burn, Richard, *The History and Antiquities of the Counties of Westmorland and Cumberland*. 2 vols, 1777.

Ogilvie, William, *An Essay on the Right of Property in Land*. 1781.

Paine, Tom, *Political Writings*, ed. Bruce Kuklick. Cambridge, 1989.

Paley, William, *A Charge delivered to the Clergy of the Diocese of Carlisle, In the Year 1790*. 1790.

—— *Natural Theology*. 1802.

—— *Principles of Moral and Political Philosophy*. 1817. (First published 1785.)

—— *Reasons for Contentment; addressed to the Labouring Part of the British Public*. 1793.

Peacock, Thomas Love, *Melincourt*, ed. David Garnett. 1963.

—— *Nightmare Abbey and Crochet Castle*, ed. Raymond Wright. Harmondsworth, 1969.

Peckard, Peter, *Am I not a Man? And a Brother?* Cambridge, 1788.

—— *Justice and Mercy Recommended*. Cam-

bridge, 1788.
—— *National Crimes the Cause of National Punishments*. 5th ed., Peterborough, 1795.
—— *Piety, Benevolence, and Loyalty Recommended*. Cambridge, 1784.
—— *The Nature and Extent of Civil and Religious Liberty*. Cambridge, 1783.
—— *The Neglect of a known Duty is Sin*. Cambridge, 1790.
Percival, Thomas, *Works*. New ed., 4 vols, 1807.
Percy, Thomas, *Reliques of Ancient English Poetry*, ed. G. Gilfillan. 3 vols, Edinburgh, 1894.
Pitt, William Morton, *An Address to the Landed Interest*. 1797.
Plaw, James, *Ferme Ornée: or Rural Improvements*. 1796.
Plumtre, James, *The Lakers*. 1797.
Pope, Alexander, *Poems*, ed. J. Butt. 1963.
Postlethwayt, Malachy, *The Universal Dictionary of Trade and Commerce*. 2 vols, 1774.
Potter, Robert, *Observations on the Poor Laws*. 1775.
—— *Poems*. 1774.
Price, Joseph, *The Saddle Put on the Right Horse: or, an Enquiry into the Reason why certain Persons have been denominated Nabobs*. 1783.
Price, Thomas, *The Life, Voyages and Adventures of Bampfylde-Moore Carew; commonly called, King of the Beggars*. 1785.
Price, Uvedale, *An Account of the Statues, Pictures, and Temples in Greece Translated from the Greek of Pausanias*. 1780.
—— *Dialogue on the Distinct Characters of the Picturesque and the Beautiful*. Hereford, 1801.
—— *An Essay on the Modern Pronunciation of the Greek and Latin Languages*. Oxford, 1827.
—— *An Essay on the Picturesque*. 1794.
—— *Essays on the Picturesque*. New ed., 2 vols, Hereford and London, 1796–98; 3 vols, 1810.
—— *A Letter to H. Repton, Esq*. 1795.
—— 'On the Bad Effects of Stripping and Cropping Trees', *Annals of Agriculture*, V, 1786, pp. 341–50.
—— *Thoughts on the Defence of Property Addressed to the County of Hereford*. Hereford and London, 1797.
Priestley, Joseph, *Discourses on the Evidence of Revealed Religion*. 1794.
—— *An Essay on the First Principles of Government*. 1768.
—— *Letters to the Rt. Hon. Edmund Burke*.

1791.
Rees, Thomas, *The Beauties of England and Wales, Vol. XVIII: South Wales*. 1815.
Reeve, Joseph, *Ugbrooke Park*. 1776.
Reid, Thomas, *Essays on the Active Powers of Man*. Edinburgh, 1788.
—— *Inquiry and Essays*, ed. Ronald E. Beanblossom. Indianapolis, 1983.
Reports from Committees of the House of Commons, vol. IX, 1803.
Repton, Humphry, *Fragments on the Theory and Practice of Landscape Gardening*. 1816.
—— *The Landscape Gardening and Landscape Architecture of the Late Humphry Repton, Esq.*, ed. J. C. Loudon. 1840.
Reynolds, Sir Joshua, *Discourses on Art*, ed. Robert R. Wark. New Haven and London, 1975.
—— *Letters*, ed. F. W. Hilles. Cambridge, 1929.
—— *Literary Works*, ed. Edmond Malone. 3 vols, 1819.
Richardson, Samuel, *Sir Charles Grandison*, ed. Jocelyn Harris. Oxford, 1986.
Robinson, Peter, *Rural Architecture*. 1823.
—— *Village Architecture*. 1830.
Romilly, Sir Samuel, *Memoirs*. 3vols, 1840.
Ruggles, Thomas, *The History of the Poor: Their Rights, Duties, and the Laws Respecting them*. 2 vols, 1793–94.
——, 'On Planting and the Use of Trees', *Annals of Agriculture*, V, 1786, pp. 180–86.
—— 'On Picturesque Farming', *Annals of Agriculture*, VI, 1786, pp. 175–84, VII, 1786, pp. 20–28, VIII, 1787, pp. 89–97.
Ruskin, John, *Modern Painters*. 5 vols, 1843–60.
—— *Works*, ed. E. T. Cook and A. Wedderburn. 39 vols, 1903–12.
Rutherforth, Thomas, *A Sermon Preached Before the President and Governors of Addenbrooke's Hospital, On Thursday, June 27, 1771*. Cambridge, 1771.
Sabatier, William, *A Treatise on Poverty, Its Consequences, and the Remedy*. 1797.
Scott, John, *Amwell, A Descriptive Poem*. 1776.
—— *Critical Essays*. 1785.
—— *Observations on the Present State of the Parochial and Vagrant Poor*. 1773.
Scott, Sir Walter, *Familiar Letters*, ed. D. Douglas. 2 vols, Edinburgh, 1894.
Secker, Thomas, *Eight Charges*. 1769.
Shaftesbury, Lord, *Characteristicks of Men, Manners, Opinions, Times*. 1711.
Shaw, Stebbing, *The History and Antiquities of Staffordshire*. 2 vols, 1798–1801.
—— *A Tour To the West of England*. 1789.
Shenstone, William, *Works*. 3rd ed., 2 vols, 1768.

Sinclair, Sir John, *Correspondence*. 2 vols, 1981.

—— 'Observations on the Means of Enabling a Cottager to keep a Cow', *Annals of Agriculture*, XXXVII, 1801, pp. 231–46.

Skrine, Henry, *Two Successive Tours throughout the whole of Wales*. 1798.

Smart, Christopher, *Selected Poems*, ed. K. Williamson and M. Walsh. Harmondsworth, 1990.

Smith, Adam, *Correspondence*, ed. E. Mossner and I. S. Ross. Oxford, 1987.

—— *Essays on Philosophical Subjects*, ed. W. P. D. Wightman and J. C. Bryce. Oxford, 1980.

—— *An Inquiry Into the Nature and Causes of the Wealth of Nations*, ed. R. H. Campbell and A. S. Skinner. 2 vols, Oxford, 1976.

—— *The Theory of Moral Sentiments*, ed. D. D. Raphael and A. L. Macfie. Oxford, 1976.

Smith, Sir James Edward, *A Tour to Hafod*. 1810.

Smith, John Thomas, *Remarks on Rural Scenery*. 1797.

Smollett, Tobias, *The Adventures of Roderick Random*, ed. Paul-Gabriel Boucé. Oxford, 1979.

—— *The Expedition of Humphrey Clinker*, ed. L. Rice-Oxley. Oxford, 1925.

—— *The Life and Adventures of Sir Launcelot Greaves*, ed. P. Wagner. Harmondsworth, 1988.

Soane, Sir John, *Plans, Elevations, and Sections of Buildings*. 1788.

—— *Sketches in Architecture: Containing Plans and Elevations of Cottages, Villas, and Other Useful Buildings with Characteristic Scenery*. 1793.

Southey, Robert, *The Doctor*. 6 vols, 1834–47.

—— *Essays, Moral and Political*. 2 vols, 1832.

—— *Letters from England*, ed. J. Simmons. 1951.

—— *Sir Thomas More: or, Colloquies on the Progress and Prospects of Society*. 2 vols, 1829.

Spence, Thomas, *The End of Oppression*. 2nd ed., 1795.

—— *Pig's Meat: or, Lessons for the Swinish Multitude*. 3 vols, 1793–6.

Stewart, Dugald, *Philosophical Essays*. Edinburgh, 1810.

Sullivan, Francis, *An Historical Treatise on the Feudal Law*. 1772.

Sullivan, Richard Joseph, *A Tour Through Parts of England, Scotland, and Wales in 1778*. 2 vols, 1785.

—— *Observations made during a Tour through Parts of England, Scotland and Wales*. 1780.

Surtees, Robert, *The History and Antiquities of the County Palatine of Durham*. 4 vols, 1816–40.

Switzer, Stephen, *Ichnographia Rustica*. 3 vols, 1718; 2nd ed., 1742.

Taylor, Thomas, *Selected Writings*, ed. K. Raine and G. M. Harper. 1969.

Temple, Sir William, *Works*. 2 vols, 1740.

Thelwall, John, *The Rights of Nature Against the Usurpations of Establishments*. 1796.

Thicknesse, Philip, *An Account of the Four Persons Found Starved to Death, at Datchworth in Hertfordshire*. 1769.

—— *A Sketch of the Life and Paintings of Thomas Gainsborough, Esq.* 1788.

—— *Memoirs and Anecdotes of Philip Thicknesse*. Dublin, 1790.

—— *Sketches and Characters of the most Eminent and most Singular Persons now Living*. Bristol, 1770.

Thomson, James, *The Seasons*. 1746.

Throsby, John, *Select Views in Leicestershire*. 1789.

Townsend, George, ed., *The Theological Works of the First Viscount Barrington*. 3 vols, 1828.

Townsend, Joseph, *A Dissertation on the Poor Laws*, ed. A. Montagu. Berkeley, 1971.

Tyrwhitt, Robert, *Two Discourses on the Creation of All Things by Jesus Christ*. Cambridge, 1787.

Vancouver, John, *An Enquiry into the Causes and Production of Poverty*. 1796.

Vincent, William, *A Sermon Preached at the Anniversary Meeting of the Sons of the Clergy, Thursday, May 14, 1789*. 1789.

Walker, Adam, *Remarks made in a Tour from London to the Lakes*. 1792.

Walpole, Horace, *Last Journals*, ed. A. Francis Steuart. 2 vols, 1910.

—— *Works*. 5 vols, 1798.

Wansey, Henry, *Thoughts on Poor-Houses*. 1801.

Warburton, William, *Works*. 7 vols, 1788.

—— *Letters from a Late Eminent Prelate to One of His Friends*, ed. Richard Hurd. 2nd ed., 1809.

Warner, Richard, *Excursions from Bath*. Bath, 1801.

—— *Literary Recollections*. 2 vols, 1830.

—— *A Walk Through Wales*. 3rd ed., Bath, 1799.

—— *A Second Walk Through Wales*. Bath, 1799.

Warren, John, *A Sermon Preached at the Anniversary Meeting of the Sons of the Clergy, on Thursday, May 14, 1778*, 1778.

—— *A Sermon Preached before the Governors of Addenbrooke's Hospital, on Thursday, June*

27, 1776. Cambridge, 1776.

Watson, Richard, *A Charge Delivered to the Clergy of the Archdeaconry of Ely on Thursday, June 12, 1788*. Cambridge, 1788.

—— *Miscellaneous Tracts*. 2 vols, 1815.

—— *A Sermon Preached before the Stewards of the Westminster Dispensary, April 1785*. With an Appendix. 1793.

Watts, William, *Seats of the Nobility and Gentry*. 1779.

Whately, Thomas, 'Considerations on the Trade and Finances of this Kingdom', in *A Collection of Scarce and Interesting Tracts* (4 vols, 1787–88) vol. II, pp. 69–205.

—— *Observations on Modern Gardening*. Dublin, 1770.

—— 'Remarks on the Budget', in *A Collection of Scarce and Interesting Tracts*, vol. I, pp. 319–43.

White, Gilbert, *Journals*, ed. W. Johnson. 1931.

—— *The Natural History and Antiquities of Selborne*, ed. Richard Mabey. Harmondsworth, 1977.

Whitehead, William, *Plays and Poems*. 2 vols, 1774.

Whiteley, Joseph, *An Essay on the Advantages of Revelation*. Leeds, 1787.

—— *An Essay on the Rewards of Eternity*. Leeds, 1785.

Wilberforce, William, *A Practical View of the Prevailing Religious System of Professed Christians*. 1797.

Wood, Isaac, *A Letter to Sir William Pulteney, Bart*. Shrewsbury, 1797.

—— *Some Account of the Shrewsbury House of Industry*. 2nd ed., Shrewbury, 1791.

Wood, John, *A Series of Plans for Cottages; or Habitations for the Labourer*. 1806.

Woodward, Richard, *An Address to the Publick, on the Expediency of a Regular Plan for the Maintenance and Government of the Poor*. Dublin, 1768.

—— *An Argument in Support of the Right of the Poor in the Kingdom of Ireland, to a National Provision*. Dublin, 1768.

Wordsworth, William, *Literary Criticism*, ed. Nowell C. Smith. 1905.

—— *The Prelude*, ed. Ernest de Selincourt. 1926.

—— *The Early Letters of William and Dorothy Wordsworth (1787–1805)*, ed. E. de Selincourt. Oxford, 1935.

—— *The Letters of William and Dorothy Wordsworth: The Middle Years*, ed. E. de Selincourt. 2 vols, Oxford, 1937.

—— *The Letters of William and Dorothy Wordsworth: The Later Years (1821–50)*, ed. E. de Selincourt. 3 vols, Oxford, 1939.

—— *The Poems*, ed. Thomas Hutchinson. Oxford, 1923.

—— *Prose Works*, ed. A. B. Grosart. 3 vols, 1876.

—— *Prose Works*, ed. W. B. J. Owen and J. B. Smyser. 3 vols, Oxford, 1974.

Woty, William, *Church Langton: A Poem*. Leicester, 1776.

Wraxall, Sir Nathaniel, *A Short Review of the Political State of Great-Britain, at the Commencement of the year 1787*. 1787.

—— *The Historical and the Posthumous Memoirs*. 5 vols, 1884.

Yorke, James, *A Sermon Preached in the Chapel of the Magdalen-Hospital, Thursday, May 4, 1775*. 1775.

—— *A Sermon Preached on Tuesday, the 30th of April, 1776, at the Parish Church of St. George, Hanover Square*. 1776.

—— *A Sermon Preached at St. Clement Dane, On St. David's Day, March 1, 1775*. 1775.

Young, Arthur, *Autobiography*, ed. M. Bentham-Edwards. 1898.

—— *An Enquiry Into the State of the Public Mind amongst the Lower Classes*. 1798.

—— *General Report on Enclosures*. 1808.

Young, Arthur, ed. *Annals of Agriculture and Other Useful Arts*. 45 vols. London and Bury St Edmunds, 1784–1808.

Young, Edward, *The Centaur not Fabulous*. 1755.

—— *Night Thoughts*, ed. G. Gilfillan. Edinburgh, 1853. (First published 1742–4.)

Young, Sir William, *The British Constitution of Government, Compared with that of a Democratic Republic*. 2nd ed., 1793.

—— *Considerations on the subject of Poor-Houses and Work-Houses*. 1796.

—— *The History of Athens Politically and Philosophically Considered*. 1786.

Zouch, Henry, *An Account of the Present Daring Practices of Night-Hunters*. 1786.

Secondary Sources

Allen, Beverly Sprague, *Tides in English Taste, 1619–1800*. 2 vols, Cambridge, MA, 1937.

Andrews, Malcolm, *The Search for the Picturesque*. Aldershot, 1989.

Barbier, Carl Paul, *Samuel Rogers and William Gilpin: Their Friendship and Correspondence*. 1959.

—— *William Gilpin*. Oxford, 1963.

Barrell, John, *An Equal, Wide Survey*. 1983.

—— *The Idea of Landscape and the Sense of Place: An Approach to the Poetry of John Clare*. Cambridge, 1972.

—— *The Dark Side of the Landscape: The Rural Poor in English Painting, 1730–1840*. Cambridge, 1980.

—— *The Political Theory of Painting from Reynolds to Hazlitt*. New Haven and London, 1986.

—— *The Birth of Pandora*. 1992.

Bateson, Gregory, *Mind and Nature: A Necessary Unity*. New York, 1979.

—— *Steps to an Ecology of Mind*. New York, 1972.

Batey, Mavis, 'Nuneham Courtenay', *Oxoniensia*, 33, 1969, pp. 108–24.

—— 'Nuneham Park, Oxfordshire', *Country Life*, 12 September 1968, pp. 640–2.

—— 'William Mason, English Gardener', *Garden History*, I, no. 2, February 1973, pp. 11–25.

Bennett, Shelley M., *Thomas Stothard*. New York, 1988.

Beresford, Maurice, *The Lost Villages of England*. 1954.

Bermingham, Ann, *Landscape and Ideology*. Berkeley, 1986.

Bicknell, Peter, *Beauty, Horror and Immensity: Picturesque Landscape in Britain 1750–1850*. Cambridge, 1981.

Börsch-Supan, E., *Garten, — Landschafts, — und Paradiesmotive in Innenraum*. Berlin, 1967.

Bray, Anna, *The Life of Thomas Stothard, R. A.* 1851.

Brown, Ford K., *Fathers of the Victorians*. Cambridge, 1961.

Butler, Marilyn, *Romantics, Rebels and Reactionaries*. Oxford, 1981.

Cantor, Geoffrey, *Michael Faraday: Sandemanian and Scientist*. Basingstoke, 1991.

Carter, George, and Goode, Patrick, *Humphry Repton*. Norwich, 1982.

Chandler, James K., *Wordworth's Second Nature*. Chicago, 1984.

Chase, I. W. U., *Horace Walpole: Gardenist*. Princeton, 1943.

Clark, J. C. D., *Revolution and Rebellion*. Cambridge, 1986.

—— *English Society 1688–1832: Ideology, Social Structure and Political Practice*. Cambridge, 1985.

Clark, Stephen R. L., *The Nature of the Beast*. Oxford, 1984.

Clarke, George B., 'Grecian Taste and Gothic Virtue. Lord Cobham's Gardening Programme and its Iconography', *Apollo*, XCVII, June 1973, pp. 566–71.

Clarke, Michael, and Penny, Nicholas, eds, *The Arrogant Connoisseur: Richard Payne Knight, 1751–1824*. Manchester, 1982.

Colley, Linda, *In Defiance of Oligarchy: The Tory Party 1714–60*. Cambridge, 1982.

Collingwood, R. G., *The Idea of Nature*. Oxford, 1945.

Colvin, Howard, et al., *Architectural Drawings from Lowther Castle*. 1980.

Cooke, William, *Collections towards the History and Antiquities of the County of Hereford*. 1892.

Cornforth, John, 'The Making of the Bowood Landscape', *Country Life*, 7 September 1972, pp. 546–9.

Cosgrove, Denis, and Daniels, Stephen, eds, *The Iconography of Landscape*. Cambridge, 1988.

Cunningham, Andrew, and Jardine, Nicholas, eds, *Romanticism and the Sciences*. Cambridge, 1990.

Daniels, Stephen, 'The political iconography of woodland' in D. Cosgrove and S. Daniels, *The Iconography of Landscape*. 1988.

Darley, Gillian, *Villages of Vision*. 1975.

[De Wolfe, Ivor] 'Townscape: A Plea for an English Visual Philosophy founded on the True Rock of Sir Uvedale Price', *Architectural Review*, 106, 1949, pp. 355–62.

Downes, Kerry, *Vanbrugh*. 1977.

Egerton, Judy, *Wright of Derby*. 1990.

Enaudi, A. 'The British Background of Burke's Political Philosophy', *Political Science Quarterly*, 49, 1934, pp. 576–98.

Erskine-Hill, Howard, *The Social Milieu of Alexander Pope*. 1975.

Everett, Nigel, 'Country Justice: The Literature of Landscape Improvement and English Conservatism, with Particular Reference to the 1790's', Ph.D. diss., Cambridge University, 1977.

Foster, John, and Robinson, Howard, *Essays on Berkeley: A Tercentennial Celebration*. Oxford, 1985.

Friedman, Michael, *The Making of a Tory Humanist*. New York, 1979.

Fuller, Peter, *Theoria: Art and the Absence of Grace*. 1988.

Gage, John, *Colour in Turner: Poetry and Truth*. 1969.

Gill, R., *Happy Rural Seat, the English Country House and the Literary Imagination*. New Haven, 1972.

Gilmour, Ian, *Riot, Risings and Revolution*. 1992.

Girouard, Mark, *Life in the English Country*

House. New Haven and London, 1978.

Gold, John R., and Burgess, Jacquelin, *Valued Environments.* 1982.

Grigson, Geoffrey, 'Kubla Khan in Wales', *Cornhill Magazine*, 162, 1947, pp. 275–83.

Hammond, J. L. and Barbara, *Lord Shaftesbury.* 1923.

Harris, John, *Sir William Chambers, Knight of the Polar Star.* 1970.

Hayes, John, *Thomas Gainsborough.* 1980.

Henrey, Blanche, *British Botanical and Horticultural Literature Before 1800.* 3 vols, London, 1975.

Hewlings, Richard, *Chiswick House and Gardens.* 1989.

Higgins, Mrs Napier, *The Bernards of Abington and Nether Winchendon.* 4 vols, 1904.

Hill, John H., *The History of the Parish of Langton.* Leicester, 1867.

Hipple, W. J., *The Beautiful, the Sublime, and the Picturesque in 18th Century British Aesthetic Theory.* Carbondale, 1957.

Honderich, Ted, *Conservatism.* Harmondsworth, 1991.

Hunt, J. D., *The Figure in the Landscape: Poetry, Painting, and Gardening during the Eighteenth Century.* Baltimore, 1977.

—— *William Kent: Landscape Garden Designer.* 1987.

Hunt, J. D., and Willis, P., eds, *The Genius of the Place: The English Landscape Garden, 1620–1820.* 1975.

Hussey, Christopher, *The Picturesque: A Study in a Point of View.* 2nd ed., 1967.

—— *English Country Houses: Mid Georgian (1760–1800).* 1956.

Hyman, Anthony, *Charles Babbage: Pioneer of the Computer.* Oxford, 1982.

Hyman, John, *The Imitation of Nature.* Oxford, 1989.

Ignatieff, Michael, *A Just Measure of Pain: The Penitentiary in the Industrial Revolution 1750–1850.* 1978.

Inglis-Jones, Elizabeth, *Peacocks in Paradise.* 1950.

Kerkham, Caroline, 'Hafod: Paradise Lost', *Journal of Garden History*, 11, 1991, pp. 207–16.

Kerry, Lord, 'King's Bowood Park', *Wiltshire Archaeological and Natural History Magazine*, 42, 1922–4, pp. 18–38.

Ketton-Cremer, R. W., *Felbrigg: The Story of a House.* 1962.

Lasch, Christopher, *The True and Only Heaven: Progress and its Critics.* New York, 1991.

Leask, Nigel, *The Politics of the Imagination in Coleridge's Critical Thought.* Basingstoke, 1988.

Lovejoy, A. O., *Essays in the History of Ideas.* Baltimore, MD, 1948.

—— *The Great Chain of Being.* Cambridge, MA, 1936.

Maccubbin, Robert Purks, ed., *'Tis Nature's Fault: Unauthorized Sexuality during the Enlightenment.* Cambridge, 1987.

Macfarlane, Alan, *The Culture of Capitalism.* Oxford, 1987.

—— *The Origins of English Individualism.* Oxford, 1978.

McKendrick, Neil, et al., *The Birth of a Consumer Society: The Commercialization of 18th Century England.* 1982.

McMordie, M., 'Picturesque Pattern Books and Pre-Victorian Designers', *Architectural History*, 18, 1975, pp. 43–59.

Mabey, Richard, *The Common Ground.* 1980.

Mabey, Richard, ed., *Second Nature.* 1984.

Mack, Maynard, *Alexander Pope: A Life.* New Haven and London, 1985.

Mayoux, Jean-Jacques, *Richard Payne Knight et le Pittoresque.* Paris, 1932.

Meirion-Jones, G., 'Dogmersfield and Hartley Mauditt: Two Deserted Villages', *Proceedings of the Hampshire Field Club*, 26, 1970, pp. 111–27.

Messmann, Frank J., *Richard Payne Knight: The Twilight of Virtuosity.* The Hague, 1974.

Mingay, G. E., *English Landed Society in the 18th Century.* 1963.

Modiana, Raimonda, *Coleridge and the Concept of Nature.* 1985.

Moir, Esther, *The Discovery of Britain 1540–1840.* 1964.

—— *Local Government in Gloucestershire 1775–1800.* Bristol, 1969.

Moore-Colyer, R. J. ed., *A Land of Pure Delight: Selections from the Letters of Thomas Johnes.* Landysul, 1992.

Nachmani, C. W., 'The Early English Cottage Book', *Marsysas*, 14, 1968–9, pp. 67–76.

Nicolson, Majorie Hope, *Mountain Gloom and Mountain Glory.* New York, 1963.

Norris, John, *Shelburne and Reform.* 1963.

Nussbaum, Felicity, and Laura, Brown, eds, *The New 18th Century: Theory, Politics, English Literature.* New York, 1987.

O'Brien, Conor Cruise, *The Great Melody: A Thematic Biography of Edmund Burke.* 1992.

Olson, Alison, *The Radical Duke.* Oxford, 1961.

Oswald, Arthur, *Country Houses of Dorset.* 1959.

—— 'Market Town into Model Village: Milton Abbas, Dorset', *Country Life*, 29 September 1966, pp. 762–6.

—— 'Milton Abbey, Dorset', *Country Life*, 30 June 1966, pp. 1718–22; 21 July 1966, pp. 152–6; 28 July 1966, pp. 208–12.

Parker, R. A. C., *Coke of Norfolk: A Financial and Agricultural Study*. Oxford, 1975.

Parreaux, A., and Plaisant, M., eds, *Jardins et paysages: le style Anglais*. 2 vols, Lille, 1977.

Paulson, Ronald, *Representations of Revolution (1789–1820)*. New Haven, 1983.

Pentin, Herbert, 'The Old Town of Milton Abbey', *Proceedings of the Dorset Natural History and Antiquarian Field Club*, 25, 1903, pp. 1–7.

Perkins, Thomas, and Pentin, Herbert, *Memorials of Old Dorset*. 1907.

Pevsner, Sir Nikolaus, *The Englishness of English Art*. 1956.

—— *Studies in Art, Architecture and Design*. 2 vols, 1968.

Pevsner, Sir Nikolaus, ed., *The Picturesque Garden and Its Influence Outside the British Isles*. Washington, 1974.

Piggott, Stuart, *William Stukeley: An 18th Century Antiquary*. New ed., 1985.

Piper, John, 'Decrepit Glory — A Tour of Hafod', *Architectural Review*, 87, June 1940, pp. 207–10.

Plumb, J. H., *The Growth of Political Stability in England 1675–1725*. 1967.

Pocock, J. G. A., *The Ancient Constitution and the Feudal Law*. Cambridge, 1957.

—— 'Burke and the Ancient Constitution — A Problem in the History of Ideas', *Historical Journal*, 3, 1960, pp. 125–43.

—— *Virtue, Commerce, and History*. Cambridge, 1985.

Polanyi, Michael, and Prosch, Harry, *Meaning*. Chicago, 1975.

Pugh, Simon, ed., *Reading Landscape: Country — City — Capital*. Manchester, 1990.

Rackham, Oliver, *The History of the Countryside*. 1986.

Roberts, J. F. A., *William Gilpin and Picturesque Beauty*. Cambridge, 1944.

Robinson, John Martin, *Georgian Model Farms*. Oxford, 1983.

—— *Shugborough*. 1989.

Robinson, Sidney K., *Inquiry into the Picturesque*. Chicago, 1991.

Rosenthal, Michael, *British Landscape Painting*. Oxford, 1982.

—— *Constable: The Painter and His Landscape*. New Haven and London, 1983.

Roskill, Lord, *Report of the Commission on the Third London Airport*. 1968–70.

Royal Commission on Historical Monuments, *An Inventory of Historical Monuments in the County of Dorset*, vol. III, *Central Dorset*. 1970.

Sambrook, James, *William Cobbett*. 1973.

Scull, Andrew T., *Museums of Madness: The Social Organization of Insanity in 19th Century England*. Harmondsworth, 1979.

Shearer, E.A., 'Wordsworth and Coleridge Marginalia in a Copy of Richard Payne Knight's *Analytical Inquiry into the Principles of Taste*', *Huntingdon Library Quarterly*, 1, 1937, pp. 63–99.

Simpson, David, *Wordsworth and the Figurings of the Real*. Basingstoke, 1982.

Smith, Olivia, *The Politics of Language 1791–1819*. Oxford, 1984.

Snell, K. D. M., *Annals of the Labouring Poor*. Cambridge, 1985.

Solkin, David H., *Richard Wilson: The Landscape of Reaction*. 1982.

Souden, David, *Wimpole Hall*. 1991.

Starobinski, Jean, *L'Invention de la Liberté 1700–1789*. Geneva, 1964.

Streatfield, David C. and Duckworth, Alisdair, *Landscape in the Gardens and Literature of 18th Century England*. Los Angeles, 1981.

Stroud, Dorothy, *Capability Brown*. 2nd ed., 1975.

—— *Humphry Repton*, 1962.

Sutherland, Lucy, *The East India Company in Eighteenth Century Politics*. Oxford, 1952.

Sykes, Norman, *Church and State in England in the XVIIIth Century*. Cambridge, 1934.

Temple, Nigel, *John Nash and the Village Picturesque*. Gloucester, 1979.

Templeman, William, *The Life and Work of William Gilpin*, Urbana, 1939.

Thomas, J., 'The Architectural Development of Hafod: 1786–1882', *Ceredigion, Journal of the Ceredigion Antiquarian Society*, VI, 1973, pp. 152–69; VII, 1974–5, pp. 215–29.

Thomas, Keith, *Man and the Natural World*. 1983.

Thompson, E. P., *The Making of the English Working Class*. Harmondsworth, 1968.

—— 'Patrician Society, Plebeian Culture?', *Journal of Social History*, 7, 1974, pp. 382–405.

—— 'The Moral Economy of the English Crowd in the Eighteenth Century', *Past and Present*, no. 50, February 1971, pp. 76–136.

—— *Whigs and Hunters: The Origin of the Black Act*. 1975.

Thompson, E. P., et al., *Albion's Fatal Tree*. 1975.

Walker, A. K., *William Law: His Life and Thought*. 1973.

Warnock, G. J., *Berkeley*. Oxford, 1953.

Watkin, David, *Thomas Hope and the Neoclassical Idea*. 1968.

—— *Morality and Architecture*. Oxford, 1977.

—— *The English Vision: The Picturesque in Architecture, Landscape and Garden Design*. 1982.

Whistler, Laurence, *Stowe*. 1956.

Willetts, David, *Modern Conservatism*. Harmondsworth, 1992.

Williams, Raymond, *The Country and the City*. 1973.

Williams-Ellis, Clough, ed., *England and the Octopus*. 1928.

Williamson, Thomas, and Bellamy, E., *Property and Landscape*. 1987.

Willis, Peter, *Charles Bridgeman and the English Landscape Garden*. 1977.

Willis, Peter, ed., *Furor Hortensis: Essays on the History of the English Landscape Garden*. Edinburgh, 1974.

Wittkower, Rudolf, *Palladio and English Palladianism*. 1974.

Woodbridge, Kenneth, *Landscape and Antiquity: Aspects of English Culture at Stourhead, 1718 to 1838*. Oxford, 1970.

Woodham-Smith, Cecil, *The Great Hunger: Ireland 1845–1849*. Harmondsworth, 1991 (first published 1962).

Index